Women's Studies
in Transition

Women's Studies in Transition

The Pursuit of Interdisciplinarity

Edited by
Kate Conway-Turner,
Suzanne Cherrin, Jessica Schiffman,
and Kathleen Doherty Turkel

DELAWARE

Newark: University of Delaware Press
London: Associated University Presses

© 1998 by Associated University Presses, Inc.

All rights reserved. Authorization to photocopy items for internal or personal use, or the internal or personal use of specific clients, is granted by the copyright owner, provided that a base fee of $10.00, plus eight cents per page, per copy is paid directly to the Copyright Clearance Center, 222 Rosewood Drive, Danvers, Massachusetts 01923. [0-87413-643-1/98 $10.00 + 8¢ pp, pc.]

Associated University Presses
440 Forsgate Drive
Cranbury, NJ 08512

Associated University Presses
16 Barter Street
London WC1A 2AH, England

Associated University Presses
P.O. Box 338, Port Credit
Mississauga, Ontario
Canada L5G 4L8

The paper used in this publication meets the requirements of the American National Standard for Permanence of Paper for Printed Library Materials Z39.48-1984.

Library of Congress Cataloging-in-Publication Data

Women's studies in transition : the pursuit of interdisciplinarity /
edited by Kate Conway-Turner . . . [et al.].
 p. cm.
 Includes bibliographical references and index.
 ISBN 0-87413-643-1 (alk. paper)
 1. Women's studies. 2. Women—Research—Methodology. 3. Feminist
theory. 4. Feminism—Research—Methodology. 5. Interdisciplinary
research. I. Conway-Turner, Kate.
HQ1180.W679 1998
305.4'07—dc21
 97-47689
 CIP

PRINTED IN THE UNITED STATES OF AMERICA

Contents

6 CONTENTS

Women's Studies
in Transition

Introduction

KATE CONWAY-TURNER

THIS volume is an expression of joy in that it commemorates the twentieth anniversary of the Women's Studies Program at the University of Delaware. This program was part of the early wave of women's studies program development. Our twenty-plus year history at this institution has created a legacy of scholarship, curriculum development, and application of feminist research that frames our current academic work. This volume illustrates the distance that this and similar women's studies programs across the country have traveled from the early 1970s, when the first programs were cautiously begun, to the current existence of many well-developed programs and departments in the 1990s. This volume also reflects the rich resources available to women's studies scholars as they work individually and collectively to explore the impact of gender from interdisciplinary perspectives.

All essays housed in this volume were originally presented at a conference commemorating the twentieth anniversary of women's studies at the University of Delaware, in April 1994. For two days, over one hundred scholars came together from across the nation and presented material focusing on the conference theme of "Interdisciplinarity and Identity." This selection of essays represents works that address the need for women's studies scholarship to cut across disciplines, to be located within a feminist framework, to continually redefine and develop appropriate methodologies, and to translate our academic work into products that address critical issues and concerns facing women and women's creative scholarship.

This volume is divided into three sections: "Feminist Theory," "Feminist Methodology," and "Translating Feminist Work into Action." In the section on feminist theory, representing varied disciplines and exploring different contextual issues, researchers explore issues of feminist theory, particularly as it guides us into the future. Robert Jensen in "Men's Lives and Feminist Theory" challenges men

to embrace feminist philosophies and Margaret Randall in "Gathering Rage: The Failure of Twentieth-Century Revolutions to Develop a Feminist Agenda" invites societies to look more closely and to use feminist theory in developing societal agendas. However, the other authors, Karen Bojar, Blanche Radford Curry, and Alma Vinyard demand that feminist theorists critically explore less obvious parameters and include often excluded subpopulations. Section 2 provides a glimpse of the diversity of methodologies that may be used when engaging in feminist explorations. Emanating from distinct disciplinary backgrounds (literature, music, theology, and human development) these scholars examine the use of, and development of, methodologies that allow them to engage in feminist research. In "Subject to Speculation: Assessing the Lives of African-American Women in the Nineteenth Century," Carla L. Peterson validates the use of speculation as a tool in feminist research; Victoria O'Reilly and Joy Bostic develop and define feminist methodologies in and through music. This section concludes with Mary Morgan in "The Process of Critical Science in Exploring Racism and Sexism with Black College Women" utilizing a participatory methodology in exploring racism in the lives of African-American college women.

In section 3, scholars focus their attention on translating feminist work into action. Investigating different domains (medicine, science/math, and family and public policy) researchers translate their feminist scholarship into areas of application. In the essay, "Crossing Boundaries: Bringing Life into Learning," Ellen Goldsmith and Sonja Jackson use poetry to enhance the teaching of a patient care course in radiologic technology. This essay provides an excellent example of how interdisciplinarity can create an environment for heightened learning. In the subsection on science and math, John Kellermeier uses social scientific information on race, class, gender, and feminist thought in the development of a class exploring Eurocentrism and androcentrism in mathematics. In "Interdisciplinarity in Research on Wife Abuse: Can Academics and Activists Work Together?," Jacquelyn C. Campbell challenges scholars and activists to cross the boundaries that have typically divided them and thus, truly meet the needs of women who have been abused. These examples are a few of the many ways in which scholars challenge the boundaries of disciplines to address concrete concerns.

The tradition of calling on multiple disciplines to explore the impact of gender is one that characterizes the national trend in women's studies. The multidisciplinary contributions to women's studies reflect the multiple domains that typify feminist scholarship nationally.

These sections together represent scholarly work that is centered in feminist theory, focused on the continual refinement of feminist methodologies, and primed to continue the challenge of translating the academic to action. These scholars represent the breadth of research across the academy that continues to explore women's issues.

Section 1
Feminist Theory

Introduction

SUZANNE CHERRIN

A man tries to break down his steady girlfriend's resistance to sexual intercourse, yet even as he coerces her, he is troubled by the mixed messages of his own sexual lessons. A woman disagrees with many of the gender directives stemming from Catholic theology, yet she continues church-based volunteer activities because through them she remains a vital member of an "enduring community." She feels that she belongs. Women in past and contemporary revolutions participate because they believe they are working for a progressive, egalitarian future. All too often, the resulting government fails to develop a feminist agenda, leaving women disillusioned and weakening the nation's humanitarian potential. An African-American woman and a European-American woman come together at a feminist conference. The white woman tries to establish rapport by focusing on their common challenges and oppressions. This strategy does not create a sense of unity; instead the black woman feels misunderstood, marginalized, at worst invisible. A women's studies professor tells students that the feminist perspective seeks to eliminate multiple oppressions, but subsequent examples almost always focus on a white middle-class U.S. norm.

Theories are constructed from real-life observations like these. General frameworks help to interpret reality and to guide social action. The best theories can be applied to a wide range of situations and can be modified when too many contradictions appear. All feminist theories critique patriarchy. They seek nothing less radical than to equalize the distribution of power between women and men. The essays in this section represent some of the most exciting examples of the uses of feminist theory and offer suggestions to enhance personal growth, to bridge differences, and to effect positive change by transforming theory into action. In some instances, concrete interpersonal and social situations challenge an application of existing feminist frameworks. By viewing feminist thought through the contingencies of diverse human experience, we open our minds to new ques-

15

tions and ultimately create better theories and develop more appropriate action.

Robert Jensen believes that feminism goes beyond an analysis of men's oppression of women. He would like to convince men to take the feminist perspective seriously and personally. Feminism, says Jensen, explains one's social location in an interlocking system of multiple oppressions "based on similar dynamics of domination and subordination." His appeal to men to embrace a profeminist perspective is probably most effective when he connects sexism to the isolation, alienation, and pain many men in our culture experience. A common theme in contemporary men's movements is the "father wound." Many males have grown up with emotionally distant to outright abusive fathers—the result of masculine socialization. Jensen may make male readers uncomfortable in his discussion of the relationship of sex to attempted rape. He strives to convince readers that male privilege has malignant side effects for men, that feminism doesn't male-bash and that as a perspective it remains the best comprehensive challenge to breaking down gender and other hierarchical systems. This essay is sure to raise questions and to open minds.

Despite the fact that all feminist perspectives share an interest in gender equality, they differ on how best to achieve it. Cultural or "difference" feminists view women and men as socially and emotionally dichotomous. In this view female advancement could be accomplished by enhancing and valuing women's unique contributions to society. On the other hand, "women's rights" feminism, expressed by a liberal feminist agenda, assumes that gender differences are a social construction and that an appropriate goal of feminism is to facilitate parity by offering women equal job opportunity, individual expression, and integration into all aspects of public life. Karen Bojar's examination of volunteerism provides a model to further explore the component of these perspectives. Her account of the history and current status of women's volunteer activities raises an important question. Does volunteerism subvert women's strides toward equality or does it provide an alternative route to public involvement and individual recognition? The answer to this question is far from simple. For example, Bojar points out that women are increasingly called on to do extracurricular work as a normal part of their jobs. Feminist organizations, like traditional organizations, rely on the unpaid services of women. She also brings personal satisfaction into the equation, declaring that women's involvement in the traditional volunteer area provides more of a "permanent" community than "progressive" organizations. (Caregiving provided through women's volunteer work supports social well-being, and

may bring about intrinsic rewards yet this work receives insufficient recognition.) Bojar gives us one of the clearest illustrations of some of the inherent contradictions contained under the fabric of feminism. This essay will spark a lively discussion.

Socialism and socialist revolutions promise that women will benefit from a reorganization of society, guided by the principle of equality for all. Margaret Randall uses the case of Nicaragua to demonstrate that a socialist agenda must go beyond rhetoric and fully incorporate the ideals of gender equality to deliver that promise. Randall provides a description of the status of women in Nicaragua from pre-Columbian times through the rise and downfall of the Sandanistas. She notes that Nicaraguan women wanted to be part of the revolutionary front (FSLN). Women who fought for the Sandanista cause risked their lives and were sometimes captured, tortured, and raped. Despite this, they were often utilized in very traditional roles, symbolized, for instance, by the "Committee of Mothers." They were rarely included in top leadership positions. Randall weighs evidence that the loss of Sandanista power many serve as a catalyst for greater inclusion of women in decision-making roles, fulfilling the promise of socialist feminism. These themes, connecting socialist ideas, willingness to fight for a cause, and unrealized gender equality repeat themselves throughout the world.

One of the most important challenges within feminism today is to honor the multiplicity of theoretical perspectives and corresponding practices while working to prevent destructive factionalism. Blanche Radford Curry describes how African-American women have been ignored and marginalized by European-American feminists. White women often believe they can best connect with their black, Asian, and Hispanic sisters by ignoring racism and by focusing on "common ground" issues. Curry helps us see that a "color-blind" approach deprives women (and men) of an important part of their identity. There are additional barriers to an inclusive, multicultural feminist framework: when white women equate sexism with racism it evades introspection of white privilege. Curry reviews and synthesizes past and current strategies to reach an equal and inclusive theoretical framework and plan of action. She accurately notes that diverse ethnic groups are interacting in societal institutions and that an increasing number of individuals have multiple cultural backgrounds. Should feminists represent the interest of "all" women by focusing on commonalities? According to Curry, feminists must first confront both the differences among women and the power dimension because of ethnic and racial stratification. They must then work to not deny each other, to "know" each other, and to learn

about others and themselves from this knowledge. The author provides an optimistic formula for enriching feminist theory and the feminist community through cultural pluralism. She shows how an inclusive feminist theory can be transformed into inclusive feminist action.

Alma Vinyard extends Curry's ideas to a challenge within the academy. She reminds us that those with more power and privilege are able to define those with less power and privilege. She cautions white women's studies scholars and professors to internalize respect for all women and to apply this principle in the classroom. The increasing diversity of the student population, along with the growth of global women's studies, makes egalitarian teaching even more important.

The selections here highlight diverse uses of feminist theory. These intriguing examples move theory from an abstract exercise into the multiple layers of our world and lives.

Men's Lives and Feminist Theory

ROBERT JENSEN

THE two main points of this essay may seem self-evident or simplistic to feminists, but they are important for men to consider: (1) For men who are confused (i.e., facing problems related to their emotional lives, sexuality, their place in society, and gender politics—in other words, me and virtually every other man I have ever met) feminism offers the best route to understanding the politics of such personal problems and coming to terms with those problems; and (2) if men accept the first point, feminism will confront and confuse us about ourselves, and our job is to embrace, not run, from that challenge. Put more simply, (1) Men need to take feminism seriously; and (2) to take it personally, for their own sake as well as in the interests of justice.

While these may seem like commonsense observations, they are not easy for men to come to terms with. When I began studying feminism six years ago, I did not immediately realize that feminism explained not only men's oppression of women, but my isolation, alienation, and pain. Nor did I realize that I could understand myself through feminism without denying my participation in the oppression of women or falsely equating men's and women's problems. While I understood that the personal is political, I was slow to realize that the phrase applied not only to women but to me; it took time for me to understand that feminism required me to not only criticize patriarchal constructions of masculinity in the abstract, but to be unrelenting in my critique of my own behavior.

I was socialized and trained to be a man in this culture, and like most men, I learned my lessons well. Feminism helps me reject patriarchal constructions of masculinity and, at the same time, reminds me that my identity was formed within that patriarchal construction. For me to both help myself and make good on my commitments to feminism, I must confront that male identity in a

This essay was originally published in *Race, Gender, and Class*, 2, no. 2 (winter 1995): 111–25.

19

responsible and politically progressive manner using feminist theory. If I want to understand myself and my society, I must be willing to apply, in ways that can be difficult and distressing, a feminist critique to my life, and to leave that process open to evaluation by women. This approach differs from the goals and methods of the men's movement (see various critiques in Hagan, 1992); I suggest that men should reject being part of any men's movements and—for their own sake as well as for the sake of women, children, and the world—engage feminism.

I am not suggesting that women in general, or that feminists in particular, should focus more on men's pain or that women have an obligation to like and trust men who advertise themselves as profeminist.[1] However, the common goal of liberation can connect men and women; I come to feminist theory with the realization that my future as a fully moral and responsible human being depends on women's liberation.

While this essay is rooted in personal experience, my goal is not to use it as a confessional or to hold myself up as a model; I do not write to cast myself as one of the "good guys," distinct from nonfeminist men. Instead, I want to use my own admittedly stumbling progress toward these goals to make some tentative claims about this liberatory process. I will begin with a short discussion of the contemporary men's movement and identity politics, then move on to explain why men should take feminism seriously and personally.

Male Identity

"Identity politics," as it is commonly used, suggests that group identities can be the basis of analysis and action. This essay is a call for a progressive male identity politics that uses a feminist critique of male power and male sexuality, and that requires of men an honest engagement with their lives and a commitment to real change. Because we usually think of identity politics as a way for marginalized groups, such as African Americans or lesbians and gays, to resist oppressive power, it may seem odd to talk of a progressive identity politics for heterosexual men. My male identity gives me privilege and protects me: What kind of liberatory identity politics can a straight white boy have?

By a progressive male identity politics, I mean the process of understanding one's social location and practicing a politics informed by that understanding. Identity is not static and dictated by biology,

but is the product of the obstacles or privileges that the culture in which one lives attaches to one's characteristics. Identity politics need not be essentialist nor falsely totalizing, but simply an acknowledgment of the pattern of those obstacles and privileges. If we view identity as a strategy for action, not as an essentialist marker, we can focus on how all oppressions in this culture are interlocking, mutually reinforcing, and based on some similar dynamics of domination and subordination. Identity politics is often criticized for turning people inward, toward themselves and others in their groups, and for inhibiting coalition-building. But rather than fragmenting resistance to oppression, an understanding of politics informed by identity can produce solidarity. In my own life, feminism was the first critical approach I discovered, and what I learned about power and oppression from feminist theory led me to a new understanding of racism, heterosexism, and the workings of class/wealth privilege.

Understanding identity in this way makes it possible that a man might choose to become a traitor to his privilege, to take an anti-patriarchal stance, and to do whatever work in resistance that one finds meaningful. Resistance to institutionalized sexism (which implies and demands, I think, resistance to white supremacy, heterosexism, and class-based oppression as well) is obviously not the only option, nor the most popular option with men. My goal is to find a way to persuade men that their identity politics should be based on a feminist critique, which is no small task in this culture. One of the hurdles is to convince men that feminism is not crude "male-bashing." To some men, any feminist criticism will be perceived that way, and countering that image is difficult. But in six years of interaction with feminists, including a number of lesbian and radical feminists, I have never been bashed. I have been held accountable for my behavior, and I have been told when my presence in a group was not preferred. I have not always felt comfortable listening to feminist critiques, of men or of me, but I have never been attacked, harassed, or intimidated simply for being a man. Whatever criticism I have received has been offered, if not kindly, at least clearly without malice.

Clearly, a commitment to feminism is not the only avenue open to men. A man might recognize his various forms of privilege and decide to actively work to shore up that privilege by being, if not antifeminist, at least nonfeminist. This is the approach of the men's rights movement, which casts men as the victims of women's liberation movements and of men's lack of attention to their own needs. The men's movement is right in identifying the way in which some men are hurt by rigid gender norms, but this analysis often fails to

distinguish between the suffering of those who, as a class, hold power and the oppression of those who do not. Many men are miserable in this culture, and that misery is sometimes tied to gender politics. Being miserable, however, is not the same as being oppressed (Frye, 1983, p. 1). When men experience things that we could call "oppression," they are tied to other systems of power, such as racism, class/wealth privilege, and heterosexism. None of these systems work wholly separately, but men are not oppressed along a gender axis; men are not oppressed *as men* in contemporary U.S. culture (Clatterbaugh, 1992). For example, men often point out that because they have been the only ones drafted into military service, they are oppressed (Farrell, 1993, chap. 5). This ignores the fact that certain men created and maintained a system in which only men are drafted and that men hold the vast majority of positions of power in the military. While it makes sense to talk about the way in which elite men tend to impose the duty of killing and dying disproportionately on poor or nonwhite men—to inject a class or race analysis—it is nonsensical to suggest that men are oppressed as men.

A less political path for men who want to obscure the real-life consequences of sexism for men and women is what is commonly called the "mythopoetic wing" of the men's movement, but that might more accurately be called a form of "masculinist nationalism . . . a reconstellation of patriarchal rules and roles and an attempt to consolidate cockocratic power in response to challenges from the women's movement" (Caputi and MacKenzie, 1992, pp. 71–72). These men acknowledge the problems with traditional gender roles—"the images of adult manhood given by the popular culture are worn out; a man can no longer depend on them" (Bly, 1990, p. ix)—and pay lip service to women's problems—how the "dark side of men" has resulted in the "devaluation and humiliation of women" (Bly, 1990, p. x). The mythopoetic men's movement understands that traditional markers of masculinity—repression of emotion and vulnerability, and a need to control and dominate—are destructive. But in its commitment to Bly's celebration of the "Wild Man"—to the idea that being a man is centrally about a power and strength that flows from an essential "deep" masculinity—the men's movement undercuts its own project. While some of these men believe that the solution to sexism lies in rescuing the concept of masculinity from crude machismo, my concern is that in a deeply entrenched patriarchal system, men's obsession with masculinity—no matter how it is reconceptualized—usually ends up reinforcing male power. Michael Kimmel (1992, p. 12) points out that this

movement is the latest attempt by men in American culture, in response to women's movements, "to create islands of untainted masculinity" rather than to examine critically the claim that there are essential characteristics of the masculine. Said another way by bell hooks (1992, p. 112), the emphasis of these men seems to be "more on the production of a kind of masculinity that can be safely expressed within patriarchal boundaries" than a critique of patriarchy.

The antipatriarchal position I take is rooted not only in feminist theory, but in a growing body of literature by men who embrace the insights of feminist theorists and activists. In general, these men reject essentialist explanations for men's behavior and view masculinity and femininity as social constructions (Kimmel, 1987a, p. 13). The way in which societies value some characteristics and denigrate others, and define those characteristics as male or female, is not natural, biologic, or inevitable. Men have the ability to resist negative definitions of masculinity and to change behaviors, and to challenge the notion that a single definition of masculinity should exist. As Patrick D. Hopkins puts it:

I personally do not want to be a "real man," or even an "unreal man." I want to be unmanned altogether. I want to evaluate courses of behavior and desire open to me on their pragmatic consequences not on their appropriateness to my "sex." . . . I want to betray gender. (Hopkins, 1992, p. 128)

Many of these profeminist writers also point out the uncertain and contradictory nature of masculinity. Kimmel (1987b, p. 237) suggests that the "compulsive masculinity" common in American life—marked by "violence, aggression, extreme competitiveness, a gnawing insecurity"—is "a masculinity that must always prove itself and that is always in doubt," hence the frantic drive by men to control their environments. Along with the privileges of male dominance come isolation, alienation, and pain (Kaufman, 1993).

Masculinity itself is marked with hierarchies; young, effeminate, and gay men, for example, are subordinated by other men. Carrigan, Connell, and Lee (1987) call the dominant definition of maleness "hegemonic masculinity." While most men do not live up to the macho-cowboy ideal of that definition, most men are responsible in some way for maintaining that hegemonic model and most men benefit from the institutionalization of men's dominance over women that comes with the model.

Echoing the theme of this essay, these writers suggest that it is in

men's interest to work toward a new definition of what it means to be a man, which requires a personal investment and commitment—acknowledging the "me in me(n)," as Joseph Boone puts it (1990), and by resisting the temptation to talk in abstractions instead of in one's own voice from one's own gendered body.

From here, I will defend the notion that feminism is a better route for men to come to terms with their own lives. This self-interest argument is not meant to obscure the more important argument about the oppressive nature of patriarchal values and structures, and the injustice of sexism. Numerous feminist works eloquently make the case for gender equality and against patriarchy on moral and political grounds (Frye, 1983). My approach here stems from the observation that a justice argument does not always persuade people with power to give up some of that power. As Marilyn Frye put it in an informal seminar at the University of Minnesota in 1991, if you have your foot on someone's head, you shouldn't have to be told that it is right to take it off. If the oppressor cannot see that, she pointed out, it is difficult to convince him of it through an argument about justice.

Taking Feminism Seriously

The deeper and more fundamental the critique of an unjust system, the more difficult it may be to persuade privileged people to be part of the dismantling of their privilege.[2] In this sense, I think most men do "get it"; while they may profess confusion about what women want from them, they understand at some level the nature of the feminist critique and the things at stake. If taken seriously, feminism requires men to evaluate not only the politics of public patriarchy, but their conduct in private, especially in the bedroom. Men, understandably, are often reluctant to do that, precisely because they "get it" (in the sense of understanding) and want to keep "getting it" (in the sense of consuming women's sexuality).

However, a clear presentation of feminism that appeals to men's self-interest[3]—while making it clear that the feminist movement is focused on women's lives and that feminists are not obligated to take care of men—can be effective. Feminism can help us answer many of our questions, ease our pain, heal our wounds, and allow us to be decent people because it is not just about concern for "women's issues" and not just a theory of gender relations; feminism also is an explanation and critique of the domination/subordination dynamic that structures power relations in this society. Feminism provides

an approach to society that allows women and men to better under-
stand the world in which they live and to apply insights about gender
to other struggles in life, both in the private and public spheres
(beginning with the realization that the private/public dichotomy is
problematic). Two examples, based on common concerns in the
men's movement, illustrate this. One is about what is often called
"the father wound," and the other has to do with intimacy and
sexuality.

Many contemporary men lived with fathers who were emotion-
ally repressed, unable to nurture, and who were absent, cruel, and
physically, and/or sexually abusive—father-as-terrorist. I have what
I take to be a fairly typical experience here, a father who could not
deal with his own emotions, could not control his anger, and gener-
ally was more trouble to me as a child than he was worth. My
mother played out the passive/aggressive counterpart to her unfeel-
ing and abusive husband, and had her own equally important role
in my emotional problems as a child and as a young adult. That
quick sketch obscures, of course, a complex network of relation-
ships, and for my purposes here more details about those emotional
problems are not crucial. My point is that some men take this kind
of scenario and cast the father as victim, the son as victim, and the
mother as, at best, an unimportant bystander or, at worst, as an
active agent in retarding the development of the son's male identity.

Feminism gives me a much different take on it. There was a power
discrepancy in my house: My father had it, and my mother did not.
Because of that, my father's personal failings dictated the tone of
our lives. My mother—shaped herself by similar abuses of power
in her childhood, constrained by cultural expectations, and lacking
certain kinds of social, political, economic, or physical power—
slipped into a role that both exacerbated the problems caused by my
father and created other problems. Gender politics structured those
roles and relationships, and for many reasons neither my mother
nor father had the resources to move beyond those constraints. Nei-
ther of them can be held accountable for the system into which they
were born, but both are responsible for their behavior. The key
difference, however, was that the power differential gave my father
more choices. Some men in his position made better choices. Some
women made better choices than my mother, as well, but it is im-
portant to remember that my mother acted in reaction to the power
my father, and other men, wielded.

This analysis is important because it allows me to see how the
ways in which I suffered at the hands of my father and my mother
were directly tied to the systematic, institutionalized, and unjust

distribution of power in my family and in the culture. The root of
the problem was the power my father would wield in a patriarchal
family and culture. If my father were to analyze his family history,
I believe he would come to similar conclusions about his parents; I
do not want to ignore the ways in which my father suffered as a
child and continues to suffer because of that. The father wound, for
both him and me, is real, and its resolution is important. But femi-
nist theory can help a man heal the father wound, and make clear
not only his mother's involvement in the creation of wounds, but
the nature of his mother's wounds.

My first example of the value of feminist theory to men—coping
with problems with parents—suggests that men will benefit directly
and immediately from a feminist critique. My second example,
problems with intimacy and sex with women,[4] is less optimistic for
the short term. However, feminism, especially radical critiques of
male sexuality, hold promise. The work of feminist critics (e.g.,
Dworkin, 1988) argues that the central dynamic of sexuality in patri-
archy is domination and subordination, sex as the exercise of power
and a form of control. As A. Dworkin writes:

> The normal fuck by a normal man is taken to be an act of invasion and
> ownership undertaken in a mode of predation; colonializing, forceful
> (manly) or nearly violent; the sexual act that by its nature makes her his.
> (Dworkin, 1987, p. 63)

That conception of sex is, I believe, deeply rooted in the bodies of
the vast majority of contemporary men. Any effort to reconstruct
a more healthy sexuality that is not overtly politicized—that is, does
not foreground questions of the play of power along gender, sexual
orientation, and race axes[5]—will fail.

My experience has shown me that the task of untangling myself
from the norms of patriarchal sex and rebuilding an egalitarian sexu-
ality is extraordinarily difficult. In this sense, I acknowledge that
trying to persuade men to accept a deep critique of patriarchal sex
is complicated by my inability to articulate specific alternatives. In
my life, I have gradually become more aware that the core sexual
lessons I learned as a child and as a young man in this culture were
about objectifying and consuming women and their sexuality. This
is fundamentally about being trained in a way of seeing women, to
view them first and foremost not as human beings, but as collections
of body parts to be evaluated for their sexual possibilities. That
statement is hardly ground-breaking; feminists have been pointing
this out for decades. What I want to contribute to the discussion is

an admission that overcoming that training, learning a new way of seeing, is more difficult than most of us want to admit. Despite some intellectual and emotional progress, I feel as if my sexuality is still rooted in the same way of seeing. I have made progress, some of it occurring as I write this and some of it encouraging, but that progress also sometimes seems minor in the face of the journey that lies ahead.

So, if I am correct about the nature of the work ahead, and if I cannot pretend to promise men that such work can be accomplished easily, what stake do men have in changing? What if, a man might ask, my body and I cannot find a way to feel comfortable about sex? My only answer is that if, while I struggle to expand my sense of the erotic and to find new language to use (see Lorde, 1984; Heyward, 1989), I am forced to choose between patriarchal-sex and no-sex, no-sex is the better choice. Those are not the only alternatives, of course, and I would hope that such a choice would be only temporary, but in this struggle feminist theory sustains me. Once I understood even the barest outlines of feminism, I realized why I had always felt vaguely uncomfortable about sex, why my use of pornography and consumption of women's sexuality had always left me feeling empty. Long before I had read a word of feminist theory, that feeling was with me, and from talking with other men I know that I am not idiosyncratic in this. Feminist theory helped me understand that empty feeling: Sex based on domination over another feels wrong to me. No matter how sensitive I was, no matter how much attention I paid to my partner's pleasure, there was no way for me to totally repress the understanding in my body that my sexuality was built on the objectification and commodification of women and on a need for control. Feminist theory did not create that feeling in me; feminist theory merely helped me understand it. Having a name and explanation for it did not clear up the problem, just as ignoring the problem did not make it go away. No matter how confusing and troubling it has been to sort through my sexual responses and life choices, I gladly choose that confusion and pain to the unnamed confusion and pain of a sexual life built on a need for power that is ultimately unsatisfying.

One purpose of this essay is to contribute to breaking down the silence among men on these issues. Michael Kimmel suggests that men face a "general confusion about how we experience our sexualities, a confusion that remains fixed in place because of our inability to talk frankly and openly with other men about our sexualities" (1990, p. 3). Confusion and fear are lessened, though not necessarily eliminated, by such open talk.

Taking Feminism Personally

So, when I talk about male identity politics, I do not mean the politics of men identifying their gender privilege and protecting it through various overt and covert mechanisms. I am interested in how men can be aware of their gender privilege, question it, and act as traitors to that male privilege. I suggest that we do that not only because it is the ethically and politically responsible thing to do, but because it will help us make sense of our own lives, even if at times that makes life seem confusing, tentative, undefined, and frightening. The only things more confusing and frightening, I would argue, are an unreflective commitment to patriarchy and the various strategies to pretend that the multiple oppressions that patriarchy supports do not really exist.

This work requires a willingness to confront not only the workings of patriarchy in the abstract, but one's own life in the most particular. I have not always done that, even after I identified myself as being committed to feminism. I am not convinced that most profeminist men do that. I believe men sometimes ally themselves with feminist theory or causes as a cover; once on the "right side," they feel protected from scrutiny themselves. Explaining her unwillingness to let men call themselves "feminists," Pearl Cleage argues that the label

> tends to lead to smugness, self-satisfaction and the feeling that the man who is struggling to overcome his own sexism and the sexism of his brothers has somehow achieved a more exalted status, a safe conduct pass that allows him to be a little less rigorous on himself, having demonstrated his good intentions. (1993, p. 28)

Maintaining an intense level of self-scrutiny, preferably within a supportive and honest community, is crucial to successful profeminist engagement. While I may fall short at times, it must be a central goal. When we evade that task, we are more prone to fall into the trap Cleage describes.

Again, a personal example is useful here. I have suggested that male sexual training focuses on a quest for domination and control over women, an approach to sex that John Stoltenberg (1989) has accurately labeled "rapist ethics." The implication is that men in our contemporary culture are trained to be rapists, which suggests that to not rape takes effort. If that is true, and I think it is, then the inescapable conclusion is that most men have raped or tried to rape.[6] By that, I do not mean that most men are guilty of rape as it is

legally defined, but rather that "normal" sexual activity has rapelike qualities (MacKinnon, 1989, p. 146). To take such a claim seriously is disturbing, and requires an examination of one's sexual history, but such an examination offers the best chance for positive change for individuals and society. Let me recount part of my self-examination.

Have I ever raped or tried to rape a woman? For the first thirty years of my life, I would have said no, without qualification. For four years after that, I typically said that I thought I had never raped, but that a complete answer required the input of the women with whom I had been sexually active. Now, I tend to answer with a simple yes, but that "yes" requires explanation and context.

First, a specific case. In my mid-twenties, I dated a fellow graduate student for several months, whom I will call Sue. As the relationship became more serious, I made it clear I thought sexual intercourse was appropriate. Sue was hesitant, but talked about it in a way that suggested she agreed that sex of that nature was to be expected. Through a variety of delaying tactics on her part, however, we never reached that point. On occasion, I pressured her on the subject, pushing the level of intimacy as far as I could. I took this lack of intercourse to be an indication of some serious flaw, either in the relationship or in her. For a variety of reasons, some related to sex and some not, Sue and I stopped seeing each other.

Were my sexual advances attempted rape? Legally they were not, but politically and morally, I think I can be said to have tried to rape her. One was my willingness to take a lack of vocal objection—the lack of a clearly stated "no"—to be consent, rather than assuming that any sexual contact should begin with mutual consent that comes out of human connection and communication. When I pressed physical contact and she resisted in subtle and covert ways, I often chose not to acknowledge her resistance. I always stopped short of forced intercourse, but that does not change the rapelike nature of the interaction.

Complicating the case even more is the fact that at the time I knew her, Sue was working with a therapist to address a troubled family history. She talked to me in guarded ways about an abusive father and angry brothers. Looking back on those conversations through a feminist lens—paying attention to what she said and did not say—I now think it likely that Sue was an incest survivor. While I have no way of knowing that for sure, what I have learned in the past five years about family dynamics, sexual abuse, and gender suggests to me that the abuse she lived through in her family was sexualized. Assuming that to be true, my actions with her are even

more problematic because of the common effects of childhood abuse on adult sexuality. That is not meant to stereotype adult survivors of childhood abuse as passive individuals waiting to be revictimized, but to acknowledge the way in which childhood abuse complicates questions of desire and agency in adults. It is impossible for me to know how Sue felt about what I saw as "harmless" inquiries and "gentle" nudges, but I can judge my inability to understand her situation as a failure. I had a moral responsibility to listen and an epistemic responsibility (Code, 1987) to understand her abusive history and how those experiences likely framed her view of sex and intimacy, or to ask for more information when I did not understand. Instead, I ignored or minimized what she said, preferring to pursue my own sexual interests. As a man, not only did I have the power to ignore her needs and interests, but the sexual script I was trained to follow called for such behavior. The fact that I stopped short of a legal definition of rape does not absolve me from the level of sexual intrusion that I did commit. In Frye's terms (1983) I looked at Sue with an "arrogant eye," organizing everything I saw with reference to myself and to my interests. The arrogant male perceiver shapes women to fit his mold, and when Sue did not fit, I saw it as something wrong with her. As Frye (1983) reminds us, such perception is not only wrong, it is coercive, a fundamental kind of harm, "a maiming which impairs a person's ability to defend herself."

What is the value of this examination of my sexual history? If I believe that the patriarchal construction of sex as dominance is politically and morally wrong, then I have an obligation to apply that belief to my life. Evaluating my past is crucial to understanding where I stand today; understanding my past is part of understanding patriarchy. Such understanding creates the possibility not only of personal change but of expanding our knowledge as a society. What I have learned from this self-reflection, and from conversations with others about it, is that separating men into two groups, rapists and nonrapists, can divert us from the deeper critique (Funk, 1993). Some men rape in violent and terrifying ways that society condemns and, on rare occasions, actually punishes. But many men have engaged in sexual acts in which their pleasure is connected to the objectification of women, the expression of power as sex, and the eroticization of dominance. One way to avoid confronting that critique is to reason that (1) rape is something bad that men do, so (2) if I raped, then I am one of the bad men; but (3) I know that I am not one of the bad men, so (4) I do not rape, and therefore (5) I do not have to critically evaluate my own sexual practices. Feminist critiques of sexuality make a compelling case that the first premise

is simply false. When I began to take seriously that critique, I began to understand myself better.

I am not suggesting that I have completed this process of evaluating my life, or that the process ever ends; it is a lifetime commitment. I argue only that it is an integral part of a commitment to feminist theory and politics. This kind of engagement with my male identity has strengthened my understanding of the feminist critique. It has been, and continues to be, difficult and painful. But it also has allowed me to grow, intellectually and personally, by acknowledging feminist insights that theory and practice are not separate, that experience is an important element of theorizing, that the public-private distinction is false.

I could live as a man working in feminist theory in the academy and avoid evaluating my own life, always talking about *men* and *men's violence* and *patriarchy* as if I lived outside of those terms. I could, in a sense, float between genders, critiquing other men and not myself, but such an approach would be based on a lie. So if a man accepts my argument that feminism can help him make sense of his life and starts down that path, it is crucial to "take it personally" and not to back away from the application of feminist theory to his own life. To back away would guarantee that the abstract engagement with theory fails to spur personal development.

Conclusion

Some men, and women, may object that my argument overgeneralizes men's experiences, especially men's sexual experiences. Men have told me that they do not believe they were taught rapist ethics or that they had moved beyond crude locker-room machismo. Others have told me that they do not have the problems with intimacy and emotion that I have referred to. I can accept these observations and still argue for the importance of my generalizations. First, no man in mainstream contemporary U.S. culture escapes sexist training. Sexism is institutionalized; sexist behaviors and values are widely seen as normal or natural and continue unless there is active intervention to counter them. If that is true, then men have an obligation to explore the ways in which that sexist training may have taken root in their bodies. And even if a man could completely erase any trace of sexism from his life, the culture continues to offer a kind of "default" identity. In the absence of an open refutation of traditional masculinity, the culture gives men an identity that assumes male dominance. With that default identity comes privileges

that one cannot always refuse to accept; they are part of being male in this culture.

I do not want to appear self-denigrating or falsely humble with this analysis. In arguing that men should acknowledge the way in which their identity is tied to patriarchy, I do not want to suggest that men cannot change, that all men are equally culpable, or that I do not realize the ways in which I have successfully combated my patriarchal training. I believe that I am a better human being than I was a decade ago, with far fewer instances in which I fail to live up to feminist ideals. I believe that I do better in this area than the majority of men in this country. I try to acknowledge my successes as well as my failures. However, I know that none of that would be possible if I had not engaged, and continue to engage, in the male identity politics that I suggest here: intense self-evaluation, with help and feedback from like-minded people.

My goal has been to write a personal but not depoliticized essay. The primary goal of a feminist-based male identity politics is not just improving men's lives, but changing structures of power to end the oppression of women and children, as well as to aid resistance to other forms of oppression in the culture. As I have suggested, while the answer to men's questions and quandaries about gender politics can be found in feminist theory, the answers are not easy, just as they are not easy for women. As Connell puts it:

> Breaking down the gender system means, to some extent, tearing down what is most constitutive of one's own emotions, and occupying strange and ill-explained places in social space. (Connell, 1987, p. 282)

It is not easy to occupy that strange space, and I realize that my argument may not convince many men. What I have written has little power unless the man reading it feels in his body and heart some of what I have talked about. It is an argument that fails if it works only at the intellectual level, which is both its strength and weakness. By bringing my own life into this essay, I hope that men who read it will be encouraged to engage feminism. I also hope that those who do will continue the conversation, so that the gaps in my understanding—both emotional and intellectual—might be filled.

Notes

A version of this essay was presented to the Interdisciplinarity and Identity Women's Studies Conference at the University of Delaware, Newark, on 15 April

1994. While I speak only for myself, it is important to acknowledge that I could give full or partial credit at the end of virtually every sentence in this essay to my friend and colleague Jim Koplin. Many of these ideas took shape over morning coffee with him, and he and I would be hard-pressed to determine authorship of any particular idea. Thanks also to Sox Sperry, Nancy Potter, Donna McNamara, and Gigi Durham for their roles in clarifying my thinking and in helping me understand more fully the scope and importance of these issues.

1. A note on terms: I do not refer to myself or to other men as *feminists*. Depending on the context, I say that I "work with feminist theory" or "work with feminists" or "am committed to feminism." I take this stance partly because it feels wrong to appropriate a women's term, and because to label myself a feminist implies that I have elevated myself to a category above other men. As Pearl Cleage (1993) writes: "Men can be enlightened, but I have never met a man who did not cling to and exemplify sexist behavior from time to time in spite of himself." *Pro-feminist* seems to be a commonly accepted term; my preference is *antipatriarchal* or *antisexist* because they accurately name the problem and put me in a stance of resistance without denying the ways in which I have privileges as a man in a male-dominant culture.

Following Lerner (1986), I use patriarchy to mean "the manifestation and institutionalization of male dominance over women and children in the family and the extension of male dominance over women in society in general." Sexism is defined as the ideology of male supremacy. Sexism and patriarchy reinforce one another, although sexism can exist in a society where official support of patriarchy has been abolished.

2. Connell (1987) suggests that there are at least five reasons for hope. Men might

1. understand that oppressive systems poison life in areas men share with women;
2. desire better lives for women in their lives;
3. suffer some injury from the present system (e.g., effeminate or unassertive heterosexuals) that makes change in their interest;
4. realize that change is happening and see the futility of clinging to the past; and
5. tap into their own caring, which is blunted but not extinguished in patriarchy.

3. John Stoltenberg (1993) makes a distinction between "acting in one's self-interest" and "acting in the interest of one's own best self," with the former implying a ruthless individualism and selfishness. Feminism does help men (and women) redefine "one's own best self," but I also argue that embracing feminism is in the self-interest of men, in that more crass sense, on the way to a new sense of gender identity and self. The difference may only seem semantic, but it is important to set out how feminism helps in both those tasks, as well as serving the interests of others.

4. I am aware of the bracketing out of gay men's experience here. I do that not to marginalize them, but because I am working from my experience as a heterosexual man and from my hesitancy to declare that those conclusions apply to gay men.

5. I continue to focus in this essay on gender issues in a heterosexual context, but I want to make it clear that other power differentials are crucial. The role of heterosexism, not only in how it oppresses lesbians and gays but also how it limits and constrains heterosexuals, and of sexualized racism (e.g., the stereotypes of the black rapist and exotic black female sexuality) also are crucial.

6. For a discussion of the broader question of men's collective responsibility for rape, see May and Strikwerda (1994).

References

Bly, Robert. (1990). *Iron John.* Reading, Mass.: Addison-Wesley.

Boone, Joseph A. (1990). Of Me(n) and Feminism: Who(se) Is the Sex that Writes? In Boone and M. Cadden (Eds.), *Engendering Men: The Question of Male Feminist Criticism,* pp. 11–25. New York: Routledge.

Caputi, Jane, and Gordene O. MacKenzie. (1992). Pumping Iron John. In K. L. Hagan (Ed.), *Women Respond to the Men's Movement,* pp. 69–81. San Francisco: Pandora/HarperCollins.

Carrigan, Tim, B. Connell, and J. Lee.(1987). Hard and Heavy: Toward a New Sociology of Masculinity. In M. Kaufman (Ed.), *Beyond Patriarchy,* pp. 139–92. Toronto: Oxford University Press.

Clatterbaugh, K. (1992). The Oppression Debate in Sexual Politics. In L. May and R. Strikwerda (Eds.), *Rethinking Masculinity,* pp. 169–90. Lanham, Md.: Rowman and Littlefield.

Cleage, Pearl. (1993). *Deals with the Devil and Other Reasons to Riot.* New York: Ballantine.

Code, Lorraine. (1987). *Epistemic Responsibility.* Hanover, N.H.: University Press of New England.

Connell, R. W. (1987). *Gender and Power: Society, the Person and Sexual Politics.* Stanford, Calif.: Stanford University Press.

Dworkin, A.(1988). *Letters from a War Zone: Writings 1976–1987.* London: Secker and Warburg.

———. (1987). *Intercourse.* New York: Free Press.

Farrell, W. (1993). *The Myth of Male Power: Why Men Are the Disposable Sex.* New York: Simon & Schuster.

Frye, M. (1983). *The Politics of Reality.* Freedom, Calif.: Crossing Press.

Funk, Rus E. (1993). *Stopping Rape: A Challenge for Men.* Philadelphia: New Society.

Hagan, Kay L. (Ed.) (1992). *Women Respond to the Men's Movement.* San Francisco: Pandora/HarperCollins.

Heyward, C. (1989). *Touching Our Strength: The Erotic as Power and the Love of God.* San Francisco: Harper.

hooks, b. (1992). Men in Feminist Struggle—The Necessary Movement. In K. L. Hagan (Ed.), *Women Respond to the Men's Movement,* pp. 111–17. San Francisco: Pandora/HarperCollins.

Hopkins, P. D. (1992). Gender Treachery: Homophobia, Masculinity, and Threatened Identities. In L. May and R. Strikwerda (Eds.), *Rethinking Masculinity,* pp. 111–31. Lanham, Md.: Rowman & Littlefield.

Kaufman, M. (1993). *Cracking the Armour: Power, Pain and the Lives of Men.* Toronto: Viking/Penguin.

Kimmel, M. S. (1992). Introduction to Kimmel and T. E. Mosmiller (Eds.), *Against the Tide: Pro-Feminist Men in the United States, 1776–1990,* pp. 1–51. Boston: Beacon.

————. (1990). Introduction to Guilty Pleasures-Pornography in Men's Lives. In Kimmel (Ed.), *Men Confront Pornography*, pp. 1–22. New York: Crown.

————. (1987a). Rethinking "Masculinity:" New Directions in Research. In Kimmel (Ed.), *Changing Men: New Directions in Research on Men and Masculinity*, pp. 9–24. Newbury Park, Calif.: Sage.

————. (1987b). The Cult of Masculinity: American Social Character and the Legacy of the Cowboy. In M. Kaufman (Ed.), *Beyond Patriarchy*, pp. 235–49. Toronto: Oxford University Press.

Lerner, G. (1986). *The Creation of Patriarchy*. New York: Oxford University Press.

Lorde, A. (1984). Uses of the Erotic: The Erotic as Power. In *Sister Outsider*, pp. 53–59. Freedom, Calif.: Crossing Press.

MacKinnon, C. A. (1989). *Toward a Feminist Theory of the State*. Cambridge: Harvard University Press.

May, Larry, and R. Strikwerda. (1994). "Men in Groups: Collective Responsibility for Rape." *Hypatia*, no. 2, pp. 134–51.

Stoltenberg, J. (1993). *The End of Manhood*. New York: Dutton.

————. (1989). *Refusing to Be a Man: Essays on Sex and Justice*. Portland, Maine: Breitenbush Books.

Volunteerism and Women's Lives: A Lens for Exploring Conflicts in Contemporary Feminist Thought, Historical Importance and Socioeconomic Value of Women's Contributions as Volunteers

KAREN BOJAR

AMERICANS have a reputation as a "nation of joiners." This is especially true for women; certainly, the history of service-oriented volunteerism has been largely a history of women's efforts. Susan Ellis (1990) in her comprehensive history of volunteerism, *By the People: A History of Americans as Volunteers,* notes that "any historical look at volunteering must pay attention to the issue of women as volunteers. Until the twentieth century women had very limited opportunities for impact except through volunteering. What becomes increasingly apparent through a closer look at the history of volunteering in the United States is that women have made vital contributions to every aspect of the country's growth, contributions that deserve permanent recognition" (p. 10).

This impressive record has become a source of controversy among many contemporary feminists because of the highly gendered nature of volunteer work. The lines of demarcation, of course, are not clear-cut and many volunteers did not conform to traditional gender roles. However, historically, most women have gravitated toward the less prestigious forms of volunteer work such as social service or charitable work, while men have been drawn to more prestigious, potentially career-advancing volunteer work such as political activism or service on a board of directors.

The major difference may not be so much the type of volunteer work but rather the relative importance of volunteer work for men and for women. For men, most voluntary organizations were a small part of their lives; for women, voluntary organizations were an alternative career ladder. Before the midtwentieth century, volunteer

work, for many well-educated women, was the only possible entry into public life. One consequence, as Anne Firor Scott (1991) has pointed out is that the women who devoted their lives to a career of volunteer work were frequently especially talented women: "As long as women had virtually no access to the professions or business, the leadership of voluntary associations was of an extremely high caliber. All the ability that in the male half of the population was scattered in dozens of directions was, in the female half, concentrated in religious and secular voluntary associations" (p. 180).

The energy and talent that women have poured into volunteer work has seldom received adequate recognition—neither recognition for the individuals involved nor recognition for the social and economic value of the work itself. Marilyn Waring (1988), a New Zealand economist, has written a brilliant and eminently readable analysis of global economics in which she argues for the inclusion of women's unpaid labor—including those countless hours of volunteer work—in computing gross national product. According to Waring (1988), "In the United States in 1980, 52.7 women million participated in voluntary work that was valued at $18 billion. It was not calculated in the nation's accounts" (p. 69).

Waring (1988) reports that women in New Zealand have mobilized around the issue of recognition for voluntary work, including tax recognition: "These women have argued that while the overwhelmingly male donations to charity are claimed as tax deductions, the overwhelmingly female capital donations of time, skills, and labor are not tax-deductible" (p. 139).

Women's Varied Responses to Their Own Volunteer Efforts

The failure to recognize the value of women's volunteer work is often shared by the volunteers themselves. As a result of a course on volunteerism that I teach at the Community College of Philadelphia, I have been struck both by the importance of volunteerism in women's lives and by the tendency to undervalue that experience. The course provides students with the opportunity to earn academic credit through volunteer work and for reading, writing, and reflecting on the social meaning and value of such experience. My students have been overwhelmingly female, and they frequently report that their commitment to community service has been a lifelong pursuit, in many cases growing out of deeply rooted family traditions.

Many of my women-students have a long history of informal volunteering—what they call "just helping out in the neighborhood." Frequently, in the beginning of my class, many women-students will say they've never done any volunteering because they don't think of their work as "volunteering." But it soon comes out that they have a long history of what they call "just helping out in the neighborhood"—bringing meals to infirm elderly people, taking care of neighborhood children, and acting as a general resource for people in need in their communities.

Affluent upper-middle-class women are much more likely to participate in organized volunteering—and to get the recognition that comes with it. This is the kind of volunteer work you can put on your résumé and use to your advantage in a variety of ways. So many of my students (many of whom are from low-income families) have said that it never occurred to them to put volunteer work on their résumés. As one woman said, "Isn't that just tooting your own horn?" This self-effacing note that has informed many women's characterizations of their volunteer work has no doubt contributed to the feminist unease with volunteerism.

Yet some women have performed volunteer work seeking just such an opportunity to "toot their own horns" and have quite openly sought recognition for their efforts. Volunteering has obviously had a range of meanings and fulfilled a wide variety of functions for many women. I suspect it will become increasingly important as our population ages and as we have growing numbers of healthy, retired women.

As Betty Friedan (1993) has noted in her book, *The Fountain of Age:* "the most important predictors of vital age are satisfying work and complexity of purpose"(p. 222). Friedan tells us that such work need not be paid employment, but rather what is needed is "a project that structures one's day and keeps alive those all-important human ties and sense of personhood"(p. 222). Women who have spent years working as volunteers in a variety of organizations are especially well-equipped to get through their later years and to enjoy the wonderful freedom to pursue an interest—freedom most of us do not have in paid employment.

Many women in the labor market have often used volunteer work as a means of compensating for what is lacking on the job and thus is as an outlet for underutilized talents. In volunteer activities, individuals have a measure of choice and control, not available to many on their jobs. For some women, confined to a pink collar ghetto and denied options for meaningful work in the paid labor force, volunteer work has been a salvation, functioning as what Sara

Evans and Harry Boyte (1986) have called "a free space"—an environment in which women could "learn a new self-respect, a deeper and more assertive group identity, public skills and values of cooperation and civic virtue" (p. 17).

The Feminist Critique of Volunteer Work

Volunteering has obviously had a range of meanings and fulfilled a wide variety of functions for many women. Yet as women have entered the work force in record numbers and have gained access to a variety of male-only professions, the volunteer tradition is sometimes seen as a holdover from a sexist past. I will explore the sharp opposition to women's volunteer work that arose in the late 1960s and early 1970s and the challenge to such opposition emerging from the "different voice" school of feminism.

The opposition case was forcefully presented in the much-quoted 1973 statement from the National Organization for Women (NOW) Task Force on Volunteerism:

> Essentially NOW believes that service oriented volunteerism is providing a hit or miss, band-aid, and a patchwork approach to solving massive and severe social ills which are a reflection of an economic system in need of an overhaul. More than this, such volunteering actually prevents needed social changes from occurring because with service-oriented volunteering, political energy is being used and will increasingly be used to meet society's administrative needs.

Yet, such service-oriented volunteerism continues despite expanded options for women and rejection of the volunteer ethic by some segments of the organized women's movement.

Even in the early 1970s, some middle-class feminists recognized the personal rewards of service—such as opportunities for career exploration and development of job skills. Doris Gold (1971), for example, writes that "feminist women can use the volunteer structure for their own ends, experimenting with its training and mind-expanding opportunities to nourish a more conscious identity. Voluntarism in new dress . . . must be judiciously altered to fit woman's growing need for real work in a real life" (p. 398). The subtext appears to be that volunteer work is OK if your purpose is to further your own personal or career goals, but not if your motive is to help

others. Such an emphasis on the potential career benefits for the individual volunteer rather than on the benefits for the community being served suggests a fundamental mistrust of service-oriented volunteerism.

NOW has since changed its bylaws to remove its prohibition against service-oriented volunteerism. From the vantage point of 1994, the 1973 NOW statement may seem somewhat extreme, but it does raise some important questions and reflects a legitimate (and prescient) concern that a parsimonious government will abdicate its responsibilities to its citizens and try to substitute "hit or miss" volunteer efforts for much-needed social programs. Although my students acknowledge the seriousness of the issues raised by the NOW statement, most think it misses something extremely important—the mutually reinforcing relationship between direct service and advocacy for social change. The political energy that NOW wants to encourage is often developed as a consequence of the experience of direct service. Determination to attack a social problem at its roots can be an outgrowth of the experience of direct service.

I have become convinced that the ambivalent responses of feminists to volunteerism is an extremely useful lens for exploring conflicts in contemporary feminist thought. The debate about volunteer work is intimately bound up with the difference/sameness debate that runs throughout the feminist thought of the past one hundred and fifty years or so. Traditional service-oriented volunteerism is more likely to be valued by "cultural feminists" or by "difference feminists" who value women's different voices and concerns and tend to emphasize women's special attributes. Volunteer work is most likely to be viewed with suspicion by that strand of feminist thought that focuses on the struggle for equality based on the assumption that men and women are fundamentally the same and should be treated the same in the public sphere. Such "equal rights feminists" usually adhere to individualist values; "cultural feminists" to communitarian values.

A helpful way to characterize the sameness/difference split is to conceive of the divide in terms of "minimizers" versus "maximizers." As Ann Snitow (1990) has put it: "A common divide keeps forming in both feminist thought and action between the need to build and identify 'woman' and give it solid political meaning [the maximizers] and the need to tear down the very category 'woman' and dismantle its all too solid history [minimizers]" (p. 9). Minimizers have tended to be suspicious of service-oriented volunteerism; maximizers have tended to celebrate women's "ethic of care."

Most of my students are more likely to be "maximizers," to be more drawn to "cultural feminism" than to "equal rights feminism" and, at least on a theoretical level, find communitarian values more appealing than individualist ones. The NOW critique of volunteerism is, for many, at variance with their experience of volunteer work and at odds with some of their basic assumptions.

A commonplace of contemporary social thought is that the middle class (or perhaps more accurately the upper middle class) values competitive individual achievement, whereas the working class values an ethic of solidarity. (See Sennet and Cobb, 1972.) Such oversimplifications can be dangerous, but my research and experience tends to confirm the existence of some such overall pattern. My working-class and low-income students are much less likely to be suspicious of the ethic of care than are my middle-class colleagues. In a *Sojourner* article on the not-so-hidden injuries of class Mary Frances Platt (1994) expressed a sentiment I think I have heard in the voices of some of my students: "Unlike our [working-class] families, middle-class feminism does not participate in the 'give all that you can and we will give that back to you' circle. Godlike importance is placed on individual needs getting met, as we have been brainwashed into believing the class-privileged concept that caregiving is a women's disease and not an ethic to be honored"(p. 27).

Most of my students have not had Platt's extensive experience in feminist organizations and do not share her sense of betrayal, but most would similarly object to viewing "caregiving [as] a women's disease." Many of my students want it both ways—both wanting the respect and compensation that men have enjoyed for their work, yet wanting to honor and to continue the uncompensated voluntary service tradition. Their ambivalence (which I share) reflects the profound ambivalence of many feminists about the equality/difference debate underlying the controversy about women's volunteer work.

Emerging Forms of Volunteer Work— Volunteering on the Job

Ironically, while NOW was focusing on the negative aspects of traditional service-oriented volunteer work, a new, insidious form of volunteer work was emerging—volunteering on the job. The self-sacrificial "Mother Teresa Syndrome" criticized by equal rights feminists now crops up in paid employment. This syndrome is mainly confined to professional women; very few of my students report the experience. It appears to be most prevalent in the less

prestigious professions such as teaching and social work. And this new kind of volunteer work has clear affinities with the kinds of volunteer activities women have traditionally performed throughout the history of American society.

For many women in education and human services, their jobs have become their volunteer work, as they put in far more time than the hours for which they are paid. A young woman teaching at a state university reports being unable to finish her dissertation because of the demands of student papers and conferences. A professor at a community college, exhausted by round-the-clock student advising and unable to ease students out of her office after their allotted fifteen-minute appointments, has all but abandoned her own research projects.

Even those women-professors who spend less time with students and thus manage to make time for their own research are often victims of the "Mother Teresa Syndrome." One young faculty member who cut back on her commitment to students was extremely guilty about her decision: "Some of my best friends spend an incredible amount of time with students, and I know they think I am hopelessly insensitive and careerist. So maybe I do have more time for my work, but a lot of my energy is sapped by guilt."

Volunteering on the job can become really insidious when a women's job is also her cause; some of the most compulsive volunteers on the job are directors of women's studies' programs and directors and staff of women's advocacy groups. I think I first realized the pervasiveness of "volunteering on the job" during a board meeting of a small nonprofit reproductive rights group of which I am a member. A student who had been hired on a part-time basis to write a grant submitted a request to be paid for overtime. Initially, we were nonplussed. Overtime? Who asks for overtime in a worthy cause? One board member noted that she had just spent eighty hours the previous week working on a grant for her agency, and she had never thought of asking for overtime. But upon reflection, we soon agreed that this was a very reasonable request—especially from a part-time employee—although as one board member said, "Getting paid for overtime is not part of the culture of the organization."

A Look at the Historical Record from the Perspective of Twentieth-Century Feminist Scholarship: Women's Participation in Religious Organizations

Both feminist scholarship on the history of women's participation in voluntary organizations and contemporary feminist theory are

helpful in gaining an understanding of the complexities of the tradi-
tion and the extent to which old patterns persist in new forms.
The sameness/difference dichotomy that runs throughout feminist
thought, and that is never far from the surface in any exploration of
women's participation in voluntary organizations, emerges in
religious-based volunteer activities.

Historically, charitable work sponsored by religious organizations
has been the major focus of American women's volunteer efforts
and, in the early days of the Republic, the only focus. Such charitable
work reinforced traditional gender roles—the ideology of women's
"separate sphere" that bears more than a passing resemblance to late
twentieth-century "different voice" feminism. Yet such religious-
based charitable work also served as a vehicle for mounting a chal-
lenge to traditional roles.

Women in such organizations did perform the kinds of service
traditionally thought to be the province of women, yet as Nancy
Cott (1977) has noted in her exploration of the role of the church in
the development of civic skills for nineteenth-century women,
service-oriented volunteerism in religious-based organizations
helped women to enter the public sphere. Their volunteer activities
enabled them to acquire some of the public, citizenship skills thought
to be the sole province of men.

Cott (1977) has argued that work in volunteer "benevolent" socie-
ties led to the development of what many years later would be la-
beled a feminist consciousness:

> women . . . exercised as fully as men the American penchant for volun-
> tary organizations noted by Tocqueville in the 1830's, but women's asso-
> ciations before 1835 were all allied with the church, whereas men's also
> expressed a variety of secular and civic, political and vocational concerns.
> (p. 133)

Cott quotes Harriet Martineau, an astute British observer who
speculated that American women "pursued religion as an occupa-
tion" (1977, p. 138) because they lacked other outlets for exercising
their intellectual and social skills. Cott tells us that in their religious
voluntary associations, "women wrote and debated and amended
constitutions, elected officers, raised and allotted funds, voted on
issues, solicited and organized new members; in other words, they
familiarized themselves with the processes of representative govern-
ment in an all-female environment, while they were prevented from
doing it in the male political system" (p. 155).

Thus, according to Cott (1977), religious activities can be seen as

a means used by New England women to define themselves and their place in the community, in contrast to men whose sense of self and social role were more likely to be defined by worldly occupations. Many of the skills developed and much of the energy generated by women's participation in religious organizations was channeled into the nineteenth-century suffragist movement that culminated in the nineteenth amendment to the Constitution granting women the right to vote. Although the nineteenth-century religious-based voluntary organizations themselves never questioned traditional gender roles, they enabled women to develop the skills needed to contest such roles.

As a secular feminist, I have been struck by the powerful connection between religion and volunteerism in many women's lives and the extent to which so many ideas and social movements I value owe much to nineteenth-century religious organizations. The church did in fact function as a school for citizenship for nineteenth-century white women, in the same way that the church functioned for African-American men and women. The nineteenth-century suffragist movement would probably not have developed when it did, nor as powerfully as it did, had it not been for the skills women developed through participation in religious organizations.

Women now have a range of opportunities in secular organizations and are no longer dependent upon religious organizations as a means of developing citizenship skills. Yet many women continue to volunteer for many of the reasons that no doubt also motivated nineteenth-century women—spiritual sustenance and a sense of community. In my interviews with women who are deeply involved in religious-based volunteer work, one theme appears to predominate: religious organizations provide a sense of an *enduring* community.

Certainly religious organizations provided this sense of community for the women Cott (1977) described, but in a highly mobile society in which family ties and friendships networks have become increasingly fragile, the sense of what one women called a "permanent community" becomes increasingly important. This woman, a college administrator, who was involved in church-based volunteer work, told me that she had a lot of disagreements with, and doubts about, Catholic theology, but she continued to focus her volunteer activities around the church because of what she called a sense of "permanent community."

Although she acknowledged that in a highly mobile society, membership in religious groups fluctuated, she contended that there was much less fluctuation than she found in women's consciousness and advocacy groups or in other "progressive" political organizations

that were constantly changing, dissolving, and reforming in new configurations. She found the religious-based organizations to be more stable over time. As a secular feminist, I could not help but feel a twinge of envy. I have sought a sense of community in a variety of "progressive" organizations, but the sense of solidarity was often fleeting and frequently did not persist over time.

Thus we can see an evolution in the social value of religious-based volunteer activity. It is no longer the only socially acceptable outlet for women seeking to enter public life, no longer the only vehicle for learning civic skills. Yet religious-sponsored volunteerism retains its function of providing a sense of community, which for so many of us has become increasingly elusive and fragile.

The "Maternalist" Ethic and Women's Participation in Voluntary Organizations

A sense of community, of solidarity, is a recurring theme in women's accounts of their motivations for participation in voluntary organizations, a theme that is mostly likely to recur in accounts of participation in religious-based organizations and in those organizations that can in some sense be called "maternalist." I intend to explore both the accomplishments and the dangers of movements that have mobilized women as mothers and as potential mothers.

Maternalism has been something of a double-edged sword and contemporary feminists have rightly become increasingly distrustful of maternalist rhetoric. Nineteenth-century American feminists did not share this suspicion of maternalism and generally recognized the strategic value of organizing women explicitly as mothers. Such recognition has a long history as Gerda Lerner (1993) has demonstrated. Lerner notes that "even the first major feminist theoretician, Mary Wollstonecraft, appealed to women as a group mainly in terms of their motherhood . . . again and again conflating women's citizenship with motherhood"(p. 136). According to Lerner, until very recently, "the main concept through which women could conceptualize their group identity was their common experience of motherhood. This experience allowed them to make claims of equality long before the concept of sisterhood could develop"(p. 137).

Motherhood was the banner under which American women in the midnineteenth century, turned their efforts toward reforming society's morals, crusading against prostitution and drink. Their activism was usually self-defined as an extension of women's traditional role rather than as an encroachment on the male sphere.

Such an insistence on their role as mothers was certainly on one level a defensive reaction, a means of countering the considerable prejudice against women who participated actively in public life. However, the maternalist rhetoric was certainly not a mere public relations ploy; most nineteenth-century women did see themselves as primarily mothers, fighting to make the world safe for their children. There is a direct line from the early nineteenth-century crusaders against prostitution and temperance organizations to twentieth-century organizations such as Mothers Against Drunk Driving (MADD).

Maternalist movements were often characterized by a broadening of social concern beyond the original project. Although the nineteenth-century campaign to eradicate prostitution was not particularly successful, middle-class women did learn a good deal about the problems of working-class women. Organizations originally devoted to stamping out prostitution evolved into shelters and employment agencies for poor women.

Unlike the crusade to end prostitution, the temperance movement did have some remarkable successes and attracted some very talented female organizers. Susan B. Anthony began her activist career as a Daughter of Temperance; she was "converted to women's rights when the men in a Sons of Temperance Convention announced that women were there to learn, not to talk" (Scott, 1991, p. 45). The Women's Christian Temperance Union (WCTU), despite its origins in church-based networks, "was an organization in which women, not male preachers, were in charge of meetings and rituals" (Skopcol, 1992, p. 326). The strong-willed women of the WCTU took to the streets with their axes and hatchets and at least for a time put many saloon-owners out of business. And in the process of fighting the saloons many of these women were redefining the role of women in public life.

Such a redefinition of the female role was rarely explicit and virtually all women in the temperance movement clung to the maternalist justification of their actions as merely an extension of their domestic role. The antiprostitution and temperance movements can be characterized as founded on the assumptions of "difference feminism" or "cultural feminism"—that is, women by virtue of their special attributes as women, and as mothers, are particularly well-equipped to improve the moral fiber of society.

Yet in these nineteenth-century movements, there is never a clear separation between "difference feminism" and "equal rights feminism" that challenged sex discrimination and that demanded equality for women. Training in maternalist organizations often was put to

use in more radical movements, and women who began as temperance crusaders sometimes ended up as suffragists. Nineteenth-century feminists were untroubled by any tension between, on the one hand, celebrating women's different voices, different values and, on the other hand, arguing that since men and women were fundamentally similar, social or legal distinctions based on gender must be abolished. As Nancy Cott (1988) demonstrates in *The Grounding of Modern Feminism,* nineteenth-century women advanced arguments stressing likenesses and differences "almost in the same breadth," untroubled by contradiction. Cott argues that the movement as a whole maintained "a functional ambiguity rather than a debilitating tension," bequeathing to its successors a "Janus face" (p. 19).

The equality/difference dilemma that has been at the center of much contemporary feminist thought can perhaps best be seen in Elizabeth Cady Stanton's writings. In most of the documents collected in the *The History of Woman Suffrage,* edited by Stanton, Susan B. Anthony, and Matilda Joslyn Gage (1881–86), the cultural framework is the liberal enlightenment tradition with its focus on the natural rights of the individual, rights that have been denied to women. "The sexes are alike," Stanton confidently asserts and thus women are entitled to equal rights (1:604).

Much of Stanton's *Woman's Bible* (1895), however, reads like contemporary cultural feminism with an emphasis on women's "difference." Stanton introduces the theory of an original matriarchal state and claims that women have certain special attributes that make them especially well-suited to govern. Stanton tends to focus on women as *mothers,* arguing that mothers have special experiences and attributes that lead them to espouse a life-affirming, nonmilitarist worldview. In the "Matriarchate" (1891), Stanton argues that all the early accomplishments of civilization—agriculture, the domestication of animals, and medicine—were the work of mothers concerned about protecting and nurturing their children. She confidently asserts: "The necessities of motherhood were the real source of all the earliest attempts at civilization" (1891, p. 144).

Stanton could easily shift from a "minimizer" to a "maximizer" stance without any sense of contradiction; one moment the sexes are alike; the next moment, women are "special" or "different." The difference argument both rang true to women's experience and was, of course, politically useful—more useful than perhaps most historians have acknowledged.

Theda Skocpol (1992) in *Protecting Soldiers and Mothers: The Political Origins of Social Policy in the United States* has argued that women's voluntary organizations were primarily responsible for setting up

the infrastructure of the American welfare state—to be sure, by European standards a woefully inadequate welfare state. Skocpol argues that "America came close to forging a maternalist welfare state, with female dominated public agencies implementing regulations and benefits for the good of women and children. From 1900 through the early 1920s, a broad array of protective labor regulations and social benefits were enacted by state legislatures and the national Congress to help adult American women as mothers"(p. 2).

Skocpol (1992) traces the work of federations of women's clubs as they worked for enactment of mothers' pensions and "protective" labor regulations designed to ease the burdens on working women. In 1912, women's groups succeeded in getting the federal government to establish a children's bureau run by reform-oriented professional women. In contrast to the "maternalist" social policies that American women's groups advocated, the emerging welfare states of northern and western Europe were organized around what Skocpol characterizes as "paternalist" policies organized around the needs of male wage earners, policies that strengthened male trade unions and that channeled benefits to women and children through male wage earners. Recent feminist scholarship has drawn attention to this "maternalist" protowelfare state overlooked by historians who analyzed the United States' fledgling attempts at the creation of a welfare state in terms of the "paternalist" European model.

Although the efforts of many organized women's groups to ease the lot of poor women and children met with at least partial success, the legacy of the maternalist movements has been viewed by many feminist scholars as a mixed one. Organizing as mothers may at times have been an effective political strategy, but it is nonetheless a strategy that reinforces gender stereotypes. Nancy Cott (1988) has argued in *The Grounding of Modern Feminism* that the struggle for protective labor legislation sought by many late nineteenth- and early twentieth-century women's groups contributed to the perpetuation of inequalities.

Many contemporary feminists share Cott's unease with "maternalist" social movements grounded in notions of women's special needs and special virtues. Recent controversies such as the 1986 legal battle between the Equal Employment Opportunity Commission and Sears, Roebuck certainly alerted many feminists to the dangers of a focus on women's specialness. Sears successfully defended itself against charges that its employment policies discriminated against women by citing the work of "difference" feminists such as Carol Gilligan (1982). Sears' lawyers argued that because of women's concerns with relationships and "connectedness," they were less inclined

to seek high-pressure, competitive, and hence more lucrative jobs. The clustering of women in low-paid jobs was thus a result of women's free choices dictated by their "different" values.

The assumptions of specialness underlying maternalist social movements clearly have their dangers, yet it is undeniably true that maternalist voluntary organizations have accomplished a great deal to improve the lives of women and children. Under the protective guise of motherhood, women have been able to raise controversial issues and to gain a hearing for radical views. Amy Swerdlow (1993) In *Women Strike for Peace: Traditional Motherhood and Radical Politics in the 1960's* describes the political mobilization of white middle-class women employing traditional maternalist rhetoric to advance their crusade against the nuclear arms race and the Vietnam War.

Swerdlow (1993) credits Women Strike for Peace with creating the climate of opinion leading to the partial Test Ban Treaty of 1963. Women Strike for Peace was the first U.S. group to travel to Hanoi on a peace mission. The organization clearly made a contribution toward swaying "responsible" middle-class opinion against the Vietnam War. To a large extent, their effectiveness had much to do with their identification as wives and mothers who would be eager to return home to their families and to their traditional roles—after they cleaned up the mess made by the U.S. military establishment.

One could perhaps argue that the Children's Defense Fund is a continuation of the maternalist tradition. Leaders of the fund such as Hillary Clinton and Marion Wright Edelman do not use explicit maternalist rhetoric to advance children's causes, yet there is a maternalist subtext—women who are themselves mothers, who are devoted to their children, are trying to make the world a better place for all children. In our taxaphobic society, the only way to advance redistributionist policies and to improve the lives of poor people may be through an emphasis on children, with women who are themselves devoted mothers leading the charge.

"Motherhood" continues to retain its power as a vehicle for organizing women across class and ethnic lines, despite increasing awareness of the dangers of maternalism and challenges to its fundamental premises. Mary Frances Berry (1993) has argued in *The Politics of Parenthood: Child Care, Women's Rights, and the Myth of the Good Mother* that, contrary to received opinion, "during the seventeenth and eighteenth centuries, first in the colonies and then in the United States, fathers had primary responsibility for child care beyond the early nursing period. They not only directed their children's education and religious worship but often decided what they would eat,

played with them, and hushed them to sleep when they awakened in the night" (p. 42).

Yet despite the feminist attempt to distinguish between gender-neutral "nurturing" behavior and gender-specific "mothering," appeals to women as mothers have continued to resonate, and the underlying assumptions of nineteenth- and early twentieth-century maternalist movements live on in the "cultural feminism" of the late twentieth century. Sara Ruddick's 1980 exploration of the personal and social consequences of mothering restates the maternalist ideology of Elizabeth Cady Stanton (1895) in *The Woman's Bible*.

The skill with which antifeminist movements (e.g., Phyllis Schlafley and the "Moral Majority") have used "motherhood" to rally women in support of an antifeminist agenda has certainly contributed to heightened awareness of the dangers of appeals to women as mothers. Sara Ruddick (1992) has modified her earlier celebration of motherhood and now argues for a "mother respecting feminism" (p. 150) which can include men as possible mothers. As Theda Skopcol (1992) has noted, in the political context of the late twentieth century "the unproblematic connections of womanhood and motherhood" (p. 538) which characterized late nineteenth- and early twentieth-century maternalist movements is no longer possible.

Women Organizing to Help Themselves: Self-Improvement and Women's Voluntary Organizations

Although much of the history of women's participation in voluntary activities has been in the maternalist tradition, a more individualistic "countertradition" does exist. Up until fairly recently, this countertradition was largely muffled by the dominant chord—that is: women professing the selfless, altruistic motives associated with the "good mother." This self-effacing note, particularly characteristic of self-consciously maternalist movements, crops up in a wide variety of contexts and organizations.

Anne Firor Scott (1991) describes the insistence of many women involved in Civil War relief efforts that they were engaged in war relief for purely altruistic motives. The Northern Ohio Soldier's Aid Society: "vehemently denied a rumor that the women who ran the organization were paid; only the draymen and porters [they] asserted got any wages at all"(p. 61). One women paid tribute "to a leader of the Northern Ohio Soldier's Aid Society by describing how she

"spent most of her time and income in the relief of the unfortunate; yet she is entirely free of personal ambition. . . ."(p. 62).

After reading the testimonies of these nineteenth-century Mother Teresas, it is something of a relief to turn to the history of women's self-improvement efforts. Denied access to formal education in the late nineteenth-century, many women's groups embarked on self-education programs. Anne Firor Scott (1991) describes the postbellum growth of ladies literary societies—a kind of voluntary organization that in the antebellum years had principally been developed by Black women. According to Scott (1991), "The white women who flocked into literary societies in the late nineteenth-century gave no sign of knowing about the precedent set by the tiny antebellum community of free black women in eastern cities" (p. 112).

Many of these women sounded a distinctly new note in the history of voluntary activity. Scott (1991) describes the women of Sorosis, New York's first women's club, as "educated and ambitious [women who] insisted that they were not concerned with benevolence or reform, but only with their own development" (p. 117). The individualistic note sounded by some of these women may appear callous viewed from the perspective of late twentieth-century America, a society in which individualism often appears to have to have triumphed over any sense of fellow-feeling. Yet in the context of the self-denying, self-effacing culture of most nineteenth-century women's organizations, the sentiments of the women of Sorosis are refreshing.

However, this self-assertion was difficult for many nineteenth-century women to maintain. Scott (1991) tells us, "Though persistently denying any charitable object, the club in its early days could not escape the expectations that women's societies would engage in welfare work and found itself contributing to the Children's Aid Society, the Working Women's Protective Union, and the Hampton Institute" (p.117). The self-improvement groups clearly felt the tug between "equal rights feminism" grounded in individualist ideas of personal freedom and personal development and "cultural feminism" closely allied with the maternalist ethic and grounded in communitarian values.

Women's self-improvement groups have also frequently functioned as support networks and thus the impulse to help oneself is never clearly separated out from the impulse to help others. The dichotomy between self-help and helping others dissolves in the notion of mutual support. This conception of mutual support clearly links these nineteenth-century self-improvement groups with the women's consciousness-raising groups of the 1970s.

Women's Voluntary Activities Across the Class and Racial Divides

Certainly a heightened awareness of the diversity of women's experience among contemporary feminist scholars has contributed to increased attention to the ways in which activist women could (or could not) reach out against class and racial divides. Participation in voluntary organizations, like everything else in American society, was sharply divided along racial and class lines: poor women were much more likely to be involved in informal volunteering, while affluent women were more likely to belong to the organized charitable groups.

Some historians, such as Nancy Cott (1977) in *The Bonds of Womanhood: Women's Sphere in New England, 1780–1835,* have viewed women's participation in voluntary organizations as a step toward developing a sense of gender solidarity. Yet there is much in the historical record to suggest that women's participation in voluntary organizations was more likely to reinforce class divisions than to promote gender solidarity. Anne Firor Scott (1991) in her case study of an elite nineteenth-century charitable organization, the Boston Fragment Society, describes a sorry record of class insensitivity and further notes that the members of the society "continually deplored the existence of poverty . . . but rarely attempted any careful analysis of its causes. . . . The members always saw alcohol as the chief cause of poverty" (p. 36).

Nancy Hewitt (1984), in *Women's Activism and Social Change: Rochester, New York, 1856–1872,* describes the callous treatment of working-class Irish Catholic immigrants by women active in charitable organizations. In the 1850s, at the height of a wave of anti–immigrant sentiment, the good ladies of Rochester closed the orphan asylum and the Home for Friendless and Virtuous Females to all Catholics, however needy. Hewitt (1984) views the anti-Catholic sentiment as very much a function of class prejudice: "Anti-Catholicism might have arisen earlier . . . except that it was not until mid–century that 'Popish' religion was linked with poverty and intemperance in the minds of Rochesterians"(p. 237).

Yet although there is no denying the unpleasant side of the "Lady Bountiful" ethic, there is at least some evidence that women's groups were more sensitive to class issues and significantly more willing to reach out to form cross-class alliances than were men's organizations. Not all the women activists in Rochester turned their backs on working-class immigrants. Hewitt describes other nineteenth-

century women's groups in Rochester that did reach out across the class divide. Similarly, Kathryn Kish Sklar (1985) has documented cross-class coalitions of middle- and working-class women in the Illinois Women's Alliance and at Hull House in Chicago and in the 1890s.

Ken Fones-Wolf has described a confrontation between young middle-class women in the Philadelphia Young Women's Christian Association who wanted to help factory workers organize unions and older women in the association who were opposed to the idea. Ultimately, the young women won. However, in the Philadelphia Young Men's Christian Association, where a similar conflict developed, local business leaders on the board managed to stamp out the prounion sentiment. According to Fones-Wolf, unlike the women reformers, the "male reformers were not involved in building cross-class alliances on gender-related issues and therefore were more easily split off from their working-class allies" (quoted in Scott, 1991, p. 109).

On class issues, the historical record is mixed and there at least exists some evidence that women in voluntary organizations had partial success in reaching across class barriers. Crossing the racial barrier, however, was far more problematic, and the history of women's efforts in this area far less edifying. True, there were the female giants of the antislavery movement, but unfortunately many of these early feminists did not maintain their concern about the plight of black women. Some, like Elizabeth Cady Stanton, engaged in ugly racist rhetoric as a consequence of the failure of many male abolitionists to support suffrage for women. As Anne Firor Scott (1991) has put it, "The white women who believed in crossing racial barriers constituted a small minority . . . for the most part the social justice train ran on two tracks, one white, one black" (p. 69). She further notes, "The few exceptions were almost always members of organizations with a strongly religious orientation"(p. 180).

The historical record clearly indicates that racism was an even more potent barrier to gender solidarity than was class. Historically, this has been as true for "equal rights feminists" as it has been for "cultural feminists." Perhaps this record should be no surprise given the virulence and persistence of racism in American society. It is at least arguable that with the increasing multiculturalism of American society, with the breakdown of racial barriers and the consequent growth of the black middle class in post civil rights movement America, that race is no longer a more potent barrier to gender solidarity than is class. Historically, however, race was clearly the greater barrier.

Conclusion

A review of women's participation in voluntary organizations reveals that contemporary feminist debates have deep cultural roots. Nineteenth-century feminist activists may not have felt the need for theoretical consistency, but they certainly did feel the pull of opposing tendencies, sometimes advancing arguments supporting women's fundamental similarities to men and at other times emphasizing their fundamental differences—what Nancy Cott (1988) has called "a functional ambiguity rather than a debilitating tension" (p. 19). Certainly the historical record demonstrates the extent to which the tension was in fact "functional." In some contexts the most powerful argument for equal rights for men and women was that advanced by Elizabeth Cady Stanton (1881, 1:604): "The sexes are alike" and by Sarah M. Grimke (1838, p. 60): "Intellect is not sexed . . . strength of mind is not sexed." In other contexts, the maternalist stance, stressing women's "special" attributes, enabled women to make gains that might have been extraordinarily difficult to achieve without its protective coloration.

The strategic advantages of maternalist movements are certainly one reason for the persistence of organizations appealing to women as mothers. The history of women's voluntary activities reveals the extent to which old patterns persist in new forms. Just as religious-based volunteerism continues, despite the existence of many more outlets for women's social concerns, so maternalist organizations continue despite decreasing numbers of women who ground their sense of self in the concept of motherhood. Even among women who are familiar with, and sympathetic to, the feminist deconstruction of motherhood, bonding with women as mothers retains its appeal—and not just for strategic reasons. As one white middle-class feminist activist I interviewed expressed, "When I had a child I finally felt a real connection with low-income women and women of color. Outreach and coalition building seemed easier, more natural."

Class and ethnic tensions have historically been a major, although frequently not fully acknowledged, part of the story of women's participation in voluntary activities. Although there were some attempts at cross-class coalition building among nineteenth-century women reformers, it is only in the late twentieth century that significant numbers of feminist activists have tried to build cross-class and multiracial coalitions. Among the divisions that have undermined such efforts at gender solidarity are the often sharply contrasting positions on traditional service-based volunteerism. Is it "a

class-privileged concept" to denigrate such "caregiving [as] a woman's disease and not an ethic to be honored" as Mary Frances Platt (1994, p. 27) has charged?

The argument continues: Is valuing "caring and connection" a trap—the "compassion trap" as Margaret Adams (1971) has called it? Or is the "competitive individual achievement" ethic a greater trap? Is the woman who organizes much of her life around her volunteer work and puts community involvement before career goals buying into stereotyped notions of "true womanhood?" Is her choice to be valued less than that of the feminist corporate lawyer working an eighty-hour week and poised to break through the glass ceiling? Can we continue to value traditional volunteer work still performed by many women without reaffirming sexist stereotypes? Are there, as Theda Skocpol (1992) suggests, lessons that contemporary feminists can learn from the "maternalists of old who, in their self-conceptions and public rhetoric, stressed solidarity between privileged and less privileged women and honor for the values of caring and nurturance?" (p. 538).

Traditional service-oriented volunteerism informed by an "ethic of care," like the maternalist ideology with which it was closely allied, was once a unifying value among women, shared by women of all social classes. Many working-class and middle-class women continue to value an "ethic of care," and in some cases, see it as an explicitly feminist project. However, with the opening of what were once exclusively male professions to middle-class women, increasing numbers of women have joined men in pursuit of individual fulfillment and success. As a result of these occupational and social changes, along with a powerful feminist critique of traditional gender roles, the "ethic of care" is less of a unifying concept among women—to some extent a class, as well as a theoretical, fault line.

Our attitudes toward women's volunteer activities are very much bound up with our theoretical stance—gender minimizers versus gender maximizers; individualists versus communitarians. The contemporary theoretical disputes can be a useful lens for exploring the history of women's participation in voluntary activities; the rich (and yet to be fully explored) historical record can be a useful vehicle for helping us to clarify—if not resolve—the theoretical issues.

References

Adams, M. (1971). The Compassion Trap. In Vivian Gornick and Barabara K. Moran (Eds.), *Woman in Sexist Society,* pp. 401–16). New York: Basic.

Berry, M. F. (1993). *The Politics of Parenthood: Child Care, Women's Rights, and the Myth of the Good Mother.* New York: Viking.

Cott, N. (1977). *The Bonds of Womanhood: Women's Sphere in New England 1780–1835.* New Haven: Yale University Press.

———. (1988). *The Grounding of Modern Feminism.* New Haven: Yale University Press.

Ellis, S. (1990). *By the People: A History of Americans as Volunteers.* San Francisco: Jossey-Bass.

Evans, S., and H. Boyte. (1986). *Free Spaces.* New York: Harper.

Friedan, B. (1993). *The Fountain of Age.* New York: Simon & Schuster.

Gilligan, C. (1982). *In a Different Voice: Psychological Theory and Women's Development.* Cambridge: Harvard University Press.

Gold, D. (1971). Women and Voluntarism. In Vivian Gornick and Barabara K. Moran (Eds.), *Woman in Sexist Society,* (pp. 384–400). New York: Basic.

Grimke, S. M. (1838; reprint, 1970). *Letters on the Equality of the Sexes and the Condition of Women.* New York: Burton Franklin.

Hewitt, N. (1984). *Women's Activism and Social Change: Rochester, New York, 1856–1872.* Ithaca: Cornell University Press.

Lerner, G. (1993). *The Creation of Feminist Consciousness: From the Middle Ages to Eighteen-Seventy.* New York: Oxford University Press.

National Organization of Women Task Force on Volunteerism. (1973).

Platt, M. F. (1994). "Class Truths," *Sojouner: The Women's Forum* (August): 27.

Ruddick, S. (1980). "Maternal Thinking." *Feminist Studies* (summer): 342–67.

———. (1992). From Maternal Thinking to Peace Politics. In Eve Browning Cole and Susan Coultrap McQuin (Eds.), *Explorations of Feminist Ethics: Theory and Practice,* pp. 141–45. Bloomington: Indiana University Press.

Scott, A. F. (1991). *Natural Allies: Women's Associations in American History.* Urbana: University of Illinois Press.

Sennett, R., and J. Cobb. (1972). *The Hidden Injuries of Class.* New York: Vintage.

Sklar, K. K. (1985). "Hull House in the 1890's: A Community of Women Reformers." *Signs: Journal of Women in Culture and Society* 10, no.41, pp. 658–77.

Skocpol, T. (1990). *Protecting Soldiers and Mothers: The Political Origins of Social Policy in the United States.* Cambridge: Harvard University Press.

Snitow, A.. (1990). A Gender Diary. In Hirsch, Marianne and Keller Evelyn Fox (Eds.)., *Conflicts in Feminism.* New York: Routledge.

Stanton, E. C. (1895 and 1899; reprint, 1972). *The Woman's Bible,* 2 vols. New York: Arno.

———, S. B. Anthony, and M. J. Gage. (1881–86). *The History of Woman Suffrage,* vols. 1–3. Rochester: Charles Mann.

Swerdlow, A. (1993). *Women Strike for Peace: Traditional Motherhood and Radical Politics in the 1960's.* Chicago:University of Chicago Press.

Waring, M. (1988). *If Women Counted: A New Feminist Economics.* San Francisco: Harper.

Gathering Rage: The Failure of Twentieth-Century Revolutions to Develop a Feminist Agenda. The Case of Nicaragua

MARGARET RANDALL

SOCIALISM, the first system in history to claim that it would bring equality for all, has moved from theory into practice in our century. In different ways, in numerous of its experiments, it succeeded in showing that economies could in fact be harnessed for need rather than for profit. Over the past several years, however, we have watched one after another of these socialist experiments come down. We—meaning the United States—have won the cold war; that's the way our news media explains the collective event; "freedom and democracy" have been restored from East Germany to the former Soviet Union, from Romania to Nicaragua.

Now that the initial fanfare has subsided, though, now that these points across our globe have ceased to be the focus of every nightly newscast, each can be seen for what it is: a nation struggling with loss as well as gain. Tight controls have been loosened. Dogmas have fallen away. Critical thinking begins to enjoy a rebirth. In some cases extreme corruption and stagnation have been revealed. But human beings have also lost jobs, security, a way of life. Social services—such as state-subsidized health care and free and universal education—have been decimated. And women, especially, have begun to speak out about the ways in which socialism freed but also stifled their lives. In the context of these contradictions, witness Poland's recent reinstitution of extreme antiabortion legislation, among other setbacks for women.

In these pages I will explore a single one of these experiments, the ten years of Sandinista administration in Nicaragua. I will show how women, in particular, have been affected by a serious war, by a decade of people's government, by the eventual (and surprising) defeat of that government, and by the several years since. I will show how a revolution became vulnerable and eventually was defeated— among other reasons—because it did not reflect the needs of more

57

than half of its population. And I will use this example to put forth
my conviction that the failure of twentieth-century revolutions to
develop a feminist agenda is proving also to be a systemic failure.
Revolutions, if they are to succeed, must be for everyone. Other-
wise, they will not belong to everyone, and not everyone will defend
them in times of attack.

Nicaragua's Sandinista revolution was not a *socialist experiment* in
the classic sense of that term. But it contained enough of its tenets—
land reform, the nationalization of major resources, equality of op-
portunity, and a redistribution of goods and services—to be useful
to our discussion. Nicaragua is close and familiar. And it lends itself
to examination, among other reasons, because its people moved
from dictatorship to revolution, on to a new form of social organiza-
tion, and to the defeat of that new social order, all in less than
two decades.

In pre-Colombian Nicaragua, men attended to agriculture; they
fished, and took care of the home. Women were in charge of com-
merce. Only in one other part of Latin America, on the Isthmus of
Tehuantepec (southern Mexico), did women control the economy
in this way.[1] Chroniclers described Nicaraguan women as the most
beautiful among the New World natives. Some believe it was their
fierce sense of independence that made them seem more beautiful.

A woman's virginity was regarded quite differently than it has
been since Spanish Catholicism took hold. Men are said to have
preferred women with sexual experience. Rape was punished by
making the rapist a slave in the service of the victim's parents.[2] Still,
it would be a mistake to assume that the original inhabitants of
Central America respected women's power or place in society—
anymore than patriarchy does today.

Contrary opinions exist, about how women did live in ancient
Mesoamerica, but it is clear that—then as now—they existed largely
for men. The Spanish invaders found gender relations in the lands
they colonized to be not that different from their own. They claimed
the land, looted precious metals and other resources, disrupted or
destroyed whole social systems, and reviled spiritual traditions. And,
because Spanish women didn't join them in the crossing, nor did
they come in any numbers for approximately one hundred years,
these men established relations of use and domination over the native
women that continue to define gender (and race) relations today.

I link gender and race because the two are inseparable on a conti-
nent where the vast majority of peoples are *mestizo:* of mixed race.
There is a story that illustrates, perhaps better than any other, the
connection between race and gender oppression in the history of

Mesoamerica. It is the story of La Malinche.[3] The year was 1519, and a young Indian girl was given as a slave to Hernán Cortéz, the Spanish conqueror of ancient Mexico. She became his translator, first from Nahuatl into Mayan and later into Spanish. The term *malinchismo* has come to mean betrayal, a fascination with that which is foreign and a disgust for, or dismissal of, one's origins. In fact, in most cultures a woman's nature is linked to this idea of the deceitful or traitorous.

But if we examine the story of *La Malinche* from a feminist point of view, it is immediately apparent that this fifteen-year-old girl was not betrayer but betrayed. From birth she had been used and abused. Her father died when she was still quite young; her mother then remarried and had a son. In order for the family wealth to be passed onto the male heir, the girl's mother sold her into slavery. By the time she was fifteen, *La Malinche* had been betrayed and disavowed by her parents, displaced from her family inheritance by her half brother, sold several times as a slave, and then given to the white male invader. And not a man from her family, her ethnicity, or her culture protested.

In legend, La Malinche has become a malignant goddess, the creator of a new race—the *mestizo*—which projects her as mother/whore, bearer of illegitimate children, destroyer of a free and glorious past. Such distortion lies at the root of the mother-blame or woman-blame so common throughout Latin America's *mestizo* society. Historically, women are made to bear the guilt of their own victimization; therein the male is exonerated.

In Latin America, to call someone *hijo de la chingada* (child of the raped one) is a terrible and common offense. This is a single example of the ways in which, in the language itself, women continue to be made responsible for the crimes of both patriarchy and conquest.

In Nicaragua, as was true for most of the region, freedom from Spanish domination was eventually won, only to be quickly replaced by the period of subservience to, and dependence upon, the United States. Nicaragua offers one of the longest continuous examples of U.S. intervention in our hemisphere. Invasions took place in 1853, '54, '57, '94, '98, '99, 1912–25, and 1926–33.[4] The United States, with its doctrine of Manifest Destiny, considered it within its right to invade, occupy, humiliate, and control.

Imperialism has been brutal in Nicaragua. For a few years, in the last century, the North American William Walker was even appointed president. Franklin Roosevelt once said of the first Somoza: "He may be a son of a bitch, but he's our son of a bitch." It is not surprising that Nicaraguans are virtually born with the sentiment—

the collective memory—of anti–imperialism. The word yanqui be-
came the equivalent of "thug," even in the discourse of those living
in remote mountainous regions. And women from the United States
were called yankas, their children yanquitos.

It is against this outrage of imperialism that a man named Augusto
Sandino, peasant/worker/general of the twenties and thirties, orga-
nized his war of liberation.[5] In my field work over the years, I have
come across a number of women who testify to the deep connections
between Sandino's campaign and the more recent Sandinista strug-
gle, connections alive in their personal experience. I want to share
one of them with you. María Lidia is a veteran of both wars, and a
link between them. A peasant-woman from Chinandega, she was
sixty-eight when we spoke:

> I'll tell you, my Segovia, those pine trees, those mountains were our
> friends, do you know? That's the way it was for us with Sandino. We
> simply said light and shadow, and then we said beautiful Nicaragua:
> your lakes speak for you and your children call you, always. Here there
> were no chiefs, no generals; here we were all Nicaraguan soldiers, to-
> gether against the Machos.[6]

María Lidia's use of the term Macho to describe the invading soldiers
is linguistically interesting. She and her generation resisted a foreign
army embodying both political intervention and male domination.

Sandino succeeded in ousting the U.S. Marines in 1934, but he
was betrayed and murdered before he could establish the independ-
ent society he envisioned. His death ushered in an increasingly re-
pressive period in Nicaraguan history: the dynasty of the Somozas.
This was a family regime—over almost half a century—that required
increasingly terrorist tactics simply to stay in power. The country's
economic model, based on capitalist agro export, meant ongoing
underdevelopment and dependence upon the United States. Peasants
were robbed of greater and greater amounts of land; and the rural
and urban poor were superexploited. Much of the population existed
at bare subsistence levels.

By the 1950s and 1960s, the violence that accompanies this type
of economy increased the destitution faced by Nicaraguan women
and children. As the decade of the seventies came to a close, women
were only 51 percent of the population but constituted two-thirds
of those living below the poverty line. While the national illiteracy
rate was 50.35 percent (1979), 93 or in some places 100 percent of
rural women could neither read nor write.[7]

Nicaragua is a largely agricultural country and in the countryside,

especially, living conditions are inhuman. In the seventies, 47 percent of the country's homes were without electricity; 90 percent lacked potable water. Malnutrition, which also engulfed two-thirds of the population, affected women in special ways, as their lives were an almost permanent cycle of pregnancy, birthing, and nursing their young. Statistics in 1975 showed rural women bearing an average of 7.8 children, while in the urban centers it was 6.2.[8] Impoverished living conditions often meant as high as a 50-percent mortality rate among the offspring of the poor.

The idea that women's incorporation into the labor force necessarily brings equality, breaks down in a country like Nicaragua (as it does throughout the dependent world); female workers generally remain exploited and oppressed in the most degrading and worst-paid jobs. Again, numbers reveal the trend: in 1950, 27 percent of the country's economically active population was female; the figure had risen to 35 percent by 1971; and to 40 percent in 1977—two years before the Sandinistas took power. These statistics are for mostly urban manufacturing and services. But even in the country-side, toward the end of the seventies Nicaraguan women made up 29 percent of all fieldworkers, a much higher percentage than in Latin America overall.[9]

The contemporary Nicaraguan family was constructed from the cultural clash between the indigenous model—with its strong tribal and matrilineal characteristics—and those patriarchal values imposed by colonialism during more than three centuries of Spanish domination. The family structure developed within the history of Nicaraguan agriculture, and was marked by its inability to create a model that included the stable presence of a man in the home.

This type of agro-capitalist development, imposed by the United States, brought with it the exploitative social structures needed to keep it in place. These affect women in particularly debilitating ways. Paternal irresponsibility—a man making one woman pregnant, then leaving her with a child or children, and going off to repeat his performance elsewhere—is a serious problem. In Nicaragua, these abandoned mothers migrated in ever larger numbers to urban areas in search of a better living. They generally ended up in domestic service, selling fruit or trinkets on the streets, or in prostitution.

By the late seventies, even the formal urban female labor force (which does not include either domestic service or prostitution) broke down as follows: 75 percent of all employed women were in commerce or the service sector, and only 19 percent in manufacturing.[10] The first serious urban employment census in Nicaragua was

carried out by the Sandinistas in 1980. It showed almost half of all women of working age laboring outside the home.[11]

Add to this economic picture the cultural legacy of conquest. Spain's Catholic tradition has been rife with mixed messages for Nicaraguan women. A strong Marianist tradition promoted Mary Mother of God as an example that was eventually also adopted by Christian revolutionaries who claimed Mary as a figure of liberation rather than of submission. Still, there are limits on the usefulness of a figure whose own sexuality was denied, who was "used by God as a vessel to bring forth His Son." Nicaraguan girls grow up with all the strictures Catholicism imposes; they are taught to be chaste, submissive, pliable, forgiving, and to lead lives of service to others, most prominently their men. Before the Sandinistas came to power, they were often chaperoned, sometimes until they passed from father to husband.

The Sandinista National Liberation Front (FSLN) was founded in 1961. A small group of young men, armed with nothing more than Sandino's example and their own defiant rage, were determined to turn their country around. Having survived devastating military defeats throughout the early sixties, the FSLN turned its attention to political education among the various social sectors: peasants, workers, students, and women. Concurrently, the new wave of international feminism began to make itself felt. It was essential to the way in which the FSLN would develop, that feminist ideas eventually became important to a number of its female members.

In 1966 the FSLN made an attempt to bring women together in the Patriotic Alliance of Nicaraguan Women. Its purpose was to organize women from the popular sectors—peasants, laborers, and students—to agitate for better working conditions, equal pay for equal work, unionization for the female labor force, day care, and like demands. The alliance, like AMPRONAC (Association of Women Facing the Problems of the Nation) and AMNLAE (Luisa Amanda Espinosa Nicaraguan Women's Association) in years to come, was part of an overall plan of struggle, and ultimately reported to the FSLN's top-level all-male leadership. In retrospect, it is easy to see how this lack of autonomy in a succession of women's organizations stifled or submerged the development of a truly feminist movement.

During the early seventies, however, the FSLN as a mixed movement began to have a profound influence on women's lives. Some joined the organization. Many more began mobilizing around specific issues. They denounced the dictator's human rights violations; supported the university students in their various political campaigns; and protested price hikes of milk, gasoline, and other necessi-

ties. These women came forward because their children were in prison, because as heads of households they were hard-hit by the economic and political crises, or because as citizens they wanted nothing more than to force Somoza from power.

Older women maintained a particularly moving presence. As has been true before and since in other parts of the world, the mothers and grandmothers of mostly very young and totally involved sons and daughters often followed their children's examples, becoming courageous and trustworthy political activists. It is interesting that older women vastly outnumbered their husbands in this type of participation. In fact, separation or divorce were not uncommon when a mother gave herself to her children's struggle, often against her spouse's will. The adult men, as their offspring referred to them, tended toward conservatism and personal fear; the adult women were more courageous, more able to assume a radical political position.

These older women formed a Committee of Mothers that was increasingly active throughout the seventies. Its members visited Somoza's prisons, became an important link between the prisoners and those on the outside, protested unfair treatment, went on hunger strikes, and occupied the national cathedral and the local office of the United Nations. This group eventually evolved into the Mothers of Heroes and Martyrs, which was active throughout the Sandinista administration and remains so today. Significantly, since the 1990 electoral defeat, these women—working with the mothers of the contras—have been pioneers in a new movement of national reconciliation.

But I'm getting ahead of myself. By 1977 the new revolutionary struggle was irreversible. In its desperate attempt to control the population that was everywhere becoming involved, the dictatorship declared a state of siege. It was then that the FSLN finally succeeded in organizing women across lines of class, age, and activity with AMPRONAC.

Why did AMPRONAC take off while the earlier attempts failed? In the first place, the liberation movement itself had accumulated greater experience. By this time the general level of misery and corruption was so high, and the repression against those who rebelled so intense, that many felt they had little to lose but the dictatorship itself. Women and others actively searched out structures in which to participate. At the same time, by the late 1970s feminism had made its mark in Nicaragua. In an atmosphere at least somewhat influenced by feminist movements in other parts of the world, the time was right for Nicaraguan women to come together in an orga-

nization they could call their own. Getting rid of the dictatorship had become a feminist issue—at the time the most urgent of them all.

Market women hid weapons under fruits and vegetables and transported them in the great baskets balanced on their heads. Catholic sisters smuggled radio equipment into the country inside the hollowed-out bodies of plaster saints and virgins. I've already touched on the role of mothers; one discovered that her daughter was involved and the daughter realized the same of her mother when they came upon one another, blindfolded and handcuffed, in the dictator's own personal dungeon—beneath a dining room where statesmen and their cronies nightly sipped expensive wines. Criminality and cruelty within the Somoza government had by then reached levels that recall ancient Rome, Nazi Germany, or the more recent Bosnia—such as mass rape, or a blindfolded woman-prisoner being tossed around a cell as if she were a ball. The few who survived those years of brutality have testified that, as an after-dinner pastime, Somoza and his buddies often came down to rape and torture the women-prisoners.

The last months and even years of war in Nicaragua saw a number of extraordinary women taking a type of leadership and successfully carrying out tasks unheard-of to that point in the history of women's revolutionary participation. The FSLN, among the revolutionary movements and organizations of the 1970s, did promote a relatively high level of female participation. There are hundreds of stories. Here is one of them, the story of Nora Astorga:

Nora was a daughter of the bourgeoisie, a lawyer who worked for an important construction company during the last years of the dictatorship. Like so many of her sisters, she at first became involved in support work: exacting information from her conservative business contacts and making it available to her comrades in the FSLN. Then a set of fortuitous circumstances and her own personal commitment led to her protagonist's role in one of the organization's most publicized actions—and one with particular significance for women.

It was International Women's Day, 8 March 1978. The notorious torturer, Gen. Reynaldo Pérez Vega, had been a client of Astorga's for more than a year. During that time, and in line with his assumption that he could quite simply take to bed any woman he wanted, he had beseiged the beautiful lawyer with sexual demands. She continued to refuse him, while skillfully keeping him interested and reporting his advances to her comrades. By March the necessary conditions had been created. Nora called the general, told him she

had decided to give him what he wanted, and arranged for them to meet that evening at her home.

Pérez Vega was known as "The Dog" among his victims and their families. The revolutionaries planned on taking him hostage and exchanging him for important political prisoners. Astorga quickly led him to her bedroom. She undressed him and then, at a prearranged signal, two comrades sprang from a closet. They tried to overpower the man but he was immensely strong and offered unexpected resistance. This forced them to shoot him instead, thereby writing a different ending to the operation. The population, however, could not have been more pleased; one of its most infamous torturers would torture no more.

As a result of this action, Astorga had to leave her own children and go underground where she would continue to participate safe from the possibility of reprisal. She spent the rest of the war on the southern front. After the Sandinista victory of 1979, she worked for a time as special attorney general in charge of prosecuting the more than seventy-five hundred ex-guards who hadn't managed to get away. Later she was named ambassador to United States, but Reagan refused to accept her credentials because of her involvement in the Pérez Vega affair. It seemed the general had also worked for the CIA.

Astorga eventually became Nicaragua's ambassador to the United Nations, where she played a significant role during the first difficult years of covert U.S. military intervention. She was an outstanding diplomat, making a lasting impression on Nicaragua's powerful enemies as well as on its friends. She used to send a single red rose to her adversaries the day before a particularly difficult debate. Even as she was being weakened by breast cancer, she continued as the Sandinistas' compassionately human and politically brilliant voice through one last General Assembly. She died in February of 1988 at the age of forty-two. Almost ten years had gone by since that action that had vindicated abused and humiliated women the world over.[12]

Many women like Astorga participated in the Sandinista war of liberation. Many worked in their country's reconstruction, some in positions of importance. But a decade later, one thing was painfully clear: the proverbial glass ceiling was still in place. The FSLN, in spite of its progressive position on women's rights, had failed to promote its extraordinary female cadre the full distance.

During the Sandinista administration there were few women-cabinet members.[13] Never more than a fourth of the legislative body was female. Men held the vast majority of top-level posts—in government, in the party, and in the armed forces. And during and for some years after the decade of Sandinista government, no woman

was admitted to the FSLN's national directorate, the organization's highest decision-making body. In May of 1994, the Sandinistas held an extraordinary congress, their second since the electoral defeat. At that meeting the national directorate was enlarged from the traditional nine to fifteen members. A couple of the men were changed, and five women were added, that is, a third of the body. These women are Mónica Baltodano, Mirna Cunningham, Benigna Mendiola, Dora María Téllez, and Dorotea Wilson.

At that same extraordinary congress, a group of women calling themselves the *autoconvocadas* (self-selected) actively fought for a quota system among party leadership at all levels. They wanted 50 percent of party positions to be filled by women. The congress wouldn't go that far, but did approve a 30 percent quota. Nicaraguan feminists know that the problem is deeper than quotas; 30 percent female leadership is still a concession, made by the men in power to placate the women. It may be a beginning, but conceptually speaking it's still nowhere near the radical change that must come if women are to achieve equality.

In the 1980s, and compared with other countries, percentages such as one-fourth of the legislature did seem encouraging. Many of us who followed the Nicaraguan process believed women's full equality to be a matter of time. But in retrospect one thing is clear: those female combatants who were able to most completely assume an analysis and conduct considered to be male, were the ones who rose in the ranks. The problem, of course, is not simply that women were not admitted to the inner circles of power, or that a male-dominated party kept its women's association under tight scrutiny and control. These were not causes, but symptoms of the revolutionary movement's failure to allow a truly feminist discourse or feminist agenda to develop.

With the 1979 victory, women as a group had enormous expectations of how the new people's government would change their lives. Some articulated these expectations in immediate demands; others just felt something had shifted, that new relationships were possible. Few who had been involved at any level of struggle believed that women would go back to their conventional roles. At the end of 1979 and throughout 1980 one frequently heard some version of the pronouncement: When women take up arms and fight alongside *their men,* they elicit a different sort of respect.

What may not have been understood was the fact that the men weren't *theirs,* but that they belonged to the men—in every spoken and unspoken aspect of the patriarchal model. Male leaders of the FSLN, the most conscious of whom had only timidly questioned gen-

der roles, set about to reorganize society. Despite affirmations by women and others that the level of female incorporation within the Sandinista process was irreversible, despite early protests that women would never return to subservient positions in the home, traditional gender inequality did remain and resurface during those ten extraordinary years. It had never really been challenged, at least not radically enough to have permitted qualitative change.

One important reason for this failure was the inability, on the part of Nicaraguan women as well as of their vanguard party, to develop a truly autonomous feminist movement. The history of the AMNLAE offers important lessons in this respect.

The new women's organization was born in September of 1979, a few months after the Sandinista victory. It took its name from Luisa Amanda Espinosa, believed to have been the first woman to die in the revolutionary struggle.[14] AMNLAE's line was clear: Building the New Nation We Give Birth to a New Woman. The theory of women's social insertion popular in Latin America at the time was alive and well in the concept the organization had as its priority goal: integrating women into the overall revolutionary process as a way of bringing about the desired changes in their social condition.

During its first two years, AMNLAE put all its energies into mobilizing women for the most urgent tasks of reconstruction, and then— as the threat from the United States materialized—for defense. Women were encouraged to take part in the literacy crusade and to join the militia. They gravitated toward such areas as education, preventative medicine, and the equitable distribution of basic necessities. A number of women's agricultural projects sprang up. Market women began struggling for their rights. In a few pilot projects, prostitutes were learning other trades. And the mostly female domestic service sector organized around such demands as the ten-hour day. AMNLAE supported all these efforts.

Women were conscious of their need to educate themselves. Of the 406,441 Nicaraguans who learned to read and write as a result of the 1980 Literacy Crusade, almost half—195,688—were women. Young women made up fully half of those who left their families, school, or work, to spend five months teaching literacy in the mountains. The women's association organized the 30,000 brigadists teaching literacy in the cities.[15]

AMNLAE women also provided the traditional female support for the crusade; they sewed knapsacks, raised money, dropped in on the brigadists' parents while their children were away, created small libraries, and in many other ways contributed to the project's success. This, after all, was what women did: created the infrastructure

without which the crusade would not have run as smoothly as it did. And when the illiteracy rate had been successfully reduced, adult education was the logical next step. Here, too, women gave generously of their time and talent. They were 44 percent of the students and 55 percent of the volunteer teachers.[16]

Meanwhile, the United States was not about to let the young revolution survive. The *contra* war was heating up, the countryside especially was beginning to suffer increased incidents of sabotage and armed incursions, and more and more troops were needed for defense. Women, who during the war had made up a third of the Sandinista army, had gradually been relieved of duty—or relegated to noncombat positions. By 1982 there were only two mixed battalions, with women never accounting for more than 10 percent of their members. Nevertheless, women flocked in great numbers to the voluntary militia.

AMNLAE's development defined its constituency. The kinds of issues it addressed and the types of activities it sponsored attracted housewives, market women, and—to a lesser degree—teachers and nurses. The mothers and wives of Sandinista soldiers gravitated toward the organization because of the support it offered with their sons and husbands away at the front. Peasant women became members in significant numbers after a December 1979 assembly attended by more than seven hundred women from remote mountain areas.

A Ministry of Labor study, carried out at the beginning of 1981, polled 4,892 working women; it revealed that AMNLAE had made no headway at all among the superexploited female laborers in the banana fields or in tobacco or coffee harvests. Neither had the organization touched women in manufacturing: in the textile mills, match or shoe factories. These women-workers were more likely to try to get their demands met through the farmers' association or union participation.[17] And professional women, generally more sophisticated and more open to feminist ideas, wanted to begin to deal with the sexism that is so much a part of the Nicaraguan (and Latin American) social fabric. AMNLAE wasn't feminist enough for these women.

Throughout its history it has been difficult, if not impossible, for AMNLAE to understand or accept feminism as a necessary component to change for women. The word has frequently been used as an epithet, with implications that go from elitist and petit bourgeois to foreign and out of touch with local reality. It wasn't until a strong independent feminist movement surfaced just before the 1990 elections, that AMNLAE was finally forced to take feminism into account.

A major problem for the women's organization has been the fact

that women's issues, at least in the beginning, were considered secondary, superfluous, outranked by the priority struggles around economy and defense. A feminist analysis would have shown how women and women's rights fit into an overall strategy for change. As it was, this analysis was not accepted, in fact was vilified, during the Sandinista administration. As a result, many of the strongest women—those who are models of feminist leadership, whether or not they choose to speak in such terms—put their energies elsewhere.

In December of 1981, after almost a year of reevaluation, the association decided to stop existing as a mass organization and to articulate itself as a movement. It was moving away from the Cuban model. What this meant was that AMNLAE would no longer concentrate on recruitment. Instead, it would generate small working committees of women within the different areas and organizational frameworks. For example, women in a factory or school might get together as AMNLAE. Women in a labor union or military unit might meet, if they were concerned, to deal with gender-specific problems in their particular sector.

The idea was that AMNLAE, without continuing to mobilize women throughout the country, could be everywhere. We Are AMNLAE was the slogan. For a while it looked like this change might save the organization. But the conceptual problems remained. It wasn't AMNLAE itself that was at fault so much as the political vision that had engendered it. Women became frustrated that their organization proved unable to address their problems as women. Real autonomy wasn't considered.

Throughout the Sandinista administration, AMNLAE did lead a number of vigorous campaigns for legislation beneficial to women and children. Just after its victory, the new government issued a decree making it illegal to use images of women's bodies in commercial advertising. The FSLN also established a Fundamental Statute in August of 1979, providing the framework for full equality between the sexes. In subsequent years, a number of reforms to the Civil Code were proposed; some passed; others failed. When they threatened "traditional family values," there was always a backlash of protest from the hierarchical church.

Responsible paternity was a goal, and an Office of Family Protection was set up where abandoned mothers could go to get financial help from the fathers of their offspring. If the father held a job and had a salary that could be attached, this was often productive. Free union (cohabiting parents and their children) was recognized and a series of women's rights were established. A new adoption law

eliminated the easy buying and selling of children that had existed in the past; men as well as women could adopt, without the prerequisite of a legally constituted marriage.

All of this legislation generated tremendous, and at times virulent, discussion. Where male dominance was most threatened, charges such as "destroying the family" or "endangering the unity of the people" were most loudly heard. The very real rigors of war, as well as increased economic crisis, made the arguments ever more complex. AMNLAE, as an organization, began to lose meaning for many revolutionary women who felt their most urgent needs were being addressed in more immediate and practical ways by the Association of Small Farmers, by the Confederation of Professional People, by their respective unions, or by the party itself. Since the women's organization proved incapable of the one thing uniquely within its province—that is, doing battle around gender-specific issues like abortion and violence against women—it became less and less important in women's lives.

The organized Right, with all its well-calculated propaganda, stepped into this vacuum created by AMNLAE's failure to develop a feminist agenda. The Right's propaganda is always rooted in traditions that are more familiar and so seem more comfortable. It is often easier to retreat into a known space than to risk the social pressures and marginalization of uncharted terrain.

Statistics on women's voting patterns in both the 1984 and 1990 elections show that the Sandinistas increasingly proved incapable of organizing women to vote for them.[18] It may be useful to examine the FSLN's preelection expectations and the type of propaganda the party directed at women in 1990. Slogans such as "*Daniel es mi gallo!*" (Daniel Is My Cock!) referring to Daniel Ortega, the FSLN's presidential candidate, say it all. On a recent visit to Nicaragua, I heard a number of women exclaim: "One cock at home was quite enough, thank-you!"

Such an overtly sexist campaign, the failure to address issues important to the female sector, and the dramatic results that failure obtained, surely contributed to the FSLN's defeat. As we will see, however, Nicaraguan feminists did not allow the Right to take over their lives. A strong and progressive independent women's movement was brewing.

With the advent of the feminist movement and the new theoretical and psychological breakthroughs it has engendered, we are beginning to define new parameters for talking about ourselves. Patriarchy, with its powerful checks and balances, has long stifled or distorted such discussion. There have been numerous moments in

history when such analysis has pushed itself to the surface, but it has always been quickly discredited. To preserve the balance of power, the men in control have called women who dared explore such issues "witches," "demons," "hysterics," "castrating females," "crazy," and troublemakers, *Malinches*.

Women often suffer from what we now understand as post-traumatic stress syndrome. As Judith Lewis Herman points out, society periodically pulls back from examining and attempting to deal with the reality of endemic and epidemic violence against women— precisely because doing so challenges patriarchy.[19] Similarly, our so-called experts have resisted examining what we once termed *shell shock*, because it means questioning "male virtues" of virility, manliness, and honor.

As a group, Nicaraguan women have been severely victimized by the duel phenomena of woman abuse and the traumas of war. As guilt-ridden *mestizas,* as victims of Christianity's traditional double message (virgin/whore), as abandoned mothers, and as females lured onto the front lines of struggle and politics only to find themselves restrained by conventional expectations every time real equality seemed possible, they suffer from an intense and collective post-traumatic stress.

Like women everywhere, Nicaraguan women have long been weighted down by a legacy of domestic violence. Earlier political systems legitimized and protected the abusive power relations that became "acceptable" in their lives. The Sandinista administration proved unable to address these relations or to change them in any meaningful way. Like women in Vietnam, southern Africa, El Salvador, Guatemala, and so many other places where war has for too long remained a fact of everyday life, women in Nicaragua also share the plight of a battle-worn population. They suffer from the stress-producing symptoms usually reserved for men who have been forced to endure prolonged combat situations, plus the special suffering reserved for women.

The initial years of the Sandinista administration freed women's psyches, but certainly not for long, nor radically enough to significantly reduce the level of collective trauma. The years 1984–85 seems to mark the turning point. At the same time, economic pressure from the United States and the *contra* war combined to heighten tensions. Finally, the 1990 electoral loss brought with it—for the Sandinistas especially—a profound identity crisis.

But Nicaraguan feminists do not simply share the trauma; their feminism has made them partners in their own recovery. They are no longer simply victims, but *survivors* in the most profound mean-

ing of the term. It takes women coming together to develop a language and a therapeutic practice *outside the patriarchal profession and its canon* for there to be a real understanding of what has been perpetrated and how best to deal with it. Paradoxically, the challenge to their identity, suffered in the wake of the 1990 electoral loss, shook the consciousness of many Sandinista women and some men. They face an experience of collective defeat and are free to begin building upon a movement that had already burst through the strictures of official disapproval. Revolutionary feminists in Nicaragua are currently engaged in a powerful coming together—outside the traditional parameters of patriarchal society, and outside the parameters of a male-dominated revolutionary practice as well. Because the vast majority of Nicaraguan feminists have come to their feminism through years of political struggle, they are able to validate collective feelings within a context of understanding how society functions. Since the electoral loss, revolutionary women have been able to break through the bind of allegiance to male-oriented party politics. With an economy in shambles, with a conservative government in office, and amid a generalized collective depression that has seriously threatened everyone's sense of self, Nicaraguan women are getting together, questioning absolutely everything, developing new ways of looking at their reality, and organizing to change it. Touching upon, influencing, and being influenced in turn by other important struggles—such as the movements for ethnic autonomy, against racial discrimination, and for gay rights—feminism in Nicaragua offers a particularly useful example of feminist struggle.

Nicaraguan feminists, tired of trying to get AMNLAE to understand and respect their positions, are creating an independent, broad-based, cross-class, and internationally connected movement that currently includes a number of research and education foundations, several excellent publications, and a guerrillalike networking system. Most of the women involved consider themselves Sandinistas; they either continue to be members of the FSLN or are sympathizers. Many of them speak emotionally about their development within the party and say they would not be where they are today without it. But they also feel it is time to discard the male leadership that has so overwhelmingly refused to address their concerns.

The lesbian movement in Nicaragua is both feminist and revolutionary, setting it apart from similar movements in the industrialized countries. It also functions in close coordination with the gay male movement and with sisters and brothers who identify as bisexual. Lesbians run foundations promoting women's health work, the publication of nonsexist educational materials, AIDS outreach and advo-

cacy, and consciousness-raising inside and outside their community. When the new conservative government pushed through an unusually comprehensive antisodomy law in June of 1992, the lesbian movement initiated the struggle that still rages against it.[20]

After more than a year of preparation, in January of 1992, Nicaragua's independent feminists hosted a gathering of women in Managua. The theme was "United in Diversity." The organizers expected an attendance of 300, but more than 800 showed up to fill the capital city's largest convention center. Women attending were indeed diverse: working women, professionals, Miskitos, and other indigenous women from the Atlantic Coast, *feminists* and those who had never heard the term, peasants, students, religious sisters, teenagers, grandmothers, Sandinistas, and even a few conservative members of the nation's extreme Right. The organizers invited AMNLAE to be a part of the conference's planning phase, but AMNLAE refused. When it became apparent that it was going to be such a success, however, some 50 AMNLAE women decided to attend as individuals.

The event produced a great number of initiatives, chief among them a series of networks in which women may work together around issues of health, education, sexuality, violence against women, and the economy. Decisions were also taken to support the celebration of Gay Pride Day in Nicaragua; revive the deposed government's program of preventative medicine (especially as it can service women's needs); promote nonsexist sex education at all levels; and initiate a campaign to bring back free, secular, and (for the different ethnicities) bilingual education. This is all very important under the current rightist regime, in which Sandinista social gains are being rolled back and public schools no longer offer sex education.

This January gathering showed the FSLN, the general public, and women themselves that Nicaraguan feminism is to be reckoned with; that it is not an import or a fad, but an indigenous movement reflecting the urgent needs of diverse women. Two months later the independent women's movement hosted a meeting of Central American feminists at a beach resort outside Managua, and since then feminists from many Latin American countries have met in a variety of forums. There is ample evidence that Nicaraguan feminists are engaged in their own profound analysis of their history, their recent past, and the ways in which patriarchy continues to distort their perception of the world.

I hope this brief overview offers some sense of the strength, excitement, and vision of Nicaraguan women. It would be incorrect to underestimate the liberating effect that Sandinism has had on generation's of women's lives. Now they must make a more radical

departure. I'd like to close with another story; it concerns Vidaluz Meneses: poet, head of Nicaragua's library system for most of the Sandinista administration, now dean of arts and letters at Managua's Jesuit University. The story is about how Vidaluz got the position she holds.

The president of the university approached her one day, and offered her the post. But Vidaluz didn't accept, not right away. Instead she said she'd have to think about it and would get back to him in a week or so. When a couple of weeks had passed and he'd heard nothing, the university president called her again. "I'll give you my answer in a few days," Vidaluz said. "I'm attending a conference this weekend where a number of other women will be, and I want to confer with them."

Finally, the following Monday, Vidaluz responded to the president's offer: "I've been talking it over with other women on campus," she told him, "and I've found at least three who could do the job as well as I. The four of us feel fine about it being given to any one of us. But whoever you choose, the other three must be named her top-ranking advisors, so we can work closely together."

This is how Vidaluz insisted upon a team of strong and talented women, not simply a token appointment. The president agreed, and these four women-comrades are now reorganizing the university.

Notes

1. Laurette Sejourne, *América Latina I. Antiguas culturas precolombinas* (Mexico City: Siglo XXI, 1979), pp. 131, 148.

2. Ibid., pp. 127–29.

3. Much of my material about La Malinche is drawn from Sofía Montenegro, "Nuestra madre: La Malinche" (Our Mother: La Malinche), *Gente* (Managua) 3, no. 138, (2 October 1992): 11; and Sofía Montenegro, "Identidad y colonialismo. El retorno de La Malinche" (essay).

4. Margaret Randall, *Doris Tijerino: Inside the Nicaraguan Revolution,* trans. Elinor Randall (Vancouver, B.C.: New Star Books, 1978), p. 165.

5. For the best account of Sandino and his war, see Gregorio Selser's *Sandino, general de hombres libres* (Buenos Aires: Editorial Triángulo, 1959); and *El pequeño ejército loco* (Managua: Editorial Nueva Nicaragua, 1980).

6. Margaret Randall, *Todas estamos despiertas: Testimonios de la mujer nicaragüense hoy* (Mexico City: Siglo XXI, 1980), pp. 22–30.

7. See Maxine Molyneaux, "¿Mobilización sin emancipación? Intereses de la mujer, el estado y la revolución: El caso de Nicaragua," in *La transición difícil: La autodeterminación de los pequeños países periféricos* (Mexico City: Siglo XXI, 1986), p. 358; Clara Murguialday, *Nicaragua, revolución y feminismo (1977–89)* (Madrid: Editorial Revolución, 1990); and Jaime Wheelock, *Diciembre victorioso* (Managua: Secretaría Nacional de Propaganda y Educación Política del FSLN, 1979), p. 27.

8. Niurka Pérez, "Subdesarrollo y población femenina en Nicaragua" (seminar

on Population and the New International Economic Order, University of Havana, 1984); Secretaría de Planificación y Presupuesto, *Informe del Seminario nacional sobre Población y Desarrollo: Hacia una política de población* (Managua: SPP, 1989).

9. Paola Pérez and Ivonne Siú, "La mujer en la economía Nicaragüense: Cambios y desafíos" (paper presented at the Fifth Congress of ANICS, OGM, Managua, 1986).

10. Elizabeth Maier, "Mujeres, contradicciones y revolución," *Estudios Sociales Centroamericanos* (San José, Costa Rica), no. 27 (1980): 131.

11. Instituto Nicaragüense de Estadística y Censo, *La inserción de la mujer en la producción social: El caso del área urbana de Nicaragua* (Managua: INEC, 1981), p. 4.

12. Some of this information is drawn from Margaret Randall, *Sandino's Daughters* (Vancouver, B.C.:New Star Books, 1981), pp. 116–28.

13. Lea Guido was the first woman-cabinet member, heading the Ministry of Welfare in the revolution's first years. Dora María Téllez became minister of health about halfway through the Sandinista administration. There were one or two other women-ministers of state, and several vice-ministers during the ten years of the Sandinista government.

14. Luisa Amanda Espinosa, born Luisa Antonio in 1948, was one of twenty-one sisters and brothers. Testimonies by those who knew her indicate that she was almost certainly abused by an uncle for whom her mother sent her to work at age seven. Luisa Amanda completed only three years of grade school, but she is remembered as unusually inquisitive and bright. She probably joined the FSLN in late 1969 or early 1970 and carried out the tasks common among women-militants at the time: keeping safe houses, cooking for the combatants, and running messages. She was twenty-one when she and a male comrade were gunned down by the National Guard in the city of LeOn, on 30 April 1970. See Randall, *Sandino's Daughters,* pp. 24–33.

15. Clara Murguialday, *Nicaragua, revolución y feminismo (1977–89),* (Madrid: Editorial Revolución, 1990), pp. 106–7.

16. Rosa María Torres, "Los CEP: Educación popular y democracia participativa en Nicaragua," in *Cuadernos de Pensamiento Propio* (Managua: 1985), p. 24.

17. Ibid.

18. A study by Cezontle, a Managua-based think tank and resource center on women, reveals that great numbers of women voted in both elections (94 percent of all eligible women were registered in 1990, an increase of 15 percent from 1984). Before the 1990 election, this study found that 59 percent of those women who had voted for the FSLN in 1984 intended to do so again. Four percent said they would vote for the opposition coalition, and as many as 38 percent were undecided. See *Nicaragua: El poder de las mujeres* (Managua: Cezontle, 1992), p. 142. Many analysts believe that this undecided group was of key importance, and that at the last moment many more women—and men—actually gave their vote to the opposition.

19. Judith Lewis Herman, *Trauma and Recovery: The Aftermath of Violence—From Domestic Abuse to Political Terror* (New York: HarperCollins, 1992). See especially pp. 27–28, 76–77, and 133.

20. This law has variously been dubbed #204 and #205. It was narrowly passed in the National Assembly against the negative votes of all the Sandinista delegates and two middle-of-the-roaders. President Chamorro could have vetoed it, but simply let it stand—thereby ushering it into law. In July 1994, Nicaragua's Supreme Court also failed to declare the law unconstitutional.

Transforming Feminist Theory and Practice: Beyond the Politics of Commonalities and Differences to an Inclusive Multicultural Feminist Framework

BLANCHE RADFORD CURRY

Introduction

As we enter the twenty-first century, most mainstream white feminist theory and practice remain steadfast in marginalizing the experiences of women of color, working-class women, and women of non–Western cultures, as well as excluding these same women from the process of building a shared feminist theory and practice that claims to be about and for them.[1] The mainstream American model of feminist theory and practice, based on the experiences of "white middle class, heterosexual Christian women," the experiences of which "generic woman" are assumed to mirror, is rooted in Greek-derived essentialism[2] and historical realities of unequal power and opportunity among women (Lugones and Spelman, 1983).

Addressing the problems of essentialism and of the reality of differences in an effort to transform the mainstream American model of feminist theory and practice has been the recent focus of feminist critics.[3] Challenging essentialism has not been easy, according to Elizabeth V. Spelman, because traditional understandings of the concept of "woman" are based on Greek-derived essentialist logic, which leads us to seek out shared, universal features of the instances of "woman" and to ignore other characteristics of individual women as features of their woman-ness as such (1988). At the same time, challenges to the language of women's commonalities are viewed by many feminists as counter to urgently needed political work in common cause.

Common to these critiques is an objection to the presumption to

speak about and for all women in supposedly universal generalizations that do not reflect the experiences and priorities of women of color (Lugones, 1991). This universalist voice ignores the importance of recognizing significant, power-structured differences among women, minimizing them into invisibility under a theoretical model of universal essential woman-ness (Lugones and Spelman, 1983). Despite a compelling combination of both methodological and moral arguments to halt ongoing perpetuation of this presumption in American feminist theory and practice, the echoes of this model are still ringing. While I agree that a major focus for transforming American feminist theory and practice is related to the "problem" of essentialism and differences, it is my position that substantial analysis of the *dynamics* of presuming commonalities and ignoring differences (essentialism) is needed if we are to change the way we do things. Among these dynamics, I explain, are the following: conceiving differences as inferior, other, and threatening; fostering "blame games," shame, and guilt that empower negative identity politics, rather than seeing differences as sources of strength; and alternatively, practicing acceptable appropriations of another's experience; recognizing the "hidden" politics of asserting commonalities over differences—politics of power; acknowledging lived reality; and being accountable for our actions.

Since 1979, many substantial critical analyses have challenged some of these essentialist theoretical constructions that hinder inclusive multicultural feminist theory and practice. Barbara Smith (1979) presents a powerful argument for rejecting "additive" and "olympic" views of oppression. Margaret A. Simons (1979) strongly reminds us of the importance of critiquing feminist theory, and of bridging theory and practice. Bonnie Thornton Dill (1979) brilliantly outlines the "dialectics of African American experience," and Adrienne Rich (1979) boldly points out [the pervasiveness of] "white solipsism." Audre Lorde (1984) addresses a related problem in her notable discussion of the "outsider-within." Deborah K. King (1988) further strengthens the discussion with her excellent examination of the phenomenon of "both/or"[4] orientation for African-American women. Johnetta B. Cole (1986 and 1993) offers another insightful example in her work on (the) "lines that divide us (and the) ties that bind us," and "when differences will no longer make a difference." There is also bell hooks (1990), whose work significantly challenges us to wake up to the reality of cultural politics.

Other recent works by African-American feminists and others provide meaningful analyses of various aspects of the *dynamics* of

mistakes in theorizing about commonalities and differences that are important to solving the problem. Patricia Hill Collins's (1990) valuable work reminds us that epistemology is important to discussions about commonalities and differences. Who are the authorities; who defines the parameters of oppression; who possesses knowledge, that is, power? Epistemology weighs heavily on feminist theory and practice; yet knowledge is often a matter of position. How we know affects our character, values, and ethics. Collins calls for an "ethics of personal accountability," a moral obligation toward acting justly and accordingly from a dynamic perspective of experience. "Not only must individuals develop their knowledge claims through dialogue and present them in a style proving their concerns for their ideas, but people are expected to be accountable for their knowledge claims" (Collins, 1990). In a related vein, Bettina Aptheker (1989) and Elsa Barkley Brown (1990) elaborate a dynamic epistemological framework that allows feminists to consider each other's standpoints without either giving up one's own or denying another, allowing space for each of us. Judith Mary Green and I (1991) offer a comprehensive model for seeing women as a multiplicity of differing group-related experiences and accordingly, feminism as remaining in flux, dynamic, and multiple. All of these theorists agree that once the theory is *right,* it is possible to practice it; to do the *right* thing!

The work of these feminists represents a notable and expanding construction of collaborative multicultural feminist theory and practice in the development of which African-American feminists have played a major role.[5] It is a paradigm of feminist theory and practice that originates from the construction of black feminist theory and practice.[6] Nonetheless, our urgent need of a new paradigm of feminist theory and practice that respects women speaking in their own culturally different voices, separately if they prefer to do so, or in equal cross-cultural collaboration if they presume to comment on each other's lives and call each other to a common cause (Lugones and Spelman, 1983; Green and Curry, 1991) will continue to be unfulfilled until we understand and effectively impact the *dynamics* of commonalities and differences. We need to realize that there is not one Big Sameness that any group of people share that is more important than all others, unless it is common humanity. Differences in race, gender, culture, class, character, and temperament intersect, and all are Big Differences. We can learn to recognize commonalities while appropriately acknowledging and learning from our differences (Curry and Green, 1994).

In examining the *dynamics* of commonalities and differences, and elaborating on why acknowledging differences is important, multi-

culturalism[7] is a clarifying perspective that can help us to re-create an inclusive feminist theory and practice. With the assistance of a multicultural perspective, we can get from here to there—from exclusive feminist theory and practice to inclusive feminist theory and practice.

Commonalities and Differences

Getting there from here involves understanding the dynamics of "commonalities" and "differences." Are considerations of differences important?—Yes. Do considerations of differences undermine our commonalities?—No. Do differences strengthen the feminist community or weaken it?—They strengthen it. Let us begin with analyzing widespread misconceptions of differences, as inferior, debased, lacking, and not as strengths, that is, our belief in the superiority of our own ethnic group—our ethnocentrism. What is the meaning of ethnic?—Cultural distinctiveness. What is the meaning of culture?—All that a people have learned and shared, including skills, knowledge, language, values, perceptions, motives, and symbols. What is the meaning of differences?—Variety, diversity, race, culture, gender, and the like. Descriptively speaking, cultural diversity[8] is a sociological reality within our nation's population and to a lesser extent, within our schools and work force, depending on the status of given schools and businesses.[9] Cultural differences are viewed as valuable by some, while as problematic for others. We are reminded by Peter McLaren (1993) that "difference is always a product of history, culture, power and ideology." J. Elsea (1984) explains:

> The way we process information about each other when meeting one another for the first time focuses on what we can see: Our differences. We see: Color of skin, gender, age, appearance, facial expressions, eye contact, movement, personal space and touch. Social scientists disagree on the precise sequence of this processing, but agree otherwise.

Although this is a normal experience for many, it is not universal. Many of us perceive people in their commonalities and argue for the alternate need of seeing both commonalities and differences as the ideal norm.[10] Too often, however, the differences we see involve negative stereotypes—"pictures in our heads" that we do not acquire through personal experience. This is a limited sense of "differences." We frequently prefer that friends, family, co-workers, and colleagues think and feel and act like we do.

Too frequently, many white feminists ignore important differences in order to emphasize similarities between women of color and white women. Margaret S. Simons (1979) notes:

> Analyses by white feminists often de-emphasize the differences in women's situations in an effort to point out the shared experiences of sexism. Too often white feminist theorists draw analogies between the situations of oppressed minorities and white women without sufficient attention to the dissimilarities

This tendency is related to what Adrienne Rich (1979) has termed *white solipsism*:

> [T]o think, imagine and speak as if whiteness described the world . . . not the consciously held belief that one race is inherently superior to all others, but a tunnel-vision which simply does not see nonwhite experience or existences as precious or significant, unless in spasmodic, impotent guilt-reflexes, which have little or no long-term continuing momentum or political usefulness.[11]

Whether we accept "white solipsism" as the explanation and/or additionally claim that white feminists consciously exclude African-American feminists' differences, both are problematic. As Audre Lorde (1984) reminds us, ". . . it is not [the] differences between us that are separating us. It is rather our refusal to recognize those differences." I contend that the refusal to recognize the *value* of differences is an additional layer of the problem. We need to remember Lorde's open letter to Mary Daly about her failure to recognize the differences between lesbians of color and white lesbians. Our failure to recognize the differences among ourselves overlooks important dimensions about ourselves. African-American feminists have experiences of domination, subjugation, devaluation, and dismissal that are quite different from those of white feminists. Similarly, white feminists easily recognize one system of domination, for instance, sexism, and not another, for instance, racism, or the interconnections between dominating systems of oppression. While Margaret Simons reminds us of white feminists' de-emphasis of racism, Gerda Lerner's remark about the nature of the oppression of black women under slavery demonstrates Simons's point. Lerner (1973) states: "Their work and duties were the same as that of men, while childbearing and rearing fell upon them as an added burden." As Angela Davis (1981) has pointed out, in recent times, the mother/housewife role (even the words seem inappropriate) does not have

the same meaning for women who experience racism as it does for those who are not so oppressed.

In accord with Angela Davis's (1981) point, that even the words seem inappropriate, a further problem of white feminists' frequent focus on commonalities and de-emphasis of differences between themselves and women of color is unacceptable forms of appropriations. Catherine Stimpson (1971) discusses the "strenuous analogies" white women draw between the women's civil rights and black civil rights movements citing examples like:

> Women, like black slaves, belong to a master. They are property and whatever credit they gain rebounds to him. Women like blacks, get their identity and status from white men. Women, like blacks, are badly educated. In school they internalize a sense of being inferior, shoddy, and intellectually crippled. In general, the cultural apparatus—the profession of history, for example—ignores them. Women, like blacks, see a Tom image of themselves in the mass media.

In addition to pointing out how the rhetorical haze of such analogies evades white women's racism, Stimpson explains that white women comparing themselves so freely to blacks "perpetuates the depressing habit white people have of first defining the black experience and then making it their own. . . ." It is this kind of comparison that poses a problem of unacceptable forms of appropriations of another's experience. Elizabeth V. Spelman (1991) argues that experiences are not the property of only one group; in fact experiences are not the property of anyone, nor can one's experiences be taken from them. On the other hand, she states that there are some experiences that one can have and that others cannot, just as there are certain kinds of experiences that only some people should have. Acceptable appropriations of another's experience involves acknowledgment, respect, and compassion for the other person's situation, as well as recognition of the differences in choices available to us.[12]

This tendency to overlook "differences" is related to understanding differences as a threat to our being—to the belief that to acknowledge another person as different from oneself is to undermine one's own being—that the recognition of "differences" leads to inferiority, for instance, of someone's (mine or theirs) family, community, spiritual, educational, social, and political *values*. Such mind-sets are the "hidden politics" of commonalities and difference, the status quo of "power." *Whose values* are important? What does it mean to accept *their values?* Too often when African-American feminists address the importance of their differences, white feminists respond that such focus undermines African-American and white feminists' need to

address the commonalities that we share. Presumably, their assumption is that emphasizing the latter would further enable us to strengthen empowerment for each of us. However, as generally reflected by white feminist theory and practice, such focuses on our commonalities negate African-American feminists to the point of marginalization, if not invisibility, in both theory and practice. Many shared commonalities, for instance, sexism, work, and violence, are frequently expressed in ways that are more representative of the experience of white feminists insofar as important experiential differences for African-American feminists are de-emphasized. Accordingly, the *values of mainstream white feminists* are rendered more important than those of African-American feminists, which in turn *places them in a significant position of power* not available to African-American feminists. It is a position of hierarchical power, dominating power that subordinates others, the same power inflicted upon others by their white male counterparts throughout history as well as today. These issues of power relations are usually ignored and obscured by white feminists.

Why this power of hierarchy, domination, and subordination? Peter McLaren (1993) reminds us that

> Anglos *somehow* see themselves as free of ethnicity, as the true custodians . . . keepers of civility and rationality. . . . Whiteness . . . becomes an invisible marker against which the Other is constituted and judged.[13]

This also remains true for many white feminists. As such, these white feminists see themselves as the "keepers" of feminist theory and practice that they justify on the basis that African-American feminists' differences are unimportant or less important than other concerns. Such white feminists' devaluation of African-American feminists differences serve to mask their view of differences as threatening, lacking, Other. Likewise, it serves as a guise to affirm their *values* over those of African-American feminists; to *validate their significant position of power* denied to African-American feminists. The continuation of such inequalities of power and privilege significantly impedes efforts to challenge the "five faces" of oppression described by Iris Marion Young (1992): exploitation, marginalization, cultural imperialism, powerlessness, and violence.

Transformative Actions

Why not value and work to develop power that is shared legitimately by all? To acknowledge differences—to recognize Others—

does not minimize one's own self. It is not an either/or matter; it need not imply dichotomies of duality, and/or polarity. Such options do not represent our lived experiences of identities that are composed of multiple interwoven and interconnected variables. There is an alternative perspective to understanding differences as a threat. Catherine A. MacKinnon (1987) reminds us that differences cut both ways: just as you are different from me, I am different from you. It is the idea that differences are simply differences, no more or less. Elsa Barley Brown (1990) explains that

> All people can learn to center in another experience, validate it, and judge it by its own standards without need of comparison or need to adopt that framework as their own. Thus, one has no need to "de-center" anyone in order to center someone else; one has only to constantly appropriately, "pivot the center."

In order for us to adopt an alternative perspective of valuing differences, it is necessary that we make the choice to confront the "hidden politics" of commonalities and differences. It is not enough for us to know of this misconception of differences. We must go beyond knowing to acting upon our knowledge. This involves what Patricia Hill Collins (1990) calls an "ethics of personal accountability":

> [P]eople are expected to be accountable for their knowledge claims. . . . It is essential for individuals to have personal positions on issues and assume full responsibility for arguing their validity. . . . It involves utilizing emotion, ethics, and reason as interconnected, essential components in assessing knowledge claims.

Likewise, Margaret A. Simons (1979) argues that

> [E]fforts on a theoretical level are not sufficient. We must extend our efforts to a personal and practical level as well. . . . As feminists, we must . . . confront racism, . . . as well as sexism, on both a personal and a theoretical level. . . .

As we get better about confronting the mind-set of differences as inferior, Other, a threat, it will become apparent that our differences represent multiple strengths that complement our commonalities. Maria Lugones and Elizabeth A. Spelman (1983) point out the urgent need for new transformative models to accommodate the rapidly changing circumstances of our society. Our identity is complex. We are individuals, as well as members of a certain ethnic group or groups. As individuals our identity includes certain attributes related

to our ethnic background(s)—certain values, language(s), beliefs, artistic forms, processes, great works, morals, customs, social conditions, and the like. Similarly, as individuals, we do not necessarily reflect all of our ethnic attributes. And we share various attributes associated with ethnic groups different from our own. We recognize commonalities and differences among the elements of our own identity. Such is the lived experiences of our multiple identities, which may be greater for some persons born of two cultures, but is common to all of us. W. E. B. Du Bois was often noted for explaining himself as the offspring of combined French, Dutch, white, and black heritages as he expressed pride in his black heritage, and so do we also today have many persons of multiple cultural backgrounds.[14] Moreover, when we add other kinds of differences, for instance, class and religion, it does not appear unusual for a woman to be simultaneously African-American, white, Native American and Chinese; or to feel more like one or the other on a given day, depending on the circumstances.[15] Valuing differences requires us to enhance our cross-cultural understanding with an emphasis on shared ideas, traditions, and values, along with emphasis on, respect for, and interest in those that we do not hold in common (Park and LaRocque, 1992). As Fred Naylor (1991) explains, we must distinguish between respecting another's culture and the right of that person to their own culture. Respecting another's culture does not mean that we agree with it, but that we understand the person's right to their culture. Clearly, our current status of cross-cultural understanding is bleak, given the minimal achievements in coalition building between African-American feminists and white feminists.[16] We must begin to heighten our crossing of cultural borders and to work to experience understanding of another's culture; on this basis, we can improve our ability and our desire to negotiate, reconcile, or transcend our cultural differences (Park and LaRocque, 1992). Experience is crucial to one's direction and emphasis in driving theory, along with morality and honesty (bell hooks, 1994). For instance, one could reflect on a "cultural collision" one has encountered and on how previously engaging in crossing of cultural borders— experiencing understanding of another's culture—could have prevented that "cultural collision."[17] We need more theorizing of multiculturalism, as well as living it. Peter McLaren (1993) explains that, multiculturalism teaches us to displace dominant knowledge that oppresses, that tyrannizes, that infantilizes, and alternatively, to imagine possible worlds, to create new languages, and to design

new institutional and social practices. He also explains the need for positive, affirmative discourses on race, ethnic identity, multiculturalism, and gender.[18] Of further importance, McLaren points out, is the need to deconstruct and redefine the Anglocentric version of U.S. culture—thereby providing opportunities for expressing and shaping alternative realities. As Alice Kessler-Harris (1992) explains: "We need to understand American identity as ever-changing, not the static version of Western civilization that some people champion today." For Lorraine Cole (1989), our nation's motto From Many, One describing the homogenization of most people in our nation since the Declaration of Independence would be more accurate as From Many, Many.[19] The definition of American culture needs to be expanded and understood not as negating a national identity, but as addressing the reality of diversity and a new pluralism. Indeed, to change is often not to loose our identity, but to find it; just as acknowledging the history and culture of others often enables us to know ourselves better.[20]

As Shelly M. Park and Michelle A. LaRocque (1992) suggest, multiculturalism is a synthesis of unity and diversity—*shared* community that maintains the integrity of the *different* groups that comprise it. It balances tension between the one and the many within a pluralistic society and strengthens the political movement for a truly inclusive democratic society. It develops moral education skills for instilling values necessary for living in and contributing to the larger society; and insofar as the ways of various cultures provide improved techniques for the ways that another culture may approach a task, we also learn intellectual skills.[21] As feminists committed to inclusive multicultural feminist theory and practice, it is necessary that we see "Through and Beyond Identity Politics," as explained by bell hooks (1994) in her keynote address at the University of Delaware Women's Studies Conference, "Interdisciplinarity and Identity," where this essay was first presented. We must break with liberal feminist praxis that forsakes or ignores diversity in pursuit of an assimilationist ideal rooted in myths of liberalism. Nor can we succumb to postmodern feminist praxis that forsakes community in pursuit of the ideal of "difference" (Park and LaRocque, 1992). While feminists of color and white feminists are conjointly concerned about equal pay for equal work, the right to choose abortion, legal protection against domestic violence and rape, status of the homeless, adequate health care, federally subsidized day care, entry into traditional male careers, quality education for all children, and the threat of nuclear war, we must acknowledge the differences between us that

impact our commonalities. We must commit to the words of the poem, "First Thoughts":

FIRST THOUGHTS

You and I—
We meet as strangers, each carrying a mystery
within us. I cannot say who you are.
I may never know you completely.
But I trust that you are a person in your own
right, possessed of a beauty and value that are
the Earth's richest treasures.
So I make this promise to you
I will impose no identities upon you, but will
invite you to become yourself
without shame or fear.
I will hold open a space for you in the world and
allow your right to fill it with an authentic
vocation and purpose. For as long as your search
takes, you have my loyalty.

—Author Unknown[22]

African-American feminist sisters and white feminist sisters must remain steadfast in exposing the *dynamics* of commonalities and differences if we are to develop an inclusive multicultural feminist framework. Moreover, the challenges presented by these dynamics reaffirm the need for new scenarios and continued efforts from us to confront these challenges.

Notes

1. The reality of life in the academy is that real multicultural feminism is genuinely transformed by feminists of color and not seen as a priority by many white feminists who take the position that this concern is overstated—that we have been there—that we have done that. On the contrary however, many feminists of color recently expressed their invisibility at the notable first national conference on Black Women in the Academy: Defending Our Name, 1894–1994, Massachusetts Institute of Technology, 13–15 January 1994.

2. Essentialism means the ignoring of differences. See Elizabeth V. Spelman (1988) for a detailed discussion of essentialism and for further elaboration of Aristotle's version of essentialism, which is the Greek root of essentialism in feminist theory and practice.

3. For notable examples of the feminist self-criticism literature on the problem of essentialism, the need to be inclusive of women of color's differences in the theorizing process, and some preliminary suggestions about how to do so, see bell hooks (1981, 1984, 1990); Maria Lugones and Elizabeth V. Spelman (1983), Spelman

(1988), Lugones (1991); Patricia Hill Collins (1990); Linda J. Nicholson (1989); Iris Marion Young (1990); and Green and Curry (1991).

4. King's idea of "both/or" orientation is related to the lived experience of African-American women being viewed as a part of two groups simultaneously, for instance, African-American and female when obtaining employment objectives in hiring and firing. Similarly, African-American women are tied to both the civil rights movement and the woman's movement. The "or," however, is African-American women being viewed as a part of one or the other of a given group. "It is a state of belonging and not belonging—[the] act of being simultaneously a member of a group and yet standing apart from it."

5. The collaborative and coalition work of white feminist sisters with African-American feminist sisters and other feminist sisters of color is important. Such work is essential insofar as it allows us to validate and correct our positionalities for the given concerns in question. At the same time, collaborative research (other than in the field of science) is not widely recognized as primary scholarship for either or any of the collaborative authors. Accordingly, such scholarship is not encouraged in academe. It is important to me, as an African-American feminist to acknowledge in theory and practice the courage of such white feminist sisters like those cited in this essay because this encourages other white feminist support. Moreover, there is the psychological *dynamic* of white feminists "hearing" other white feminist allies of African-American feminists.

6. The use of "black" here is meant as inclusive of women of color, whereas African-American women represent only one of many women of color. Often reference to "black feminist thought" is intended to encompass not only African-American feminists, but other women of color too. It reflects a practical and political meaning of "black." A recent example of this emphasis was expressed at the Black Women in the Academy: Defending Our Name, 1894–1994, national conference, Massachusetts Institute of Technology, January 1994. The conference was an explicit move to invite women of color to embrace other women of color under the umbrella of black feminist thought. One objection to this emphasis focuses on the de-emphasis of diversity among women of color in grouping them under the umbrella of black women; a polarization of women as simply black and white. Another one focuses on the use of race as a questionable category for identifying ourselves. See Namoni Zack (1993). A detailed consideration of such objections to the emphasis of "black" here is beyond the focus of this essay.

7. Multiculturalism is realizing that we can no longer afford to think of one race only or of simply black and white, that we need to go beyond the bipolarity of black and white and embrace all cultures. It is a true synthesis of the many and one—diversity amid unity. See footnote 19 for further elaboration.

8. Current literature distinguishes between cultural diversity, group difference, cross-culture, pluralistic multiculturalism, particularistic multiculturalism, internal multiculturalism, and external multiculturalism. Cultural diversity emphasizes group differences. Cross-cultural emphasizes the ability and desire to "negotiate, reconcile or transcend our cultural difference." Multiculturalism emphasizes synthesis of unity and diversity. For a more detailed discussion of these distinctions see Diane Ravitch (1990), Francis P. Crawley (1994), and Shelly M. Park and Michelle A. LaRocque (1992).

9. The cultural diversity of specific businesses and schools can depend upon the regional and urban versus rural location of schools and businesses along with their position of power.

10. For a further discussion of this idea see Green and Curry (1991).

11. Italics mine.

12. For a further discussion of acceptable and unacceptable appropriations of another's experience see Curry and Green (1994).

13. Emphasis is mine. Also see Frantz Fanon's (1967) analysis of this *somehow* as related to a "warped" sense of what it means to be a person that in turn leads to false notions of the superiority of inferiority.

14. See Edelman's (1992) discussion of balancing her children's double culture backgrounds.

15. A further implication here is the idea that it is becoming very difficult if not impossible to speak of people having only one cultural heritage. The related example was cited by an African-American woman at the "Black and White Perspective on the American South" Conference, University of Georgia, Athens, Georgia, September 1994.

16. Cross-cultural understanding within our educational institutions is at a crisis level as reflected by the incidents of high sexual and racial harassment and violence. As we consider our positionalities as intellectual and social agents of transformative valuable change, we can have an encouraging impact on this crisis. For further discussions of coalition building and shared power, see Guinier (1994), West (1993) Green and Curry (1991), and Evans and Boyte (1986).

17. One frequent example of the positive incidence of crossing cultural borders includes eating different cultural food. On the other hand, this can create a cultural collision. See Brenda Williams's (1994) story, "Accepting Another Culture Can Sometimes Be Hard to Swallow: Agouti" that focuses on an African-American female not being able to partake of the culturally special dish prepared by her fiancée's mother at great financial expense to the family. Useful assessments of border-crossing skills include ones like: "Diversity Self-Assessment: How Well Do You Value Diversity?" "Intercultural Skills That Make a Difference," and "Important Tips in Working with Different Cultural Backgrounds."

18. For other exceptional discussions of multiculturalism and education, see Raechele L. Pope (1993); Shelly M. Park and Michelle A. LaRocque (1992); Greenman et al. (1992); Ronald Takaki (1993); and Vincent G. Harding (1994). For excellent discussions on an objective understanding of race, see Boyce Rensberger (1994), who discusses the physical anthropological perspective of race, and Alain Locke (Harris, 1989), who addresses the contribution of race to culture and what humans have in common. Johnnetta B. Cole (1990) discusses ways in which women can assertively address racism.

19. Some persons argue that Lorraine Cole's position is a misinterpretation. Their point is that "From Many" represents our diversity, while "One" represents our unity. Clearly, such an interpretation is plausibly possible. However, Lorraine Cole's position speaks to the lived interpretation of our nation's motto rather than, for instance, Alain Locke's discussion of diversity amid unity (Harris, 1989).

20. See Taylor and Wolf (1992) for a further discussion of this idea and related issues.

21. Two examples of the idea here include Kenyans as very "service" oriented and Japanese as very "space efficiency" oriented.

22. Author unknown as is true of so many other provocative noteworthy poems from which we can learn so much. Italics mine.

References

Aptheker, B. (1989). *Tapestries of Life: Women's Work, Women's Consciousness and the Meaning of Daily Life*. Amherst: University of Massachusetts Press.

Brown, E. B. (1990). African-American Women's Quilting:A Framework for Conceptualizing and Teaching African-American Women's History. In Micheline R. Malson et al. (Eds.) *Black Women in America: Social Science Perspective.* Chicago: University of Chicago Press.

Cole, J. B. (ed.) (1986). *All American Women: Lines that Divide Ties that Bind.* New York: Free Press.

———. (1993). *Conversations: Straight Talk with America's Sister President.* New York: Doubleday.

———. (1990). "What If We Made Racism a Woman's Issue, . . ." *McCall's.*

Cole, L. (1989). E Pluribus Unum: Multicultural Imperative for the 1990s and Beyond, ASHAS of Minority Concerns.

Collins, P. H. (1990). *Black Feminist Thought: Knowledge, Consciousness, and the Politics of Empowerment.* London: HarperCollins Academic.

Crawley, F. P. (1994). Absolute Truth, Radical Relativism, & the Euroversity. *International Educator* 4, no. 1.

Curry, B. R. (1995). Racism and Sexism: Twenty-first Century Challenges for Feminists. In Linda Bell (Ed.), *Overcoming Racism and Sexism.* Lanham, Maryland: Rowman & Littlefield.

——— et al. (1994). On the Social Construction of a Women's and Gender Studies Major. In Sara Munson Deats and Lagretta Tallent Lenker (Eds.), *Gender and Academe: Feminist Pedagogy and Politics,* Lanham: Rowman & Littlefield.

Curry, B. R., N. Greenman, and E. Kimmel.(1992). Choosing Change, American Philosophical Association's Newsletter on The Black Experience, Spring.

Curry, B. R., and J. M. Green. (1994). Crosssroads of Race and Gender: Anita Hill as Shero and Enemy, presented at conference on Black Women in the Academy: Defending Our Name, 1894–1994, Massachusetts Institute of Technology.

Davis, A. (1981). *Women, Race, and Class.* New York: Random House.

Dill, B. T. (1979). "The Dialectics of Black Womanhood." *Signs* 4, no. 3.

Edelman, M. W. (1992). *The Measure of Our Success: A Letter to My Children and Yours.* Boston: Beacon Press.

Elsea, J. (1984). *The Four Minute Sell.* New York: Simon and Schuster.

Evans, S. M., and H. C. Boyte. (1986). *Free Spaces: The Sources of Democratic Change in America.* New York: Harper & Row.

Fanon, F. (1967). *Black Skin White Masks.* New York: Grove Press.

Green, J. M., and B. R. Curry. (1991). "Recognizing Each Other Amidst Diversity: Beyond Essentialism in Collaborative Multi-Cultural Feminist Theory." *Sage: A Scholarly Journal on Black Women* 8, no. 1.

Greenman, N. P. et al. (1992). "Institutional Inertia to Achieving Diversity: Transforming Resistance into Celebration." *Educational Foundations* 6, no. 2.

Guinier, L. (1994). *The Tyranny of Majority: Fundamental Fairness and Representative Democracy.* New York: Free Press.

Harding, V. G. (1994). "Healing at the Razor's Edge: Reflections on a History of Multicultural America." *The Journal of American History* 81, no. 2.

Harris, L. (1989). *The Philosophy of Alain Locke: Harlem Renaissance and Beyond.* Philadelphia: Temple University Press.

hooks, bell. (1981). *Ain't I a Woman: Black Women and Feminism.* Boston: South End Press.

———. (1990). *Yearning: Race, Gender, and Cultural Politics.* Boston: South End Press.

———. (1994). Through and Beyond Identity Politics, presented at Conference on Interdisciplinarity and Identity, University of Delaware, Newark, Delaware.

Kessler-Harris, A. (1992). Multiculturalism Can Strengthen, Not Undermine, a Common Culture. *The Chronicle of Higher Education.*

King, D. K. (1988). "Multiple Jeopardy, Multiple Consciousness: The Context of a Black Feminist Ideology." *Signs* 14, no. 1.

Lerner, G. (1973). *Black Women in White America: A Documentary History.* New York: Vintage Books.

Lorde, A. (1984). *Sister Outsider.* New York: Crossing Press.

Lugones, M. C. (1991). On the Logic of Pluralist Feminism. In Claudia Card (Ed.); *Feminist Ethics.* Lawrence: University of Kansas Press.

———., and E. V. Spelman. (1983). "Have We Got a Theory for You! Feminist Theory, Cultural Imperialism, and the Demand for the Woman's Voice." *Women's Studies International Forum* 6, no. 6.

MacKinnon, C. A. (1987). *Feminism Unmodified: Discourses on Life and Law.* Cambridge: Harvard University Press.

McLaren, P. (1993). "A Dialogue on Multiculturalism and Democratic Culture, Kelly Estrada." *Educational Researcher* 22, no. 3.

Naylor, F. (1991). "Freedom and Respect in Multicultural Society." *Journal of Applied Philosophy* 8, no. 2.

Nicholson, L. J. (1989). The Category of Gender, presented at the Eastern Division Meetings of the American Philosophical Association (Atlanta, Ga.), 12 December.

Park, S. M., and M.A. LaRocque. (1992). Feminism, Multiculturalism and the Politics of the Academy, presented at the South Eastern Women's Studies Association Conference, Tampa, Fla.

Pope, R. L. (1993). "Multicultural-Organization Development in Student Affairs: An Introduction." *Journal of College Student Development* 34.

Ravitch, D. (1990). "Diversity and Democracy: Multicultural Education in America." *American Educator* 14.

Rensberger, B. (1994). Racial Odyssey. In Aaron Podolefsky and Peter J. Brown (Eds.), *Applying Anthropology: An Introductory Reader.* Mountain View, Calif.: Mayfield Publishing Co.

Rich, A. (1979). *On Lies, Secrets and Silence.* New York:Norton.

Simons, M. A. (1979). Racism and Feminism: A Schism in the Sisterhood, *Feminist Studies* 5, no. 2.

Smith, B. (1979). "Notes on Black Feminism." *Conditions* 5.

Spelman, E.V. (1988). *Inessential Woman: Problems of Exclusion in Feminist Thought.* Boston: Beacon Press.

———. (1991). Changing the Subject: Studies in the Appropriation of Pain, presented at Symposium on Racism and Sexism: Differences and Connections, Georgia State University, Atlanta, Ga.

Stimpson, C. (1971). Thy Neighbor's Wife, Thy Neighbor's Servants: Women's Liberation and Black Civil Rights. In Vivian Cornick and Barbara K. Moran (Eds.), *Woman in Sexist Society: Studies in Power and Powerlessness.* New York: New American Library, Signet Books.

Takaki, R. (1993). *A Different Mirror: A History of Multicultural America*. Boston: Little, Brown and Company.

Taylor, C., and S. Wolf. (1992). *Multiculturalism and the Politics of Recognition*. Princeton: Princeton University Press.

West, C. (1993). *Race Matters*. Boston: Beacon Press.

Williams, B. (1994). "Accepting Another Culture Can Sometimes Be Hard to Swallow: Agouti." *Essence* (March).

Young, I. M. (1990). The Ideal of Community and the Politics of Difference, In Linda J. Nicholson, (Ed.), *Feminism/Postmodernism*. New York: Routledge.

———. (1992). Five Faces of Oppression. In T.E. Wartenberg (Ed.), *Rethinking Power*. New York: State University of New York Press.

Zack, N. (1993). *Race and Mixed Race*. Philadelphia: Temple University Press.

Identification and Self-Definition: A Twenty-First Century Agenda for Interdisciplinary and International Women's Studies

Alma Vinyard

The universal generalization is that historically and culturally women have been identified with, and defined by, terms of inferiority and subordination. To this end, women have been socialized to fill subordinate and restricted roles in most world societies. Stereotypes of women, as less than men, prevail in the literature and mores of many cultures; these myths serve as strong, sometimes detrimental, influences on the perceived value of women. The most widely accepted definition of a good woman is one who is nonassertive and who conforms to self-sacrificing and passive patterns of behavior. These roles are idealized and revered in both modern industrial societies and in less developed and developing societies. The globalization of feminism in interdisciplinary women's studies programs is one significant step toward obliterating stereotypes and toward replacing them with paradigms for self-identification and self-definition.

All of us who have experienced any human interaction are faced with the constant multifaceted nature of definition. We are defined by ourselves, by others, and by many external perceptions of what we are, what we do, where we live, what we wear, and the list goes on. Women have been victimized by the war of definitions throughout the history of civilization. For this reason, it is imperative to examine this legacy of definition. Many women's studies scholars are working across disciplines to revisit the most crucial elements of the defining process: looking at the purposes, institutions, and people, and the impact of definition on those who define and those who are defined.

Women's studies leads the trend toward multiculturalism because it strives to include an intensive critical analysis of the oppression(s) of racism, sexism, classism, and the diverse cultural environments of the intersection of these oppressions in order to be viable in the global society of the twenty-first century. Women's studies must

fffffff

effectively combine theory and activism; local, national and international concerns; embracing well-established and new disciplines; as well as including new technologies.

Scholarship and teaching in women's studies encourages respect and support for the world's many and varied movements. Women's studies research includes exploring national and international health care systems; implementation of local, national, and international laws; and expansion of women's studies programs into global arenas. As women begin to share information, worldviews, resources, and perceptions of the future, a chorus of international voices, if heard and heeded, will change the course of the world. This task is inextricably linked to the pursuit of identity and definition. This quest for identity and definition necessitates a systematic and persistent perusal of the facts and reporting of the cultural histories of women's struggles. A women's studies program that focuses on themes of identification and definition in all courses offered, across varied disciplines, fosters an understanding of interdisciplinarity within women's studies. Consequently, it is incumbent upon women's studies to educate students about the contributions of all women, to the gains of women's movements, and to increase the interest in, and support of, these programs by expanding their cultural, academic, and gender parameters. Women's issues are not confined by national boundaries nor disciplinary ideologies.

To develop and maintain strong and effective women's studies, it is my contention that

1. Extensive research and analysis be undertaken to reveal the impact of race, social class, and culture as well as gender, and definitions.
2. Women writers and theorists must examine the extent to which racism, classism, ethnocentrism, and other oppressive ideologies are manifested in the arbitrary treatment and/or exclusion of Africana women, other Third World women, and poor women from their works.
3. Course offerings on Africana women and women of diverse cultures and backgrounds must be included in women's studies curricula and given the same status and academic rigor of all other departmental offerings.
4. Women's studies curricula should be augmented by extensive research and study of Africana women and of other nonmainstream women and of many opportunities for women of diverse backgrounds to share their experiences and intellectual thought. Students should have access to persons, regardless of gender, who espouse the identification and definition tenets of a liberationist movement. These tenets are the ideologies that will not allow artificial boundaries created by

others (and sometimes ourselves) for purposes of oppression to limit and obscure the commonalities that bind all women in a liberation movement. Finally, the ideal program will provide a diversity of disciplines, political ideologies, instructional methodologies, and associated activities that allow flexibility and growth in an academic and world community setting.

5. Women's studies should be interdisciplinary in structure and ideology.

Because women's studies around the world exists in various stages of development, from offering some courses at the University of Nigeria, Nsukka, to the University of Delaware offering both a minor and a major, to offering a graduate degree at Clark Atlanta University, the curricula reflect those programmatic differences related to enrollment, budgets, and other logistic factors. Whatever the level of women's studies offerings, programs should invoke women's perspectives from diverse positions and viewpoints on world issues. The growth of women's studies has attracted students from various backgrounds, disciplines, orientations, religions, socioeconomic status, and varying degrees of activism. Some have little or no knowledge of political theory or participation in social movements based on radical politics. Others have participated in protest rallies, voter registration campaigns, and run for campus or political office. Still other scholars are simply drawn to women's studies by the diversity of issues related to women, but are not compelled to engage in social revolution. Women's studies seeks students from a variety of backgrounds to enrich the dialogue and critique within our programs. Students in women's studies often benefit from both the academic content of courses and the forums and programs offered. Women's studies programs like those at the University of Pennsylvania, the University of Delaware, and Temple University, are all good examples of programs that offer in addition to courses, public lectures, dinner series, film series, special seminars, and regional programming to further enrich students and faculty with women's studies interests.

Many programs strive to give students an understanding of the historical development of women. Initially women activists were concerned about nonsexist education and, in some cities, taught classes for adults that offered a variety of courses from self-defense to women's literature and history. As interest increased and as the need for the intrinsic importance of women as subjects for scholarly study and research became apparent, many of these feminist activists became academics and pioneered women's studies on college cam-

puses. Since those beginnings, women's studies has taken many shapes, forms, and realities. Initially, most of these programs began with a monolithic focus; but growing interests mandated changes. Because so many different issues and views are inherent in women's studies, interdisciplinary women's studies embrace, multiple feminist theories when exploring women's lives. Controversies about theories and tactics should be viewed as subjects of academic inquiry and curriculum content, rather than as factions for program divisions. Diversity is the strength of an academically sound program.

Within most departments, there is generally a wide range of theoretical orientations and positions. Many scholars pride themselves on the differences in ideological identifications within their disciplines; universities usually support these differences and departments assure their reflection in the curriculum. Interdisciplinary women's studies must likewise welcome these differences among its constituents. Such inclusion in the academic program allows students and faculty to identify their own interests in gender scholarship and to clarify their own defining parameters.

As with any movement, there is much controversy about the goals, strategies, and gains of the feminist movements. In the midst of controversy and what sometimes resembles chaos, identity and definition arise as crucial aspects of the movement that must be continually addressed by students and faculty in women's studies. Margaret C. Hall (1990) offers some propositions that may serve as a rationale for focusing on identity as one of the tenets in an interdisciplinary, international women's studies program. She postulates:

> Identity results from choices. The clarity and effectiveness of our identity depends on whether or not we are aware of the choices we make. Identity is our closest personal link with social values. Due to the depth and intensity of interactive influences between self and values in identity processes, identity motivates behavior to achieve goals.
>
> Women's heightened awareness of their values and identity allows them to become more autonomous in their decision-making. Their recognition of the conflict of values in their social milieus increases, and they identify more deliberately with values that have the most powerful personal and social, (and political) meanings for them. (Hall, 1990, p. 14)

If we accept Hall's notion, then clearly, women's studies programs that provide the most choices for identification by faculty, students, and the university community are the most effective in achieving the goals of inclusion. Women's studies must embrace a commitment to enlarge the realm of participation. Women's studies programs and

departments throughout the United States have borrowed from other academic units the tools to enlarge our participation. National and regional conferences, recruitment activities aimed at students and faculty, and the development of program endowments are but a few that are being employed. Efforts to further develop programs and to gain firmly financial footings are met with mixed results. Some programs flourish while others attempt to hold on.

Our mixed successes make it even more important that we have a clear sense of self. Definitions are inextricably linked to the valuations, expectations, and worldview of women's studies theory and curricula. Patricia Hill Collins (1990) offers an explanation of the importance of identification and self-definition in black feminist ideologies and programs that I contend can be generalized and extended to all women's studies.

> "Black groups digging on white philosophies ought to consider the sources. Know who's playing the music before you dance," cautions poet Nikki Giovanni. . . . We Black women are the single group in the West intact. And anybody can see we're pretty shaky. We are . . . the only group that derives its identity from itself. I think its rather unconscious but we measure ourselves by ourself, and I think that's a practice we can ill afford to lose." (quoted in Collins, 1990). Black women's survival is at stake, and creating self-definitions reflecting an independent survival stake, and creating self-definitions reflecting an independent Afrocentric feminist consciousness is an essential part of that survival. (p. 104)

Self-definition is an essential aspect of any women's studies program.

"Feminism is usually defined as an active desire to change women's position in society. . . . Feminism is an ideological offspring of certain economic and social conditions. It both abets critical change and envisages it with an imagination that goes beyond it" (quoted in Mitchell and Oakley, 1986). Feminist theories range from biological determinism to ethnic and parochial ideas to inclusive liberationist thought. Students must be able to recognize themselves in the theories, curriculum subject matter, activities, and outcomes of women's studies; such programs cannot homogenize the identities of women. Naming and defining empowers the person who names and defines. If a movement is to survive, from time to time it must reevaluate its missions, goals, scope, and definitions. So it is with the feminist movements, especially with the emergence and expansion of women's studies globally.

Africana women have claimed the mandate to record their experiences with the triple oppression of race, sex, and class and with the

intersection of cultural biases on this oppression. For the most part, Africana women have been absent from the annals of the women's movement, but some have assumed prominent places in the women's movement and given their voices to the process of identifying and defining. Collins (1990) explains, "Feminists are seen as ranging from biologically determined—as is the case in radical feminist thought, which argues that only women can be feminist—to notions of feminists as individuals who have undergone some type of political transformation theoretically achievable by anyone." She extends this analysis to the concept of Black feminists and suggests the following definition:

> I suggest that Black feminist thought consists of specialized knowledge created by African-American women which clarifies a standpoint of and for Black women. In other words, Black feminist thought encompasses theoretical interpretations of Black women's reality by those who live it. (Collins, 1990, p. 22)

Like Collins and others, I call attention to a way of understanding the issues of interdisciplinarity, identification, and definition in women's studies. Many women-writers who address the future of women's studies focus on those three important aspects of their realities. The postulations offered here are not new concepts; I am convinced that a multidisciplinary and multicultural approach to women's studies is a concept of inclusion that should be given significant and persistent consideration. Identification and definitions must be broad enough to account for diverse perspectives on the dialectics of gender roles, class, race, sex, and cultural ethnicity. I have made a personal commitment to be the voice of the conscious reminder, lest some forget and regress to exclusion practices of the past. I have come to this decision because I was actively involved in two women's studies programs. Neither of the programs sought to validate the experience of every woman. One was exclusively based on race, ethnicity, and class; the other excluded students and faculty along lines of political values and academic disciplines. The exclusiveness in both instances was relegated to informal power networks (of students and faculty) based on friendship and elitism.

In cases where there is exclusion of any kind, we must realize that certainly there is genuine stratification among people and among women; but that reality must inform our scholarship and our social and political action, not segment us. We can accentuate the positive; celebrate our commonalities and our differences by offering realistic

introspection of our strengths and weaknesses. Women's studies must advocate sisterhood without advocating sameness.

Identity, definition, and inclusion also predict the parameters of international women's studies. Oftentimes the degree to which program objectives are inclusive or exclusive will determine the thrust of interdisciplinary programs. Future women's studies programs must recruit and accommodate scholars who are able to bring diverse academic backgrounds and feminist orientations into programs. Feminist writers recognize this dilemma and offer recommendations. Kum-Kum Bhavnani (1993, p. 28) declares, "Women's Studies is thus a challenge to much academic work; however to write about *a* feminism which analyzes and challenges [only] capitalism and patriarchy implies that women have common interests. These assumed similarities of interest are defined in such a way that they override the differences of interests amongst us" (Italics mine).

Similar sentiments are asserted by Victoria Robinson (1993): "What and how we teach is reflected on by ourselves, and in our classrooms." She further points out:

> If the 1980's revealed to us that Women's Studies could be seen as white and Eurocentric in its theories and approaches, and the situation of women worldwide refutes the myth of post-feminism, then one of the most important tasks of Women's Studies is to be aware of its development internationally and the diversity of women's experience.

Other Africana women's ideas have also influenced the complexity of the multiplicity of theories, traditions and critiques of women's movements. Hudson-Weems (1994) discusses the differences between mainstream feminism and the Africana womanist and the importance of the intersection of identification and self-definition in these movements. She explains:

> There is no need to defend the legitimacy or viability of the feminist in society. Clearly the needs of the white woman are just as real and valid for her as are those for the Africana womanist. However, when one considers that Africana women suffer from the triple marginality, one must also consider the order in which to attack those problems. This is not to suggest that any one is insignificant. Instead, the intent here is to point out the need for Africana women themselves to (identify) their special interests, to define their reaction to their plight, and to take charge in their lives by dealing with first things first.

bell hooks also discusses the pitfalls and the monolithic identification with, and definition of, the feminist movement. In reference

to the impact of Betty Friedan and *The Feminine Mystique* on the contemporary feminist movement, hooks presents this scenario of identification and definition exclusion within that movement:

> Like Friedan before them, white women who dominate feminist discourse today rarely question whether or not their perspective on women's reality is true to lived experiences of women as a collective group. Nor are they aware of the extent to which their perspectives reflect race and class biases, although there has been a greater awareness of biases in recent years. (hooks, 1984, p. 3)

Collins (1990) defines black feminism as the recurring humanist vision and suggests that, "a wide range of African American women intellectuals have advanced the view that Black women's struggles are part of a wider struggle for human dignity and empowerment."

Alice Walker also sees women's struggles as a human struggle. By redefining all people as "people of color," Walker universalizes what are typically seen as individual struggles while simultaneously allowing space for autonomous movements of self-determination (quoted in Collins, 1990, p. 38).

This humanist vision is also reflected in the growing prominence of international issues and global concerns in the works of contemporary Africana women intellectuals. This perspective should also be incorporated in women's studies to make it relevant for the twenty-first century. Some mainstream feminists have begun to look at the efficacy of black feminist theory—"its Afrocentric, post colonial, and post-modernist moments—which seemed to cohere usefully in the paradigm 'feminist theory in the flesh'" (Collins, 1990).

It is in such a context that Nancie Caraway (1991) proposes in *Segregated Sisterhood: Racism and the Politics of American Feminism* a multicultural feminism that draws on some aspects of identity politics and that allows for diverse definitions of women's experience. In the conclusion of her book, she delineates the important concepts that are endorsed as a part of the polemics of mainstream feminism and multicultural feminism. In the final pronouncements, she advises white feminists to "keep alive the politics of memory" and become accountable for those "silences which denied the feminist spirit" of women to bond with multicultural feminism. Her analysis is that multicultural feminism demonstrates an "inherent commitment to and appreciation for many social densities beyond those to which our specific skin color and history consign us" (Caraway, 1991, p. 203).

After careful perusal of the works of some of the many black women writers/intellectuals, I hope that feminist movements em-

brace the ultimate findings of Caraway and of other white feminists who are moving toward a new wave of feminist solidarity. The impetus for this modified feminist thinking is ensconced in Patricia Hill Collins's (1990) definition of black feminism "as a process of self-conscious struggle that empowers women and men to actualize a humanist vision of community." bell hooks (1984) provided the explanation for perceiving Africana women's thought as a key contributor to a broader-based feminism and explained her continuous challenge to feminist theory as a unique and valuable contribution to the formation of a liberatory theory and praxis long before the recent attention to multicultural feminism. In "Black Women: Shaping Feminist Theory," she concludes:

> Though I criticize aspects of the feminist movement as we have known it so far, a critique which is sometimes harsh and unrelenting, I do so not in an attempt to diminish feminist struggle but to enrich, to share in the work of making a liberatory ideology and a liberatory movement. (hooks, 1984, p. 15)

Inclusive women's movements of identity and definition are rudimentary in multidisciplinary international women's studies agendas. Again, women have written about the significance of these precepts. Rona Fields (1985) contends that the contemporary women's movement early recognized the importance of allowing definitions of reality through discussion and talk. For this reason, one of the triumphs of the contemporary women's movement is that more women are ceasing to speak in muted voices. Bhavnani envisions a global sisterhood that requires struggle. She continues, "It has to be a goal rather than a starting point." At the same time, the Hunter College Women's Studies Collective (1983) views definitions as starting points or building blocks (1983, p. 60). Hall insists that the most important commitment women make to enhance their life satisfaction is to maintain efforts to increase their awareness of identity and its implied goals.

It is evident that women have given thought, voice, and pen to the ideals of identity, definition, and global feminism. The question still remains, however, are these conceptions actualized? On the brink of the twenty-first century, women's studies scholars must ensure that all of the talking and writing was not in vain. Interdisciplinary and international women's studies can be the conduit through which women shape the future domains of their identification and definition.

References

Adler, L. L. (1989). *Women in Cross Cultural Perspectives*. New York: Praeger.

Bhavnani, K. (1993). Talking Racism and the Editing of Women's Studies. In *Thinking Feminist: Key Concepts in Women's Studies*. New York: Guilford Press.

Caraway, N. (1991). *Segregated Sisterhood: Racism and the Politics of American Feminism*. Knoxville: University of Tennessee Press.

Collins, P. (1990) *Black Feminist Thought: Knowledge, Consciousness, and the Politics of Empowerment*. New York: Routledge.

Davis, M. (1983). *Third World, Second Sex*. London: Zel Books.

Fields, R. (1985). *The Future of Women*. Bayside, N.Y.: General Hall.

Gilligan, C.(1982). *In a Different Voice*. Cambridge, Mass.: Harvard University Press.

Hall, C. M. (1990). *Women and Identity: Value Choices in a Changing World*. New York: Hemisphere Publishing Corporation.

hooks, b. (1984). *Feminist Theory: From Margin to Center*. Boston: South End Press.

Hudson-Weems, C. (1994). *Africana Womanism: Reclaiming Ourselves*. Troy, Michigan: Bedford Publishers.

Hunter College Women's Studies Collective. (1983). *Women's Realities, Women's Choices: An Introduction to Women's Studies*. New York: Oxford University Press.

Mitchell, J., and A. Oakley. (Eds.) (1986). *What Is Feminism?* New York: Pantheon Books.

Paludi, M., and G. A. Steuernagel. (Eds.) (1990). *Foundations for Feminist Restructuring of the Academic Disciplines*. New York: Haworth Press.

Robinson, V. (1993). Introducing Women's Studies. In *Thinking Feminist: Key Concepts in Women's Studies*. New York: Guilford Press.

Section 2
Feminist Methodology

Introduction

KATHLEEN DOHERTY TURKEL

THE spring/summer 1996 issue of *Social Text* carried an article by Alan Sokal. In this article, Sokal reviewed a number of current ideas in mathematics and physics. He criticized these ideas in a way that he believed would appeal to those academics who question the claim to scientific objectivity, among them those who argue that scientific research exhibits gender, class, and race bias.

The article turned out to be a hoax. Sokal admitted the hoax once the article was published and said that he had submitted the article to demonstrate the level to which standards of academic research had sunk. He picked *Social Text* as a target because he saw it as a journal that was particularly guilty of publishing nonsensical academic work (Weinberg, 1996).

The Sokal hoax drew many and varied responses. On the one hand, there were those who supported his views regarding a decline in academic vigor, the pretension of contemporary social criticism, and the emptiness of critiques of traditional scientific methods. On the other hand, there were those who believed that Sokal had violated the trust of the editors of *Social Text* who were led to believe on the basis of his own academic credentials that his work was legitimate. Still others were left wondering what, if anything, the Sokal hoax proved beyond embarrassing the editors of *Social Text*.

To be sure, Sokal's hoax does raise some legitimate questions about overblown claims made in the name of critical inquiry. Indeed, long before Sokal, Karl Marx warned against "critical critics" who gave their trivial analyses the aura of great importance. Yet Sokal's hoax neglects and obscures the failures and underlying problems with traditional theories and methods.

Feminist scholars, in particular, point to the limitations of traditional disciplines and traditional modes of inquiry for doing feminist research. These researchers have argued that traditional research methods have excluded the experiences of women and denied that women could be agents of knowledge. Feminist researchers have proposed alternative theories of knowledge that legitimate women's

105

experiences and give voice to women as knowers. While feminist scholars may incorporate traditional research methods into their work, they often use these methods in new or varied ways (Harding, 1987).

Harding argues against the idea of a single distinctive feminist method on the grounds that a preoccupation with method obscures what is so interesting and powerful about feminist research. In Harding's view, feminist research offers three distinctive features that contribute to its power: (1) women's experiences as new empirical and theoretical resources; (2) new purposes for research by focusing on issues important for women; and (3) locating the researcher in the same critical plane as the subject matter.

The four essays in this section demonstrate the broad range of research methods and knowledge generated by recent feminist scholarship. The subject matter covered varies widely from the experiences of nineteenth-century African-American speakers and writers to recent feminist scholarship on music, from the work of constructing a feminist theological approach to racism and sexism experienced by college women. What these essays share is an interdisciplinary research approach, a frustration with the limitations of traditional disciplines and methods, and the use of innovative methodological approaches for understanding women's experiences.

In Carla Peterson's essay, "Subject to Speculation: Assessing the Lives of African-American Women in the Nineteenth Century," she reflects upon the methodological issues she faced while writing her book, *Doers of the Word: African-American Speakers and Writers in the North, 1830–1880*. Peterson found she was interested in more than purely literary considerations. She wanted to investigate how writing was part of a broader social activism in which these writers were engaged. Beyond this Peterson wanted to explore how recovery of the past can enhance an appreciation of African-American cultural traditions in the formation of African-American identity. This led Peterson to include forms of cultural activism, such as public speaking, community activism, and newspaper editorship in her investigation. She found that the traditional methods of literary criticism were inadequate because of their exclusionary and hierarchical nature. Instead, Peterson relied on more interdisciplinary approaches. She found, however, that even an interdisciplinary approach could not answer all of her concerns since much of what she wanted to know about the writers and speakers she was studying was missing from the historical record. She found herself engaging in speculation about aspects of the lives of the women she was studying. She argues

that speculation is liberating for the feminist researcher and may well be a feminist activity.

Victoria O'Reilly surveys feminist scholarship in music, highlighting accomplishments since the 1970s. She argues that methodologies developed by feminist scholars in other fields have influenced the creation of feminist music research. Traditional musicology excluded most women's activity from the historical record. An interdisciplinary approach grounded in feminist theory makes it possible to extend traditional methodologies of music and to raise research questions that transcend traditional boundaries. O'Reilly argues that there is a need for more work from a diversity of feminist perspectives as well as a need to revisit earlier work in light of recent findings.

Joy Bostic describes the role of interdisciplinarity in "It's a Jazz Thang: Interdisciplinarity and Critical Imagining in Constructing a Womanist Theological Research Method." Like the other authors in this section, she speaks of the limitations of traditional methodologies to document and analyze the experiences of women. The dichotomous thinking characteristic of traditional methodologies has produced scholarship that is often ahistorical and acontextual, thus removing it from women's lived experiences. Bostic also discusses the limitations of both feminist theology and black liberation theology in analyzing the experience of black women. The black aesthetic tradition, Bostic argues, provides womanist theologians with the basis for constructing methodologies rooted in reciprocity, mutuality, and relatedness. Such methodologies make it possible to ask new questions and to imagine new alternatives to oppressive ideologies and institutional structures.

Mary Morgan analyzes the ways in which college women perceive racism and sexism as sources of oppression in their own lives. Morgan argues in favor of a research approach that can overcome the limitations of traditional methodologies. She uses a critical science approach to analyze the experiences of women in her study and explains that she chose this approach because its purpose is to critique the status quo and to build a more just society. It is also an approach that uses dialogue to gather information. Morgan sees dialogue as important in her research because it opens the possibility for the black women in her research to create a collective experience and a shared understanding. It enabled Morgan, as a white researcher, to gain insight into the pervasiveness of racism in the lives of the women she was studying.

Each of the authors in this section demonstrates the ways in which feminist researchers question traditional research assumptions and

traditional methods of research. They document the limitations of traditional methods, at the same time that they demonstrate the importance of reformulating research questions and methods so that the experiences of women can be discovered, explored, and analyzed.

References

Harding, S. (1987). *Feminism and Methodology: Social Science Issues*. Bloomington: Indiana University Press

Weinberg, S. (1996). "Sokal's Hoax," *New York Review of Books,* 8 August.

Subject to Speculation: Assessing the Lives of African-American Women in the Nineteenth Century

CARLA L. PETERSON

THIS brief essay is intended as a retrospective meditation on some of the methodological problems I encountered—specifically, my inability to answer questions that I had posed for myself—while writing my book *"Doers of the Word": African-American Women Speakers and Writers in the North (1830–1880)*, published in 1995. It constitutes, so to speak, a speculation on speculation. The book is a study of ten nineteenth-century northern African-American women—among them the religious evangelists, Sojourner Truth and Jarena Lee; the travel writer, Nancy Prince; the journalist, Mary Ann Shadd Cary; the antislavery lecturer, Sarah Parker Remond; the poet, Frances Ellen Watkins Harper; and the slave narrator, Harriet Jacobs—who turned to social work, public oratory, and writing in order actively to participate in the most important reform movements of their time. It argues that these women were routinely excluded from official positions of power within the national institutions of the black male elite—namely freemasonry, the church, the press, and the convention movement in which African Americans met on an annual basis to debate issues of vital concern to their communities. Although they were sometimes able to find (temporary) authority in unofficial relations with male leaders, I contend that they also sought sites of power in the liminal spaces of religious evangelicism, travel, public speaking and, finally, fiction-making. Their experiences on the margins as well as their literary representation of these experiences are highly complex, suggesting both power and pain, radical subversion, and a desire for legitimation.

When I started this project many years ago, my initial plan had been to examine the specifically "literary" production of these black women. I soon discovered, however, that my interests went well beyond purely literary considerations to an investigation of how the

act of writing was in fact part of a much broader social activism engaged in by these women, how this social activism itself is constitutive of a long tradition of black civil rights and liberation movements that still continues today; and finally, how such a recovery of the past can enhance our appreciation of African-American cultural traditions, enable the formation of identity, and thereby encourage us to claim agency as historical subjects. I thus sought to broaden my field of investigation to include forms of cultural work other than the purely literary—public speaking, community activism, religious proselytizing, newspaper editorship, and so forth. I also found that I needed to abandon the more traditional methods of my discipline—literary criticism—that are still marked by exclusionary and hierarchical practices in order to adopt more interdisciplinary approaches.

In recent years, critical work in the humanities has offered us cultural studies as a model of interdisciplinary scholarship. Indeed, as certain theorists have maintained:

> Cultural studies is an interdisciplinary, transdisciplinary, and sometimes counter-disciplinary field that operates in the tension between its tendencies to embrace both a broad, anthropological and a more narrowly humanistic conception of culture. It . . . argues that all forms of cultural production need to be studied in relation to other cultural practices and to social and historical structures. Cultural studies is thus committed to the study of the entire range of a society's arts, beliefs, institutions, and communicative practices.

These theorists have further argued that cultural studies cannot be viewed simply as a "chronicle of cultural change but [rather] as an intervention in it," as politically engaged activity. As a consequence, they have begun to worry that in its current setting in the United States "the institutional norms of the American academy [might] dissolve its crucial political challenges."[1]

In her keynote address "Through and Beyond Identity Politics" at the University of Delaware's Women's Studies Conference "Interdisciplinarity and Identity," bell hooks recalled how both feminist studies and black studies are in fact interdisciplinary fields that antedate the contemporary cultural studies movement.[2] Both fields came of age in the 1960s under intense pressure for radical political and social change. Both fields have insisted on the need to analyze the lives, thought patterns, modes of behavior, and cultural production of women and African Americans by relying on methodologies from disciplines as diverse as history, sociology, political science, economics, and literary criticism. And both are explicitly political fields of

study as they conceive of scholarship as a tool for understanding the
past and present in order to plan for a better future.

My book embraces such a commitment to interdisciplinarity as it
insists on (1) a historical specificity that places the women studied
within American, and especially African-American, "social and his-
torical structures" of the period; (2) anthropological perspectives that
interpret the work of these women in relation to their "beliefs, insti-
tutions, and communicative practices"; and (3) a literary criticism
that not only analyzes the themes and narrative/rhetorical strategies
found in these women's writings, but also examines how these were
shaped by a politics of publication (access to mainstream publishing
houses, self-publication, and white abolitionist patronage) and a
politics of reception (multiple audiences, consequent audience con-
straints, and the need to negotiate this divided readership). And, as
noted earlier, my project is explicitly political in its commitment to
recovering aspects of our African-American past in order to rethink
ourselves as historical subjects and claim agency. As a consequence,
such an interdisciplinary approach comes to significantly transform
"literary criticism" itself.

As I proceeded to carry out such interdisciplinary work, however,
I found myself repeatedly asking questions about the activities of
these nineteenth-century African-American women cultural workers
to which the historical record was unable to provide answers.
Searching unsuccessfully for written accounts that would detail the
lives of these women, I soon found myself repeatedly engaging in
acts of speculation, obliged to theorize about these women without
having garnered sufficient evidence that would have enabled me to
present conclusions with unquestioned authority. Such speculative
activity ultimately led me to reflect on my own subjective position
and agency as a black intellectual working in the white academy at
the end of the twentieth century.

Although I could offer any number of examples of my need to
speculate, those that I would like to concentrate on here concern the
relationships that these nineteenth-century black women might have
had with other black leaders of the period—male or female—and
also with each other; they point to an apparent model of working
in relative independence from other leaders once outside the local
community, and raise questions about gender relations, audience
reception, and interiority. Yet, how to interpret this model remained
unclear to me. Should it be seen as a position of disempowerment
or as a radical challenge to existing social structures?

For example, as I started to investigate the life of Sojourner Truth,
I was struck by the degree to which she appeared in her adult life

to have had an ambiguous relationship with the larger northern black community of social activists, affiliating instead primarily with whites. Indeed, following her emancipation from slavery Truth joined two white experimental communities—first the religious kingdom Matthias and; after its demise, the socialist Northampton Association. After the failure of this latter organization, Truth affiliated with the Garrisonian antislavery movement. From the mid-1840s to the Civil War, she often lectured on its behalf as well as on that of the nascent women's rights movement led by Stanton and Anthony. Was it Truth's nonconformism, the black elite's disdain for this "uncultured negro" as Frederick Douglass once referred to her, or a combination of both, that separated her from the community of black reformers?[3] And how did she feel about her marginalized status within white organizations? Finally, what was I to make of the reactions of white auditors to Truth's public speeches that almost unanimously labeled her oratorical style as eccentric, peculiar, and idiosyncratic? Must we simply concur that Truth's English was faulty or may we read into these assessments the troubling presence of a double discourse, in which the language of the dominant culture is shot through with Africanisms, thus allowing Truth to reach beyond her immediate white audience to speak to those of her race and, following Benedict Anderson's formulation, "imagine community"?[4]

I was equally struck by other apparent forms of unconnectedness in the lives of still other women. For example, Frances Watkins Harper became active in black reform movements in the early 1850s shortly after her uncle, William Watkins, had left these movements but at a time when his son, William J. Watkins, had emerged as a leading spokesman. Yet I could uncover no evidence that might have indicated the kind of collaborative work that might have occurred between Watkins Harper and her male relatives. Given the fact that both men explicitly condemned the black community's apathy toward reform work, it would be reasonable to suppose that they welcomed and encouraged Watkins Harper's social activism. Yet it is also possible that given the negative attitudes of many men of the black elite toward women's activities in the public sphere, they might have felt quite uncomfortable with her presence. Indeed, femininity does not appear to be congruent with William J. Watkins's concept of the social reformer: "The bold and dashing Reformer, who walks to and fro, with the besom of destruction in his right hand . . . comes with flaming sword, and must penetrate, if he would be successful in the end, the incrustations of ignorance, in which he finds imbedded, man's mental and moral organism."[5]

Yet, perhaps the most perplexing aspect of these women's relationships was what appears to have been their relative institutional independence from one another as they carried forth their social activist goals outside their local communities. Why did concerted black female activism remain on the local level until the Civil War? To what extent were black women able to forge a group authority as they participated in national reform organizations that were either racially mixed or led by white women? Given their exclusion from positions of power in black national institutions, why didn't black women, or why could they not, band together to form national organizations of their own?

Burdened by such speculative pressures, my narration of the social activism and cultural production of these women-reformers may be seen to break down at certain textual junctures. At such moments, my narrative is disrupted by unanswered questions that mark the loss of a professional authority traditionally granted literary critics or historians and of the single interpretive reading that they produce. Confronting such an authorial breakdown, I was forced to wonder whether I was faced here with an instance of the "postmodern turn," through which postmodernism critiques modernist notions of authorial power claiming "that the very criteria demarcating the true and the false, as well as such related distinctions as science and myth or fact and superstition, are internal to the traditions of modernity and cannot be legitimized outside of those traditions."[6] Yet I also worried that the postmodern questioning of the coherent social subject, of the commensurability of language, and of the meaning of value may finally be of little help to the researcher who remains committed to empiricist methods and points of view to bring about political and social change.

More pertinently, does such speculative activity take place under the sign of woman—woman as both the object and the subject of speculation? Indeed, as I proceeded in my research I became aware that the necessity of resorting to speculation resided in large part in the fact that the historical figures I had chosen to study were women. Had I decided to focus on their male counterparts—Frederick Douglass, Henry Highland Garnet, Martin Delany, and Alexander Crummell, for example—a wealth of written historical documentation would have been available to me to help shape my narrative. But I had chosen to study women, specifically black women, and discovered that history—both historical events and historical writing—had shrouded them in silence and invisibility in several important ways. First, because they were women they had been excluded from assuming official positions of power, and often even from partici-

pating, in the most important national institutions of the period whose history was even then being recorded, obliged instead to seek sites of empowerment in liminal spaces that lie outside the economy of writing. Second, because they were women, researchers have not until recently deemed the cultural work that they engaged in to be important, but have allowed whatever existing written record of their activities to remain buried in silence.

Finally, as black women living in the nineteenth century these women seemed to have blocked any easy access to the interiority of their lives even through our reading of their personal letters and diaries. The prevailing cult of sentimentality popular among antebellum middle-class white women had situated women within a domestic sphere characterized by values of privacy, interiority, and feeling, which are made public through the act of literary composition. In contrast, slave culture and the slave narrative are marked by a kind of textual opacity, a refusal to speak or to interpret the secret facts of African-American folkways. The women-reformers I studied appear to have adopted this latter rhetorical strategy such that their absence both from national institutions and from historical records is compounded by their decision to maintain their interior lives secret. Given this lack of documentation, speculation then becomes the only alternative to silence, secrecy, and invisibility.

If speculation in my book was initiated because woman was its object, it was also prompted by the fact that woman—myself as researcher—was its subject as well, suggesting that I needed to speculate about the possibilities of speculation as a feminist activity. Indeed, speculation may be viewed as one aspect of that broader feminist epistemology that questions masculinist modes of inquiry and knowledge stemming from the Enlightenment—modes that assert the existence of a transcendent, generalized perspective convinced of its power to reveal "general, all-encompassing principles which lay bare [and explain] the basic features of natural and social reality," and its consequent ability to construct narratives whose adequacy would be independent "from the historical context of their genesis."[7]

The standpoint of speculative activity lies in the "I." On the one hand, the use of the "I"—the statement of personal opinion, the description of personal experience—has been interpreted negatively as trivial, banal, nontheoretical, and thus has been associated with female discourse. On the other hand, critics such as Barbara Sichtermann have suggested that "personal view" carries with it its own authority and generates privileged meanings that guarantee the writer an audience, "favored status," and "self-importance"; this au-

thority is of course typically gendered as male. Sichtermann further argues that the articulation of personal view is a form of speculative activity that most often takes place outside of institutions and is thus bereft of institutional legitimation; if its enactment is a challenge to men, it is all the more problematic for women for whom the permission to speak and the ability to be heard has always been difficult.[8]

I would like to suggest, however, that for the woman willing to take the risk, speculation may in fact be liberatory. Speculative activity may place the feminist researcher in liminal spaces on the margins of established institutions where she may come to test and challenge institutional conventions and constraints. Refusing to allow thought to be disciplined, speculation may encourage the researcher to cast aside disciplinary rules and to create her own methodologies, and perhaps even to claim the personal "I" as its own authority. In my own particular case, simply claiming speculation as a possible methodology allowed me to reflect on my own position not only as a feminist researcher but as a black intellectual—as a black feminist critic. Paraphrasing Cornel West, the dilemma of black intellectuals today is that we are no longer "organically linked" to the African-American community; we have lost those "strong institutional channels" that foster "serious intellectual exchange" and "sustain tradition," and we engage in activities that remain marginal to, and *de*legitimated by, the white academies in which we work. West suggests that we need to question current "regimes of truth" and to "dislodge prevailing discourses and powers" in order to "enable alternative perceptions and practices" that might then lead to "meaningful societal transformations."[9]

In my case, to the extent that I was able to free myself from the institutionalized rules of my discipline and to engage in speculative activity, I found that I was able to make common cause with the black women cultural workers that I had been studying. For, as I noted earlier, these women had themselves been excluded from official positions of authority in the national institutions of the black male leadership and had thus been obliged to seek sites of empowerment outside of institutions in liminal sites such as the "clearing" of the Second Great Awakening or the platform of the public lecture hall where they encountered that difficulty of being heard described by Sichtermann. Yet, despite this they had made themselves heard.

How, then, did I proceed in the writing of my book? From the outset, I acknowledged the constructed nature of my narration of the lives, social activism, and cultural production of these black women. I acknowledged the political agenda embedded in my recovery of these aspects of our cultural past. I acknowledged the limita-

tions to what I could factually know on the basis of reading books and doing archival research. I refused to invent an interior life for these women, leaving this task to fiction writers such as Toni Morrison who has stated that she wrote *Beloved* because nowhere in their narratives could she find a record of the inner life of slaves. At the same time I rejected the temptation to offer conclusive interpretations, but left open the possibility that Sojourner Truth might, of might not, have constructed her oratorical style in order to reach beyond her present audience of whites to a broader audience of blacks and thereby "imagine community"; that Frances Watkins Harper might, or might not, have gained the approbation of her male relatives and worked collaboratively with them to achieve racial uplift; that these women might have deliberately chosen, or might have been forced by economic and political circumstances, to work without the benefit of strong organizational networks outside of their local communities.

Throughout this process, I was well aware of the fact that the selection of one or the other of these alternatives might have led to the construction of a specific kind of narrative, each one of which would have been fraught with its own political ideology—the one emphasizing what might loosely be called "agency," the other "oppression." This is not to say that my work is then ideologically pure, eschewing political positionalities. Far from it. But by maintaining an approach that encourages speculation and resists closure, my narrative points to the ways in which nineteenth-century African-American women "doers of the word" were neither totally accommodationist nor totally subversive, but repeatedly negotiated agency and oppression, institutions and liminiality, and subversion and legitimation. As a black feminist working largely within the white academy but engaged in speculative activity, I like to think of myself as an heir to these doers of the word chosen to carry their legacy forward.

Notes

1. Cary Nelson, Paula Treichler, and Lawrence Grossberg, "Cultural Studies: An Introduction," in *Cultural Studies,* eds. Lawrence Grossberg, Cary Nelson, Paula Treichler (New York: Routledge, 1992), pp. 3, 4, 5.

2. bell hooks, "Through and Beyond Identity Politics," Interdisciplinarity and Identity, Women's Studies Program Conference, University of Delaware, 15 April 1994.

3. Quoted in Esther Terry, "Sojourner Truth: The Person Behind the Libyan Sibyl," *Massachusetts Review* 26 (summer–autumn 1985): 442.

4. Benedict Anderson, *Imagined Communities: Reflections on the Origin and Spread of Nationalism* (London: Verso, 1991), pp. 6–7.

5. William J. Watkins, "The Reformer," in *The Black Abolitionist Papers,* eds. C. Peter Ripley et al. (Chapel Hill: University of North Carolina Press, 1988–92), 4:212.

6. Linda J. Nicholson, Introduction to *Feminism/Postmodernism,* ed. Nicholson (New York: Routledge, 1990), pp. 4, 7.

7. Ibid., p. 2.

8. Barbara Sichtermann, "Woman Taking Speculation into Her Own Hands," in *The Politics of the Essay: Feminist Perspectives,* eds. Ruth-Ellen Boetcher Joeres and Elizabeth Mittman (Bloomington: Indiana University Press, 1993), pp. 90–91.

9. Cornel West, "The Dilemma of the Black Intellectual," *Cultural Critique* 1 (fall 1985): 112–23.

Creating/Reclaiming Herstory in Concert: Twenty Years of Feminist Musical Research

VICTORIA O'REILLY

THIS essay surveys feminist scholarship in music and highlights ac-
complishments of women working in the varied aspects of musical
life from the early 1970s forward within the United States. Three
major developments are examined:

- the rediscovery of women's musical heritage;
- efforts to advance awareness of this heritage and to perpetuate
 it through both traditional and alternative institutions; and
- the creation of a substantial body of feminist research in music
 by extending the traditional methodologies of music's subdisci-
 plines using perspectives and tools developed by feminist schol-
 ars in other fields.

The feminist musicologist Jeannie G. Pool has urged the docu-
mentation of women's work in music "to insure that each generation
of women musicians need not 'remake the wheel'."[1] In this spirit,
it seems appropriate and necessary to begin to construct a historiog-
raphy (or herstoriography?) documenting the work of the past quar-
ter century and its contributions both to music and women's studies.
This essay offers an initial framework for that larger analysis.

Sandra Harding observes that, ". . . every discipline *has* a history
which is taught—formally or informally—to its students."[2] The for-
mal study of history is central both to the discipline of music and
to that of women's studies. The respective histories of these fields
also play a central part in musical life and in the women's movement
outside of the academy. The interdisciplinary history of feminist
music scholarship and of women's work in music reflects the inter-
section of both fields. This history has been shaped in part by the
limits placed on women's participation and recognition in music
history and practice, and by the emergence of women's studies

within the academy. I will discuss each of these factors briefly before turning to the research and actions they influenced.

Feminist musicologist Eva Rieger has said, "Musicology has the reputation of being an extremely conservative discipline—even more so than theology."[3] Symptomatic of the discipline's conservativism has been its exclusion of most of the record of women's activity from the traditional account of Western music history. Feminist musicologists Jane Bowers and Judith Tick note that "[o]ne reason for such neglect has to do with the nature of musicology as it has developed in this century. Musicologists have paid little attention to the sociology of music, . . ."[4] Music history has given insufficient attention both to the forces that define "appropriate" roles in music based on sex, class, and race, and to women's activity within those spheres of musical activity that have been considered acceptable for particular groups of women. These gaps reflect the fact that, as musicologist Ruth A. Solie states,

> . . . the formulation of the most basic questions about what pieces of music can express or reflect of the people who make and use them, and thus of the differences between and among those people . . . have not traditionally been central questions in musicology—a fact which bewilders many historians and critics in other fields. . . ."[5]

The exclusions and limitations of music's history and of its institutions influenced the course of women's reclaiming process in recent decades. In response to the limits that sexism imposed, many women were prompted to look beyond traditional musicology and musical institutions to identify their musical heritage and to construct new opportunities for artistic expression and development, as well as means of advancing their careers in the musical mainstream. Their efforts have shown that "[t]he absence of women in the standard music histories is not due to their absence in the musical past."[6]

Though women have played a part in this past, efforts to construct a larger view of women's collective musical life, and to systematically analyze the implications of limitations placed on acceptable roles for women in musical life for women and for music, have not always been present. Such endeavors have been tied to larger women's movements. Bowers and Tick note that "[w]hen cultural feminism surfaced around the turn of the century, we find women organizing concerts of women's music, compiling handbooks and dictionaries about women musicians, and writing articles about the 'woman question' in music, much as we do today."[7]

While the research and actions documented in this essay from 1970

to date have clear precedents in the late nineteenth century and in the first half of this century, they are distinguished from earlier activities by the advent of women's studies. Bowers and Tick place more recent efforts in context, stating:

> Although musicians and musicologists such as Ethel Smyth, Yvonne Rosketh, Marie Bobillier (Michel Brenet, pseud.), Kathi Meyer, and Sophie Drinker—pioneers to whom the present generation is in debt—gave the study of women in music its essential impulse, the current activity is part of the new feminism and the larger field of women's studies that began to emerge in the 1960s and 1970s.[8]

The actions of earlier generations of women musicians advanced women's status in many aspects of music by the late 1970s (a notable example being the inclusion of women in mainstream orchestras during and after World War II, following on the success of all-women orchestras formed in the 1920s and 1930s), yet women continued to encounter barriers. Writing in 1986, Bowers and Tick acknowledged progress but observed,

> Nevertheless, pressure from the disparity between the numbers trained and the numbers recognized, hired, or advanced equally has led to another wave of cultural feminism. Within the last decade or so there has been a resurgence of women's performing groups, concerts and festivals of women's music, and feminist organizations formed to promote professional advancement.[9]

The activities cited by Bowers and Tick, and in the following pages, can be read as a direct, strategic response to limits inscribed by sexism. The particular expressions and forms of these musical actions and the course of feminist research in music over this period has been shaped both by the women's movement and by the development of feminist methodologies across disciplines.

Following a synopsis of significant activities and trends by decade, I will conclude with a discussion of the major influences and strategies that shaped the period and of anticipated directions for the future. A selective chronology of events and a brief list of resources complements the essay.

1970s

Women having, until very recently, been virtually denied their history as musicians, everyone was starting from the same position of ignorance

and was discovering something of that history for the first time together. A real sense of community developed in the class.

(Jane Bowers, on first teaching a course entitled "Women–Musicians and Composers" in 1976)[10]

In the early and mid-1970s feminist musicologists restated the question posed by art historian Linda Nochlin in her 1971 essay, "Why Are There No Great Women Artists?"[11] They began to examine women's work as composers and performers, redefining assumptions behind the question as they formed their responses. Through research, they reconstructed the lives and music of their musical foremothers, mostly within the Western music tradition. They also began to perform, publish, and record this music.

Most of the initial work undertaken on this subject was by women and took the form of ". . . attempts to 'add women' to traditional analyses."[12] Pianist and music professor Barbara Rogers recently recalled, "At first it was largely a matter of discovering 'forgotten' or unheralded female composers."[13] The majority of entries in a 1975 bibliography of "Recent Research and Popular Articles on Women in Music" compiled by Jane Bowers are studies of individual women active as musicians or composers in Western music from the Middle Ages to the twentieth century. Similarly, Bowers notes that "several extensive lists of women composers are currently being compiled or revised."[14] The 1974 documentary film *Antonia: A Portrait of the Woman* illustrated the limits faced by an exceptional female musical talent, the conductor Antonia Brico, despite her early successes in the 1930s.[15] Leonarda Productions, founded in 1979, produced recordings of works by women composers.[16] The decade of the 1970s culminated with a major achievement in documenting women's work in music in this country and in identifying resources on this topic: publication of Adrienne Fried Block and Carol Neuls-Bates's *Women in American Music: A Bibliography of Music and Literature*.[17] The first comprehensive research guide to this subject, it remains a valuable reference source.

At the same time, women's music was defining itself as a cultural and art form with a political agenda. Presentation of women's music was increasingly formalized through festivals, marketing, and communications tools. In 1975, the first Michigan Womyn's Music Festival was held. The 1970s also saw publication of *Paid My Dues,* a national journal focused primarily on women's music but providing some coverage of women's work in other musical styles. Ethnomusicologist Carol E. Robertson has noted the development of the D.C. Area Feminist Chorus, founded in 1976, and its changing rela-

tion to women's networks and culture in the Washington, D.C., area.[18] Similar ensembles were formed in other communities. The 1976 advent of Ladyslipper, a women-run, music distribution service based in North Carolina, provided a vehicle for the national marketing of recordings and other materials produced by women's music performers and women artists in other musical genres.

Women also came together around their roles in the field of music to document and mutually advance their status. At the 1972 meeting of the College Music Society (CMS), a professional organization for college music faculty, "a group of women formed a Committee on the Status of Women whose initial purpose was to discover how women fare in college music."[19] Three years later several papers given at the CMS annual meeting presented initial findings on women in the profession. These were collected and published by the CMS.[20]

Two organizations formed in this decade to unite and offer mutual support to women composers: the League of Women Composers in 1975 and the American Women Composers (AWC) in 1976. Composer Jeanne Singer was affiliated with both groups. A charter member of the league, she was also a founding member and board member of the AWC. She later described the importance of her involvement in these groups to her identity as an artist: "From the age of 5, I wrote music but never considered myself a legitimate *composer* (*no role models*) until I became an activist in the women composer groups that started in the '70s after the United Nations proclaimed the Decade of Women (1975–85)."[21]

Formation of the New England Women's Symphony, with Kay Gardner as conductor, offered a forum in Boston for the work of women composers, conductors, and many women musicians. The group issued one recording that includes a performance led by Antonia Brico. In the field of jazz, the first of what was to become an annual Women's Jazz Festival was held in Kansas City, Missouri.

1980s

I hope this is encouragement for other women. It's kind of a good sign for the world. We're not that far away from the days when orchestras resisted having women players. I'd like to think I won for my piece, not as a symbol. But I don't mind being a positive symbol.
<div align="right">(Ellen Taaffe Zwilich on winning the Pulitzer Prize
for music, becoming the first woman to do so)[22]</div>

The awarding of the 1983 Pulitzer Prize in music to Ellen Taaffe Zwilich for her Symphony No. 1 marked a musical milestone for

women, as Heidi Waleson later wrote in the *New York Times,* "a woman had finally acquired a credential that could not be ignored." Interpretations of just how much change within the music world Zwilich's prize symbolized varied, as Waleson succinctly noted:

> To some, Ms. Zwilich's prize indicated that women, spurred and aided by the feminist movement had made their way into mainstream composition; to others, it seemed a belated, isolated recognition, not really indicative of anything more than a slight, grudging change of attitude in the concert music world.[23]

Reflecting these differing views, work on and by women in music in the 1980s employed a dual strategy akin to that articulated by Catharine Stimpson and Nina Kressner Cobb in their assessment of women's studies at that time: "The women's studies movement is correct in wanting its own independent structures, . . . and the incorporation of its goals within less women-specific structures.[24]

Musical academe and the music industry afforded ample "less women-specific structures" into which feminist scholars and women performers and administrators sought to introduce their work. Their efforts occasioned a stronger presence in the field and greater recognition of women's achievements, while falling short of full incorporation. At the same time, many of the organizations and networks established in the 1970s to advance the work of women performers and to further scholarship on women in music continued to evolve and new ones were formed. Together, these trends generated an increase in published and recorded information on women in music, both in music and in women's studies, and the continued development of institutional support, through separate institutions and within existing academic structures. Opportunities for performances of music by women also grew. As Wang An-Ming, a Chinese-born composer active in the United States in this period observes,

> I definitely feel participation in women's groups[s] helps me in getting my music across. Being a minority enables me to have my music represented in a variety of programming which otherwise may not happen.[25]

Collectively, books published on women in music in the 1980s (which grew significantly in number over the previous decade), demonstrate the coexistence of three major types of feminist scholarship in music described by Ruth Solie and Gary Tomlinson in 1988 as:

- • . . . recovery and documentation projects, still vitally necessary in a field that has yet to establish much of its female past,
- • . . . rereadings of familiar works and ways of conceiving music, exploring in the process phenomena of cultural representation and gender construction; and
- • . . . rais[ing] methodological and historiographic questions, to date the least developed area of feminist work in musicology.[26]

(These approaches are neither mutually exclusive nor do they represent a hierarchy of value.)

As in the 1970s, new checklists, directories, and bibliographies were published and continued to serve the essential function of helping scholars and musicians identify women active in the field and to locate recordings, compositions, records, and other resources. One example is Diane Peacock Jezic's *Women Composers: The Lost Tradition Found* (1988) which brought together biographical information, musical analysis, and discographical and bibliographic listings on twenty-five women composers active in Western music from the medieval period into the 1980s.[27]

Most works written in this period contributed to recovery and documentation in some measure because they were often the first texts (or at least the first modern texts) on their subject. Nancy B. Reich's *Clara Schumann: The Artist and the Woman* (1985) is a good example. It overlaps the first two approaches, reexamining the life of a "woman worthy" and in the process offering a rereading of musicology's traditional account of Clara and Robert Schumann's lives and art. The work received critical recognition for its valuable contributions to music history and to women's history.[28]

Research also expanded into topics beyond white women working in Western classical music. Four titles that illustrate this direction are D. Antoinette Handy's *Black Women in American Bands and Orchestras* (1981); Linda Dahl's *Stormy Weather: The Music and Lives of a Century of Jazzwomen* (1984); Ellen Koskoff's anthology *Women and Music in Cross-Cultural Perspective* (1987); and Judith Vander's *Songprints: The Musical Experience of Five Shoshone Women* (1988).[29] Handy's study of black women musicians recovers and documents an important part of women's work in music and of African-American musical life, another active field of research in this time period. *Stormy Weather* identifies numerous jazzwomen, famed and forgotten; Dahl's inquiry into the relations between the art form and gender roles offers new insights for jazz history and women's studies. Both Handy and Dahl by their focus on women whose identities and/or art forms are beyond the bounds of mainstream musicology inher-

ently raise methodological questions for feminist musical research. Similarly, Koskoff and Vander's books raise questions about the limits and possibilities of the interdisciplinary techniques of ethnomusicology for feminist research.[30]

Notable both for insightful "rereadings" and for raising methodological questions are essays written by Susan McClary between 1987 and 1989. Described by McClary as "the beginnings of a feminist criticism of music," the essays grapple directly with issues of gender construction and sexual politics in works by an eclectic mix of musicians, including Monteverdi, Beethoven, Laurie Anderson, and Madonna.[31]

The body of literature created and published in journals and books on women in music increased throughout the 1980s. Feminist journals such as *Signs* carried articles and book reviews bringing knowledge of women's work in music to an audience of women's studies scholars. Feminist arts journals incorporated the work of women in music: *Heresies* published a *Women in Music* issue in 1980; *Helicon Nine* included an interview with Nancy Reich in its winter 1986 issue, as well as a recorded insert of Clara Schumann songs. *Hot Wire* followed in the path of *Paid My Dues* as a periodical focused on women's music and culture.

As with women's studies journals, some books on women's studies incorporated material on women in music. Ora Williams, Thelma Williams, Dora Wilson and Ramona Matthewson contributed a bibliography on "American Black Women Composers" to *All the Women Are White, All the Blacks Are Men, But Some of Us Are Brave: Black Women's Studies* (1982).[32]

The growing number of women's studies programs created a supportive climate for feminist work in music. Sharon Shafer, a performer, composer, and music professor, recently commented, "I have had more support from Women's Studies Programs, . . . than from music departments in academic institutions for my research in women composers."[33]

Although some of the performance showcases created in the 1970s disappeared in the 1980s, women continued to build organizations and networks to sustain their efforts. The New England Women's Symphony folded, in part due to financial difficulties; however the formation of women's orchestras continued to be a strategy used by women to advance the work of women composers, performers, and conductors. The best-known ensemble is the Bay Area Women's Philharmonic (BAWP), founded in 1980. It has grown to offer a subscription season and recordings. In the late 1980s, the BAWP established a sister organization, the National Women Composers

Resource Center. The center maintains a library of scores by women composers and facilitates research on women composers and programming of their music. The Maryland Women's Symphony was founded in 1985 by conductor Deborah Freedman and the pianist Selma Epstein. In its early seasons the ensemble presented music by women composers as well as by lesser-known works by men. By 1989, the ensemble was renamed the Women Composers Orchestra and led by the conductor Antonia Joy Wilson. Its repertoire focused more exclusively on works by women composers.[34]

Conferences were another strategy used to strengthen the network of women in music and to disseminate their research findings through papers and performances. Conferences focused specifically on women in music included:

- the 1981 First National Congress on Women in Music, forerunner of the International Congress on Women in Music, coordinated by Jeannie G. Pool and sponsored by New York University's music department; and
- the 1986 American Women Conductor/Composer Symposium sponsored by the School of Music and the Center for the Study of Women in Society of the University of Oregon at Eugene.

Feminist scholars also used existing professional conferences to gain a greater audience for their work. In what Solie and Tomlinson described as "an unprecedented burgeoning of women's musical studies," the 1988 annual meeting of the American Musicological Society (AMS) included at least fifteen papers on women in music and/or feminist methodology.[35] The 1989 AMS conference included two sessions specifically linking feminist theory and music: "Feminist Scholarship and the Field of Musicology," organized by Jane Bowers and others; and "The Implications of Feminist Scholarship for Teaching," organized by Susan Cook; as well as other papers on women in music.

In addition to making inroads in academe, women gained a greater presence as composers, conductors, and performers in the mainstream of musical life during the decade. As just noted, composer Ellen Taaffe Zwilich received the Pulitzer Prize in 1983. While no similar level of recognition was accorded women orchestral conductors, they continued to advance their individual careers. Beyond the symphonic music world, women performers increased their commercial success and received media attention for their work as women. Holly Near founded her Redwood Records label, initiating a new phase in women's music, commercially and artistically. Two

Newsweek stories in 1985 focused on the success of women working in country and rock music, respectively, the latter with a cover proclaiming "Rock and Roll: Woman Power."[36]

1990s

> . . . the structures graphed by theorists and the beauty celebrated by aestheticians are often stained with such things as violence, misogyny, and racism. And perhaps more disturbing still to those who would present music as autonomous and invulnerable, it also frequently betrays fear—fear of women, fear of the body.
>
> It is finally feminism that has allowed me to understand both why the discipline wishes these to be nonissues, and also why they need to be moved to the very center of inquiries about music.
>
> (Susan McClary, introduction to *Feminine Endings: Music, Gender and Sexuality* [1991])[37]

Three trends emerged in the early 1990s that indicate the directions that feminist scholarship and the actions of women working in music will take through this decade. First, feminist music scholarship increasingly defines its focus as nothing less than restructuring the traditional field of musicology using feminist theories and criticism. The first major national conference to focus exclusively on the links between feminist theory and music, titled "Feminist Theory and Music: Toward a Common Language," was held at the University of Minnesota at Minneapolis in 1991. The conference announcement stated: "The study of music from the perspective of feminist theory raised significant questions that transcend the methodologies of any one subdiscipline of music." The conference provided the first substantial, public forum in which to address these questions.[38]

The 1993 anthology *Musicology and Difference: Gender and Sexuality in Music Scholarship,* edited by Ruth Solie is an important contribution to this line of inquiry. As Solie states, "This is, to my knowledge, the first book about musicology and difference, . . ." It offers analytic perspectives critical to understanding ". . . what roles musics play in the construction and reinforcement of ideologies of difference and, conversely, how they may challenge or resist those ideologies." Solie suggests that ". . . the musicological disciplines . . . [are in the process of] reorient[ing] their focus of attention, . . . to encompass such issues."[39]

This first goal is accompanied by more direct ties between feminist scholarship in music and women's studies generally. Feminist musicologists continue to acknowledge that their development as feminist

scholars and the methodologies they evolve for their work are influ-
enced by feminist theory and methodology in other disciplines.
Shafer has said, "Feminist theories and methodologies have made it
possible to have some of the discussions that are necessary in order
to discover 'A History of Their Own'."[40] These ties are becoming
more evident. For example, the inclusion of J. Michele Edwards's
essay "All-Women's Musical Communities: Fostering Creativity and
Leadership" in the 1990 anthology *Bridges of Power: Women's Multi-
cultural Alliances* presents an aspect of women's work in music in the
larger context of feminist research and action, affirming that
women's work in music is an integral part of feminist inquiry and
struggles.[41]

Women's studies conferences now commonly include sessions
presenting women's work in music in the context of feminist analy-
sis and action, as well as performances. The 1993 National Women's
Studies Association conference presented two panels on music:
"Women's Lives in Music" and "Feminist Perspectives on Opera,"
in addition to performances by folk-artist Anne Feeney, Saffire: The
Uppity Blues Women, and the women's trio Reel World String
Band. The present conference on "Interdisciplinarity and Identity"
featured an earlier session titled "Women in Art and Music: An Inter-
action" in addition to this panel, "Women and Music: Redefining
the Center."

A third trend is the strengthening of women's separate musical
institutions and of the role of women in mainstream musical organi-
zations. Women's orchestras remain active, generating audiences for
the work of women composers, conductors, and musicians. The
Bay Area Women's Philharmonic celebrated its tenth anniversary in
1990. In 1992, the National Women's Symphony of Washington,
D.C., gave its premiere concert under the direction of Amy Mills,
who continues to lead the group.

Conductors and administrators of symphony orchestras continue
to advance their careers. For example, in 1990, conductor Marin
Alsop debuted as music director of the Long Island Philharmonic.
She also continues to lead her own New York City-based ensemble,
Concordia, and to conduct a summer festival in Eugene, Oregon,
among other activities. Alsop's career highlights what appear to be
improved possibilities for women who have the talent and training
to enter this demanding field to build careers in the same manner as
their male colleagues: complementing a roster of appointments at
smaller symphonies with guest conducting and residency opportuni-
ties that propel them forward to gain permanent posts with more
widely recognized orchestras. No woman has yet broken through

the glass ceiling to capture the music directorship of a major orchestra.

The 1991 appointment of Deborah Borda as managing director of the New York Philharmonic marked the first time that a woman held a top administrative post with a major orchestra. While Borda's appointment was an important first, a noteworthy "second" also occurred in 1991 when the Pulitzer Prize in music was awarded for only the second time to a woman, Chicago-based composer Shulamit Ran.

Women performers have made gains in the 1990s but inequities persist. As one instrumentalist expressed it, "Women are no longer being excluded, yet we are not yet on equal footing. Perhaps this will change."[42]

Conclusion

This brief survey of feminist scholarship in music and of women's work in music in the United States from 1970 forward provides an initial framework for discussion of the major influences that have shaped research approaches, as well as the strategies used to advance this research and women's status in the field. It also suggests areas that merit further attention and the directions in which future feminist research and action will likely lead. Feminism and women's studies have had a major influence on the development of research and theory by feminist scholars in music. Just as women's work in music provides a microcosm that parallels women's experiences in the larger world, the course of research on women in music has paralleled that of feminist research in other disciplines. The three research approaches outlined in this essay—re[dis]covery, rereadings, and raising methodological questions—all are necessary and will continue to be used by feminist scholars of music as the decade progresses. However, feminist research in music increasingly raises questions characteristic of the latter approach. Though these questions differ from those asked by most research in the early 1970s, they clearly flow from the combination of those studies and from the intervening investigations and writings of feminist scholars on musical life. This approach shares essential attributes with McClary's proposals for feminist criticisms: techniques and points of view from women's studies and feminist theories are at the center of the inquiry and analysis, rather than the methodologies and values of traditional musicology and criticism. Raising questions leads to the redefinition and re-creation of methodologies.

One of the most pervasive strategies used to advance research on, and the status of, women in music has been the construction of a sense of community. This community-building has been accomplished by means of publications, recordings, performance showcases and ensembles, and conferences. It has been employed in mainstream musical and academic settings and in separate, women-focused contexts.

Looking backward, the course of the study and advancement of women's work in music, with its parallels to women's studies research and familiar community-building strategies, may seem predictable. How could it have been otherwise? However, given that just a little over twenty years ago most of the research and means just cited, as well as the methodologies and strategies needed to realize them, were (for the most part) only beginning to take shape, the accomplishments of this period are considerable. The research, organizations, and performances created and presented since 1970 constitute an impressive oeuvre and valuable resource for future efforts.

It must be acknowledged, however, that feminist musical research has too often been bounded by the limits of traditional musicology. This has re-created some of the gaps common in music research around questions of whose music is considered "art" and whose voices guide the analysis.[43] It has also left largely intact taboos in both the academic and commercial music worlds against crossing genre categories. Feminist cultural critic Michele Wallace's analysis of the limits of white middle-class feminist scholarship in the visual arts speaks to similar limits in music. Taking as her starting point Linda Nochlin's essay on art history, cited earlier in the discussion of the 1970s, Wallace states,

> Her [Nochlin's] article shared a parallel conceptual framework with other initiatives taking place around gender issues across a variety of discourses in the social sciences, the humanities, and the other arts. This moment founded a new kind of feminist scholarship and criticism . . . upon which alternative institutions and alternative critical practices are built.
>
> Now the problem with all of this, as we well know, was that it proved to be a very white middle-class affair; and even for those who were white and middle-class, this feminist scholarship was and is still experienced as alienating and too abstract.
>
> . . . But the most radical elements of that very institutionalization have not managed to graduate from their rather tenuous foothold on the margins of the art world and the academic establishment.[44]

There is a need for more work that breaks through boundaries and taboos from diverse feminist perspectives. As in any active field, there is also a need to revisit earlier research in light of recent findings and to continue the performance and recording of works by women, adding a newly discovered (and written) repertoire, updating performance techniques and technology as appropriate, and reaching new audiences. Finally, there remain many unanswered questions, and others not yet posed.

As Susan McClary observes,

> music and its procedures operate as part of the political arena—not simply as one of its more trivial reflections. . . . Struggles over musical propriety are themselves political struggles over whose music, whose images of pleasure or beauty, whose rules of order shall prevail.[45]

The work of feminist musicologists, and of women performers and composers in all musical styles, from the 1970s forward, has created supportive scholarly networks and creative communities within music, as well as in the discipline of women's studies and among feminists more generally, which will continue to nurture those engaged in these struggles. I look forward to reading and hearing their work in the coming decade—and to reporting on their successes when we gather to mark the thirtieth anniversary of the University of Delaware's women's studies program.

Chronology

1970

Pauline Oliveros, "And Don't Call Them 'Lady' Composers," *New York Times,* 13 September 1970, sec. 2, pp. 23 and 30.

1972

Willia E. Daughtry, "Sissieretta Jones: Profile of a Black Artist," *Musical Analysis* 1, no. 1 (winter 1972): 12–18.

1973

Judith Rosen and Grace Rubin-Rabson, "Why Haven't Women Become Great Composers?" *High Fidelity and Musical America* 23, no. 2 (February 1973): 46–52.
"Available Recordings of Works by Women Composers," *High Fidelity and Musical America* 23, no. 2 (February 1973): 53.
Judith Tick, "Women as Professional Musicians in the United States, 1870–1900," *Yearbook for Inter-American Musical Research* 9 (1973): 95–133.

1974

Antonia: A Portrait of the Woman, Made by Jill Godmilov and Judy Collins. Film documentary of the life of the conductor Antonia Brico (1902–89).

1975

League of Women Composers founded.

First Michigan Women's Music Festival.

Meeting on Women in the Profession, College Music Society annual meeting, Iowa City, February 1975.

Don. L. Hixon and Don Hennessee, *Women in Music: A Biobibliography* (Metuchen, N.J.: Scarecrow Press, 1975).

1976

American Women Composers, Inc. founded.

Ladyslipper formed.

1977

Jane M. Bowers, "Teaching about the History of Women in Western Music," *Women's Studies Newsletter* 5, no. 3 (summer 1977): 11–15.

1978

Anya Laurence, *Women of Note: 1,000 Women Composers Born Before 1900* (New York: Richards Rosen Press, 1978).

First Women's Jazz Festival, Kansas City, Miss.

First concert of the New England Women's Symphony, Sander's Theater, Cambridge, Mass., 3 December 1978. Kay Gardner, conductor.

Paid My Dues: Journal of Women and Music, in publication.

1979

Women in Music Feature in *Music Educators Journal* 65, no. 5 (January 1979), Including Jeannie G. Pool, "Up from the Footnotes," pp. 28–41.

Adrienne Fried Block and Carol Neuls-Bates, compilers and eds., *Women in American Music: A Bibliography of Music and Literature* (Westport, Conn.: Greenwood Press, 1979).

1980

Heresies #10: Women and Music.

Christine Ammer, *Unsung: A History of Women in American Music.* Contributions in Women's Studies, no. 14 (Westport, Conn.: Greenwood Press, 1980).

Bay Area Women's Philharmonic founded by Miriam Abrams, Nan Washburn, and Elizabeth Min.

1981

D. Antoinette Handy, *Black Women in American Bands and Orchestras* (Metuchen, N.J.: Scarecrow Press, 1981).

Judith Zaimont and Karen Famera, eds., *Contemporary Concert Music by Women: A Directory of the Composers and Their Works* (Westport, Conn.: Greenwood Press, 1981), pp. x, 355.

First National Congress on Women in Music, New York City. Organized by Jeannie Pool.

1982

Ora Williams et al., "American Black Women Composers: A Selected Annotated Bibliography," in Gloria T. Hull, Patricia Bell Scott, and Barbara Smith, eds. *All the Women Are White, All the Blacks Are Men, But Some of Us Are Brave: Black Women's Studies* (Old Westbury, N.Y.: Feminist Press: 1982), pp. 297–306.

1983

Composer Ellen Taaffe Zwilich awarded Pulitzer Prize for music, first woman so honored.

Judith Tick, *American Composers Before 1870,* Studies in Musicology 57 (Ann Arbor: UMI Research Press, 1983), pp. xix, 283.

Film: "Gotta Make This Journey: Sweet Honey in the Rock," 1983, 58 minutes by Michelle Parkerson.

1984

Linda Dahl, *Stormy Weather: The Music and Lives of a Century of Jazzwomen* (New York: Limelight Editions, 1984).

1985

David Gates, "Nashville's New Class," *Newsweek,* 12 August 1985, pp. 58–61.

Newsweek, 4 March 1985. Cover story: Rock and Roll: Woman Power.

————Jim Miller et al., "Rock's New Women," pp. 48–54, 57.

————Cathleen McGuigan and Tony Clifton, "The Sexy Godmother of Rock," pp. 50–51 (Tina Turner).

————Bill Barol, "Women in a Video Cage," p. 54.

Nancy B. Reich, *Clara Schumann: The Artist and the Woman* (Ithaca: Cornell University Press, 1985).

Maryland Women's Symphony is active (by the 1992–93 season becomes the Women Composers Orchestra).

1986

American Women Composers, Inc., Tenth Anniversary Celebration (13 April 1986–15 February 1987).

Jane Bowers and Judith Tick, *Women Making Music: The Western Art Tradition, 1150–1950* (Urbana and Chicago: University of Illinois Press, 1986).

Hot Wire, The Journal of Women's Music and Culture in publication (continues at least through fall 1991).

American Women Conductor/Composer Symposium, 21–23 February 1986, University of Oregon. Sponsored by the Center for the Study of Women in Society of the University of Oregon School of Music, Eugene.

Ellen Koskoff, ed., *Women and Music in Cross-Cultural Perspective* (Urbana and Chicago: University of Illinois Press, 1987).

Frank C. Taylor with Gerald Cook, "Blues Singer Alberta Hunter: The Forgotten Years," *Ms.* (March 1987): 46–48, 71, 72.

National Museum of Women in the Arts opens March 1987. Premiere of Ellen Taaffe Zwilich, *Images for Two Pianos and Orchestra,* Leanne Rees and Stephanie Stoyanoff, duo-pianists. National Symphony Orchestra, Fabio Mechitti, conductor. Commissioned by NMWA with NEA assistance.

Mademoiselle: A Portrait of Nadia Boulanger, produced by Dominique Parent-Altier, Crocus Films, Inc. 56 minutes, color, ½″ VHS, ¼″ U-matic. Indiana University Audio-Visual Center Field Services Dept. 1-800-552-8620.

Diane Peacock Jezic, *Women Composers: The Lost Tradition Found* (New York: Feminist Press, 1988). Foreword by Elizabeth Wood.

1990

J. Michele Edwards, "All-Women's Musical Communities: Fostering Creativity and Leadership," in *Bridges of Power: Women's Multicultural Alliances,* eds. Lisa Albrecht and Rose M. Brewer (Philadelphia: New Society Publishers, 1990), pp. 95–107.

Margaret Ericson, "Women and Music 1988/89: A Selective Bibliography on the Collective Subject of Women in Music."

Susan McClary, *Feminine Endings: Music, Gender, and Sexuality* (Minnesota: University of Minnesota Press, 1990).

Marin Alsop, 1990–91 in first season as music director, Long Island Philharmonic, Melville, N.Y.

Catherine Comet appointed music director of the American Symphony Orchestra.

1991

Deborah Borda appointed managing director, N.Y. Philharmonic.

"Feminist Theory and Music: Toward a Common Language," conference, 1991 June 23–30, School of Music, University of Minnesota, Minneapolis.

1992

National Women's Symphony premiere concert, 14 June 1992, Washington, D.C. Amy Mills, music director and conductor.

1993

Ruth A. Solie, ed., *Musicology and Difference: Gender and Sexuality in Music Scholarship* (Berkeley and Los Angeles: University of California Press, 1993).
This document may be reproduced and/or cited without the author's permission. Please credit appropriately.

Resources

Ladyslipper
P.O. Box 3124
Durham, N.C. 27715
(800) 634-6044
Recordings of music by/for/about women

William Grant Still Music
4 S. San Francisco Street, Suite 422
Flagstaff, Ariz. 86001-5737
(602) 526-9355
Recordings and writings by minority composers and writers, as well as women composers

Arsis Press
1719 Bay Street, SE
Washington, D.C. 20003
(202) 544-4817
Publishes music by women composers

See also the *Directory of Women's Media* published by the National Council on Research for Women for a listing of organizations related to women in music.

Notes

1. Jeannie G. Pool, "Etudes for Women: Making Music Our Own," *Paid My Dues 4*, no. 1 (ca. 1979): 10.
2. Sandra Harding, ed., *Feminism and Methodology: Social Science Issues* (Bloomington: Indiana University Press, 1987), p. 15.
3. Eva Rieger. "'Dolce semplice'? On the Changing Role of Women in Music," in *Feminist Aesthetics* ed. Gisela Ecker, trans. Harriet Anderson (Boston: Beacon, 1985), p. 137.
4. Jane N. Bowers and Judith Tick, eds., *Women Making Music: The Western Art Tradition, 1150–1950.* (Urbana and Chicago: University of Illinois Press, 1986), p. 3.
5. Ruth A. Solie, ed., *Musicology and Difference: Gender and Sexuality in Music Scholarship* (Berkeley and Los Angeles: University of California Press, 1993), p. 3.
6. Bowers and Tick, *Women Making Music,* p. 3.

7. Ibid., 8.

8. Ibid., 10.

9. Ibid.

10. Bowers, "Teaching about the History of Women in Western Music," *Women's Studies Newsletter* 3 (summer 1977): 15.

11. Linda Nochlin, "Why Are There No Great Women Artists?" in *Woman in Sexist Society: Studies in Power and Powerlessness,* eds. Vivian Gornick and Barbara Moran (New York: New American Library, 1972), pp. 480–510.

12. Harding, *Feminism and Methodology,* 3.

13. Correspondence with Barbara Rogers, April 1994.

14. Bowers, "Recent Research on Women in Music," in *The Status of Women in College Music: Preliminary Studies,* College Music Society Report no. 1, ed. Carol Neuls-Bates (Binghamton, N.Y.: College Music Society, 1976), pp. 4–9.

15. *Antonia: A Portrait of the Woman,* made by Jill Godmilov and Judy Collins (New York: Phoenix Films, 1974). Collins, who studied with Brico while growing up in Colorado, created the film with Godmilov as a tribute to her teacher. The film aired on public television and renewed interest in Maestra Brico, leading to a number of conducting engagements for her.

16. Diane Peacock Jezic, *Women Composers: The Lost Tradition Found,* with a foreword by Elizabeth Wood (New York: Feminist Press, 1988), pp. 239–42 for a partial listing of Leonarda recordings.

17. Adrienne Fried Block and Carol Neuls-Bates, *Women in American Music: A Bibliography of Music and Literature* (Westport, Conn.: Greenwood Press, 1979).

18. Carol E. Robertson, "Power and Gender in the Musical Experiences of Women," in *Women and Music in Cross-Cultural Perspective,* ed. Ellen Koskoff, (Urbana and Chicago: University of Illinois Press, 1987), pp. 225–44. See pp. 239–41 for the discussion cited herein.

19. Block, "The Woman Musician on Campus: Hiring and Promotion Patterns," in *Status of Women in College Music,* p. vi.

20. Neuls-Bates, *Status of Women in College Music.*

21. Letter to the author, 4 April 1994.

22. *New York Times,* 4 May 1983, quoted in Jezic, *Women Composers,* p. xi.

23. Heidi Waleson, "Women Composers Find Things Easier—Sort Of," *New York Times,* 28 January 1990.

24. Catharine R. Stimpson and Nina Kressner Cobb, *Women's Studies in the United States: A Report to the Ford Foundation* (New York: Ford Foundation, 1986).

25. Letter to the author, 4 April 1994.

26. Solie and Gary Tomlinson, "Women's Studies in a New Key," *NWSAction* (spring 1989): 6.

27. Jezic, *Women Composers.*

28. Nancy B. Reich, *Clara Schumann: The Artist and the Woman* (Ithaca, N.Y.: Cornell University Press, 1985).

29. D. Antoinette Handy, *Black Women in American Bands and Orchestras* (Metuchen, N.J.: Scarecrow Press, 1981); Linda Dahl, *Stormy Weather: The Music and Lives of a Century of Jazzwomen* (New York: Limelight Editions, 1984); Ellen Koskoff, ed., *Women and Music in Cross-Cultural Perspective* (Urbana and Chicago: University of Illinois Press, 1987); and Judith Vander, *Songprints: The Musical Experience of Five Shoshone Women* (Urbana and Chicago: University of Illinois Press, 1988).

30. See Koskoff's discussion of feminist scholarship and the study of women in

ethnomusicology and related fields," in Koskoff, ed., *Women and Music in Cross-Cultural Perspective,* pp. xi–xii and 1–23.

31. The essays were collected and published with an introduction by Susan McClary, *Feminine Endings: Music, Gender, and Sexuality* (Minneapolis: University of Minnesota Press, 1991). Quoted passage is from p. 31.

32. Ora Williams et al., "American Black Women Composers: A Selected Annotated Bibliography," in *All the Women Are White, All the Blacks Are Men, But Some of Us Are Brave: Black Women's Studies,* eds. Gloria T. Hull, Patricia Bell Scott, and Barbara Smith (Old Westbury, N.Y.: Feminist Press, 1982), pp. 297–306.

33. Correspondence with the author, 5 April 1994.

34. In recent years, the orchestra has generally presented chamber music programs, generally without a conductor.

35. Solie and Tomlinson, "Women's Studies," p. 6.

36. David Gates, "Nashville's New Class," *Newsweek,* 12 August 1985, pp. 58–61. Jim Miller et al., "Rock's New Women," *Newsweek,* 4 March 1985, pp. 48–54, 57. McGuigan and Tony Clifton, "The Sexy Godmother of Rock," ibid., pp. 50–51. Bill Barol, "Women in A VideoCage," *ibid.,* p. 54.

37. McClary, *Feminine Endings,* pp. 4–5.

38. "Feminist Theory and Music: Toward a Common Language," conference announcement.

39. Solie, *Musicology and Difference,* pp. 1, 19.

40. Correspondence with author. Shafer's comment alludes to Bonnie S. Anderson and Judith P. Zinsser's book *A History of Their Own* (New York: Harper, 1988).

41. J. Michele Edwards, "All-Women's Musical Communities: Fostering Creativity and Leadership," in *Bridges of Power: Women's Multicultural Alliances,* eds. Lisa Albrecht and Rose M. Brewer (Philadelphia: New Society Publishers, 1990), pp. 95–107.

42. Correspondence with author, 10 April 1994.

43. Koskoff, *Women and Music,* p. 1 mentions Bruno Nettl's discussion of how male biases shape "approaches and methods" even in the field of ethnomusicology that has what Koskoff terms "a large proportion of women." Koskoff cites Nettl, *The Study of Ethnomusicology: Twenty-Nine Issues and Concepts* (Urbana: University of Illinois Press, 1983), pp. 334–35.

44. Michele Wallace, "Afterword: 'Why Are There No Great Black Artists?' The Problem of Visuality in African-American Culture," in *Black Popular Culture,* ed. Gina Dent. A project by Michele Wallace. Dia Center for the Arts, Discussions in Contemporary Culture, no. 8 (Seattle: Bay Press, 1992), 340.

45. McClary, *Feminist Endings,* pp. 20, 27, 28.

It's a Jazz Thang: Interdisciplinarity and Critical Imagining in the Construction of a Womanist Theological Method

Joy Bostic

Introduction

As scholars of an emerging discipline, womanist theologians as well as biblicists, ethicists, historians, and so forth are constructing methodological approaches that enable us to speak to Black women's experiences. Traditional methods of scholarship hold inadequate methodologies to address Black women's multidimensional experiences. Even contemporary liberation theologies are limited in their ability to address black women's concerns. In this essay I will work toward the development of a womanist theological methodology that will (1) explicate the sociohistorical experiences of Black women and (2) enable womanist theologians to engage in activist struggles against the system of domination that affects the lives of African-American people, particularly African-American women. First, I will explore the meaning of the term *womanist*. Secondly, I will discuss the problems of traditional methods of scholarship as well as of contemporary white feminist and Black liberation methods. Finally, I will suggest a framework and strategies for a womanist theological method.

Defining Womanist

The term *womanist* was first introduced by Alice Walker in the early eighties. She may have first used the term in her short story "Coming Apart: A Way of Introduction to Lorde, Teish and Gardner" found in her book You *Can't Keep a Good Woman Down* published in 1981.[1] In Walker's book of "womanist prose," *In Search of Our Mothers' Gardens*,[2] she provides a dictionary-style definition of *womanist* and discusses the term in her review "Gifts of Power: The

Writings of Rebecca Jackson."[3] I develop my understanding of the term *womanist* within the context of these writings.

Walker identifies a womanist as a "black feminist" in "Coming Apart." This story portrays a black woman who develops a black feminist consciousness after she begins to question the images she sees of women and begins to resist being objectified particularly as an African-American woman. This woman objects to her husband's use of pornographic magazines. At one point she attempts to verbalize her objections.

> "Why do you need these?" she asks.
> "They mean nothing," he says.
> "But they hurt me somehow," she says.
> "You are being a.) silly, b.) a prude, and c.) ridiculous,
> he says. "You know I love you."
> . . . She cannot say . . . that she feels invisible. Rejected.
> Overlooked. She says instead, to herself: He is right. I will
> grow up. Adjust. Swim with the tide.[4]

As a female who is expected to be dependent, subordinate, and deferential her concerns have been trivialized and she has been characterized as childish and foolish. However, despite the dismissal of her feelings the woman continues to raise questions as she is further exposed to the way in which women, particularly African-American women, are depicted in a racist, patriarchal society. The woman begins to read the works of black feminists Audre Lorde, Luisah Teish, and Tracey A. Gardner. Not only does she read these works but she also reads them to her husband. While both the husband and the wife are at first in denial regarding the oppression of African-American women as black *and* as women, both of them are compelled to think more critically as they digest the black feminist literature and reflect upon their circumstances. Finally a gradual but definite transformation takes place. They come to understand how racist, sexist structures perpetuate destructive images of them both. They both begin to realize that they are connected in the struggle against oppression.

Walker tells the reader that "the wife has never considered herself a feminist—though she is, of course, a womanist."[5] According to Walker the term *womanist* approximates a "black feminist" and she identifies herself as one.[6] Walker states that a "womanist is a feminist, only more common."[7] This black woman while being characterized as childish, takes responsibility for developing her own consciousness and finally refuses to be objectified. Her resistance activity not only affects her own sense of identity and ways of being, but also

her struggle against racist patriarchal images and structures also af-
fects the consciousness of others—namely her husband.

In her essay *Gifts of Power: The Writings of Rebecca Jackson,* Walker
writes about a black female mystic of the nineteenth century. In her
home and church Jackson had been expected to fulfill roles pre-
scribed by dominant males. Following a conversion experience,
Jackson discovered that she had "spiritual gifts" and subsequently
was compelled to follow the voice of the Spirit within her. She went
out preaching the gospel and she dreamed dreams and saw visions
that were filled with symbols and imagery.

After joining a group of white Shakers, Jackson's inner voice told
her to minister to her own people. While the Shakers were resistant
to this, Jackson followed the Spirit and ministered to black people.
Later she established a Shaker settlement and lived in this group of
women until her death. Walker lifts up Jackson as a woman who
loves the Spirit. The Spirit directed Jackson in how "to live her own
life, creating it from scratch."[8] It is the Spirit that empowers Jackson
to transcend the barriers and limitations of the roles she was expected
to play in a patriarchal culture and to exercise autonomy and to carry
out her own way of being in the world.

In this review Walker suggests the term *womanist* to name Jack-
son's way of being. Walker goes on in this essay to emphasize the
critical need for black women to develop our own language and to
name our own experiences as an act of freedom in itself. She argues
that whatever language black women appropriate to name the expe-
riences of women like Rebecca Jackson this language should be char-
acteristic of the reality of black women's experiences. This language
should not reflect a static reality but should be organic and dynamic,
reflecting both the spiritual and the concrete and rooted in African-
American cultural traditions and values.

Walker provides a dictionary-like definition of "womanist" in her
book *In Search of Our Mothers' Gardens:*

> **Womanist 1.** From *womanish.* (Opp. of "girlish," i.e., frivolous, irre-
> sponsible, not serious.) A black feminist or feminist of color. From the
> black folk expression of mothers to female children, "You acting wom-
> anish," i.e., like a woman. Usually referring to outrageous, audacious,
> courageous or *willful* behavior. Wanting to know more and in greater
> depth than is considered "good" for one. Interested in grown-up doings.
> Acting grown up. Being grown up. Interchangeable with another black
> folk expression: "You trying to be grown." Responsible. In charge.
> *Serious.*
> **2.** *Also:* A woman who loves other women, sexually and/or nonsexu-
> ally. Appreciates and prefers women's culture, women's emotional

flexibility (values tears as natural counterbalance of laughter), and women's strength. Sometimes loves individual men, sexually and/or nonsexually. Committed to survival and wholeness of entire people, male *and* female. Not a separatist, except periodically, for health. Traditionally universalist, as in: "Mama, why are we brown, pink, and yellow, and our cousins are white, beige, and black?" Ans.: "Well, you know the colored race is just like a flower garden, with every color flower represented." Traditionally capable, as in: "Mama, I'm walking to Canada and I'm taking you and a bunch of other slaves with me." Reply: "It wouldn't be the first time."

3. Loves music. Loves dance. Loves the moon. *Loves* the Spirit. Loves love and food and roundness. Loves struggle. *Loves* the Folk. Loves herself. *Regardless.*

4. Womanist is to feminist as purple to lavender.[9]

In this definition Walker appropriates the term *womanist* from Black folk expression and again makes it synonymous with being a Black feminist or feminist of color. According to Walker, a womanist is one who loves—loves women and men, sexually or nonsexually, loves dance, *loves* the Folk, and *loves* the Spirit. She describes a woman who is connected—connected to the activist tradition of Black women, connected and committed to community, as well as to all of humanity.

Thus, within the context of these writings Walker uses the term *womanist* as a way to name Black women who develop a Black feminist consciousness, to exercise radical subjectivity and autonomy while being committed to the survival and wholeness of our own communities as well as all of humanity, value African-American (particularly African-American women's) cultural traditions, affirm the reality of the authority and power of the Spirit in the lives of African-American people, recognize dreams and visions as ways of knowing, and engage in activist struggle against oppressive systems, structures, and images. These women subvert traditional notions of womanhood and femininity in which women are expected to be childlike, dependent, passive, silent, and deferential. Instead, womanists are "courageous, "audacious," "willful," "serious," "responsible," and "in charge." What Walker is articulating is a style, an ethos, and a spirituality that arises out of the peculiar sociohistorical location of black women.

Black women-theologians, biblicists, ethicists, historians, and other scholars have appropriated the term *womanist* in order to name the particular sociohistorical experiences of African-American women. Womanist theology has emerged as a discipline that places black women's experiences at the center of theological discourse.

These experiences are defined by multiple forms of oppression such as sexism, racism, classism, and homophobia. Because of the multidimensional nature of black women's experiences womanist theologies hold great potential for developing methodologies. Womanist theologian Jacquelyn Grant articulates the significance of womanist thought.

> Womanist theology begins with the experiences of Black women as its point of departure. . . .
> Those experiences had been and continue to be defined by racism, sexism and classism and therefore offers a unique opportunity and a new challenge for developing a relevant perspective in the theological enterprise. . . .
> Black women must do theology out of their tridimensional experience of racism/sexism/classism. To ignore any aspect of this experience is to deny the holistic and integrated reality of black womanhood.[10]

Because of the interconnected reality of black women's experiences womanists must be committed to an integrated analysis of the various dimensions of oppression[11] that effect the lives of African-American women. As Grant suggests, failure to conduct an integrated analysis of Black women's experiences would in effect marginalize black women's experiences and be tantamount to our acquiescence to a racist, patriarchal system. Kelly D. Brown argued in her article "God Is as Christ Does: Toward a Womanist Theology" that the appropriation of the term *womanist* by black women has been symbolic of black women's resistance to the multidimensional nature of our oppression.[12] As womanists we must develop methodologies that facilitate resistance activity against the manifold forms of oppression that pervade the lives of our people.

Critique of White Masculinist, White Feminist, and Black Male Liberation Methodologies

This resistance to our multidimensional oppression is a critical task for black women living in a racist, patriarchal culture. Elite white males have historically monopolized and exerted the power to interpret and define history, control modes of discourse and the production of knowledge in ways that justify, protect, perpetuate, and legitimize a racist patriarchal system of domination. These white men have particularly exercised this power in the academy. Historically elite white men have produced scholarship that has been based

upon what Patricia Hill Collins calls a "Eurocentric masculinist" approach.[13] This traditional approach to scholarship is rooted in dichotomous, either/or thinking. In dichotomous, either/or thinking an oppositional and hierarchical relationship is assumed between such categories as white/black, male/female, rich/poor.[14] Thus, traditional methodologies of white male scholars have contributed to "maintaining interlocking systems of oppression"[15] based on such dynamics as race, gender, and class. Because of black women's multidimensional reality black women, in particular, are affected by these interlocking systems.

The dichotomous thinking underlying traditional methodologies extends to such aspects of reality as the abstract and the concrete, reason and imagination, the material and the spiritual, intellect and emotion, and thought and action in ways that fragment and distort a holistic reality. This dualistic and fragmented understanding of reality has also led white male scholars to confine so-called legitimate scholarship within the boundaries of particular disciplines. Scholarship based upon this kind of dualism and fragmentation has oftentimes been acontextual and ahistorical.

Much of traditional theological scholarship has also been based upon a white masculinist approach. Rooted in a Western philosophical tradition of either/or, dualistic thinking, the traditional methodologies of white male theologians have assumed hierarchy as normative. Because these theologians also have valued the rational over the intuitive, the intellect over the emotions, thought over action, and the abstract over the concrete, their theological work has been removed from the sociohistorical experiences of African-American women. Therefore, traditional theological methods exclude the experiences of black women from the interpretive circle of the theological enterprise. These theological methods fail to challenge, and in many ways help to perpetuate, the interlocking structures of oppression operating within a racist, patriarchal system of domination.

Based upon assumptions of hierarchy and opposition, white male theologians have constructed and legitimized symbols, images, paradigms, ideologies, doctrine, rituals, biblical interpretations, and traditions that often justify, perpetuate, and legitimize a racist, patriarchal system of domination and serve to control, define, and objectify marginalized people—particularly black women. These symbols, images, biblical interpretations, doctrine, and so forth are in many ways internalized by the marginalized. What is particularly insidious about the theological work of white masculinist theologians is that it is often legitimized and even sacralized by claims to

be doing theology from a "universal," "objective" perspective and from appeals to divine authority. In making these claims of universalism, objectivity, and divine authority, white masculinist theologians are able to fix the parameters as well as the particular articulations of Christian theology.

Traditional approaches to scholarship that are based upon dichotomy, opposition, and hierarchy are antithetical to black life. In these methodologies our experiences as black women are marginalized and even rendered invisible. A white masculinist approach, then, must be rejected as a methodology for womanist theologians who are committed to resistance activity against a racist, patriarchal system.

While womanist theology arose as a challenge to white masculinist ideology, it also arose as a response to the limitations of so-called feminist theology and black liberation theology in speaking to the experiences of Black women. Womanists have argued that feminist theology has involved sources that refer almost exclusively to white women's experiences, yet feminist theology has presumed to speak to all women's experiences. Black women's experiences differ markedly from white women's experiences and womanists critique feminist theology because white feminists often ignore those differences even as they claim to speak on behalf of all women.[16] Feminist theology then should be more appropriately referred to as *white* feminist theology.[17]

The womanist critique of black liberation theology has been that while black male liberation theologians have claimed to speak to the African-American experience, the particular experience of African-American women is often ignored by black liberation theologians.[18] Finally, womanists also point to the tendency of white feminist theology and black theology to be primarily concerned with one dimension of oppression. For white feminists gender is predominant and for the black male liberation theologian race is the primary issue. Thus white women may ignore the way in which they are privileged by their whiteness and black men are able to ignore the ways in which they are privileged by their maleness. Methodologies that focus upon one dimension of oppression fail to address the interconnectedness of oppression and fail to overcome fully the dichotomies established by white masculinist ideologies. Therefore, black women remain objectified as the Other. Even if white feminist or black male liberation theologians reject some aspects of the white masculinist approach, their methodologies may still be inadequate in allowing for an integrated analysis of the interlocking systems of gender, race, and class that are characteristic of black women's experiences.

Because of the failure of the traditional theological methods of white men, and the limitations of white feminist, and black male liberation theological methods, womanist theologians must develop our own methodologies. In developing our own methodologies we are engaging in resistance activity that subverts the very racist, patriarchal system that has dominated our lives and the lives of our people. The question then becomes how do we construct alternative womanist methodologies that transcend the dichotomies of white masculinist ideology as well as overcome the limitations of white feminist, and black male liberation theological methods?

The Black Aesthetic Tradition as a Basis for Developing a Womanist Theological Method

First of all, in order for us as womanists to overcome the limitations of a white masculinist approach we must locate the basis for our theological work within an alternative framework. Because a dichotomous, either/or perspective objectifies black women as the Other, a womanist theological method must be based in an inclusive "both/and conceptual orientation."[19] According to Collins, black women have rejected dichotomous thinking throughout history because of its inconsistency with black women's experiences.[20] Instead, black women have often embraced a both/and conceptual system because of our multidimensional experiences. To accept dichotomous ways of thinking would be absurd as this acceptance would be a denial of black women's multidimensional realities and would serve as an obstacle to our full human liberation. Rather than accepting the dichotomies assumed by white masculinist theologians, a womanist theological method should affirm the interdependence between emotion and the intellect, spiritual and material, abstract and concrete, reason and imagination, thought and action as parts of a holistic human reality.

A womanist theological method that would allow for an integrative, holistic understanding of reality, then, must be based upon a framework rooted in a both/and conceptual system. Where do we find resources that will accommodate an inclusive both/and orientation? In her autobiography *To Be Young, Gifted and Black,* Lorraine Hansberry provides some clues that could assist us in locating an alternative framework for a womanist theological method in the chapter entitled "The Bridge Across the Chasm."[21]

In a dialogue that takes place between a white man and a black

woman Hansberry illustrates the differences between the assumptions of elitist white male thinking and black women's perspectives. The white man is critical of black artists who incorporate black idiomatic expressions to their work (even while he assumes the legitimacy and value in the English idioms of his own tradition), argues that black artists should "transcend" racial matters and address more universal "human" issues, and he discounts emotions as inconsistent with intellectualism. This man is operating out of an either/or perspective. The black woman, in contrast, operates out of a both/and conceptual orientation. She affirms the importance of black artists remaining rooted in the culture of their communities, and recognizes the connectedness between the emotions and the intellect as well as the spirituality and material conditions of black people. For her black art becomes the conduit for making these connections.

> . . .I could see the bridge across the chasm. It was made up of a band of angels of art, hurling off the souls of twenty million. I saw Jimmy Baldwin and Leontyne, and Lena and Harry and Sammy. And then there was Charlie White and Nina Simone and Johnnie Killens and—Lord have mercy, Paul was back! Langston and Julian Mayfield coming on the run. There was Odetta and Josh and Sidney acting all over the place; and lo Sister Eartha had gotten herself together and was coming too! And there was Ralph Ellison and Pearly Mae had Frank Yerby by the hand, bringing him too!
>
> Oh, it was a wondrous thing I could see. On and on they came, Sarah and the Duke and Count and Cannonball and Louis himself, wearing the crown that Billie gave him before she died. Oh yes, there they were, the band of angels, picking up numbers along the way, singing and painting and dancing and writing and acting up a storm! and the golden waves rose from their labors and filtered down upon the earth and brought such heavenly brightness. . . .[22]

Here "angels of art" serve as revelatory agents bridging the chasm between the abstract and the concrete, the emotional and the intellectual, the spiritual and the material. Thus it is within the context of the black aesthetic tradition that synthesis of what has been deemed by a white masculinist approach as oppositional categories occurs. The black aesthetic tradition takes seriously an inclusive understanding of human reality. Art produced out of the black aesthetic tradition not only affirms the inclusivity of life, but it also reflects and speaks to the sociopolitical conditions of black people.

The black aesthetic tradition has in many ways articulated alternate views of life and thought to those of white masculinist traditions.

The writer Toni Cade Bambara notes the differences between the concerns of Western and African-American traditions.

> . . . Our tradition tends to be dynamic. Our art is not a separate entity, reflecting the immortal aspects of the human condition, the "universality" of men; it is, rather, a literate attempt to offer up an ample moral vision, to articulate that life fluctuates from day to day. It is, then, timely rather than "fixed." For our needs and our perspectives shift.[23]

Therefore, the black aesthetic tradition has not been a tradition that has been marginal to the material reality of our people; rather, black art, literature, music, story, and so forth have served as primary vehicles for resistance activity. For womanist theologians developing methodologies that affirm a both/and conceptual system, value African American cultural traditions, recognize reality as inclusive and dynamic, and enable us to engage in resistance activity the black aesthetic tradition could give rise to a theo-philosophical framework for a womanist theological method.[24]

It's a Jazz Thang: Jazz as a Framework for a Womanist Theological Method

The black aesthetic tradition provides us as womanist theologians with rich and varied resources for constructing our methodologies. The myriad of artistic forms that we have used to express our experiences such as poetry, story, myth, dance, drama, sermons, narratives, and visual arts as well as the forms that we have created out of our experiences as Africans in this country such as the spirituals, blues, and jazz are all sources for a womanist theological method. For example, jazz is an art form rooted in the black aesthetic tradition that could provide a framework for a theological method.

Rather than hierarchy, dualism, and opposition, the norms of jazz are reciprocity, mutuality, and relatedness. The highest value of the jam session is improvisation (individual and collective).[25] In the jam session no composition is fixed in its presentation; however, through improvisation there are unlimited possibilities in the way in which compositions can be played. Rather than a static universe, jazz affirms a dynamic, interactive, inclusive reality where individual freedom and autonomy are valued within the context of a community. Rather than being ahistorical or acontextual jazz composers and musicians improvise—create and re-create in a present moment—out of the tradition established by those who have gone before them.

The principles and norms of jazz subvert the racist, patriarchal system of domination that is maintained by white masculinist thinking and by the assumptions of Western theological and philosophical traditions. The principles of jazz are also consistent with the womanist principles discussed throughout this essay. Jazz, then, has potential for serving as a theo-philosophical framework for a womanist theological method.

In appropriating jazz as a theo-philosophical framework or conceptual system for a womanist theological method, we can look further to formulating strategies that we could use within this framework to accomplish what we perceive to be our tasks as womanist theologians and the purpose of a womanist methodology. A womanist theological method must take seriously the multidimensional experiences of black women as a primary source for our theological enterprise. A womanist theological method should also assist African-American women in particular as well as African-American men and the wider society in developing critical consciousness regarding the ways in which we have internalized racist, patriarchal ideology and how interlocking oppressive structures affect our lives. This method should also equip us to resist systems of oppression. A womanist theological method, then, which would facilitate an integrative analysis of black women's sociohistorical experiences, counter the images, interpretations, paradigms, and symbols created by white masculinist thinking, and contribute to critical consciousness regarding the ways in which white masculinist thinking maintains and perpetuates a system of domination, should incorporate both analytical-interpretive and dialogical-pedagogical strategies.

Analytical-interpretive strategies would assist us in exploring the multidimensional realities of black women and interlocking systems of oppression, and also enable us to engage in creative reflection on, and interpretation of, black women's experiences. These analytical-interpretive strategies would help us deconstruct the images, paradigms, and interpretations constructed out of a white masculinist approach that distort our human reality. These strategies would also help us to construct alternative interpretations, paradigms, representations, and so forth that provide a more accurate understanding not only of black women's sociohistorical experiences, but also of the wider sociohistorical reality.

In order for our methodologies to be effective in bringing about change, we must develop strategies that build upon black women's activist tradition of liberation struggle with and among the masses. These strategies must be consistent with a theo-philosophical framework rooted in a both/and conceptual system and allow for inter-

active, dynamic, and creative activity among the masses, and for the bringing together of thought and action, emotion and intellect, spiritual and material, abstract and concrete. A womanist theological method should include dialogical-pedagogical strategies that would engage people across lines of age, class, or status in transformative, creative and critical dialogue, reflection, and articulation. Therefore, as womanists we must incorporate dialogical-pedagogical strategies that would be effective not only in the classrooms of the academy but also in high schools, elementary schools, churches, synagogues, shelters, community centers, college campuses, and prisons. Both our analytical-interpretive, and our dialogical-pedagogical strategies should be informed by the norms and principles of our theo-philosophical framework.

Interdisciplinary Analysis and Critical Imagining: Analytic-interpretive and Dialogical-Pedagogical Strategies for a Womanist Theological Method

The legal scholar Patricia J. Williams discusses a methodological approach used in her book *The Alchemy of Race and Rights*[26] that suggests analytical-interpretive and dialogical-pedagogical strategies for a womanist methodology. Williams's approach is an alternative to the methodology of traditional legal scholarship. Her approach is twofold. Recognizing reality as dynamic, "multilayered" and complex, Williams contends that interdisciplinary analysis is necessary in order to bridge the gap between theory and practice and to transcend the limitations of traditional legal scholarship that she argues produces "a narrow, simpler but hypnotically powerful rhetorical truth."[27] Williams incorporates insights from other disciplines such as sociology, history, psychology, philosophy, and criticism as an "analytic technique" in order to bring experiences to the interpretive circle that have formally been excluded.[28]

In order to deconstruct the claims of traditional legal scholarship, Williams uses literary devices such as story, parable, poetry, and metaphor to reveal the subjective nature of legal rhetoric. She invites the reader/listener to consciously participate in the construction of meaning. Through the text, the reader/listener is able to make connections with the text itself and between "lived experience" and social perceptions. This process empowers the reader/listener to act as subject and be transformed.[29]

Interdisciplinary analysis is critical to conducting an integrative analysis of the multidimensional reality of black women's experi-

ences. As Williams contends, scholarly methods that demand adherence to strict disciplinary boundaries marginalize and render invisible the experiences of oppressed people, particularly black women. Through interdisciplinary analysis we as womanist theologians are able to engage in integrative analyses that unravel the interlocking systems of oppression and expose the ways in which images, interpretations, doctrines, traditions, and symbols of white masculinist ideologies maintain these systems.

If we are to gain a clearer understanding of black women's multidimensional experiences as sources for doing womanist theology, it is critical that we not be confined to the artificial boundaries of discipline but that we reach across the various disciplines in order to provide nuanced analyses and interpretations. This interdisciplinary approach would not only include those disciplines traditionally linked with theology such as biblical studies, ethics, and history, but this methodology would also include analysis across other fields such as psychology, law, philosophy, sociology, and economics.

In conducting our interdisciplinary analysis we must be in dialogue with black feminist/womanist scholars across the various disciplines. As we are in dialogue with other black women-scholars we can affirm, challenge, and inform one another's work. It is out of this interactive context that we can discover and create sources, norms, and themes that will inform our analyses and interpretations. For womanist theologians using jazz as a theo-philosophical framework, black women-scholars working in various disciplines make up a jazz community. In this community black women-scholars participate together in the creative, interactive environment of the jam session. Through the dynamic process of individual and collective improvisation themes, norms, and styles emerge that fit the present moment.[30]

As black women-scholars working in the academy we must resist the temptation to assimilate by adopting white masculinist approaches to scholarship and teaching that are disconnected from the real lives of people. Instead, we must develop dialogical-pedagogical strategies that are consistent with black women's activist tradition. These strategies must engage "the Folk"—the masses of African-American women, men and children—in the process of critical reflection, and theological interpretation. Moreover, these dialogical-pedagogical strategies must bridge the gap between thought and action, abstract ideas and concrete reality, emotion and intellect, reason and the imagination in order to translate the fruit of our analytical-interpretive work to the masses, and provide a context for dialogue and interaction that can lead to creative transformation. It

is within this context that we participate together in an activist struggle to resist an oppressive racist, patriarchal system of domination and affirm and create our own traditions.

As Patricia Williams has suggested, the use of these artistic/literary forms will enable persons to engage in processes of critical analysis and creative interpretation of our sociohistorical experiences. This process can effect individual and collective psychological and spiritual transformation that can lead to sociopolitical liberation. As Angela Y. Davis suggests art can have personal and social impact that can empower us to resist a system of domination.

> Progressive art can assist people to learn not only about the objective forces at work in the society in which they live, but also about the intensely social character of their interior lives. Ultimately, it can propel people toward social emancipation.[31]

Thus, literary/artistic forms such as story, poetry, and music that are highly valued within the African-American context, nuanced with the black idioms, cultural references, and memories of the black aesthetic tradition can serve as effective mediums to engage "the Folk" in the process of critical, theological reflection, and construction. Story, poetry, song, and music can serve as mediums through which we bring together the abstract and the concrete, the emotions and the intellect, ideas, and experience. Ivan Van Sertima describes the effect that such artistic forms as storytelling can have upon the consciousness.

> The object of this highly imaginative exercise is to demonstrate the capacity of the human spirit and substance to recreate itself to feel its way toward a Consciousness that breaks down and breaks through apparently fixed and frozen, partial and polarized, states of being and belief. The revolution implied here is a revolution of the imagination, a revolution in consciousness, a fundamental revision and reassessment of static and ritualized modes of seeing, thinking, feeling. . .[32]

In incorporating literary/artistic sources rooted in a black aesthetic tradition we as womanist theologians can counter and transcend the seemingly fixed and static definitions, doctrines, traditions, symbols, and images that have sustained a racist patriarchal system of domination. As a dialogical-pedagogical strategy the use of literary/artistic texts can enable us to ask new questions and imagine new alternatives to racist, sexist, classist, and homophobic ideologies, assumptions and interpretations.

If we are to use literary/artistic sources from the black aesthetic

tradition, then we must affirm, recover, and be well versed in these sources. As Walker declares we must become "revolutionary artists" who are able to "drag it out and recite it" as we participate with the Folk in dialogue, reflection, and re-creation.

> For that is also the role of the black revolutionary artist. [She] must be a walking cabinet of poems and songs and stories, of people, of places, of deeds and misdeeds.[33]

However, as womanists we must also be critical of those African-American cultural traditions and sources that reflect racist, sexist, classist, or homophobic thinking. As we recover our cultural traditions we must also evaluate them in light of our critical analyses and interpretations based upon a theo-philosophical framework that values reciprocity, mutual respect, inclusivity, improvisation, and individual autonomy within the community and that recognizes reality as dynamic and interactive. Thus as womanists we engage in "critical imagining" by lifting up cultural traditions, stories, and images that counter oppressive structures.

Critical imagining also involves the critique of African-American cultural traditions, stories, literature, poetry, and so forth revising some while rejecting those that are oppressive and cannot be redeemed. Critical imagining, then, is improvisational activity. In our critical imagining we also create new myths, stories, images, and paradigms as alternative imagery. As womanists we must also construct new biblical interpretations, and write our own stories, liturgies, prayers, plays, monologues, and songs that aid in the revisioning of human relationships within the context of our own communities as well as in the wider world community. Not only do we recover our cultural traditions and create new resources but also as artists we are the dramatic artists, storytellers, dancers, singers, and poets who serve as mediums for challenging the imaginations of people.

Critical imagining rooted in the black aesthetic tradition with jazz as a theo-philosophical framework, then, can serve as a dialogical-pedagogical strategy for a womanist theological method. In our critical imagining we, like the jazz musician, engage in improvisational activity in our theological work. In describing the work of Toni Cade Bambara, Eleanor W. Traylor describes this activity.

> The vitality of the jazz musician, by analogy, is this ability to compose, in vigorous images of the most recent musical language, the contingencies of time in an examined present moment. The jam session, the

ultimate formal expression of the jazz musician, is, on one hand a presentation of all the various ways, past and present, that a tune may be heard; on the other, it is a revision of the past history of a tune, or of its presentation by other masters, ensuring what is lasting and valuable and useful in the tune's present moment and discarding what is not.[34]

In the jazz community womanists participate in resistance activity and re-create language, images, and symbols that counter the ideologies, rhetoric, images, and paradigms that have worked to maintain a racist, patriarchal system of domination that has oppressed black women and our communities. In this way black women-scholars as the jazz community are discordant voices in the academy, church, and in society.[35] In the book *Wild Women in the Whirlwind: Afra-American Culture and the Contemporary Literary Renaissance,* Andrée Nicola McLaughlin's description of "wild women in the whirlwind" accurately articulates the resistance activity of womanist theologians operating out of a jazz framework.

> To establish a new relationship to the planet and cosmos, black women are . . . redefining themselves in their entirety and, hence, the men, children, Earth, and the universe. By symbolmaking, idea making, and worldmaking, they are creators in the preeminent sense. Through this activity, Black women, . . . expose the truths of their existence. Demythified by the intensity of their own actions, they turn Western imagery of black women and their experience on its head . . . these Wild Women in the Whirlwind make real change in the real world through real means.[36]

Notes

1. A. Walker, *You Can't Keep a Good Woman Down* (San Diego and New York: Harcourt, 1981).
2. A. Walker, *In Search of Our Mothers' Gardens* (San Diego and New York: Harcourt, 1983).
3. Ibid.
4. Walker, *You Can't Keep a Good Woman Down,* p. 43.
5. Ibid., p. 48.
6. Ibid.
7. Ibid.
8. Walker, *In Search of Our Mothers' Gardens,* p. 79.
9. Ibid., pp. xi–xii.
10. J. Grant, "Womanist Theology: Black Women's Experience as a Source for Doing Theology," *The Journal of the Interdenominational Theological Center* 13(spring 1986): 195–212, 201.
11. E. M. Townes, ed., *A Troubling in My Soul: Womanist Perspectives on Evil & Suffering* (Maryknoll, 1993), Orbis, 1.

12. K. D. Brown, "God Is as Christ Does: Toward a Womanist Theology," *Journal of Religious Thought* 46(summer/fall 1989): 7–16. 8.

13. P. H. Collins, *Black Feminist Thought: Knowledge, Consciousness and the Politics of Empowerment* (New York: Routledge, 1991), p. 203.

14. Ibid., p. 69.

15. Ibid., p. 70.

16. J. Grant, *White Women's Christ and Black Women's Jesus* (Atlanta: Scholars Press, 1989), p. 200.

17. Ibid.

18. Grant, "Black Theology and the Black Woman," in *Black Theology: A Documentary History, vol.1: 1966–1979*, eds. J. H. Cone and G. S. Wilmore (Maryknoll, N.Y.: Orbis Books, 1993), pp. 323–28; 418.

19. P. H. Collins, *Black Feminist Thought: Knowledge, Consciousness and the Politics of Empowerment* (New York: Routledge, 1991), p. 29.

20. Ibid., p. 28.

21. L. Hansberry, *The Bridge Across the Chasm. To Be Young, Gifted and Black* (New York: Signet, 1969), pp. 213–22.

22. Ibid., pp. 213–22, especially pp. 217–18.

23. T. Cade, ed., *The Black Woman: An Anthology* (New York: Mentor, 1970), p. 237.

24. I am indebted to womanist theologians M. Shawn Copeland who, when I was struggling to articulate my developing methodology was able to name it as an aesthetic and Delores S. Williams who announced in our womanist theology class at Union Theological Seminary that "this is a time for artist" and called for a black philosophy to inform our work. These scholars helped me to name and clarify my developing methodology.

25. K. Parker, *Jazz as a Way of Knowing, as a Philosophy of Life*. (1994).

26. P. J. Williams, *The Alchemy of Race and Rights: Diary of a Law Professor* (Cambridge: Harvard University Press, 1991).

27. Ibid., p. 10.

28. Ibid., p. 7.

29. Ibid., p. 8.

30. K. Parker, *Jazz As a Way of Knowing, As a Philosophy of Life*. Prof. Kellis Parker is doing work on jazz as a alternative method for law and as a philosophy. He argues that there is an African–American common law. The norms, rules, and regulations emerge out of the jazz community. This jazz community is a functioning community of the working-class people that generates norms.

31. A. Y. Davis, *Women, Culture, & Politics* (New York: Vintage Books, 1990) p. 200.

32. I. V. Sertima, "Trickster and the Revolutionary Hero," in *Talk that Talk: An Anthology of African-American Storytelling*, eds. L. Goss and M. E. Barnes (New York: Simon & Schuster, 1989), p. 109.

33. A. Walker, *In Search of Our Mothers' Gardens* (San Diego and New York: Harcourt, 1983),p. 136.

34. E. W. Traylor, "Music As a Theme: The Jazz Mode in the Works of Toni Cade Bambara," In *Black Women Writers (1950–1980) A Critical Evaluation*, ed. N. Evans (New York: Anchor Books, 1984), pp. 58–70; especially p. 59.

35. D. S. Williams, "Womanist Theology: Black Women's Voices," *Christianity and Crisis*, 2 March 1987, pp. 66–70, especially p. 69. In this article Delores Williams contends that a womanist theological method should serve a didactic and liturgical elements and womanist theology should be prophetic in challenging worship tradi-

tions, liturgies, and so forth. She uses a jazz analogy and argues that womanists give "discordant and prophetic messages" as they engage in multidialogical activity.

36. A. N. McLaughlin, "Black Women, Identity, and the Quest for Humanhood and Wholeness: Wild Women in the Whirlwind," in *Wild Women in the Whirlwind: Afra-American Culture and the Contemporary Literary Renaissance,* eds. J. M. Braxton and A. N. McLaughlin (New Brunswick: Rutgers University Press, 1990), p. 176.

Works Cited

Brown, K. D. (1989). "God Is as Christ Does: Toward a Womanist Theology." *Journal of Religious Thought* 46(summer/fall): 7–16.

Cade, T. (Ed.). (1970). *The Black Woman: An Anthology.* New York: Mentor.

Collins, P. H. (1991). *Black Feminist Thought: Knowledge, Consciousness and the Politics of Empowerment.* New York: Routledge.

Davis, A. Y. (1990). *Women, Culture, & Politics.* New York: Vintage Books.

Grant, J. (1986). "Womanist Theology: Black Women's Experience as a Source for Doing Theology." *The Journal of the Interdenominational Theological Center* 13(spring) 195–212.

Grant, J. (1989). *White Women's Christ and Black Women's Jesus.* Atlanta: Scholars Press.

Grant, J. (1993). Black Theology and the Black Woman. In J. H. Cone and G. S. Wilmore (Eds.), *Black Theology: A Documentary History. Vol. 1; 1966–1979,* (1:323–28). Maryknoll: Orbis Books.

Hansberry, L. (1969). The Bridge Across the Chasm. In *To Be Young, Gifted and Black,* pp. 213–22. New York: Signet.

McLaughlin, A. N. (1990). Black Women, Identity, and the Quest for Humanhood and Wholeness: Wild Women in the Whirlwind. In J. M. Braxton and A. N. McLaughlin (Eds.), *Wild Women in the Whirlwind: Afra-American Culture and the Contemporary Literary Renaissance.* New Brunswick: Rutgers University Press.

Parker, K. (7 March 1994). Jazz as a Way of Knowing, as a Philosophy of Life. (Lecture)

Sertima, I. V. (1989). Trickster and the Revolutionary Hero. In L. Goss and M. E. Barnes (Eds.), *Talk that Talk: An Anthology of African-American Storytelling.* New York: Simon & Schuster.

Townes, E. M. (Ed.). (1993). *A Troubling in My Soul: Womanist Perspectives on Evil & Suffering.* Maryknoll: Orbis.

Traylor, E. W. (1984). Music as a Theme: The Jazz Mode in the Works of Toni Cade Bambara. In M. Evans (Ed.), *Black Women Writers (1950–1980) A Critical Evaluation,* pp. 58–70. New York: Anchor Books.

Walker, A. (1981). *You Can't Keep a Good Woman Down.* San Diego and New York: Harcourt Brace Jovanovich.

Walker, A. (1983). *In Search of Our Mothers' Gardens.* San Diego and New York: Harcourt Brace Jovanovich.

The Process of Critical Science in Exploring Racism and Sexism with Black College Women

Mary Morgan

My interest in women's perceptions of their own oppression and belief in the process of empowerment through critical reflection grew out of a course I regularly teach. This course focuses on the inequalities women experience in their relationships and in their work roles and on ways to create change. What I consistently observed from the students, primarily from female seniors in female-dominated majors, was the resistance of many to the notion of women's oppression and to the empowerment realized by some through a focus on their own personal experience. Thus I was led to more systematically investigate the ways in which college women perceive and understand the presence of sexism and racism as agents of oppression in their lives and to explore the meaning of oppression through an interpretation of their personal experiences.

Critical science was the mode of inquiry I chose because its purpose is to critique the status quo and to build a more just society (Lather, 1986) by freeing people from oppressive ideological beliefs (Brown, 1989). Critical science is directed toward unjust social situations that people, through their misunderstanding, unknowingly support by accepting the existing reality as the way things are supposed to be (Brown, 1989). According to Yamato (1990), oppression is internalized when members of an oppressed group "are emotionally, physically, and spiritually battered to the point that they begin to actually believe that their oppression is deserved, is their lot in life, is natural and right, and that it doesn't even exist" (p. 20). In critical science research thoughts and actions that perpetuate domination—such as upholding norms that only serve the interest of a special group or believing certain societal outcomes or social arrangements are naturally occurring—are identified, documented, and critiqued (Brown, 1989). Critical science assumes that people are potentially capable of altering repressive forces that inhibit their

development through self-reflection and a deeper understanding of their own oppressive realities (Lather, 1986).

Research from "a critical, praxis-oriented paradigm," according to Lather (1986) is "concerned both with producing emancipatory knowledge and with empowering the researched" (p. 258). Emancipatory knowledge empowers the researcher by increasing their "awareness of the contradictions hidden or distorted by everyday understandings" and by directing their attention "to the possibilities for social transformation" (p. 259). This is an important outcome for black college women, who experience oppression on various levels, and for white researchers, who need more understanding of the issue of racism for black women. As A. Hurtado (1989) states,

> White feminist theory has yet to integrate the facts that for women of Color race, class, and gender subordination are experienced simultaneously and that their oppression is not only by members of their own group but by whites of both genders. White feminist theorists have failed to grasp fully what this means, how it is experienced, and, ultimately, how it is fought. (p. 839)

Thus, my intent was to engage in emancipatory research that would generate knowledge about black college women's experiences with oppression and that help the participants better understand and challenge oppressive situations.

I asked for volunteers from a women's studies course I was teaching in the fall of 1991, and three black women agreed to participate in out-of-class group conversations based on class readings. As I approached the study, a dilemma for me as a white woman concerned my ability to understand the issues of racism for black women, quite apart from trying to create an environment to facilitate their own empowerment. How does a white woman understand what racism and sexism means to a black college woman? How could I describe these experiences for black women? Should I? Even more difficult was the issue of authenticity. How does a white woman engage black women in a critical science process designed to empower them regarding the oppression they experience in their lives? Some black feminists argue that black women are the ones who should be researching black women's experiences. I shared with the black women my hesitation and they responded, "But if you don't, who will?" So we proceeded together.

The research project's three primary objectives were to provide opportunities: to explore the black women's experiences with sexism and racism as agents of oppression in their personal lives; to analyze

the ways in which those experiences were connected to the dominant social culture; and to generate possibilities for change by identifying characteristics of an alternative paradigm. Sexism and racism in this study were broadly defined as gender- and race-based inequalities as evidenced in behavior, conditions, and/or attitudes. The purpose of this essay is to illustrate that process for the black participants and for me as a white researcher: to describe the ways in which we interacted with each other and to note the ways in which we were empowered by the process.

Critical Science as Feminist Emancipatory Research

From a feminist perspective, critical science research uses women's own experiences as a fundamental basis for knowledge and through reflection analyzes their experience as "a way of appropriating reality" (Hartsock, 1986, p. 12). This is a way for women to claim their own reality as opposed to that which has been socially constructed for them to believe. Enabling women to connect their everyday lives with an analysis of the social institutions that shape their lives leads them to an understanding of social process and to "the realization that we not only create our social world but can change it" (Hartsock, 1986, p. 13).

The method of critical science research is dialogue. Dialogue is essential "to heighten its subjects' awareness of their collective potential as active agents in history" (Comstock, 1982, p. 371). For the black women in my group, dialogue served to create a collective experience, a shared understanding and support, and subsequently a change in perspective and strategies for dealing with racism and sexism. During ten, one-hour sessions we explored the ways in which sexism and racism affected them, how they felt about those experiences, and how they reacted to those experiences. Sometimes I gave them assignments to think about ahead of time (i.e., What are some ways in which sexism/racism affects you?) and many times we drew from what we had discussed in class that week.

The critical science research process from a feminist perspective must be collaborative. "The full articulation of black feminist thought," Collins (1989) writes, "requires a collaborative enterprise with black women at the center" (p. 25). Lather describes it as involving "the researched in a democratized process of inquiry characterized by negotiation, reciprocity, empowerment" (1986, p. 257). I collaborated with the participants by facilitating dialogue and by generating interpretations for their consideration. My own under-

standing was part of the process, just as the women were active participants rather than passive subjects. Oakley (1981) writes, "A feminist interviewing women is by definition both 'inside' the culture and participating in that which she is observing" (p. 57). Together, we negotiated meaning from their experiences and gained a shared understanding of the phenomenon of oppression in their lives.

I shared my own experiences as I thought it would help in our understanding theirs. My goal was to engage in what Du Bois (1983) calls "passionate scholarship." This follows Oakley's (1981) belief that there is "no intimacy without reciprocity" and that personal involvement is "the condition under which people come to know each other and to admit others into their lives" (p. 58).

The criteria of validity for critical science research is reasoned reflection and change (Jax, 1985). According to Fay, however, "Not only must a particular theory be offered as the reason why people should change their self-understandings, but this must be done in an environment in which these people can reject this reason" (1977, p. 227). Participants in critical science research must feel safe to say anything. They must feel free to openly contribute to the discussions by originating, examining, and developing analyses of the social culture and its influence on their lives. Ultimately, they must be free to accept or reject these analyses and their implications for change. Throughout the process I struggled with this central challenge of praxis-oriented research: "how to maximize the researcher's mediation between people's self-understandings and transformative social action without becoming impositional" (Lather, 1986, p. 269).

The dialogue and discussion that follow illustrate ways in which we, as participants and researcher, were empowered through this research. The separation of the process of empowerment for them and for me is for the purpose of focusing the discussion only, as the significance for all of us was interwoven throughout the dialogue.

Process of Empowerment

For Black Participants

Initially these black women said that they could not readily identify experiences of sexism or racism. In the first session, Emma said, "I had a hard time thinking of a sexist experience." Yet from the beginning they offered numerous examples of sexism and racism from their own lives. Sexist experiences related to the car repair

shop ("I don't think they listen and it makes me mad every time I go"); "sexist remarks" on television and in advertising, not being able to go to the mall alone or to feel safe walking on campus, gender-based housekeeping responsibilities, and segregated male/female roles in the church. Several examples related to their relationships with men, such as: Birth control is "my responsibility, he doesn't feel he should be responsible for it"; "If we wanted to be together, usually he was the one that decided"; and "I'm not allowed to speak my mind."

Racist examples emerged throughout the sessions, but during the sixth session we focused almost entirely on racism. The following are excerpts from the dialogue that day to show the variety of examples two of these women shared, their feelings, and how the experience of sharing changed their perceptions of racism. To initiate discussion I asked them to share times they remembered being discriminated against, and Sina began by telling about going to a recreation center in her neighborhood:

> I remember on our way back we stopped at a little convenience store and went in and the man said, "I'm sorry, but we won't serve you all here." And I know I was no more than 8 years old then. And I kept sayin', "Why not? Why didn't we stay?" I was just totally confused! And the teenagers were all ranting and raving, and I was like, "What's going on?" [She laughs] I was like the dumb one!

Emma explained that her first experience with racism was hard to remember, and she wondered if her mom and grandmother had tried to lessen its effect on her. But she told about the first time she had seen the KKK:

> I was a sophomore in college, and it made me so mad. I went home and I was just cryin' and my grandmother kept sayin, "It's okay." And I'd keep thinkin' about how in the 50's and the 60's when all the lynchings went on, how strong everyone else was. I wanted to be able to be that way: for someone just to come and get in your face, and you just stand there and not do anything.

These are not new or unique experiences for black women, yet the fact that we still see these examples of racism as we approach the twenty-first century is powerful.

The sharing of these experiences exposed the prevalence of racism in our culture and some of the consequences for these women. They recognized the prevalence of racism through negative stereotypes that abound—in the news, in the job market, and so forth. Conse-

quently, they felt a need to overachieve in order to overcome the effects of these negative images and beliefs. Emma remarked about the difference in news coverage for blacks and whites and her response:

> You can always tell when it's a Black person. If they don't have a picture, they'll say "a Black male," and if they don't say Black male, then you know it's a white person. I figured it out, all the news channels do it. . . . And that frustrates me. . . . It's like you have to overachieve just so you can say, "Well, I'm sorry, but I'm not what you think I am."

Sina concurred:

> I remember even when I was small, my mom would always say, "You have got to do your very best because if you ever apply for a job—and she always used this example—and you and a white person go in, and you're equal, you may think you're equal, but you're not equal, you know, cause normally a white person is doing the hiring." And she said, "You always need an edge . . . because they always have that edge, color is always an edge for them, but you need something else to equal that out."

Another consequence of racism they recognized was the strain it placed on interpersonal relationships. With black friends, blackness itself became an issue. Emma had noticed an ad for different shades of black dolls, all with white features, which reminded her of studies where black children preferred white dolls. She said softly,

> I don't know, it seems like they're not changing at all, and it's sad in the 1990's that for a Black kid to be playing with a white doll is good and a Black doll is not good.

She realized how this connects to adult life when she recalled a conversation with a friend. Her friend had read an article that stated that men were "going back to the old stereotype that lighter skin females are better than darker skinned ones." The friend said she believed it, and Emma lamented, "Some people still buy into the skin color thing." This highlights the way in which racism is played out in their personal relationships.

Experiences with "sympathetic" white friends sometimes made them question their own interpretations of events. They weren't always sure how to label experiences except that they didn't feel good about them. Sina recollected an encounter with a restaurant manager and a "really close" friend of hers who was white. Her

friend had placed a special order and when the waitress couldn't comply, her friend asked to speak to the manager. Sina continued,

> So the manager comes out and he looks at me first; he says, "Yes ma'am?" At that time she opened her mouth to speak, so—[M: So tell me how that made you feel then?] Well, I didn't say anything cause she and I talk race stuff all the time, and I never, I don't quite know the way it made me feel. I mean I know it wasn't a good feeling, but I can't put my finger on it. Cause I was even wondering, I don't know, she probably didn't even notice, but I noticed. [M: She didn't have to notice.] It was just, I mean, she's very, when it comes to a lot of Black issues, I know she's not Black, but she understands a lot, cause she's taken Black studies courses, and her eyes are open more so than a lot of white people eyes. But I noticed that he looked at me first. [M: Would you have felt comfortable making that request yourself?] Like she did? I probably, I don't know, because I told her, cause I kind of looked at her, and she said, "Did I embarrass you?" And I said, "No, you handled it very well." She said to him, "I'm sorry," and he says, "Okay, no problem." But it did make me wonder. Would he have been that willing and understanding with me?

Part of Sina's discomfort was clearly the perceived racism of the manager. Another difficulty for Sina, it seemed, was acknowledging the inability of her friend to understand the racism inherent in that particular situation, and perhaps to comprehend racism as it is expressed in life experiences rather than in theory. This illustrates the power of racism to create uncertainties about the legitimacy of what ones knows and how one feels.

At this point in the conversation I asked, "So you experience this (racism), you have experiences like this regularly?" Sina replied, "Mm-hum, well, I guess you could say regularly." I asked, "Every week?" Sina replied: "I don't think I could say every week." Emma replied: "Once or twice a month." Sina replied: "Yeah." Yet they continued with stories for another forty minutes. At the end of the hour, I commented, "I need to let you go, and Sina said, "Let me tell you about this" and laughed. "I mean things are coming to me now." Several examples later I asked, "It is everyday?" And Sina replied, "Oh, yeah, if you think about that, it is everyday." Well past our allotted time, Emma exclaimed, "Oh, one more example, then I'm gonna have to go." Their examples were indicative of the way in which oppressed people are aware of "patriarchal politics from their lived experience, just as they develop strategies of resistance" even though they may be "unable to articulate the nature of their oppression" (hooks, 1984, p. 10).

Having talked together about their experiences gave Sina and Emma a new perspective from which to dialogue in the next session with Ida. They began with an exchange regarding the effects of subtle racism, and Emma said, "You're gonna be sittin' there thinkin', 'What's wrong with me?'" Sina continued, "Cause whenever someone has negative feelings toward you, you always get negative vibes from them. You always think, 'Well, what did I do to that person? Did I say something wrong?'" At that point Ida added,

> Maybe that's what I need to do then. Because I'm always sayin', "What did I do? And why did I make so and so do that?" Then I try to change my ways so I can. Maybe if I did label it, it would probably relieve a lot of stress.

They were dealing with the power of racism to affect feelings about themselves and were recognizing the temptation to internalize it. As Yamato (1990) writes,

> Internalized racism is what really gets in my way as a black woman. It influences the way I see or don't see myself, limits what I expect of myself or others like me. It results in my acceptance of mistreatment, leads me to believe that being treated with less than absolute respect, at least this once, is to be expected because I am black, because I am not white. (p. 22)

Ida demonstrated the power of internalized oppression and how she overcomes it in the following story. When things needed to be done, her boss acted like she didn't comprehend, and Ida asked,

> Why does she tell me this? I already know how to do it. And it's like I'm dumb or somethin'; I don't remember anything. So I guess that was sexism. But I had never thought about that. My mom says, "It's not you; it's *her*."

It seemed to me that this was not "sexism" but "racism," so I suggested, "It may not be her perception of you as a person, but you as a woman or you as a Black woman." Ida continued,

> Or not gettin' stuff done. I can't do everything by myself—I finally realized that—but when things have to be done at the nursery, if I'm not able to get to it or somethin', she's like, "Well, you're not doin' this and you need to do that." [Ida now spoke faster and more forcefully] And it's makin' me feel like she's tryin' to say I'm lazy but I'm not lazy; it's just that I don't have time to get to that. [Pause] Whoa. [and she laughed softly]

This was the woman who, a few minutes earlier, had said, "I don't see the racist part. If I do, I ignore it or something. I have a difficult time pickin' out racism right now." Yet given opportunity to share her own experiences and to interact with Sina and Emma, Ida seemed to see the situation in a new light. It wasn't about her "not getting stuff done"; it was about an assumption that she was "lazy." It was as though she just got it; she realized there was something going on outside herself. Ida concluded, "I think I better start lookin' at those situations." She was also able to connect the social view with feelings about herself and about the value of labeling oppression to change those feelings.

At times their understanding and articulation of the issues were extraordinary. For example, Sina once related the distinction made between groups of black women and white women: "Black girls are making a scene, being loud; white girls are having fun. It's always like that." Another excellent example of Sina facing racism, as well as the pervasiveness of racism, is evidenced in this experience:

> We all went to get the groceries [in Mississippi on the 4th of July]. . . . We asked the cashier to subtotal it cause we had some things set aside that we didn't necessarily need. She goes "okay" and when she'd finished, she pressed the percentage thing—cause you know with food stamps you still get a certain percentage taken off. Then we handed her the cash; she was like, "Oh, I'm sorry." I thought [Emma interjected quietly, "Oh my God."] And I thought about her, and I looked at the way, I was like, "Are we *dressed* like we're extremely poor?" Everyone was dressed really nicely, I mean, our hair was combed, we were clean, we didn't smell, you know, you know? [M: The assumption is that you don't have money.] Oh, yeah, I mean *everybody's* poor, I mean, I would say, I'm not a wealthy person, but a lot of times I consider myself poor, but I know how to carry myself so no one says, "Oh, you poor child [laughing], you know?" Or, "Oh, look at her, isn't that pitiful." I mean, the kinds of things we say about homeless people. And sometimes I feel like I'm kind of equivalent with a homeless person with that attitude, with the attitudes we are given.

Sina's telling of this story also revealed her internalized stereotypes about class that were not explored in this session.

Their identification of racism and its effect was revealed in their struggle to voice their thoughts. This is illustrated in Sina's poignant question that followed their complaint that loud music was always associated with black people: "I mean do they really, do they only see, do they really only ever see black men playing music loudly?"

Their struggle with the complexities of the issues and knowing

how to respond was apparent after a discussion in another class about children at risk and teenagers having babies. Sina reported that one of the students had stated, "Tie their damn tubes!" She continued,

> And then, I mean I was sitting there and it was like I just wanted to say somethin', but I couldn't get it together, you know what I mean? And another lady says, "I'm sorry, who are we and who are *you* to say, 'Well, look, you can't have anymore babies'?" She was like, "Well, look, they can't take care of 'em; we're takin' care of them."

Considering the implicit reference to black unwed mothers, I asked Sina if this was a class issue or if she thought it was also a race issue. Sina's response was illustrative of her struggle, "Well that, see, I couldn't, I was tryin' to, sittin' there I was really into it tryin' to figure out which, which it was, or both."

Much of the time they admitted that they did not challenge a racist/sexist situation even when they are aware something inappropriate had occurred. Why? (1) Sina: It's not going to help anything. (2) Ida: You don't want to hurt the person's feelings. (3) Ida: You don't want them to be mad at you. (4) Ida: It's the wrong time. (5) Sina: Or the wrong place. (6) Sina: Everybody'll think you're weird. (7) Ida: Think you're mean and won't talk to you. (8) Ida: I might be overreacting. (9) Sina: I'm just so afraid that I'm gonna be too blunt. These reasons are almost identical to those given by white college women for why they did not challenge the sexist situations they recognized (Morgan and Rhoden, in press).

For black women, of course, the situation is more complicated. The instances are more frequent, more global, more difficult to assess, more painful, more risky to confront. In the ninth session Emma explained:

> A lot of times I'm able to look over stupidity and ignorance. I've learned to do that when a lotta of times I should probably stand up and say, "Look, you've just offended me. I really wish you hadn't said that." . . . Yeah, a lot of times you just slide by because you don't even want to get in the hassle of goin' through it. I know I do it personally because I just get so fed up and tired of it. It's like the same stuff over and over that a lot of times I can ignore it unless it just smacks me in the face.

Ida concurred:

> Okay, my boyfriend says some days you don't feel like goin' to work, but you still go in with a smile. Or if somebody has upset you, you don't say anything to 'em.

Ultimately Emma summed up much of their feelings when she responded very softly, "It's sad, depressing, that even though it's almost the year 2000, these things are still takin' place, and it's ridiculous, I think." Their voices are testimony to the struggles they experience as black women.

Changes. During the last session I asked them how being in the group had affected them. Ida started, "It's nice to know that I'm not the only one who feels the way I feel. And I talk more now." Emma offered a similar view,

> I'm more aware of certain things now. I can label it more readily as racism or sexism. Before I could say, "Well, I don't think this is right," but I really couldn't pinpoint exactly what it was. But now I'm able to do that more. Before meeting with this group, I didn't really think about racism. Even though it's smackin' me in the face. But now, I'm able to say, "Well, you know, I experienced this five minutes ago. I'm able to point it out more now."

I asked her how being "able to point it out" changed what she did or how she felt, and Sina interjected,

> I want to be at the point where when it happens I know what to say right then rather than think about it and "Well, hmmmmm, next time I'll say this." . . . Here we are getting ready to graduate from college and we're still having trouble just saying, "I didn't appreciate what you just said."

Emma continued:

> I think you just have to go with your gut feeling. If you're talkin' to someone, and if they say something that offends you or that you feel is racist or sexist, if you identify it and tell them what it is, I think they may come up with, "I didn't mean anything by it" as a defense mechanism when really deep down they did. But if you really feel that they did, then I think you need to explore it, "Well, this time I felt"—

"Even though you say you didn't mean anything by it," Sina interrupted, "this is the way it sounds. That sounded like a sexist remark, or may be taken as being racist. So, I don't think you should say that type of thing anymore."

Then Ida responded, "The question is: Will I do it?" This is often the question, yet I believe the experience of having been in the group will encourage the process to continue. As a result of this process all of them were better able to identify racism and sexism, to recog-

nize their own feelings about their experiences, and to respond to oppressive situations in ways that were empowering to them.

The change that occurred was not only in them. The research process was also empowering for me. Reinharz (1992) states, "In any research project . . . the researcher [should] learn about herself, about the subject matter under study, and about how to conduct research" (p. 194). This critical science project with black women provided me with the opportunity for learning in all these areas; the next section illuminates some of my learning.

For a White Researcher

I was struck by the pervasiveness of racism in their lives, and I was made more aware of subtle racism when they provided examples that had never occurred to me. For example, Sina once asked, "Why do Black parents teach kids about Santa Claus? What white man is gonna come to your house and give you all these things?"

I learned that being aware (as aware, perhaps, as an outsider can be) that we live in a racist society was different from hearing personal racist experiences from women you have a relationship with. Many times I was touched by their emotions and by their struggles in dealing with these issues. Their willingness to share with me their struggles connected me to their lives, and their ability to make me laugh made me feel included. This is demonstrated in the following dialogue. Emma had been offended by a white classmate who she felt wasn't willing to listen to the opinions of black authors and reported,

> I don't think she even read the article. . . . When I started reading the article, I really got into it. I couldn't really believe what she said knowing that it was about Black women. And I was thinkin', "Well, just think about all the stuff that we have to read that's by a white woman."

At that point I asked Emma, "What would have made you feel better about that situation?" She replied,

> If she had maybe, I don't know . . . I don't understand why she couldn't understand what they were saying, you know . . . I woulda felt better if she hadda said, "Well, you guys, I had a problem with this article; I couldn't really understand where they were comin' from or what they were saying. Could you explain it to me?" And that's why I asked them if they had anything to say.

After a pause, I pressed the issue by asking, "Given where she was, that she wasn't really interested in trying to figure it out, then what

would have made you feel better?" And Emma retorted, "Her shut-tin' up. No, I don't know." Whereupon there was loud laughing. As in this example, their sharing problems, revealing unedited thoughts, and laughing together created for me a connection to them that informed me more about the experiences of racism and sexism than the facts themselves.

The experience also provided insight into the research process that Edwards (1990) proposes we explore: "the interview situation in which white researchers are asking Black women questions about their lives" (p. 478). While I was often in awe of what they knew and how they felt, I was still trying to facilitate their understanding of their experiences—an awkward position for a white woman whose research group is black women. I was sometimes uncertain about how to approach a topic and explained to them my hesitancy in making interpretations about their lives. Reinharz (1992) writes,

> In feminist participatory research, the distinction between the research-er(s) and those on whom the research is done disappears. To achieve an egalitarian relation, the researcher abandons control and adopts an ap-proach of openness, reciprocity, mutual disclosure, and shared risk. Dif-ferences in social status and background give way as shared decision-making and self-disclosure develop.

Our meeting together as a group over several weeks served to build cohesion and an egalitarian relationship from which to learn from each other. This concurs with Lather's (1988) belief, "Group interviews provide tremendous potential for reciprocally educative encounters" (p. 574). Being in class together also facilitated the proc-ess by providing a common experience for us as well as a point of departure for discussion. I encouraged self-disclosure, and thus a sense of collaboration, by sharing my questions, feelings, experi-ences with sexism, and observations of racism.

Another factor that helped in creating an environment of "open-ness, reciprocity, and shared decision-making" was a belief held by all of us that they were the experts. In fact, they admitted that they were more conscious of trying to relate their feelings and ideas to me because, as a white woman, I wouldn't know. As Sina put it,

> With a Black woman, some things that I thought about, I may say, "Well, she probably already knows that." [E: mm-hm] You know, we may talk about it, but that may be it. But then, I kind of felt like, "Well, I need to tell her about this cause she might not be enlightened on this point!"

I believe this helped balance our differences in race and position. My assuming a learning, rather than teacher or researcher, role opened the possibility for shared risk.

I want to believe that there were positive consequences from my being white yet I am both pleased and haunted by a statement from Emma who said, "It seems like when we've been talking, you've always been honest and open and sincere and not, you know, looking down on us or anything like that." I know that racism was present in our interaction in ways none of us recognized.

I was made aware of the "multilayered texture of black women's lives" (Combahee River Collection, 1982, p. 17) and the difficulty of facing "multiple jeopardy," racism multiplied by sexism multiplied by classism (King, 1989). When asked, "What's it like being a black women?" these women acknowledged that they could not differentiate between racism and sexism. Emma answered, "It's hard to separate bein' a woman and bein' a Black woman." Sina explained, "You don't know if it's because of your race or because of the sexism." The Combahee River Collective states,

> We believe that sexual politics under patriarchy is as pervasive in Black women's lives as are the politics of class and race. We also often find it difficult to separate race from class from sex oppression because in our lives they are most often experienced simultaneously. We know that there is such a thing as racial-sexual oppression which is neither solely racial nor solely sexual. (p. 16)

These women's experiences reflected this difficulty. It was made clearer to me how racism, sexism, and classism are interdependent systems of control that together form an interactive model of oppression. At our last meeting, Sina added:

> It's a continuous struggle because I always feel like no matter what I do, I have to strive to do even better simply because if it's not criticized because I'm a woman, then I'm going to be criticized because I'm Black. But you know, the race comes first. Yeah. I would think most of the time race comes first.

This research process has influenced my teaching in that it has empowered me to create a women's studies course that is more of what one ought to be, that is, focused on race and class as well as gender. Following the research project in the fall of 1992, the interaction between the black women and the white women in this course was the most engaging it had ever been. They talked to each other, asked questions, listened to each other, and laughed together. Some-

times I simply observed as they interacted. Although it certainly may be attributed to that particular group of students, I realize that it was at least partially due to a change in me because of the black women in my research group: I was more focused on the issue of diversity. I was more aware of the issues. I was less uncertain about how to approach the issues. I was more encouraging, demanding even, that all voices be heard. I was a stronger advocate for those whose voices are less often heard. These changes promoted an environment in which student interaction could develop that approached what the research group experienced in our intimate conversations.

My evaluations in fall 1993 spoke to my increased ability to integrate issues of race and class into a course that had originally focused primarily on gender. At the end of the semester some of the students responses included: (1) "I had no idea that I would learn so much about sexism, racism, and classism." (2) "The course brought out discrimination and prejudices we don't normally notice." (3) I expected this course to be on women in society; it met my expectations even more by discussing race, class, and gender issues. (4) "We looked at a wide area of inequality and injustice across the board— not just white middle-class women."

This research process was a learning experience for me in many ways. I have an increased awareness of racism for black women and an appreciation for the multilayered nature of their oppression. My belief in the power of connection to women's personal experience to facilitate understanding has been confirmed and strengthened. I have gained new insights into a process that provides emancipatory research, insights that speak to the method itself and to the researcher/participant relationship. All of these contribute to my knowledge and skills in teaching as well as research.

Conclusion

Lather (1988) suggests, "For those wishing to use research to change as well as to understand the world, conscious empowerment is built into the research design" (p. 570). Critical science research, which focuses on collaborative engagement in critical reflection and dialogue, provides a vehicle. My goal in this project was to generate knowledge about black college women's experiences with oppression and to enable all of us (researcher and participants) to better understand and challenge oppressive situations. As part of a collective, the black women in this study identified and critiqued thoughts and actions that perpetuate oppression. Hence, through changes in

perception, they became better able to "name" racism, to discern their feelings about their experiences, to connect their feelings and experiences to the dominant culture, and to identify ways to transform oppressive situations. Their openness with me provided insights into the experience of being a black women I could not have had otherwise. This in turn enables me to more effectively change oppressive situtions, particularly in my role as teacher/researcher. This process of change points to the importance of educators and researchers understanding the variety of ways oppression works in order to help students and ourselves understand and overcome its pervasiveness.

References

Brown, M. (1989). What Are the Qualities of Good Research? In F. Hultgren and D. Coomer (Eds.), *Alternative Modes of Inquiry in Home Economics Research,* pp. 257–97. Peoria, Ill.: Glencoe Publishing Company.

Collins, P. Hill. (1989). "The Social Construction of Black Feminist Thought." *Signs* 14, 745–73.

Combahee River Collective, The (1982). A Black Feminist Statement. In G. Hull, P. Scott, and B. Smith (Eds.), *All the Women Are White, All the Blacks Are Men, But Some of Us Are Brave* pp. 13–23. Old Westbury, N.Y.: Feminist Press.

Comstock, D. (1982). A Method for Critical Research. In E. Buedo and W. Feinburg (Eds.), *Knowledge and Values in Social and Educational Research,* pp. 370–90. Philadelphia: Temple University Press.

Du Bois, B. (1983). Passionate Scholarship: Notes on Values, Knowing and Method in Feminist Social Science. In G. Bowles and R. D. Klein (Eds.), *Theories of Women's Studies* pp. 105–16. London: Routledge.

Edwards, R. (1990). "Connecting Method and Epistemology: A White Woman Interviewing Black Women." *Women's Studies International Forum* 13 no. 5, 477–90.

Fay, B. (1977). How People Change Themselves: The Relationship Between Critical Theory and Its Audience. In T. Ball (Ed.), *Political Theory and Praxis,* pp. 200–269. Minneapolis: University of Minnesota Press.

Hartsock, N. (1986). Feminist Theory and the Development of Revolutionary Strategy. In M. Pearsall (Ed.), *Women and Values: Readings in Recent Feminist Philosophy,* pp. 8–18. Belmont, Calif.: Wadsworth Publishing.

hooks, b. (1984). *Feminist Theory: From Margin to Center.* Boston: South End Press.

Hurtado, A. (1988). "Relating to Privilege: Seduction and Rejection in the Subordination of White Women and Women of Color." *Signs* 14, 833–55.

Jax, J. (1985). "Alternative Frameworks for Research in the Field of Home Economics." *Journal of Vocational Home Economics Education* 3, pp. 3–7.

King, D. K. (1989). Multiple Jeopardy, Multiple Consciousness: The Context of a Black Feminist Ideology. In M. Malson, et al. (Eds.), *Feminist Theory in Practice and Process,* pp. 75–105. Chicago: University of Chicago Press.

Lather, P. (1988). "Feminist Perspectives on Empowering Research Methodologies." *Women's Studies International Forum* 11, no. 6, pp. 569–81.

―――. (1986). "Research as Praxis." *Harvard Educational Review,* 56, no. 3, pp. 257–77.

Morgan, M. and L. Rhoden. (in press). "Empowerment through Critical Science: Change in White College Women Regarding Sexism." *NWSA Journal* 7, no. 2.

Oakley. A. (1981). Interviewing Women: A Contradiction in Terms. In H. Roberts (Ed.), *Doing Feminist Research* pp. 30–55. London: Routledge and Kegan Paul.

Reinharz, S. (1992). Feminist Action Research. *Feminist Methods in Social Research* pp. 175–96. New York: Oxford University Press.

Yamato, G. (1990). Something about the Subject Makes It Hard to Name. In G. Anzaldua (Ed.), *Making Face, Making Soul: Haciendo* Caras, pp. 20–24. San Francisco: An Aunt Lute Foundation Book.

Section 3
Translating Feminist Work into Action

Introduction

KATE CONWAY-TURNER

A significant accomplishment of feminist scholars has been the ability to utilize feminist theories and methodologies to tackle women's "real-life" concerns. Calls to tackle "real issues" are not new. The voices of Sojourner Truth, Margaret Sanger, and Eleanor Roosevelt are a few of many distant voices that can still be heard as a reverberating echo reminding us that practical concerns must be addressed. The scholars in this section represent authors who continue to hear the voices of the past and present women and men who seek greater understanding of concerns that face our communities. This section will highlight several arenas where academics informed by feminist frameworks have crossed disciplines, asked critical questions, and addressed realistic concerns that impact the lives of women.

The first subsection examines scholarship dealing with medical matters. Here three scholars seek to illuminate old and new issues affecting women's health. In "Breast Cancer: A Critical Evaluation of the Current Advice to Women," Suzanne Cherrin places herself among the one hundred eighty thousand U.S. women who are diagnosed with breast cancer each year. The author critically explores the current information provided to women facing this medical crisis. She guides the reader through an exploration of the causes, treatments, reactions, and psychobiological consequences of breast cancer in an effort to provide information that enhances empowered choices.

In "Crossing Boundaries: Bringing Life into Learning," Ellen Goldsmith and Sonja Jackson suggest that there are important benefits in humanizing technological training. They present their experiences of merging radiology techniques and poetry focusing on women's health concerns. In a unique curricular development, the authors challenge radiology students to understand the impact of illness by "hearing" and "empathizing" with women who are the recipients of oftentimes cold radiological technology.

The concluding essay in this section, "Midwifery and the Medical Model" by Kathleen Doherty Turkel, investigates the relationship

between the midwifery model and the medical model as it exists within the United States today. By examining scholarly literature and primary interview data, the author explores what each model offers the birth process, and the evolution of the relationship between these often competing models. As in the Goldsmith and Jackson essay, the author sees value in the "nonmedical" aspects of what is often a technological process.

In each of these three essays, the reader is guided through a feminist exploration in understanding critical issues that affect women's health or health choices. These articles assist in our present understanding of women's medical concerns, and center them within a series of evolving relationships.

The essays housed under "Math and Science," examine how feminist work has transformed issues within fields that traditionally were unaccessible to women. In the first essay, "Addressing Eurocentrism and Androcentrism in Mathematics: The Development and Teaching of a Course on Mathematics, Gender, and Culture," John Kellermeier utilizes a feminist pedagogy to enlarge students' understanding of mathematics and mathematicians. The article documents how the author crossed disciplinary boundaries to create teaching tools to enable students to explore sexism, racism, and elitism within traditional mathematics courses. The result is students who are empowered to challenge mathematics to become a more inclusive field.

Sue Rosser, in "Interdisciplinarity and Identity: Women's Studies and Women in Science Programs," also explores the impact of race, class, and gender. This essay seizes the difficult question of understanding how feminist theorists, frameworks, and feminist pursuits have impacted women's interest in the scientific fields. The maturation of various feminist tenets and how they have influenced the evolution of programs to attract and retain women in science are central issues that are addressed.

The sciences and mathematical disciplines have been slow to include women in representative numbers, but as evidenced by the articles in this section movement continues to be made. Both essays reinforce the importance of recognizing the impact of multiple "isms" and finding new ways to address their effects in order to change women's roles within these spheres.

The section on "Family and Public Policy" challenges feminist work to address these issues. Brenda Crawley, in "Twenty-First-Century Sociocultural and Social Policy Issues of Older African-American and Older African Women," explores demographic profiles of African women and women of African descent. Crawley focuses on aging as a feminist issue, and stresses the empowerment

of resolutions that come directly from lived experiences that recognize the heterogeneity of these women. The realities of aging for African descent women have direct relationships to public policy development.

In "Interdisciplinarity in Research on Wife Abuse: Can Academics and Activist Work Together?" Jacquelyn C. Campbell leads the reader through a search to understand how varied committed feminists address the issue of wife abuse. She both explores the false dichotomies that are often displayed when activists and academics working within wife abuse come together, as well as presenting a discussion of the importance of understanding the complexity of this issue. Campbell concludes with concrete suggestions for healing the rifts between academics and activists in order to develop an inclusive effort to address violence against women.

Concluding this section, Bonnie Kime Scott interprets the work of Rebecca West in "Rebecca West's Traversals of Yugoslavia: Essentialism, Nationalism, Fascism, and Gender." In this piece, the author addresses the impact of shifting political tides and the treatment of women in West's writings. The importance of understanding the contextual issues surrounding West's work is central as Scott steers the reader through the world West chronicled and suggests parallels in current world affairs. West, an outspoken activist, crosses boundaries as she centers her work to do more than chronicle, but to impact the public policy of her times.

In all cases these authors tackle issues that are fundamental to understanding women, family, and public policy issues. This clarifies critical issues such as the importance of the heterogeneity of women, the complexity of the issues that women face, and how such social relationships were developed.

These subsections taken together provide a careful view of feminist scholarship impacting concerns that women face. Although the authors in this section are drawn from a variety of singular and interdisciplinary backgrounds, they have chosen to move toward investigating complex issues, utilizing feminist frameworks and methodologies, and crossing disciplinary boundaries. The success of these authors' works provides examples of feminist scholarship that translate feminist academic work to action.

MEDICINE

Breast Cancer: A Critical Evaluation of the Current Advice to Women

SUZANNE CHERRIN

Introduction

IN 1991 I had a benign cyst removed from my left breast. I was told I had "fibrocystic breast disease," that I might get more of these cysts, and that I should eliminate caffeine from my diet. In 1992, I read a controversial article about mammograms and elected not to have one until 1993. In the spring of 1993, I could feel another lump in my left breast, but my general practitioner told me she "wasn't worried," and because I *knew* I had fibrocystic disease, I thought it was that rather than cancer. I was wrong. In the summer of 1993, I had a modified radical mastectomy and had to face six months of chemotherapy.

I, like approximately 180,000 U.S. women per year, became part of the matrix that services breast cancer patients. I have come to believe, however, that entry into the varied systems of advice and opinions regarding the threat of breast cancer begins much earlier in a woman's life. If you are female, and have reached adulthood, ready or not, you need to listen to the frightening, confusing, and often contradictory statistics and recommendations surrounding the disease of breast cancer. The stakes in a woman's choice of action in this issue are high. Approximately 45,000 women die each year from complications of breast cancer (Brinker, 1990). The decisions one makes may be the difference between life and death. This is the primary concern, but there is an important secondary concern, one that sometimes obscures clarity of insight in sorting out decisions and treatment of breast cancer. A woman's breast in this culture, and many others, is something more than just another body part. It is, in Dr. Susan Love's words, "the external badge of our woman-hood" (1991, p. xvii). It is both a source of nurturance, closely connected to motherhood, and an aspect of sexual identity. The eroticization of breasts is especially pronounced in this culture; there-

fore the threat of, or real loss of, one's breast assaults a woman's self-esteem. The disease threatens one's sense of self in two ways: the fear of death and the fear of loss of one's sexual self.

Can a Woman Prevent Breast Cancer?

According to the current state of conventional wisdom there is only one guaranteed method of preventing breast cancer—to have bilateral total mastectomies. This solution is, of course, completely unsatisfactory to the vast majority of women since it would destroy the very organs they want to protect. Those who believe that cancer is primarily a function of certain types of foods and food additives believe that a macrobiotic diet will prevent, or even cure, breast cancer. Those who believe that emotional stress and negative thinking can cause cancer recommend such practices as meditation, relaxation, and visualization to stay healthy or to reverse the disease. Some of the suggestions contained within the less conventional strategies may be beneficial; there are no scientifically proven methods of preventing cancer. Advice from the established medical community, often voiced through the American Cancer Society (ACS), sounds like it is offering a method of prevention, but in actuality it focuses on educating the public about known risk factors and advocates early detection as the best offensive against breast cancer.

All women, but especially those who fall in a high risk category (suspected causes of breast cancer will be discussed later in this essay) are advised to participate in their own early detection program. Because there is seldom any pain associated with early stage breast cancer, there are only three ways in which a woman may become aware that she could have the disease: professional breast exam, breast self-examination (BSE), and mammography.

Breast Self-Exam:

There is no question that BSE is very important in the detection of breast cancer. Over 75 percent of malignant lumps are found by women themselves through BSE or by accident (Hirshaut and Pressman, 1992). Dr. Love (1991) states that women are rarely given adequate information about what to look for and this causes much needless anxiety. She reports that about 90 percent of her patients do not perform BSEs, and most of the doctors and nurses that she knows do not follow this practice either. Love hypothesizes that much of the reluctance to touch and probe one's own breast is a

legacy from an era of sexual prudery that disapproved of anything approaching masturbation. This may be a factor, but it seems just as likely that the main reason why women fail to do BSEs is fear of the lumps and contours that they do find. The reluctance may be heightened for women who have "lumpy" breasts. Love advises: "In general, what you're looking for is one lump (or possibly two or three—rarely more) that's at least half an inch in size, stands out, and is persistent and unchanging" (Love, 1991, p. 22). Breast self-exam and professional tactile exams, with clear guidelines of what to look for, should be stressed and explicated to a greater extent by the American Cancer Society and by other official sources of information, as it remains the primary indication that breast cancer might be present. The other type of detection method, mammography, is much more controversial than tactile exams and has been touted as the only way to detect breast cancer in the early stages.

Mammography:

During mammography an X-ray beam is passed through the breast to produce a black-and-white, two-dimensional picture of the tissues of the breast. Currently this technology is the only screening indicator for the very early stages of breast cancer. It can reveal abnormalities such as microcalcifications, tiny nonpalpable flecks of calcium, which, if clustered in one area of the breast, would require further investigation. A frequent recommendation is to come back for another mammogram in three to six months, to see whether there has been any change. However, the physician might also decide that a biopsy (surgical removal and examination of the suspicious breast tissue) is necessary. Sometimes this can be done through needle aspiration, but the formal biopsy requires open surgery. If the tumor is small, it can be removed completely and is called an excisional biopsy; if only a portion is removed for examination, it is called an incisional biopsy.

So the established order of inquiry to ultimately answer the question "Is it cancer?" almost always utilizes mammography. The American Cancer Society recommends that every woman have a baseline mammogram at age thirty-five and then, starting at age forty, to continue having them every one to two years. They recommend having one every year starting at age fifty. One of the concerns that women have about this advice involves the safety of the mammogram itself. We know that low level radiation can be carcinogenic and the possibility of radiation damage increases with accumulative exposures. Therefore, a legitimate question is: What is the risk that

exposure to radiation during the procedure—and from repeated mammograms over the years—will itself cause cancer? The official answer to this question about the risks of radiation from mammography is that: "The risk has been greatly reduced in recent years as mammography techniques have been improved. . . . The probability of danger from mammography seems to be a great deal smaller than the probability of danger from an undetected cancer" (Hirshault and Pressman, 1992, p. 66). The authors go on to say that the risk can not be reduced to zero and explains that younger women (in their teens and twenties) would be most sensitive to low level radiation. Before women accept the advice to be "good girls" and have our yearly mammograms, there are other questions to ask: Do mammograms save lives? Will my insurance cover it? Will it decrease the need for extensive surgery and systemic treatment? Will it increase or decrease anxiety?

Two recent studies assessed whether mammography saves lives and the results were instrumental in a reversal of the advice of the National Cancer Institute (NCI). Unlike the recommendation of the American Cancer Society, the NCI no longer recommends routine mammograms for women in their forties. The results of the Swedish studies involving 282,777 women were reported in *The Lancet* (1993). With respect to women who had regular mammograms, they conclude: "No trial has so far recorded convincing evidence of a mortality reduction in women aged 40–49" (p. 974). The largest reduction of mortality, due to mammograms, was in women aged 50–69. The Canadian National Breast Screening Study, released November 1993, studied 50,430 women in the 40–49 age group. In this study there were actually more deaths from breast cancer in the group receiving annual mammograms than in the "usual care" group. They conclude that "screening with yearly mammography and physical examination of the breasts detected considerably more node-negative, small tumors than usual care, but it had no impact on the rate of death from breast cancer up to 7 years' follow-up from entry" (Miller et al., 1992, p. 1460).

Although there is much controversy about the value of mammograms, there is little doubt that there are at least some advantages to them. The studies indicate that early detection through a mammogram does save lives for women over fifty. Another benefit of early detection from mammography is that it is possible to catch a tumor while it is still small enough to save one's breast (by having a lumpectomy rather than a mastectomy). Susan Reimer (1994), from the *Baltimore Sun,* expresses the frustration of receiving mixed messages about mammograms in an article about the NCI's reversal of policy.

She forecasts monetary consequences of the agencies' equivocation: "Insurance companies will stop paying for them [mammograms]. That means the women who don't have $75 to pay for a screening, or who just need one more reason not to have a test they fear, won't have one" (Reimer, 1994).

Indeed, the cost of mammography, like other aspects of American health care at the present time, presents an obstacle to poor women, many black women, and many women over sixty-five years of age. E. Calle et al. (1993) report in the *American Journal of Public Health* that the use of mammography varies widely with family income, location, age, and education. In the study they reviewed, they found that of 6,353 women age forty or older, about 80 percent of women below the poverty line had never had a mammogram.

The incidence rates of breast cancer are higher in white women than in black women over age forty-five, they are similar between ages forty to forty-four and they are higher for black women under forty (Kelsy and Gammon, 1991). Despite the fact that older black women are less likely to develop breast cancer, they are more likely to die from it. According to an article entitled "Public Health Focus: Mammography," (JAMA, July 22/29, 1992, p. 452) white women account for 82 percent of years of potential life lost (YPLL) from breast cancer, but "the estimated rate of YPLL during 1988 was approximately 25% higher for black women than white women." The poorer prognosis for poor and black women is related to inadequate screening and late diagnosis. Although there is some indication that older African-American women are more reluctant to use mammography (Tessaro, Eng, and Smith 1994; Jepson et al., 1991), cost of the procedure and greater poverty in the black community must be considered as primary factors in high mortality among older black women.

The Older Women's League (OWL) reports (1994) that despite the fact that almost half of new breast cancers (45 percent) are found in women over sixty-five, this is the group least likely to use mammography. They state that "only about 20 percent of older women have annual mammograms" (*The Observer*, OWL, 1994, p. 1). Explanations for a low rate of screening among older women range from their own reluctance to have this done to a higher poverty level among this group. According to the OWL, older women face discrimination both from physicians, many of whom fail to recommend mammography or to even perform a clinical breast exam, and researchers, who include very few women over sixty-five in their studies (*The Observer*, OWL, 1994).

What Causes Breast Cancer?

If the causes of breast cancer were clearly understood, we might be able to return to the topic of prevention and establish guidelines with some degree of confidence. We might also be able to chart individual and social programs of treatment with a greater probability of success. But, the state of knowledge is nowhere near that level of sophistication. The cancer industry speaks to the public in terms of "risk factors."

The risk for breast cancer increases with age. For instance, yearly figures show that at age 30 one woman in 5,900 will develop breast cancer compared with one in 420 at age 60 (Love, 1991). The risk also increases if there has been personal and family history. If a woman has had breast cancer in one breast, she is at greater risk for developing it in the other breast. Likewise, risk is increased if one's mother, sister, or another close relative has had the disease. In fact, hereditary factors may account for as much as 10 percent of the 180,000 cases of breast cancer diagnosed in the United States each year. "Experts now believe that at least half of these inherited cases involve flaws in a single gene, which they've dubbed BRCA 1 (for Breast Cancer 1)" (Cowley, 1993, p. 46).

There are additional biological factors that render a woman more vulnerable to breast cancer. Women have a greater risk of breast cancer if they had an early menarche (before age 12) or late menopause (after age 55). Women who are nulliparous (have never been pregnant) or who have had their first child after age 30 are more vulnerable. This information indicates that hormonal factors are related to the development of breast cancer. The more periods a woman has had, the more prone she is to the disease. If ovaries are removed and no estrogen replacement therapy is given, the risk for breast cancer is reduced.

There are also some external factors, some related to lifestyle, that are purported to increase the risk of breast cancer. The two variables that one hears about the most are a diet high in fat and alcohol consumption. Of these two, the high-fat diet hypothesis may be the most worthy of consideration—if the studies supporting it are accurate. Animal studies have shown that fat content does matter, and cross-cultural data also indicates that this variable may be important. Japanese women, both in Japan and those who migrate to the United States, have a low-fat diet and a low incidence of breast cancer. The rate of breast cancer increases for second-generation Japanese women who have adopted a more Westernized diet. Dr.

Susan Love (1991) questions the reluctance of the medical profession to give credence to the high-fat diet theory and she speculates that a strong dairy and meat lobby, coupled with insufficient evidence, has influenced opinion. There is evidence that both diet and alcohol consumption, like other environmental factors, have their greatest effect when the body is young and breast tissue is developing.

Interestingly, "70 percent of breast cancer victims have none of the classical risk factors in their background" (Love, 1991, p. 143). The much-quoted figure that one in nine U.S. women will get breast cancer refers to the cumulative risk for white females over a lifetime. For many individual women, the figure is unnecessarily scary since it overestimates the likelihood of developing breast cancer in one's younger years. In another sense, however, this figure is very alarming because it reflects an overall increase over time. In the 1940s, the lifetime figure was one in twenty. This is why some say there is a breast cancer epidemic.

Almost all official sources in the breast cancer matrix (the American Cancer Society, the National Cancer Institute, and the medical community) publicly ignore larger environmental causes of the increase in the breast cancer rate. They explain breast cancer by the personal and life-style factors already discussed, and they explain the increase as the result of better detection and the fact that women are living longer. These explanations are not satisfactory for many concerned about why breast cancer is much more prevalent in industrial nations and those who have worried that one of the major costs to industrial development has to be an increase in the cancer rate.

Breast Cancer and External Carcinogens

In 1962, Rachel Carson, in her acclaimed book *Silent Spring,* wrote, "The new environmental health problems are multiple—created by radiation in all its forms, born of the never-ending stream of chemicals of which pesticides are a part, chemicals now pervading the world in which we live, acting upon us directly and indirectly, separately and collectively" (p. 188). Two years later Carson died of breast cancer at age fifty-six. It is extremely disturbing that breast cancer, like a number of other cancers, has risen disproportionately in all industrialized countries and yet the focus remains on individual (blame the victim) factors and on the search for after-the-fact treatment.

Although the environmental factor has been recognized for more than thirty years, there is very little research into this connection. Those who advance environmental causation are often marginalized

by the scientific community. Devra Lee Davis, an advisor at the Department of Health and Human Services, is described as a "maverick" because she has proposed that synthetic chemicals permeating the environment and mimicking estrogen in the body could be causing breast cancer (Beardsley, 1994).

The major impetus to look at environmental causes of cancer is through grassroots organizations rather than through the established agencies. Greenpeace is active in a campaign to educate the public about the link between organochlorines and breast cancer. Their goal is to phase out the production of both organochlorines and chlorine itself (quarterly publication, July, August, September 1993). Organochlorines are created when chlorine gas is bonded to carbon-rich organic matter. They include known carcinogenic chemicals such as DDT, PCBs, CFCs, and dioxins. "More than 177 organochlorines have been found in the tissues of the general population of the United States and Canada" (Paulsen, 1993, p. 85). The following evidence suggests there is a link between exposure to these substances and breast cancer:

- Women exposed to higher than normal levels of organochlorines in the workplace have been found to have higher rates of breast cancer. This was true of workers in a German pesticide plant and of U.S. chemical workers (D'Argo & Thornton, 1993).

- A study of 229 New York City women with breast cancer revealed significantly higher levels of DDE (a DDT by-product) in breast tissue than a control group (Paulsen, 1993).

- A 1989 study found that counties with hazardous waste sites had a higher breast cancer rate than counties without such sites (Paulsen, 1993).

- In Israel, breast cancer rates were one of the highest in the world, in the 1970s. Action was taken to aggressively phase out several pesticides. The amount of organochlorines in mothers' milk has declined as did the breast cancer rate among younger women (D'Argo & Thronton, 1993; Paulsen, 1993).

- The results of a two-year study, performed by the New York State Department of Health to determine whether women in the Long Island area, who live near chemical plants, have a higher risk of breast cancer, were released in April 1994. The study found that residence proximity to chemical plants were associated with higher rates of breast cancer for postmenopausal women (McQuiston, 1994).

In light of these worrisome correlations, many wonder why there is virtually no funding of research into the environmental causes of breast cancer and how carcinogens (a word rarely mentioned by the NCI and the ACS) may interact with bodily processes to produce a steady increase in the number of breast cancer cases. The same giant chemical companies responsible for toxins, such as the suspicious organochlorines, also manufacture drugs designed to treat breast cancer and help to fund the research carried out by the cancer establishment. An example of this is Imperial Chemical Industries (ICI), who together with Cancer Care Inc. (a support group), founded National Breast Cancer Awareness Month (BCAM). "ICI has been allowed to approve-or-veto every poster, pamphlet, and advertisement BCAM uses. Not surprisingly, carcinogens are never mentioned in BCAM's widely distributed literature" (Paulsen, 1993, p. 87). Not only are potential sources of breast cancer in the environment ignored, but some of the substances and procedures advocated by the official cancer matrix may, in reality, play a contributory role in the development of breast cancer.

The Role of Estrogen in Breast Cancer

Even the most conservative authorities admit that there is a link between estrogen and breast cancer. Many of the established risk factors, for example, late menopause or having no children, are explained by a woman's increased exposure to estrogen. Many of the organochlorines just discussed mimic estrogen. It is puzzling, therefore, that the same medical community entrusted with helping us to identify and treat breast cancer is prescribing estrogen replacement therapy for an increasing number of women each year.

During the 1940s and 1950s, it was popular to give women estrogen for menopausal symptoms. Estrogen, when given alone, was linked to an increased risk for uterine cancer. When this danger became public, doctors stopped prescribing it and women stopped taking it. Since then, it has been determined that if estrogen is used in conjunction with progesterone (Premarin and Provera), it nullifies the threat of uterine cancer. There has not been the same reassurance, however, that progesterone protects against breast cancer. The results of research in this area have been inconsistent. However, one of the more alarming studies was performed in 1989 in Sweden on 23,244 women aged 35 and older who were taking postmenopausal hormones. "After an average of 5.7 years of follow-up they found 253 women with breast cancer, indicating both an increased incidence of breast cancer in women who took estrogen for more than

nine years (relative risk of 1.7) and an even higher increase in women who took both estrogen and progesterone for more than six years (relative risk of 4.4)" (Love, 1991, p. 166).

Apparently gynecologic "experts" in the United States have not seen studies such as this one as any reason to change current practice. The medical community embraces the notion of hormone replacement therapy (HRT). "A whopping 75 to 95 percent of ob-gyns surveyed said they would prescribe hormones—either estrogen alone or in combination with progestin—to most of their recently menopausal patients" (Spake, 1994, p. 47). The medical justification for the widespread use of estrogen is that it relieves menopausal symptoms like hot flashes, night sweats, vaginal dryness, and moodiness, and it prevents osteoporosis and cardiovascular disease. Hormone therapy is also believed by many to curb the effects of aging and to promote sexual interest. In the midsixties, Robert Wilson wrote a book called *Feminine Forever* in which he urged middle-aged women to replace their estrogen deficiency or else to become sexless old crones. The combination of medical endorsement; health-related factors, and the lure of youth, beauty, and sexuality (so heavily promoted for women in U.S. culture), makes HRT difficult to refuse. Most books, pamphlets, and verbal advice from doctors either fail to mention that estrogen has been linked to breast cancer, or downplay this hazard. The spring 1994 issue of "HealthWords for Women," published by a major U.S. medical center, advocates hormone therapy and offers just two sentences on the risks associated with this "wonder drug." "Some physicians may not recommend HRT to women who have a strong family history of breast cancer. However, the risk of breast cancer is small, and must be weighed against the reduced incidence of disease and the other benefits provided by estrogen" (HealthWords, 2).

Emotions and Breast Cancer

When a woman is diagnosed with breast cancer, she can almost guarantee that doctors, alternative health care professionals, friends, and relatives will tell her to "have a positive attitude," although if one is too positive others assume that she's "in denial," and that is not considered good either. It often appears that those who deal with breast cancer patients wish to regulate their moods in the direction of what is culturally acceptable for women, possibly with the latent motive of influencing an external presentation of self, designed to make others feel comfortable. Women patients are rewarded for being good natured, friendly, realistic (with a stiff upper lip), and

above all, not angry. The extension of this psychological advice is ominous because it assumes a blame-the-victim notion that mood and outlook might have caused the cancer in the first place and either warns that the disease can spread if one does not develop a positive outlook, or promises unrealistic results (a cure) through mind control alone.

Ideas that emotions are essentially linked to diseases like breast cancer did not enter everyday culture by accident. The relationship between illness and personality or mood has a historical tradition: Hippocrates observed that sometimes the sickest patients got well through their contentment with their physician. In recent times Norman Cousins's 1979 *Anatomy of an Illness as Perceived by the Patient*, Colin R. Richardson's 1988 *Mind Over Cancer*, Lawrence LeShan's 1989 *Cancer as a Turning Point*, and Bernie Siegal's 1988 best-seller *Love, Medicine and Miracles* did much to promote the new popularity of the mind-body connection. Lousie Hay in *Heal Your Body* implies that we cause cancer by our thoughts and beliefs. She finds some of the most damaging patterns to be resentment, criticism, and guilt. One of the latest renditions of the same theme comes from Angela P. Trafford (1993) who writes about her own triumph over breast cancer. She says, "I began to realize through my own experience, and through communicating deeply and honestly with the people in the hospital, that the roots of cancer were emotional, deeply imbedded in pain and inner suffering, and that the first step to wellness was a feeling of hope that healing was possible" (Trafford, 1993, p. 6). She goes on to claim that she was able to eliminate malignant calcifications in her breast through meditation, visualization, and proper attitude. Her message is that women should learn to love themselves. They should get out of abusive relationships, but accept others, with all their imperfections. This is, no doubt, good generic advice, but her book is dangerous in that it leads the reader to believe that breast cancer stems from psychological causes alone and that a new psychology can, by itself, cure breast cancer.

A major thesis of Susan Sontag's book *Illness as Metaphor* is that if, as a culture, we do not understand and can not explain the epidemiology of an illness, we tend to "psychologize" it. The description of the type of personality most prone to cancer is likely to change over time, as is the psychological advice to the patient. Sontag states that emotional contributories to breast cancer in the last century were thought to be grief, anxiety, and repressed feelings, whereas today a manic or manic-depressive character type is more in vogue (1978). Current assumptions about which personality deficiencies "cause" breast cancer are varied and contradictory.

Traditional advice directed women with breast cancer to accept the situation, to comply with the instructions of physicians, and to continue playing conventional roles. The newer advice incorporates letting go of negative thought patterns and empowering oneself by letting love replace anger, fear, or grief. Neither of these approaches deal with changing the reality of an oppressive lifestyle, or with working to change a society in which women are increasingly developing breast cancer. The focus is on one's mental outlook; we can and should control our reaction to the situation. The psychological approach has enormous appeal to women because it gives them the illusion that they are stepping out of the victim role and really doing something for themselves. Feminist advice, on the other hand, would encourage women to get angry about what has happened to them, to question authority, and to enlist others in a quest for answers. Sue Wilkinson and Celia Kitzinger, writing an article on feminist advice and treatment of breast cancer, recommend consciousness raising, political lobbying, and feminist support groups (Women's Studies International Forum, 1993).

If there is an indication that a particular psychological/behavioral reaction does have any relation to individual prognosis, the less conforming style may stand one in better stead. N. Waxler-Morrison et al. (1991) discuss the results of studies on psychological coping mechanisms and on short- or long-term survival potential. The Derogatis study, reported originally in the *Journal of the American Medical Association* (1979), suggests that long-term survivors were, according to their health-care professionals, less well-adjusted and less cooperative. In a review of other studies, the authors state: "After controlling for clinical factors, three psychosocial factors were significant for survival: the extent to which the woman, at the time of her diagnosis, engaged in expressive activities in the home; her level of extroversion; and *the extent to which she expressed felt anger*" (italics mine) (Waxler-Morrison et al., 1991, p. 177).

The criticism of the current advice on emotions targets the assumption that a woman is to blame for her breast cancer and that there is one certain way to think and to act that can result in a cure. Psychological advice is not in itself delusional or bad. Some women who develop breast cancer may be entirely satisfied with their individual or social characteristics, self-confidence, life course, and relationships. For others, breast cancer may be the catalyst for reevaluation and for change in a new and better direction.

Slash, Burn, and Poison

Once a woman receives the diagnosis of breast cancer, she has a number of important and agonizing decisions to make. The current

state of treatment has cynically been summed up as "slash, burn and poison," denoting the most common treatment for breast cancer . . . mastectomy, radiation, and chemotherapy. Also popular is a hormonal treatment with the drug tamoxifen, recently the subject of much controversy. Every choice has drawbacks and there is a real lack of adequate information with which to make an informed decision. This is further complicated by a medical system in which many doctors believe that it is in the patient's best interest to not know too much about their own condition or about the side effects of the treatment they are receiving.

We have all heard horror stories of the woman anesthetized for a lump biopsy who awakens to realize that her surgeon performed a radical mastectomy. This and other physician only decisions, we hope, are a thing of the past. Informed consent legislation for breast cancer treatment was introduced and debated in twenty-two states during the 1980s. It was passed in sixteen states, but defeated or died in the others. Theresa Montini (1996) analyzes the persuasion rhetoric of proponents and opponents to informed consent legislation. She finds that the arguments of those against informed consent center around the belief that women are particularly emotional, weak, and not able to reason out a "correct" course of action. It is certainly true that when a woman first learns she has breast cancer, she is most vulnerable and scared, and yet this is the very time in which she has to be more assertive than she has ever been in her life if she is to be the one who makes treatment decisions on her own behalf. Ideas to help women formulate an appropriate personal plan of action will be discussed after a brief overview of the common treatment options.

For those women who use the official medical establishment, the first decision a breast cancer patient will have to make will be which type of surgery to have, either a lumpectomy or a mastectomy (usually a modified radical mastectomy). The lumpectomy, usually followed by radiation, is preferred by many women because they can then keep their own breast. Press releases during 1993 and 1994 sought to reassure women that the survival rate with lumpectomy and radiation is not statistically different than that of a mastectomy. This reassurance was necessary after reports were disclosed that a Montreal cancer research team, connected to the National Cancer Institute's 1980s clinical trials, had falsified data. The NCI has maintained that independent research confirms the validity of the 1985 findings, but investigators for the *Chicago Tribune* cast doubt on the honesty of at least one foundation involved in independent lumpectomy research. The *Tribune* found that the Memorial Cancer Re-

search Foundation of Southern California had "enrolled ineligible women," had altered patients' records, and "at least two women were reported alive and well after they had developed new, spreading tumors following their lumpectomies. One woman was reported to be healthy after her death" (Associated Press, 1994, p. A3). It may well be that lumpectomy is a safe and viable alternative, but the discovery of fraud in research certainly undermines women's confidence.

Some women are not candidates for the lumpectomy because their tumor is too large and/or their breast is too small. In addition, some women choose a mastectomy to help them avoid long-term unknown effects of radiation treatment or because they feel they will have less anxiety if the breast is completely removed.

Chemotherapy is a systemic treatment to stop the spread of cancer with cytotoxic drugs—agents that kill fast-growing cells. Because the numerous drugs used in chemotherapy cannot distinguish between normal fast-growing cells and cancer cells, there are many potential side effects associated with this treatment. Some of the most obvious are loss of hair, loss of energy, nausea, vomiting, and increased susceptibility to infection. There also may be deterioration of bone marrow, mouth ulcers, rashes, changes in skin pigment, blood in the urine caused by bladder inflammation, lung damage, heart damage, and the increased risk of contracting other cancers. This is a general summary of the most unpleasant to the most serious consequences. Chemo regimens differ considerably, as does individual reaction.

Hormone therapy is frequently employed when there is the presence of estrogen or progesterone in the breast cancer. The drug tamoxifen, an estrogen blocker, has been widely used to treat these breast cancer patients. The side effects had originally seemed less severe than those of chemotherapy, although some of the more serious ones included depression, blood clots, elevated levels of calcium in the blood (rarely), and the remote possibility that it will act in an opposite way, causing the tumor to grow (Brinker, 1990). In 1993, researchers at the NCI reported evidence that tamoxifen increased endometrial and gastrointestinal cancers, and that animal studies showed an increase risk of liver cancer with tamoxifen (National Women's Health Network, 1994). This latest news release is all the more startling in light of the fact that trial "preventative" research using tamoxifen on eight thousand healthy, but high-risk women, is proceeding. The National Women's Health Network (NWHN) has been critical of this experiment. Adrienne Fugh-Berman (of the NWHN) "points out that approving a potent, hormonal drug in

healthy women and calling that 'prevention' sets a dangerous precedent" (Arditti and Schreiber, 1993, p. 252).

The decisions are not easy to make. It is a matter of deciding which is the least damaging course of action. There are good books available that give detailed insight into the issues involved (some of these are listed in the reference section of this essay). Some of the information in these books, however, is already obsolete. New data on breast cancer and on its treatment appear frequently in medical journals and then in newspapers. But when a woman first becomes aware that she has breast cancer, she experiences a crisis in which she feels (and is often made to feel) that a decision must be reached quickly. It is then that face-to-face communication is most often the medium through which answers are sorted out. But, because the state of knowledge regarding the best treatment of breast cancer is still primitive, friends, strangers, and even physicians, disagree on the best course of action for any given individual to take. This dissonance can be very distressing.

Some of the best suggestions to help women make the right decisions for themselves are to bring a support person to the doctor's office; to keep a notebook full of questions and answers; not to be afraid to ask for a second opinion; and not to be reluctant to change doctors. This last bit of advice is offered self-consciously, knowing that it is not always an option for poor women. Often one of the most helpful steps will be to talk with other women who have had breast cancer or to join a support group. "Reach to Recovery" is a program sponsored by the American Cancer Society. The volunteers, all breast cancer survivors, talk with a woman newly diagnosed with breast cancer, either before or after her surgery, but only if her physician authorizes the visit. There are rather stringent rules governing the type of information a "Reach to Recovery" volunteer can relay. If medical questions arise, for example, she is expected to refer them to the "proper medical personnel." There is no question that communities all over the United States need women's advocacy groups to help other women during this crisis.

Appearance and Sexuality

Matuschka, an artist and activist, makes art out of her mastectomy with poster-size, one-breasted self-portraits that force people to see what cancer does. On 15 August 1993, she displayed her mastectomy on the cover of *The New York Times Magazine*. Following this revelation, letters poured in; about two-thirds were supportive ("Fantastic! A cover girl who looks like me,") but one-third were critical, reflec-

tive of our national obsession with women's appearance, and the priority many place on the illusion of normalcy. One of the letters, which presumably fit in the supportive category, was written by the television reporter Betty Rollin. Rollin took a leading role in informing women about breast cancer with her 1976 best-seller *First You Cry,* based on her own experience. She writes in her letter: "For most of us who've had the disease, that's what breast cancer *used* to look like. But now, with reconstruction, a woman who loses her breast can get a pretty good replacement (preferably saline-filled), sometimes right away" (6). With all due respect for her past contributions, Rollin makes the decisions surrounding appearance and reconstruction appear easy. She assumes that all women want to "look" symmetrical and will gladly undergo reconstruction. She also intimates that great advances in reconstructive surgery have made this procedure as safe and easy as getting a haircut.

There is no question that breast cancer produces distress and insecurity about one's appearance, sexuality, and relationships. The turmoil felt from the loss of a breast is certainly exacerbated by the cultural significance of the breast as sexual, but each reaction is also individual, and therefore there is not just one solution to the restoration of mental well-being. The "Reach to Recovery" program emphasizes help in meeting the cosmetic needs of women who have had a mastectomy. They bring a kit containing a temporary breast form, provide information on types of a permanent prosthesis (a false breast), and on reconstruction. All of the advice and literature about sexuality and relationships assumes the woman to be heterosexual and most of it assumes that she is married.

Audre Lorde, a black lesbian writer and poet, vowing not to be silent, wrote *The Cancer Journals* in 1980 before her death from breast cancer. She states: "When other one-breasted women hide behind the mask of prosthesis or the dangerous fantasy of reconstruction, I find little support in the broader female environment for my rejection of what feels like a cosmetic sham. But I believe that socially sanctioned prosthesis is merely another way of keeping women with breast cancer silent and separate from each other" (Lorde, 1980, p.16). She further observes, "With quick cosmetic reassurance, we are told that our feelings are not important, our appearance is all, the sum total of self" (Lorde, 1980, p. 57).

Breast reconstruction is performed solely for the sake of a "normal" appearance and the comfort that appearance may provide. It does not restore sensation to the breast and it makes recurrences of cancer on the chest wall harder to detect. The two general types of reconstruction now available are: (1) implant placement, which is

performed by opening the mastectomy scar and inserting an implant of saline, surrounded by silicone, in a pocket created under the chest muscle; and (2) tissue transfer, which involves the moving, or transfer, of tissue from one part of the body to another. One type is to transfer abdominal tissue, including abdominal muscle to the breast area. This is presented to women as also being a "tummy tuck," making it appear attractive and useful, but is an extensive operation and leaves the woman with a scar in the abdominal region. When muscle is removed, it hinders the ability to tighten one's abdomen through natural muscle control (Hirshaut and Pressman, 1992).

Breast reconstruction is a procedure not to be undertaken lightly. In the first place, it requires additional surgery, usually with a general anesthesia. As stated previously the new breast will not have feeling in it, will not look exactly like a real breast and will have at least one scar across it. Often the plastic surgeon will want to "modify" the other breast by reduction. enlargement, lifting or performing a mastectomy followed by reconstruction, all in order to make a better fit. Additional complications may result. In about 20 percent of patients, there is a response called "capsular contracture," in which the body creates a firm, thick, fibrous capsule around the implant. This is one condition that may require additional surgery and removal of the implant. Other reasons for additional surgery are infection and shifting of the implant's position. In the case of tissue transfer, sometimes all or part of the transferred tissue fails to survive. And if abdominal tissue is removed, an abdominal hernia may develop following the excision (NCI, 1986).

Until recently, breast implants were routinely filled with silicone gel. Women complained that these implants were "making them sick" and filed a lawsuit to this effect. In response to mounting evidence, there was a federal ban on the implants in 1992. Dow Corning, one of the manufacturers of the silicone gel, has released the results of a 1975 experiment showing that its product could do harm to the immune system. The FDA retorted that had they known of this study, these implants would have come off the market eighteen years earlier (Rensberger, 1994). More recently, the FDA has opened inquiry into the safety of saline breast implants. If these saltwater-filled implants leak or rupture, there is concern that bacteria from them can cause infection. The controversy over both silicon and saline implants often pits women against other women, as some demand the freedom to choose to have reconstruction and others believe that society's obsession with breasts endangers women's health (Cimons, 1994).

Why is it important for so many women to do everything possi-

ble, including taking additional health risks for the sake of appearance, sexuality, or both? As previously stated, the weight of the culture makes the one-breasted or no-breasted woman feel especially deficient and unattractive. A woman who has had a mastectomy can not watch television, go to a movie, or walk through the lingerie section of a department store without sensing a contrast between themselves and "desirable" women, who have both breasts intact. Both women and men have been exposed to the androcentric and heterosexist culture that says clearly that women's sexual identity determines her value and that she should use this asset to find or keep a man. It is, therefore, not surprising that most of the advice and literature directed to women who have had breast cancer operations perpetuates the importance of sexual allure and assumes a very narrow range of relationship types. The American Cancer Society publishes a booklet called *Sexuality and Cancer,* written especially for the woman who has had breast or other types of cancer. It contains some valuable information, but it is exclusively heterosexual and most of it is directed to the married woman. For example, descriptions and illustrations of sexual activity all employ a male/female model. Of breast reconstruction, it states: "Breast reconstruction can help a woman enjoy sex more because of the boost it gives to her feelings of wholeness and attractiveness, even though it might not fully restore the pleasure she used to feel from breast touching" (p. 21). This subtle bias in the direction of reconstruction exerts influence on the reader and contradicts other assertions of choice.

Change and Activism

When I was informed that I had breast cancer, it never occurred to me that I might want to keep this traumatic event in my life a secret. Pre-1970s, the disease was considered embarrassing, shameful, something one would not share even with a close friend. It is not surprising that the origins of the "breast cancer movement" began in the same era as did the women's movement, at a time when it became acceptable to disclose other matters formerly defined as individual or private problems (i.e., domestic violence). Prominent women who contracted breast cancer and spoke publicly about it (i.e., Betty Ford and Betty Rollin) aided the transition from silence to openness. The increasing number of support and information groups made breast cancer a women's issue, but it was not until recently that breast cancer has emerged as a feminist issue.

A feminist analysis of the current advice to women about breast cancer notes that this advice is distributed through patriarchal insti-

tutions. Men occupy the top positions in these institutions. (For example, in 1994, out of the 287 board members of the American Cancer Society, 225 were men and 62 were women. Of the 30 members composing the executive committee, 22 were men [3 African American] and 8 were women. There were no women from minority populations represented.) The health care profession is likewise male-dominated and hierarchical, with physicians (males predominate and rank higher in prestige) at the pinnacle of power and nurses and other subordinate roles occupied by women. When a woman patient enters this system, she is often placed in an submissive position on two levels, because of the authority of the doctor as "expert" and because of his traditional authority as male. Liberal feminists would therefore seek to remedy this situation by increasing the number of women in all decision-making positions of the breast cancer matrix. They would also seek to demystify the advice coming out of the establishment, make it accessible to the average woman, and encourage women to become knowledgeable, ask questions, and act collectively toward real prevention and positive treatments.

The breast cancer matrix is imbedded in capitalist society, a system much critiqued by socialist feminists. This essay has observed that the environmental causes of breast cancer (and perhaps other cancers and illnesses) have been largely ignored; that the same companies that manufacture carcinogenic agents profit from manufacturing chemicals and agents used in the treatment of breast cancer. Both socialist feminism and radical feminism frame an analysis critical of the combination of search for profit and heteropatiarchical values that have facilitated the marketing and commerce surrounding synthetic estrogen for menopausal women, breast forms and protheses, mastectomy bras and bathing suits, wigs for chemotherapy patients, and breast reconstruction.

All feminist perspectives need to be concerned with the women who are left out of or treated as marginal by the current system. Economically disadvantaged women may not have the same access to mammography screening, various treatment choices, or the option to undergo reconstruction as do wealthier women. Both black women and older women of all races are disproportionately poor and suffer discrimination also because of stereotypes. Myths that black women are less likely to develop breast cancer may result in a careless attitude in which the possibility is overlooked and the diagnosis made too late. Older women are seldom represented in clinical trials and they often report that their physicians fail to refer them for a mammogram. The existence of lesbians, many of whom have not had children (a risk factor in breast cancer) is ignored by

the official breast cancer matrix. Advice given out by the American Cancer Society, about sexuality after breast cancer, assumes heterosexuality.

A psychological perspective that implies that women cause their breast cancer by destructive thoughts and attitudes, and can cure it by so-called positive ones, like love and acceptance, both blames the victim and fails to consider the material realities of women's lives. Much of the psychological advice offers the false illusion of empowerment and may interfere with the need for real collective power as women, informed by a feminist analysis, join forces to ask questions and demand economic support and political action.

Fortunately many women have already discovered that the best healing comes through grassroots organizing. Indeed, the formation and subsequent successes of many activist groups, as well as the National Breast Cancer Coalition (NBCC), comprise an exciting development. The Women's Community Cancer Project (WCCP) serves as an example of a local group that predated and helped found the NBCC. The WCCP got its start in Boston in 1989, when Susan Shapiro, herself dying from breast cancer, called for a feminist analysis and action plan. The women who carried her banner were often motivated by rage. They gathered data and published fact sheets. Ellen Crowley (1993) describes how a 1990 demonstration by the WCCP received national attention, thereby linking them to other grassroots groups. By late 1991, the umbrella organization, the NBCC, was established. They immediately brought together 160 local groups and they continue to grow. The NBCC and its local constituents borrowed assertive strategies from AIDS activist groups, like ACTUP. Political pressure in the form of massive demonstrations, letter-writing campaigns, and 2.6 million signatures delivered to President Clinton has resulted in a National Summit on Breast Cancer and a significant increase in federal funding, including money appropriated through the Department of Defense.

It is evident that many women are no longer willing to be obedient and passive consumers of the traditional advice of the established breast cancer matrix. However, the movement for change has just begun. We must continue to fight for attention, funding, relevant research, and the dissemination of findings. We must insist on involvement in the decisions that affect our lives.

Resources

African-American Breast Cancer Alliance
1 West Lake Street, #423
Minneapolis, Minn. 55408

National Alliance of Breast Cancer Organizations
1180 Avenue of the Americas, 2d Floor
New York, N.Y. 22036

National Breast Cancer Coalition
P. O. Box 66373
Washington, D.C. 20035

National Coalition of Feminist and Lesbian Cancer Projects
P. O. Box 90437
Washington, D.C. 20090–0437

National Women's Health Network
1325 G Street N.W.
Washington, D.C. 20005

Reach to Recovery
American Cancer Society
1599 Clifton Rd. N.E.
Atlanta, Ga. 30329-4251

Women's Community Cancer Project
c/o The Women's Center
46 Pleasant Street
Cambridge, Mass. 02139

Y-Me National Organization for Breast Cancer
Information and Support
18220 Harwood Avenue
Homewood, Ill. 60430

(Stocker, 1993)

Bibliography

American Cancer Society 1994 Board of Directors. (1994). American Cancer Society, Inc.

Arditti, R., and T. Shreiber. (1993). Killing Us Quietly: Cancer, the Environment, and Women. In Stocker (Ed.), *Confronting Cancer, Constructing Change*. Chicago: Third Side Press.

Associated Press. (1994). "More Problems in Cancer Study," *News Journal*, May:A3.

Beardsley, T. (1994). "A War Not Won." *American Scientific* (January): 130–38.

Brinker, N. (1990). *The Race Is Run One at a Time*. New York: Simon & Schuster.

Calle, E. et al. (1993). "Demographic Predictors of Mammography and Pap Smear Screening in U.S. Women." *American Journal of Public Health* 83, pp. 53–61.

Carson, R. (1962). *Silent Spring*. Boston: Houghton.

Cimons, M. (1994). "Breast Implant Inquiry Begins." *The News Journal* (June).

Cousins, N. (1979). *Anatomy of an Illness as Perceived by the Patient.* Boston: Norton.

Cowley, G. (1993). "The Hunt for a Breast Cancer Gene." *Newsweek,* December, pp. 46–52.

Crowley, E. (1993). Grassroots Healing. In Stocker (Ed.), *Confronting Cancer, Constructing Change.* Chicago: Third Side Press.

D'Argo, J., and J. Thornton. (1993). "Breast Cancer: The Chlorine Connection." Greenpeace, July-September.

Derogatis, L., M. Abeloff, and N. Melisaratos. (1979). "Psychological Coping Mechanisms and Survival Time in Metastatic Breast Cancer." *Journal of American Medical Association* 242, no. 14, pp. 1504–8.

Ferraro, S. (1993). "The Anguished Politics of Breast Cancer." *The New York Times Magazine,* 15 August 15, pp. 25–27.

Grady, D. (1992). "Think Right." *American Health* (November): 50–54.

Hay, L. (1984). *Heal Your Body.* Santa Monica, Calif.: Hay House.

Hirshaut, Y., and P. Pressman. (1992). *Breast Cancer: The Complete Guide.* New York: Bantam Books.

Jepson, C. et al. (1991). "Black-white Differences in Cancer Prevention Knowledge and Behavior." *American Journal of Public Health* 81, pp. 501–5.

Kelsey, J., and M. Gammon.(1991). *The Epidemiology of Breast Cancer.* Atlanta: American Cancer Society.

LeShan, L. (1989). *Cancer as a Turning Point,* New York: Dutton.

Lorde, A. (1980). *The Cancer Journals.* San Francisco: Aunt Lute Books.

Love, S. (1991). *Dr. Susan Love's Breast Book.* Reading, Mass.: Addison-Wesley.

Marshall, D. (1994). "Breast Cancer: The Toxin Trail." *Lear's* 7, no. 2, pp. 36–37.

McQuiston, J. (1994). "Cancer Study Renews Old Concerns." *New York Times,* 13 April, B6.

Miller, A. et al. (1992). Canadian National Breast Screening Study: 1. Breast Cancer Detection and Death Rates among Women Aged 40 to 49 Years. *Canadian Medical Association Journal* 147, pp. 1459–76.

Montini, T. (1996). Gender and Emotion in the Advocacy for Breast Cancer Informed Consent Legislation. *Gender and Society* 10, no. 1, (February): 9–23.

The Owl Observer (1994). "Breast Cancer: The Older Women's Plague." *The Owl Observer* 14, no. 1.

National Cancer Institute. (1986). *Breast Reconstruction: A Matter of Choice,* U.S. Dept. of Health and Human Services, (March), no. 86–2151.

National Women's Health Network. (1994). "A Tamoxifen Alert Becomes a Tamoxifen Crisis," (June).

Nyström, L. et. al. (1993). "Breast Cancer Screening with Mammography: Overview of Swedish Randomized Trials." *The Lancet* 341, pp. 973–78.

Paulsen, M. (1993). "The Politics of Cancer." *Utne Reader* 60, no. 81–89.

"Public Health Focus: Mammography." (1992). JAMA 268, no. 4, pp. 452–53.

Reimer, S. (1994). "Cancer Agency Policy Injects Confusion into a Woman's Darkest Fear." *Wilmington News Journal,* 24 January, p. C1.

Rensberger, B. (1994). "Study: Dow Corning Knew of Implant Dangers in 1975." *Wilmington News Journal,* 11 April.

Richardson, C. R. (1988). *Mind over Cancer.* London: W. Foulsham.

Sanazaro, P. and D. Mills. (1991). A Critique of the Use of Generic Screening in Quality Assessment. JAMA 265, pp. 1977–81.

Schemo, D. (1994). "L.I. Breast Cancer Is Possibly Linked to Chemical Sites." *New York Times,* April 13, p. A1.

Siegal, B. (1986). *Love, Medicine and Miracles,* New York: Harper.

Sontag, S. (1978). *Illness as Metaphor.* New York: Farrar.

Spake, A. (1994). "The Raging Hormone Debate." *Health* 8, no. 1, pp. 47–55.

Stocker, M. (Ed.) (1993). *Confronting Cancer, Constructing Change.* Chicago: Third Side Press.

Tessaro, I., E. Eng, and J. Smith. (1994). "Breast Cancer Screening in Older African-American Women: Qualitative Research Findings." *American Journal of Health Promotion* 8, no. 4, pp. 286–93.

Trafford, A. P. (1993). *The Heroic Path,* Nevada City, Calif.: Blue Dolphin Publishing.

Waxler-Morrison, N. et al. (1991). "Effects of Social Relationships on Survival for Women with Breast Cancer: A Prospective Study." *Social Science Medicine* 33, no. 2, pp. 177–83.

Wilkinson, S., and C. Kitzinger. (1993). "Whose Breast Is It Anyway?" *Women's Studies International Forum* 16, no. 3, pp. 229–38.

Wilson, R. (1967). *Feminine Forever.* New York: M. Evans.

Crossing Boundaries: Bringing Life into Learning

Ellen Goldsmith and Sonja Jackson

> The categories we are taught, the sources of evidence that we
> believe count, the language that we learn to use govern our
> world-views. How we come to see the world, what we think it
> means, and eventually what we believe we can do about that
> world are intimately related to the technologies of the mind we
> have acquired.
>
> —E. W. Eisner. *Cognition and Curriculum:*
> *A Basis for Deciding What to Teach*

On 25 October 1993, one of the authors, Ellen Goldsmith of the
Developmental Skills Department at New York City Technical Col-
lege/CUNY, was a guest in the lecture sections of the patient care
course in the Radiologic Technology Department. Sonja Jackson,
coauthor and faculty member in the Radiologic Technology Depart-
ment, had selected ten poems from Ellen's breast cancer series that
she felt were most relevant to radiologic technology students. Ellen
read her poems. After each, she invited responses. A follow-up as-
signment further explored students' reactions to the poems and pro-
vided the occasion for them to envision contacts with future patients.

It is not usual for a faculty member from the liberal arts division
to take over for a period in a patient care course. Nor is it usual to
have poetry form the substance of a class and an assignment. This
unusual situation arose because one of the authors was anxious to
use her difficult medical experience with breast cancer to positively
inform the experiences other patients would have through educating
health care practitioners. The other was ready to move beyond
textbook-centered teaching and to bring the experiences of life into
the classroom.

The work this essay describes thus joins a defining experience for
one of us to a commitment to develop a more personal teaching
style for the other of us. Both authors are interested in enlarging

the understanding and experience of treatment so that it includes emotional as well as physical dimensions, psychological as well as technological realities. The particular illness this project focuses on, breast cancer, has especially potent implications as a women's health issue. According to the National Cancer Institute, one in eight women, based on a life expectancy of more than eighty-five, will develop breast cancer. Furthermore, breast cancer is the second largest cancer killer of women. Beyond the scope and threat of the disease, its locations at an intersection of women's sexual and maternal identities gives it great psychological and emotional meaning.

Sonja's Story

In the fall of 1990, I returned to the Department of Radiologic Technology after serving in an administrative capacity for five years. That spring I was teaching a course in Imaging Modalities to a class of senior students. Perhaps it was the break from teaching. Perhaps I was changing. In any case, it suddenly came to me as I carefully planned each week's lesson about the different imaging systems—magnetic resonance imaging, computerized topography, and sonography—that I could teach this technical material and never really mention the patient in more than a peripheral way. I was shocked.

I thought back to how the medical supervisors at the hospital sometimes asked why our students are so mechanical in their actions with patients. I heard in my mind the words of patients: "Why can't technologists be more sensitive to my illness?" "Are all the technologists so cold?" I heard in my mind the words students often used to describe a procedure they are getting ready to perform. They would say: "I have a GI series in Room 1." "I'm going to do a hand." In marked contrast to this dehumanization was a personal revelation from a radiologic technology student who had had an MRI. In class, he talked about his responses to an MRI, how afraid he felt when he was placed in the MRI tunnel. Other students responded with silence. This was not what was talked about in class.

At this time, I came upon Elliot Eisner's words, quoted at the beginning of this essay, and began to question "the technologies of the mind" that we were presenting. As a health science educator, I began to worry that the technical education that my students were acquiring was not adequately balanced with the liberal arts. I asked myself: Are our students being taught to think about the human condition of illness? Are our students encouraged to think about the economic, social, and psychological dimensions of illness? Do we as

health science faculty engender in them a real concern for patients' feelings? I wasn't sure.

These issues were in the forefront of my mind when I read Ellen Goldsmith's poem "Bone Scan" in *Perspectives,* our faculty journal. I wanted to bring the felt experience of the patient to life in the classroom. I wanted to make sure that students really knew that bone scans and MRI's are emotional as well as technological events. Here might be a way. The tone in the room after I read "Bone Scan" told me I was on the right track. When Ellen offered to make more of her poems about her breast cancer experience available to the students, I was thrilled. It was clear to me that bringing Ellen and her poems into the patient care courses was a step toward my personal goal of breaking the traditional segregation of the hardware of technology from the passion of the liberal arts. Including the personal experience of one woman in language full of feeling and emotion might make the personal dimension of illness a reality for our students.

One of the greatest American poets among physicians, most would agree, is William Carlos Williams. During his long life he wrote essays, memoirs, stories, and some of the most original and influential American poetry of this century. His autobiography, which chronicles his life as a poet and practicing physician in Rutherford, New Jersey, for over forty years, tells that

> As a writer I have never felt that medicine interfered with me but rather that it was my very food and drink, the very thing which made it possible for me to write. Was I not interested in man [people]? There the thing was, right in front of me. I could touch, smell it. It was myself, naked, just as it was, without a lie, itself to me in its own terms. The haunted news I get from some obscure patient's eye is not trivial. It is profound. Whole academies of learning, whole ecclesiastical hierarchies are founded upon it.[1]

Williams's work, like the work of so many physician writers, reminds us that there are voices that can emerge to balance the sometimes sterile and technical professional environment. To balance the technical with the human side of health care, that was my goal in integrating Ellen Goldsmith's poetry into the allied health curriculum.

Ellen's Story

An interchange at New York City Technical College's graduation set the stage for me to extend my identity as a poet beyond self-

expression into an educational sphere. This graduation day, Sonja Jackson greeted me warmly, hugged, and kissed me, and said "Thank you." Sonja and I had been on a few committees together and while I welcome warmth, I did not have a reference point for the affectionate greeting or the thanks. Sonja went on to explain her gratefulness to me for "Bone Scan." Reading it in her imaging class was an important experience for her, she told me. She was impressed with the quality of silence and the presence of feeling that filled the classroom after she read the poem. She wanted that kind of silence and those feelings to enter her classrooms more frequently.

It seemed the air changed around me. Sonja's communication was important to me. I saw a new place for my poems.

I had been writing poetry for a number of years before being diagnosed with breast cancer. And I would have said that I was serious about my writing as evidenced by my membership in a poetry group and the time I gave to writing and revising poems in my life. Breast cancer brought a new dimension to my writing self. No longer was I looking for a topic to write about. My experiences with two mastectomies, chemotherapy, and lymphedema provided ample content for poems.

I wrote poems throughout the experience. The poems gave a great deal to me. They provided the opportunity to document and to reflect, to get right in close to what was happening to me, and also to separate myself from it. With the poems, I made the experience live for and through me.

My poetry also functioned as a very important way of being open and public. Disclosure was a way to not be marginalized by having a serious illness, to fill the accusing silence that can accompany breast cancer with words of my choosing. Thus, sharing the poems assumed importance. Of course, there was my poetry group, where I brought these poems—"Bone Scan," "Chemotherapy," and "On Losing My Hair."—There my fellow poets responded, not with "How terrible," but with "I think you could find a stronger word" or "This poem isn't finished." In addition, I found numerous contexts in which to share my poems with women who were also dealing with breast cancer. In the spirit of public disclosure and with pride about the poems, I submitted a few for consideration to my college's faculty journal *Perspectives,* where I had already published poems on other less personal topics.

"Bone Scan" appeared in *Perspectives.*

Lying on the imaging table
with the gamma camera

traveling the length of my body
first below, then above,
a silent wind drawing my skeleton
I remember stretching out
on freshly fallen snow
in Sharon Abrams' backyard

How my hands swam carefully
up and down in the cold to make
one perfect snow angel after another

But in this room of magical instruments
various and silent as snowflakes
where I am not to move at all
I am again that girl whose body brushed
an empty field with heaven

After Sonja told me about reading my poem in her class, I began to envision future radiologic technologists listening to "Bone Scan." I thought back to my many interactions with doctors, radiologists, and nurses, to the treatment I had received. Certainly, there were some good stories. But in many cases, I wish I had been treated differently.

"Silent Treatment" tells one of the more extreme stories.[2]

I am under strict instructions.
My doctor's orders. He needs to concentrate.
The treatments are dangerous.
If a medicine leaks, it will scar me.

He inspects the veins in my arm
and inserts the needle in my hand instead.
He begins to attach the rubber tube
that will provide entry for the dark potion.

Just then, his three nurses burst in
all wanting to show off Maria's Yiddish.
Coyly, she asks my doctor: "Do you have a *schmattah?*"
He chuckles. "Why? Are you *schmutzig?*"
Everyone laughs. I say nothing
as the chemicals enter my left hand
and begin their invasion.

The thought came. I wish all the health care professionals who had treated me had been more attuned to my feelings and to the emotional dimensions of breast cancer. Poems, my poems among

them, could convey a reality not in textbooks, not in medical lectures—"Carrier," for example.

> I try to shape these months,
> to find a carrier for all the separate events—
> the news, mastectomy, the first treatment,
> unraveling inconveniences, awful tiredness.
> A symphony with discomfort
> both backdrop and undertow.
> A sudden entrance of horns for dramatic moments,
> cellos for those moments of delight
> in friends, in the clarity of a day.
>
> But which instrument sounded the betrayal—
> the breast that joined an alien group
> and needed to be banished?
>
> Surrounded by fancy imported candies,
> patés, black forest cakes, I sip
> cappuccino from a spoon, trying not
> to touch the sores in my mouth.
>
> I hear a waitress saying about a regular customer,
> a young man who a moment ago was drinking coffee:
> "He always leaves mysteriously."

My poetry could be a vehicle for the better, fuller, more humanistic education for future health care workers. My poems could play a role in developing sensitivity on the part of health care professionals, of assuring that future radiologic technologists will attend to the human dimension of illness, to patients' feelings as well as blood counts. I began to see not just my poems but also me in the classroom with future radiologic technologists. Beyond the poems, the contact with a person who had had the experience might provide a bridge to students between their intentions to provide good treatment and the world of the patient. This was the beginning of my crossing the disciplinary lines between liberal arts and the health sciences, of my intention to broaden the boundaries of my work in my college.

As I reflect on it, there are two parts to the personal satisfaction this work held out to me. First, I saw a chance to play a role in developing sensitivity on the part of health care professionals. I could bring some of the lessons I learned from my illness into an educational context. Primary among these lessons is the importance of the emotional dimension of illness, the value of humane care, a touch,

a look, a question asked, a question unasked. Second, I saw the opportunity to bring my poetry and my personal experience into my professional world. Here too I was applying lessons from illness. Breast cancer taught me in a new way the importance of having a vehicle of communication. Breast cancer brought me closer to my own voice.

Student Responses

How did students respond to the introduction of very personal, feminist content into the classroom? What were their reactions, thoughts, and questions? A question that followed "When I Had Breasts" showed their desire to know more.

> Sometimes on a hot day I would feel
> a layer of sweat just where my breasts almost ended
> on my midriff and I would lift them out of their bra
> and raise them so a breeze would cool
> that hot strip and I would hold them up
> so for just a little longer.
>
> Now I have no hiding places on my chest
> nowhere to tuck my change or a note.
> I have become much more even terrain.
> The scar on the right begins to make a well
> and when my fingers move along that rope
> I feel bones and ribs, no softness.
> For softness, I go to my belly.

One woman asked: "How do you feel about your womanhood?" Another student wrote: "By hearing the poems read by the patient who wrote them, I felt deep down that a patient is a human being first."

One student said "Bone Scan" had an effect on him because he was a patient himself. "While you are alone in the room, you start to remember things from your past. It is true. I've experienced it myself." The questions that "Bone Scan" produced led Ellen back to feelings she had had during these tests when she would search the expressions of the technologists for meaning. What were they seeing? What was my body doing? Was it good? Was it bad? A number of students said that as future technologists, they will be very much aware of their facial expressions. One woman told her story of when she was eight years old and diagnosed with Hodgkin's

disease. "I can totally relate to what she is saying as far as the treatment I was given by the hospital employees. Although I was young, I can remember being very scared and not knowing what was going to become of me."

One man's question about "Bone Scan" as a poem offered an opportunity for Ellen to talk about where some poems come from. "I understand the description of the procedure in the beginning. But where did the snow scene come from?" We talked about how a sensory experience allows you to reclaim another time, to bring it into the present, to create, by linking disparate times, events, or feelings, something larger.

So many students had personal entries into the material.

In the Beginning

When I first learned of the lump
I dreamed of losing
my car, my purse, my way.
I started losing things—
a white nightgown left in a Boston hotel room,
a gold earring disappeared.

All these preparations were false.
I did not lose my breast.
It was taken.

"When I found a lump in my breast, I just cried."

Many empathized. "When she read the poem 'Silent Treatment,' I felt bad about her doctor and the three nurses who burst into the diagnostic room and just laughed." "In the poem 'Silent Treatment,' we see how some health professionals can be unprofessional and insensitive. We, as potential health professionals, must not fall into the same mental state as with the doctor and nurses described in the poem."

These comments stand in stark contrast to the questions from patients that Sonja had been hearing through the years:

Why can't technologists be more sensitive to my illness?
Are all the technologists so cold?
Why are your students so mechanical in how they act with patients?

Patients asking for sensitivity, warmth, and humanity on the part of health care providers would be pleased with comments like these.

I think that every health worker must feel sorrow and compassion for the patient. In my opinion, every health professional has to treat the patient as a human being, not as an inanimate object.

Before the reading my impressions of patient care were very broad. Now I see things differently and also view every patient as an individual.

For professionals, it is important to be very kind and sensitive, to feel and understand others. Sometimes one kind word, touch or even look helps a very sick patient survive.

I believe that every medical worker should try to understand patients' problems and should establish emotionally supportive communication with patients in order to help the patient to overcome the stress and anxiety.

Of great interest, we thought, were comments that demonstrated an awareness, perhaps new, of the need to look at things from the patient's perspective or, as one student said, "to see through the eyes of the patient."

Mrs. Goldsmith's presentation gave me a better understanding of her thoughts and feelings about her treatment by the doctors and her expectations of them.

We as medical professionals focus so much on a patient's illness itself, forgetting that they are human beings with feelings like our own. The poems gave me a more focused perspective on the patient as a person.

The reading of the poems enlightened me as to the feelings patients might have when they come into the hospital.

From the author's experience, we understand that what she needed the most during the process of treatment was people's support and sympathetic response.

I heard a strong desire and need for a patient to be understood. The need to be cared for as a person and not as an object or another case. Mrs. Goldsmith made me aware of how the patient might feel and what they might be expecting from me as the tech.

Students developed more insight about an illness.

One of the most important ideas that was brought to my mind after hearing the poems was the pain, embarrassment, and debilitating psychological strain brought upon individuals by a mastectomy.

Students expressed intentions for behavior.

> As a future technologist, I will be very much aware of making my patient feel as comfortable as I possibly can.

> Knowing real cases like hers teaches us how to behave toward patients, with respect, treating them like human beings and not like numbers or another job that has to be done.

> I found the reading of the poems very interesting. The poems gave me an idea of how a real patient interprets my actions and attitudes as a radiologist. It made me see the importance of behaving as a professional at all times and also the importance of never forgetting that the patient is a real person with feelings.

In addition to articulating the need for emotional sensitivity to a patient and tuning in to the idea that patients have expectations for health care workers, another set of responses made personal connections between Ellen's experience as expressed in the poems and their own.

> I didn't expect to cry, but my eyes were full of tears because I remembered my father who died of lung cancer sixteen years ago.

> My own mother had breast cancer when I was very young and I didn't really understand what was going on. I do remember feeling helpless angry, and lost in an uncontrolled situation.

Many students reactions were multilayered combining a clinical application with a personal application. It seems as if hearing a patient's story through poems established the patient's perspective in a way that also included the medical history of the health worker. This connecting of another's experience to one's own, we feel, demonstrates the truly humanizing quality of literature. In our view, nothing is more likely to translate into changed behavior than a felt link between a patient's condition and one's own—past, present, or future. These links animate responses like:

> I thought the presentation was excellent. It gave me more of a desire to treat every patient like they were a member of my family because if one of my family members were going through this I would want the best care for them, so I should do unto others as I want done to myself and loved ones.

Sonja's questioning of whether a concern for patients permeates the entire curriculum, of whether students think about the human condi-

tion of illness, of whether students develop a real concern for the patients' feelings, frames the final excerpts.

> The presentation gave me a lot of insight as to how I should interact with patients.

> These poems made me realize how delicate the patient's emotional state can become and how important the health care workers handling of this patient must be.

> I think that it is very important for future health care workers such as rad techs and others to meet and talk to actual patients in order to understand what they are going through emotionally and mentally while undergoing medical procedures. This will help medical workers to be more sensitive and attentive toward the patients.

> By hearing the poems read by the patient who wrote them, I felt deep down that a patient is a human being first.

The Humanizing Power of Literature

Bringing poetry about breast cancer into the radiologic technology classroom is part of an important tradition of using literature to illuminate experience. After all, literature expands our opportunities for experience and reflection. Poetry in particular, according to Audre Lorde,

> . . . is a vital necessity of our existence. *It forms the quality of the light within which we predicate our hopes and dreams toward survival and change, first made into language, then into idea, then into more tangible actions.* Poetry is the way we help give name to the nameless so it can be thought. The farthest horizons of our hopes and fears are cobbled by our poems, carved from the rock experiences of our daily lives.[3] (italics ours)

The sentence in italics suggests the developing use Ellen made of her poetry. For Ellen, her poetry was a survival tool, the way she changed a difficult personal experience into personal learning. Next, as a result of Sonja's interest, came a more tangible action, Ellen reading her poems in patient care classes. "By hearing the poems read by the patient who wrote them, I feel deep down that a patient is a human being first." It seems that in this project, the presence of the person who had the medical experience was part of the illumination. It seems that the performance aspect of our project, the power of the face to face contact along with the literature, was important.

Implications for Health Science Education

In most colleges and universities the liberal arts and the technology faculties are separated by floor space as well as by philosophies, needlessly divided into opposing camps at a time when future technical workers will confront increasingly complex issues that will require a humanistic angle. In relation to the health sciences, the AIDS epidemic has made it clear that the metaphors and underlying assumptions that attach to illness have an important impact on patient care. Increasingly, we are aware of how, if unexamined, some thoughts and images can be translated into negative practice.

In the allied health professions, it is important for the students we teach to develop caring as well as analytical minds. They need a curriculum that provides a strong contextual and humanistic background and makes them feel as well as think. In learning to perform professional roles competently, students must meld past, current, and future-oriented perspectives. They must draw upon values and attitudes as well as skills and information. To ensure this ability, educators must develop educational models that draw upon the real problems, concerns, and challenges students will face in their professions, that begin to make the people they will be working with a reality.

In relation to allied health, the specialization that has affected all medicine combined with the advent of technology has often led to a narrow perspective on illness. This resulting narrow perspective may be forestalled through systematic educational efforts to broaden the understanding of illness. The infusion of poetry and literature about illness into the allied health curriculum can be a most powerful method of linking the technological influences with the humanistic side of health care. We feel that including women's personal experiences in language full of feeling and emotion will make the human dimension of illness a reality for our students. We began with breast cancer. We will tackle other women's health issues as well.

The philosopher and writer W. E. B. DuBois wrote in his famous essay entitled "The Talented Tenth,"

If we make money the object of man-training [person-training], we shall develop money makers but not necessarily men and women; if we make technical skill the object of education, we may possess artisans but not, in nature, men and women. Men and women we shall have only as we make humanity the object of the work of the schools . . . intelligence, broad sympathy, knowledge of the world that was and is, and of the

relation of people to it . . . this is the curriculum of higher education which must underlie true life.[4]

Bringing poetry into the radiologic technology course of study is our way to make humanity the course of study. We began with a visit to patient care classes, an hour and a half out of the regular curriculum. For us, it was an example of crossing boundaries. Traditionally, poetry and patient care, Developmental Skills and Radiologic Technology would not meet. But it was valuable, an important beginning. And we hope that our experience will stimulate others to think about more crossing of boundaries, other boundaries perhaps. For by crossing boundaries, we see anew. And when we cross back, we are enriched.

The issues and the lives that find expression in the various fields and disciplines will vary. What will not vary, we think, is the increased depth and scope of the preparation students will receive for their work and their lives. Adrienne Rich tells us that poetry begins with "the crossing of trajectories of two (or more) elements that might not otherwise have known simultaneity" and leads to "a piece of the universe revealed for the first time."[5] We have come to feel that poetry is necessary in the health science course of study. It can provide the basis for an important change of focus and quality in the delivery of health care.

Notes

We appreciate the participation and enthusiasm of Dr. Leroy R. Sparks, chairperson of the Radiologic Technology Department at New York City Technical College, in this project.

1. *The Autobiography of William Carlos Williams* (New York: New Directions, 1967).

2. *Schmattah* means rag and *schmutzig* means dirty.

3. Audre Lorde, *Sister Outsider* (Freedom, Calif.: Crossing Press, 1984), p. 37.

4. W. E. B. DuBois, *The Negro Problem: A Collection of Essays by Leading Black Figures of the Day* (New York: James Pott Co, 1903), p. 69.

5. Adrienne Rich, *What Is Found There: Notebooks on Poetry and Politics* (New York: Norton, 1993), p. 8.

All poems are © 1993, Ellen Goldsmith. The following poems have appeared or are forthcoming in the following journals:

"In the Beginning" as "False Preparation" in *Encodings*
"Bone Scan" in *Footwork: The Paterson Literary Review*
"Carrier" as "Chelsea Foods" in *Sing Heavenly Muse!*

References

DuBois, W. E. B. (1903). The Talented Tenth. In *The Negro Problem: A Collection of Essays by Leading Black Figures of the Day,* pp. 33–75. New York: James Pott Co.

Eisner, E. W. (1982). *Cognition and Curriculum : A Basis for Deciding What to Teach.* New York: Longman.

Lorde, A. (1984). *Sister Outsider,* Freedom, Calif.: Crossing Press.

Rich, A. (1993). *What Is Found There: Notebooks on Poetry and Politics.* New York: Norton.

Williams, W. C. (1967). *The Autobiography of William Carols Williams.* New York: New Directions.

Midwifery and the Medical Model

KATHLEEN DOHERTY TURKEL

Introduction

IN the United States it is estimated that over 95 percent of births occur in hospitals (Eakins, 1986; Jordan, 1993). Cesarean sections account for 22.7 percent of all U.S. births (Ruzek, 1993). At present, 80 percent of birthing women in the United States have their labors augmented (either induced or speeded up) with pitocin, and in some hospitals over 80 percent of laboring women receive epidural anesthesia (Jordan, 1993).

What are the grounds for the medicalization of childbirth, and how is medicalization maintained over the experience of birthing women? This essay explores this question through approaches rooted in the work of Foucault (1973), Arney (1982), and Rothman (1982, 1989). While it is not the purpose of the present essay to develop or to fully assess these theoretical frameworks, it uses Foucault, Arney, and Rothman's analyses of institutions, power, and knowledge to examine both the dominance of the medicalization of birth and the formation of women-centered birthing.

The essay proceeds by examining the medical model and the midwifery model of birth. It demonstrates that these models operate according to different frameworks, concepts, theoretical orientations, and underlying assumptions. The medical model maintains its power by controlling the physical and institutional setting of birth, by constructing accounts of risk and normalcy, and by fostering definitions of birth that rely on high-technology, medical devices, and procedures. The midwifery model, in contrast, is not rooted in hierarchy and control. This model defines birth as a healthy process and it recognizes and fosters the power of women to control birth. Accounts of the experiences of birthing women underscore the appropriateness of the midwifery model.

The essay then considers relationships among professionalism, power, and models of childbirth. In this section, I consider some of the developing relationships within midwifery, and medical and le-

gal authority. The essay concludes by arguing that midwifery pro-
vides theory and practice that locates women at the center of birth,
rather than at the periphery as objects to be manipulated.

The Medical Model: The Hospital, Risk, and Technology

In our society it is difficult to think about birth in other than
medical terms. The medical model shapes our basic assumptions
about pregnancy and birth as well as about the dominant practices
surrounding these events.

When women are defined as patients in need of medical services,
decision-making shifts to doctors. Technical knowledge is viewed
as the solid basis for decision-making while the experiential knowl-
edge of birthing women is discounted throughout pregnancy, and
most particularly, during labor and birth within a hospital setting
(Rothman, 1982; Jordan, 1993).

The medical model views all births as potentially pathological. At
the center of this way of thinking about birth is the idea of risk.
Over the years obstetricians have tried to develop systems of pre-
dicting which women are at risk for developing complications
(Oakley and Houd, 1990).

Underlying the risk approach are several assumptions about birth
that heighten the power of doctors and marginalize birthing women.
This approach views "delivery" as the most important aspect of
maternal health and maternity care. Obstetricians become advocates
for the fetus and the newborn while the birthing woman becomes
a passive object. The separation of the mother and the fetus is charac-
teristic of the medical model of birth.

Arney (1982) argues that the fetus first captured obstetricians' in-
terest around 1940. In 1941, *Williams Obstetrics* used the term *fetal
distress* for the first time in its text. It was not until this time that
the fetus became viewed as a separate entity creating a "new object
in the field of the obstetrical gaze" (Arney, 1982, p. 134). Interest
in the fetus as a separate entity continued to grow. By 1976, *Williams
Obstetrics* contained a separate chapter on fetal health and the fetus
came to be viewed as a second patient. In fact, it was no longer
clear whether the primary patient was the mother or the fetus. In
Arney's words:

> Obstetricians became fetal advocates and women were left to mount
> their struggle against an adversary who had acquired a potent ally in the
> fetus. (Arney, 1982, p. 137)

The risk approach assumes not only that the mother and the fetus are separate, but also that they are at odds. There is a distrust of the mother as the best and most obvious advocate for the fetus.

All births are viewed as potentially life threatening. As a result, birth is seen as requiring surveillance and control to monitor any deviation from what is judged to be normal. The tools of surveillance are many. They include a host of technical procedures, screening and diagnostic tests, and monitoring devices. Some of these are used during pregnancy including ultrasound screening, Alpha-Fetoprotein Testing, Chorionic Villius Sampling, and amniocentesis. Others, such as electronic fetal monitoring (EFM), drugs to induce or speed up labor, and cesarean section, are used during labor and birth. The risks involved with the routine use of such procedures, rates of diagnostic errors, and the benefits of other low-tech alternatives are rarely discussed.

Ruzek (1993) argues that advice to pregnant and birthing women often lacks information about the actual incidence of negative outcomes of procedures within a particular population. In the case of electronic fetal monitoring, for example, women often are not told that the conditions that might be "prevented" through the use of the monitor are extremely rare. And despite a lack of evidence about the benefits of electronic fetal monitoring, this remains a routine part of labor in many hospitals. There is very little consideration of risk relative to benefits for high-technology procedures. Rather, high technology is viewed as the solution to the problems of poor birth outcomes. When low-technology approaches, including prenatal care, smoking cessation, and nutrition supplementation are considered, they are held to much higher standards of efficacy and cost-effectiveness. As Ruzek notes, what are actually being compared here are capital-intensive versus labor-intensive technologies:

> The cutting-edge interventions involve the development and sale of machines—machines that are profitable to produce and market worldwide. Many of these machines are marketed as a way to avoid labor costs. EFM, for example, is often touted as an alternative to having more labor nurses. The labor-intensive, low-technology inter-ventions are viewed as too costly, not because they are not cost-effective. They are costly because they do not generate profit and without the promise of profit, they are not aggressively marketed. Thus, the entire medical-scientific literature is biased in the direction of assessing capital-intensive products over labor-intensive approaches to reducing birth risks. (1993, p. 401)

The risk approach has been criticized for a variety of reasons. Oakley and Houd (1990) argue against the methodology of the risk

approach. The risk approach is scientifically awkward because in order to identify deviations from normal, it is first necessary to define what is normal. Obstetricians are inadequate in their knowledge of the many variations within normal birth. Normality is an artifact of medical procedures, settings, and discourses. Consequently, birth can be defined as normal only in retrospect.

Moreover, the belief that birth is life threatening instills fear in women. This fear leads to a greater dependence upon the medical model of birth and medical practitioners, which promise the "safest" route through this risky process. Birth, within a high-technology hospital, with a physician in attendance, becomes the only way to contain the risk.

The hospital setting is very important because it is the core location of medical procedures and knowledge. It controls what can be seen, and by doing so, maintains the medical model. As Rothman points out:

> The institutions of medicine prevent anomalies in the model from showing up. This is done most effectively . . . by defining all anomalies as pathological, and treating them. (Rothman, 1982, p. 284)

The hospital setting institutionalizes the social relationships, power differences, knowledge, and our beliefs about birth. The beliefs bolster the practice of birthing in hospitals through the medical model.

Just as the hospital supports the medical model, it undermines birthing women. Within the high-technology hospital, what women know through their bodily experience is given no status. Physicians in the same setting are recognized as having "authoritative knowledge." Authoritative knowledge is not necessarily correct, but is, rather, the knowledge that all of the participants agree counts within a particular situation. It is the knowledge that is seen as the legitimate basis for decision-making and for justifying actions taken. There is no room for competing information:

> What the woman knows and displays, by virtue of her bodily experience has no status. Within the official scheme of things, she has nothing to say that matters in the actual management of her birth. Worse, her knowledge is nothing but a problem for her and the staff. What she knows emerges not as a contribution to the store of data relevant for decision-making, but rather as something to be cognitively suppressed and behaviorally managed. In the labor room authoritative knowledge is privileged, the prerogative of the physician, without whose official certification of the women's state, the birth cannot proceed. (Jordan, 1993, p. 157)

Having authoritative knowledge gives the physician the power to make judgments and pronouncements about the events surrounding birth. It is the physician, for example, who gives official permission for the birthing woman to begin pushing her baby out. The time of the physician's pronouncement is marked and this time becomes the official beginning of the second stage of labor. This official record, however, does not match the birthing woman's experience. She may have been fully dilated and may have felt the urge to push prior to the physician's arrival and, if left to her own devices, might indeed have started to push earlier.

In observing births in U.S. hospitals, Jordan (1993) witnessed many examples of the artificial and arbitrary identification of the stages of labor. She argues that these arbitrary time frames become part of the official statistics regarding average lengths of labors and then are put to normative use in managing labor in hospital settings. This stands as a direct example of Rothman's point that the setting of birth controls what can be seen and, consequently, controls what is known about birth.

The setting is also directly related to the level of birthing technology used. The routine use of high-technology equipment in a hospital setting contributes to the marginalization of birthing women. They lack access to the information provided by hospital technology that often requires expert interpretation. Often women themselves begin to believe that the machines know more about how their labor is going than they do.

Accounts by Birthing Women

While medicalization silences women and makes them objects of technical control, it is possible to articulate their understanding of their own experience. One way to accomplish this and to begin to establish knowledge based on the knowledge and experience of birthing women, is through ethnographies and interviews. We can counterpose medical knowledge with the knowledge that women have of their bodies, opening a different pattern of relationships and discourse.

In the course of my research on childbirth, I have conducted interviews with a small group of women who have had both hospital and home birth experiences. The descriptions of the hospital experiences among the women I interviewed reflect the characteristic features of the medical model. The women within hospitals described unfamiliar settings where they exercised no control. They felt they should

not make too much noise, should do what they were told, and should be as cooperative as possible.

None of the women I interviewed was satisfied with her hospital experience, but the reasons for this dissatisfaction varied. One woman, whom I will call Julia, said that initially she felt that her hospital experience had been fine. She had an episiotomy, but otherwise there was little intervention. Two weeks following her birth, however, Julia suffered a postpartum hemorrhage. Her doctor was unable to explain why this had happened, and she found this very upsetting because she was afraid it would happen following subsequent births. In addition, Julia found her doctor's attitude to be very patronizing. He said she shouldn't worry about the cause of the hemorrhage, that everything would be OK.

Susan had planned a home birth but ended up in the hospital with a cesarean section. Her baby was in a breech position, but she felt her doctor was much too anxious to intervene. In Susan's opinion, the cesarean was unnecessary.

She was disappointed in the way the birth turned out. She had been in labor for over ten hours before the doctor suspected that the baby was in a breech position. She felt that if more time had been taken, she could have birthed her baby and surgery could have been avoided.

Lynn had planned a hospital birth, but had very clear ideas about what she wanted her birth to be like. She wanted as little intervention as possible and searched until she found a doctor who was willing to agree to her wishes. She put all of her wishes in writing and had her doctor sign the list as an indication that he had agreed to her requests. Lynn describes the early part of her labor as wonderful. She was at home with her husband. They had a whirlpool bath that she used for relaxation. She describes feeling the process of labor, of moving around and changing positions in response to the contractions. Everything changed once she arrived at the hospital.

Lynn describes the nurses on duty as being annoyed at circumstances in general and at her in particular. She arrived at the hospital just prior to giving birth and the nurses proceeded to scream at her through the rest of her labor and birth. Although Lynn had made very specific arrangements with her doctor beforehand, he was not on call and was not present at the birth. In fact, no doctor was present at the birth. Although both Lynn and her husband were willing to question the judgment of the nurses, they found the nurses to be threatening and intimidating.

Although no doctor was present for the birth, a doctor did show

up about one and a half hours afterward. What follows is Lynn's description of what happened:

> After I had the baby another doctor did come. It was six o'clock on Sunday morning. He was drunk. He had obviously been up all night drinking. There was a mirror at the bottom of the delivery table. I could see him taking his bare hands and he literally tore me apart with his bare hands. I could see. I could obviously feel. He was drunk. It was not a good experience. And then he proceeded to sew me up without any anesthesia. I could see blood squirting out as he ripped me apart with his bare hands. He was drunk. All the while he was talking about, he wanted to get a sandwich from Seven-Eleven. I was laid on this table, my legs were up in stirrups. I was saying stop, that hurts. I started screaming. I was in pain; it hurt.

Lynn had entered pregnancy with the confidence that birth will, in most instances, happen on its own if interference does not occur. She had consciously chosen a practitioner who shared her views and who expressed a willingness to respect her wishes. Despite her best efforts, she had a hospital experience during which she was intimidated and violated.

Pat had planned to give birth at a free-standing birth center. The dates of her pregnancy had been miscalculated. When she went into labor a month prior to the calculated due date, the nurse-midwives at the birth center believed that Pat was going to have a premature baby. They estimated the baby's weight to be less than five pounds. Under these circumstances, Pat was transferred to a hospital. She was given Pitocin to stimulate her labor. In her words, "There was a lot of interference with the birth." It turned out that the baby was not premature. He weighed six and a half pounds at birth, and in Pat's opinion, the "interference" had been unnecessary.

The specific circumstances of each of these births were different. In each instance, however, the birthing woman felt that she did not have control over the circumstances of the birth. The women felt that hospital procedures were unnecessary intrusions into the birth process.

Women who wish to avoid unnecessary intrusions often find it difficult if not impossible within the hospital setting. Often their requests are ignored and the women making them are viewed with contempt. In the course of my research, I had a discussion with a top administrator at a large medical center about the desire of women to avoid an episiotomy, a cut in the perineum made just prior to birth to enlarge the vaginal opening. He seemed to have some difficulty

understanding why women would want to avoid this and responded by saying:

> Frankly, hospital administrators don't make policy like this but that's one I would love to make. If I could, I would absolutely forbid every obstetrician from doing an episiotomy. Forbid it. Absolutely. For a very simple reason, because I know that by doing that not only would I insure the revenue strength of this hospital immediately because of what's going to happen when a gal tears herself from stem to stern and we have to respond with major surgical procedures and lots of blood and prolonged stay in the hospital. But I know also that ten years down the road that woman is going to come back in to have everything put back in place.

There is a lack of evidence that routine episiotomy prevents either perineal trauma or pelvic floor relaxation, and, there is evidence that associates perineal trauma with episiotomy (Edwards and Waldorf, 1984). What is most striking about this quote is not only the certainty with which this administrator predicts extremely unlikely outcomes, but also the absolute derision that he expresses toward the women who pay to give birth at this hospital.

The specific circumstances of hospital births will vary. Some physicians are more willing to work with their "patients" than others. Some institutions have more flexible rules and policies than others. What remains true in every instance, however, is that within the hospital setting, control rests in the hands of the medical personnel who work within the parameters set by the administrative rules of the institution. Physicians exercise a virtual monopoly over attending women in childbirth and of defining standards of treatment. Locating birth within the hospital has been a primary factor in the creation and maintenance of this monopoly, because "hospitalization of childbirth is the medium through which the philosophy of interventive obstetrics is carried into practice" (Tew, 1990, p. 20).

Tew (1990) argues that every culture has its own medicine men on whom it relies to solve its problems of illness and death. In contemporary Western culture it is academically trained doctors who enjoy this status. Physicians in relation to patients have what Starr (1982) has termed *cultural authority:* the authority to interpret symptoms, diagnose illness, and prescribe treatment. Physicians shape the patients' understanding of their own experience and by doing so "create the conditions under which their advice seems appropriate." Physicians usually do not have the power to force patients to accept their interpretation of symptoms or to follow their advice. With respect to childbirth, however, there are instances where physicians have sought the assistance of the courts to coerce women to accept

both the medical interpretation of the situation as well as the medically recommended course of action. In these cases, the state has intervened on behalf of the fetus, to order that women undergo cesarean sections against their wills (Rothman, 1989, p. 195). Under more typical circumstances, however, women follow the advice and directions of physicians not because of the threat of coercion, but out of fear of the consequences of ignoring medical authority (Starr, 1982, p.14).

The Midwifery Model

We have seen that women often come to birthing with their own desires, their own knowledge and, through the medicalization of birth, a sense of being manipulated. To a large degree fulfilling these desires and going beyond manipulation is blocked by the hospital setting and medical authority.

The medical model claims to offer the only responsible way to give birth. Deviations from this model are viewed as being fraught with risk. Physicians are viewed as the only practitioners who can provide competent care for birthing women.

The midwifery model offers a different philosophy of birth and consequently different practices as well. From the perspective of the midwifery model, childbirth is viewed as a healthy activity and as an important event in the lives of women and their families. During pregnancy and birth, women require physical care involving examination and screening, but they also require social and emotional support and comfort. Throughout pregnancy and birth, midwives act as teachers and guides for pregnant women. In this model, birth is something that women do, not something that is done to them, offering a view of childbirth that is woman-centered. Women give birth and midwives assist them in doing so (Rothman, 1982). The experiential knowledge of birthing women is seen as equally important or more important than technical knowledge. What women know through their bodies is neither discounted nor ignored. The physical and emotional health of the mother is seen as essential for the health of the baby. Babies and mothers are viewed as one unit and mothers are not viewed as threats to their babies.

In the midwifery model, midwives and mothers work closely together. Midwives become an intimate part of the birthing process. Oakley and Houd (1990) offer a clear example in this description of labor:

> The woman gets on her knees. The midwife is sitting in front of her, also on her knees. The woman puts her head on the midwife's shoulder,

who then holds her head in her hands. They are finding a rhythm to-
gether. (Oakley and Houd, 1990, p. 72)

Page (1988) identified five principles that should characterize mod-
ern midwifery care: (1) continuity of care; (2) respect for the normal;
(3) enabling of informed choices by pregnant and birthing women;
(4) recognition of birth as more than just a medical event; and (5)
the provision of family-centered care.

Page argues that because of the nature of midwifery care, mid-
wives are able to develop a relationship of trust with their clients.
Midwives approach birth with a confidence in, and respect for, the
physiological process of birth. Midwifery practice is based upon a
broadly defined notion of prevention that includes many aspects of
life that affect well-being such as the provision of food, shelter, and
income. As a result, midwives are often involved in the information
of social policy and in outreach programs for communities of
women who are in need. Midwives work to see that parents are
able to experience birth to the fullest by providing the information
necessary to make informed choices and by recognizing the diverse
needs of birthing women and their families.

The midwifery model offers an alternative to the "risk-approach"
toward pregnancy and birth. The midwifery model focuses instead
on what Oakley and Houd call primary prevention.

> The meaning of the concept primary prevention in relation to pregnancy
> and birth is that it is essentially a question of strengthening the woman
> to give birth and take care of her own baby. The mother is the central
> person in maternity care, and the midwife, the doctor, and other health
> workers are her assistants. (Oakley and Houd, 1990, p. 128)

Primary prevention, then, is not based upon surveillance and con-
trol, but rather it is based upon the need to offer support and to meet
the needs of each individual birthing woman within the individual
circumstances of each birth. Rothman (1989) believes that midwif-
ery—working with the labor of women to create the birth experi-
ence so that it meets the needs of women—is feminist praxis.

The medical monopoly regarding childbirth has meant defining
childbirth in medical terms, leaving out other factors. By doing so
we limit our understanding of birth.

> What midwifery offers us is not just tossing in a few social or psychologi-
> cal variables, but a reconceptualization of the "facts" of procreation. A
> profession controls not only people—as doctors control the nurses who
> "follow orders," the patients who comply—more important, a profes-

sion controls the development of knowledge. The profession of medicine determines not only who may attend a birth, or what birth attendants may do, but it controls also what we know of birth itself. (Rothman, 1989, pp. 172–73)

So, what midwifery offers then, is not simply a gentler birth in prettier surroundings, but rather an alternative conception that offers nothing less than a different understanding of birth itself. With this new understanding, much of what were formerly understood as "facts" of birth, come to be seen as "artifacts" of the medical model (Rothman, 1989; Jordan, 1993; Oakley and Houd, 1990).

Professionalism, Power, and Models of Childbirth

If we de-medicalize childbirth, then the medical profession loses its monopoly over the management of childbirth in the United States. But the politics that surround the medical model do, of course, complicate the issue. The authority of the medical profession has given it the power to control and sometimes to block alternatives to the medical model of birth and, in other cases, to influence the shape alternatives will take and the circumstances under which they will exist.

In order to understand how this is accomplished it is necessary to consider the status and organization of the medical professions. A profession is an occupation that has acquired or has convinced others that it has acquired certain characteristics associated with a profession including: (1) a body of theoretical knowledge acquired through extensive study; (2) altruism or service orientation; (3) autonomy in controlling the profession including selecting and training new members, establishing a code of ethics, and disciplining its own members; (4) having authority over clients who are thought to be unable to judge their own needs; (5) having a distinctive occupational culture; and (6) enjoying recognition in the law and by the community that the occupation is a profession (Stromberg, 1988, p. 206).

It is important to note, as Stromberg points out, that professions may actually vary with regard to these characteristics. What is significant for a profession is having the power to convince others that it has these characteristics and therefore deserves a monopoly over practice (Stromberg, 1988, p. 207).

Among the medical professions it is physicians who enjoy the highest professional status. No group of midwives enjoys this level of professional status and the autonomy it brings. It is important to say that not all midwives see themselves as practicing medicine nor

as vying for a place in the medical hierarchy. But in this society, attending women in childbirth is viewed as practicing medicine, so all midwives are placed within this hierarchy, regardless of how they view themselves.

Different groups of midwives do indeed view themselves differently. Up until this point in the discussion, the focus has been on the contrast between the medical model and the midwifery model. The two models represent different philosophies of birth and, consequently, promise different practices in relation to pregnancy and birth. Among practicing midwives, however, currently a distinction is made between (1) certified nurse-midwives; (2) lay, empirical, or independent midwives; and (3) direct entry midwives.

Certified nurse-midwives (CNMs) are nurses who have received advanced training in midwifery and who are certified by the American College of Nurse Midwives. They practice in hospitals, free-standing birth centers, and sometimes at home. Lay, empirical, or independent midwives gain their expertise through an apprenticeship to an experienced midwife. Direct-entry midwives, like lay midwives, do not come to this field through a background in nursing, but they have completed a course of training that meets the requirements for state licensing (Kitzinger, 1988, p. 40; Myers-Ciecko, 1988, p.63). Lay midwives and direct-entry midwives usually attend births at home. It is important to note that many states do not have provisions for licensing direct-entry midwives. It is also important to note that sometimes the terms *lay, empirical, independent,* and *direct-entry midwives* are used interchangeably. No group of midwives enjoys the legal status of physicians who are consistently recognized in every state as having the legal right to attend women in childbirth. Yet the law does distinguish between nurse-midwives and direct-entry midwives. Virtually every state allows nurse-midwives to attend women in childbirth, but most states require nurse-midwives to have an alliance with a physician, for the purposes of backup services and oversight. Direct-entry midwives find themselves in very different legal circumstances from one state to the next. In some states, their practice is legal, in others it is illegal, and in still others it is alegal (Sullivan and Weitz, 1988; Bidgood-Wilson, Barickman, Ackley, 1992).

All midwives are commonly viewed as less well-trained and less competent than physicians. The power of the medical model distorts what is known and what can be seen about midwifery practice. A study of nearly twelve thousand births in free-standing birth centers showed very little intervention and excellent outcomes (Rooks et

al., 1989). Studies on home births show similar positive outcomes (Mehl, 1978; Sullivan and Weitz, 1988).

Gender is also an important factor in determining the status of midwives. As Sullivan and Weitz argue:

> The male gender of most physicians significantly increases their credibility and lobbying power in the legal and judicial systems which continue to be dominated by men. At the same time, the female gender of most midwives works against them. Moreover, the fact that it is women who are encroaching on their occupational turf appears to threaten physicians' egos and heighten their hostility. (Weitz and Sullivan, 1988, p. 94)

The issue of gender is even more heightened in the case of nurse-midwives since nursing as a profession developed as an ancillary occupation providing support for physicians, under the direction of physicians and hospital administrators. Nursing developed as a female-dominated occupation with a female image. As a result, nurses are made even more vulnerable than women in general to sex-stereotyping and sex discrimination (Stromberg, 1988, pp. 208–9).

The status of nurse-midwives as health professionals creates a dilemma. Nurse-midwives enjoy greater legitimacy in the culture and in the law than do lay or direct-entry midwives. Their greater legitimacy comes from their status as medical professionals and from their direct links to physicians as well as to some health care institutions. Because of this, nurse-midwives sometimes seek to distance themselves from other midwives. During a debate over midwifery legislation in Vermont, one nurse-midwife noted, "One of the problems now is that you can't differentiate who the lay people are, who the professional people are, and what the nurse-midwife is" (Teasley, 1986, p. 269). In the state where I did my own research, there is virtually no interaction between nurse-midwives and other midwives. Lay and direct-entry midwifery are illegal in the state and nurse-midwives have no interest in jeopardizing their own somewhat vulnerable standing by networking with midwives who operate outside the law.

Relations between nurse-midwives and other midwives are sometimes more cooperative. The Midwives Alliance of North America (MANA) was formed in April 1982. The purposes of the organization include: (1) expanding communication and support among North American midwives (including Canadian midwives); (2) promoting guidelines for the education and training of midwives; (3) promoting midwifery as a quality health care option for women and their families; (4) promoting research in the field of midwifery care; and (5)

establishing a link between midwives and other professional and nonprofessional groups concerned with the health of women and their families (Ashford, 1983, p.101).

Membership in the MANA is open to all midwives, students, and supporters of midwifery. While there are nurse-midwives who are members of the MANA, there has been very little official communication between the MANA and the American College of Nurse-Midwives (ACNM) (Myers-Ciecko, 1988). In recent years, the ACNM has shown an interest in coalition building, reflected in an ongoing discussion in which the ACNM has been engaging that centers around three questions:

1. Should the American College of Nurse Midwives accredit educational programs for midwives that don't require nursing?
2. Should graduates of such programs sit for the American College of Nurse-Midwive's exam?
3. If the group should say yes to these first two questions, should the American College of Nurse-Midwives then extend membership to nonnurse-midwives?

The ACNM continued to discuss these issues at their spring 1994 meeting, although they have not yet been resolved. These are controversial questions among the members of the ACNM. An affirmative answer to these questions would change the nature of the ACNM as a body and would also raise some interesting legal questions in the many states where the law makes a clear distinction between nurse-midwives and nonnurse-midwives. Consideration of these questions, however, indicates an awareness of the need for midwives to network across barriers and differences in order to strengthen their profession.

At the same time that nurse-midwives derive some benefit from their status as health professionals and as their links to physicians, these same things lock them into an inferior status in relation to physicians. As Rothman argues:

> It may be that nurse-midwife is a contradiction in terms, with an inherent dilemma. Nurses, in our medical system are defined by their relationship to doctors, and midwives are, in the meaning of the term derived from Old English, "with the woman." Nurse-midwives operating in the medical establishment have a hard time as "advocates of the childbearing couple." The essential elements of cooption—job, prestige, professional recognition are all right there. (Rothman, 1982, p. 73)

The situation of the midwives I have studied is a case in point. As mentioned before, direct-entry midwives practice outside the law in the state that I studied. Nurse-midwives stand on much firmer legal footing. They are recognized as health professionals who can practice as long as they have an alliance with a physician(s) who can provide obstetric support. The major medical center in the state offers no practicing privileges to nurse-midwives. Some smaller hospitals in the state have offered privileges to a few nurse-midwives. The professional autonomy of the nurse-midwife is extremely limited. Doctors and hospital administrators exercise a great deal of control over their ability to practice and over the circumstances under which they may practice. Often, efforts on the part of nurses or nurse-midwives to increase their professional autonomy, are met with opposition from physician organizations that try to block or co-opt such efforts.

In a number of states, nurse-practitioners and advance practice nurses do have the legal right to govern their own practice and to engage in practices that they were formerly prohibited from doing, such as prescribing drugs, and admitting patients to hospitals. Yet, within the medical hierarchy, physicians continue to enjoy greater status and autonomy that allows them to continue to influence the degree of professional autonomy afforded to nurses and nurse-midwives. It is this lack of professional autonomy that needs to be addressed. It may be that professional autonomy for midwives requires severing these links to the medical system. This, of course, is not easy to do because of the need for networking and backup services (Rothman, 1982, p. 73–74).

Despite the differences among midwives, it is important to consider the overwhelmingly positive responses of women and families who seek the services of midwives. Eakins (1986) found that women who gave birth out-of-hospital with a midwife, whether at home or in a free-standing birth center, expressed a high degree of satisfaction with their birth experiences.

In the course of my own research, I have interviewed women who have given birth at home as well as in a free-standing birth center. These women expressed highly positive feelings about their birth experiences and toward their midwives. In the cases of the women who gave birth at home, these are the women who had also reported extremely negative hospital experiences.

Earlier in the essay, I included a quote from Lynn who described her experience with a drunk physician. What follows is a quote from Lynn about the subsequent birth of her twins at home:

> Here it was my house and I could have those babies how I felt comfortable. And I felt like I could provide the best birth for them. Whereas in

the hospital I was at people's mercy . . . I got up, took a shower in my own bathroom and came back. They [the midwives] had changed the sheets, dressed the babies. It was wonderful. That morning was just one of the best mornings of my life. Just to snuggle with those babies, and the sun was coming up and it was just—it was wonderful. There's nothing to compare with it. It was just terrific.

This is how Julia described her labor at home:

It was a hard labor but I felt so supported and just whatever I wanted to help me through this they would do for me. Barbara [labor support person] was massaging the balls of my feet that I recommend to everyone I run into—it was wonderful. Rich [husband] was rubbing my back, Karen [one of the midwives] was rubbing my legs. That really helped a lot.

Women who gave birth at the free-standing birth center report similar experiences. They describe the support and encouragement they felt and the control they exercised over the circumstances of their births. Often these positive feelings apply even when a desired birth center experience ends with the birth taking place in a hospital. While the nurse-midwives from the birth center have no practicing privileges at either of the nearby hospitals, they do go along as support persons, often acting as a buffer between the birthing woman and the hospital staff. Many birth center clients form lasting relationships with their midwives as well as with the nurses who provide support and assistance at the center. Some clients become childbirth activists as a result of their birth experience.

Conclusion

Because of what midwifery has to offer, it is important that it be nurtured and sustained. Midwifery is not obstetrics. It offers us a different understanding of birth. It leads us to question long-held beliefs about the physiology of birth that come out of medical management and it reminds us that birth is not only a physiological event. Birth is also an important event in the lives of women and families and midwifery honors that fact. Midwifery offers us a view of birth that does not revolve around the concept of risk and is not rooted in fear. It offers theory and practice that are enriching and empowering for women.

As Rothman reminds us:

The demand by midwives to practice their profession is not an attempt by a less qualified group to engage in the practice of medicine, but

rather of a more qualified group to engage in the practice of midwifery. (Rothman, 1992, p. 183)

Midwives need autonomy to regulate and practice their profession. Autonomy for midwives seems to require de-medicalization of childbirth. Within the current structure nurse-midwives are defined as subordinate to doctors. Licensed direct-entry midwives often complain about state restrictions on their practice following licensure. DeVries (1985, p. 140) has argued that state sanction of midwives does not increase their autonomy. Rather it formalizes the power and control that physicians have over midwives.

As many midwives have pointed out, midwifery is an art as well as a science. It requires skills such as intuition and sensitivity as well as more technical and quantitative abilities. Seeing birth in nonmedical terms creates the possibility for autonomy for midwives as well as for the full recognition of what the theory and practice of midwifery has to offer.

References

Arney, W. R. (1982). *Power and the Profession of Obstetrics*. Chicago: University of Chicago Press.

Ashford, J. I. (1983). *The Wholebirth Catalog*. Trumansburg, N.Y.: Crossing Press.

Bidgood-Wilson, M., C. Brickman, and S. Ackley, (Eds.). (1992). "Nurse-Midwifery Today: A Legislative Update, Parts 1 and 2." *Journal of Nurse-Midwifery* 37, no. 2 (March/April 1992): 37, no. 3 (May/June).

DeVries, R. G. (1985). *Regulating Birth: Midwives, Medicine, and the Law*. Philadelphia: Temple University Press.

Eakins, P. S. (1986). *The American Way of Birth*. In P. S. Eakins (Ed.), *The American Way of Birth*. Philadelphia: Temple University Press.

Edwards, M. and M. Waldorf. (1984). *Reclaiming Birth: History and Heroines of American Childbirth Reform*. Trumansburg, N.Y.: Crossing Press.

Foucault, M. (1963–73). *Birth of the Clinic*. New York: Pantheon.

Jordan, B. (1993). *Birth in Four Cultures*. Prospect Heights, Ill.: Waveland Press.

Kitzinger, S. (1988). *The Midwife Challenge*. London: Pandora Press.

Mehl, L. (1978). The Outcome of Home Delivery in the United States. In S. Kitzinger and J. A. Davis (Eds.), *The Place of Birth*. Oxford: Oxford University Press.

Myers-Ciecko, J. (1988). Direct-entry Midwifery in the U.S.A. In S. Kitzinger (Ed.), *The Midwife Challenge*. London: Pandora Press.

Oakley, A. and S. Houd. (1990). *Helpers in Childbirth: Midwifery Today*. New York: Hemisphere Publishing.

Page, L. (1988). The Midwife's Role in Modern Health Care. In S. Kitzinger (Ed.), *The Midwife Challenge*. London: Pandora Press.

Rooks, J. A. et al. (1989). "Outcomes of Care in Birth Centers: The National Birth Center Study." *New England Journal of Medicine* 321, pp. 1804–11.

Rothman, B. K. (1982). *In Labor: Women and Power in the Birthplace*. New York: Norton.

―――. (1989). *Recreating Motherhood: Ideology and Technology in Patriarchal Society*. New York: Norton.

Ruzek, S. B. (1993). "Defining Reducible Risk: Social Dimensions of Assessing Birth Technologies." *Human Nature* 4, no. 4, pp. 383–408.

Starr, P. (1982). *The Social Transformation of American Medicine*. New York: Basic.

Stromberg, A. H. (1988). "Women in Female-dominated Professions." In A. H. Stromberg and S. Harkess (Eds.), *Women Working: Theories and Facts in Perspective*. Mountain View, Calif.: Mayfield Publishing Co.

Sullivan, D. and R. Weitz. (1988). *Labor Pains: Modern Midwives and Home Birth*. New Haven: Yale University Press.

Teasley, R. L. (1986). "Nurse and Lay Midwifery in Vermont." In P. Eakins (Ed.), *The American Way of Birth*. Philadelphia: Temple University Press.

Tew, M. (1990). *Safer Childbirth? A Critical History of Maternity Care*. London: Chapman and Hall.

SCIENCE/MATH

Addressing Eurocentrism and Androcentrism in Mathematics: The Development and Teaching of a Course on Mathematics, Gender, and Culture

John Kellermeier

Introduction

What does a mathematician look like? Pause for a moment and visualize for yourself an answer to that question. Notice what this person looks like. Notice the sex and race of this person. Chances are you pictured a white male. In fact, whenever I have tried this exercise with my students or in a workshop the majority of people do indeed picture a white man.

I recently received a birthday card with a popular media image of a mathematician: a white male, middle-aged or older with gray hair and a beard, and standing before a blackboard covered with mathematical symbols and notation. There is no doubt that this is what a mathematician looks like. This image is so pervasive in our society that its use immediately implies a mathematician. Images like this appear in cartoons such as Gary Larson's syndicated cartoon *The Far Side,* or those appearing in *The Chronicle of Higher Education* (Hobart, 1992; Richter and Bakken, 1993).

These images inform us that our society perceives mathematics as the domain of white men. In fact, it is, at least in academia. Out of Ph.D.'s in mathematical sciences given to U.S. citizens, approximately three out of four go to white men and only one out of a hundred go to women of color (National Research Council, 1989). The production and teaching of mathematics in our society is overwhelmingly in the hands of white men.

Now, let me ask you to pause a moment and picture the first people to do mathematics. What race and sex did you see? This exercise usually elicits one of two responses. The first is cavemen, that is, hairy white men wearing animal skins. The second response

is Greek men. Again, the origins of mathematics are seen as coming from white men.

Most histories of mathematics state that mathematics began with Greek men from about 600 BCE to 300 CE, went into decline through the Dark Ages, was rediscovered by European men during the Renaissance, and was developed from there by Western men. This history is described by Joseph (1987) as "the 'classic' Eurocentric approach," and as a result, "Mathematics is perceived as an exclusive product of white men and European civilizations." According to Joseph, this Eurocentric bias results from:

1. a general disinclination to locate mathematics in a materialistic base and thus link its development with economic, political, and cultural changes
2. a tendency to perceive mathematical pursuits as confined to an elite, a select few who possess the requisite qualities or gifts denied to the vast majority of humanity
3. a widespread acceptance of the view that mathematical discovery can only follow from a rigorous application of a form of deductive axiomatic logic and hence that "intuitive" or empirical methods are dismissed as of little relevance in mathematics
4. the belief that the presentation of mathematical results must conform to the formal and didactic style following the pattern set by the Greeks over 2,000 years ago

However, the reality is that the first mathematicians were women and most likely African women. The oldest known mathematical activity is calendar making. Bone fragments with incisions have been found in Europe and Africa dating back as far as 37,000 BCE. The most famous of these is the Ishango bone found on the shore of a lake in Zaire, Africa (Zaslavsky, 1992). The incisions on these bones correspond to lunar cycles or lunar calendars. This is the earliest mathematics, the recognition of the basic periodicity of nature.

And when we ask which sex is most likely to have first developed an understanding of lunar cycles, the answer is women. One obvious reason is the menstrual cycle. A second reason is that early agriculturalists used calendars. But again, these were women. This was an expression of mathematics that was not elitist, not divorced from the surrounding world by logical reasoning. Rather this mathematics was based on what Sjöö and Mor (1987) call "organic reasoning," emerging "from a 'esire to cooperate with the natural world, and from a real integral observance of the needs and rhythms of the personal self and the human community."

Since these early beginnings, **all** cultures have developed mathe-

matical ideas. Yet today, Western society has an androcentric and Eurocentric view of mathematics that self-perpetuates in the training of mathematicians. What we usually think of as mathematics, the way it is done and taught and even conceived in our society, is in fact Eurocentric and androcentric, in other words, racist, sexist, and elitist.

The Course Development

This essay will describe a course on Mathematics, Gender, and Culture I developed to address the Eurocentrism and androcentrism in mathematics. This course was developed during the spring of 1993. At that time, I took part in a faculty development seminar designed to help faculty at SUNY Plattsburgh develop courses for our General Education category of Perspectives on Global Issues.

Several years earlier I had proposed a course on gender and mathematics dealing exclusively with gender differences in mathematics. That course was quickly rejected by the Mathematics Department because it was perceived as having no "real" mathematics content. Since then, I have also been teaching Introduction to Women's Studies. Teaching this course has taught me the importance of dealing with the issues of race and class as well as gender.

The new course was to be developed for the Perspectives on Global Issues category that would require a global perspective and, in the words of our General Education Program, "substantive inclusion of recent scholarship on women and minorities." Consequently, this course was designed with two objectives: first, to examine from a global perspective the experiences of women and people of color with mathematics; and second, to consider the effects of culture particularly nonwhite culture, on the development and doing of mathematics.

The first of these objectives would make use of the extensive scholarship on women and mathematics from the past two decades. Much of the information on scholarship from North America is available in *Mathematics and Gender,* edited by Fennema and Leder (1990), while a global perspective can be found in *Gender and Mathematics: An International Perspective,* edited by Burton (1990).

Including issues of race and class is not as easy. As Campbell (1989) points out, in a review of the literature on equity in mathematics, while research on sex discrimination in mathematics is extensive, similar research on racial discrimination is limited. "Social class and socio-economic status are equally important variables that are

even more rarely factored into the mathematics and equity equation." Both Campbell and Reyes and Stanic (1988) discuss the lack of, and need for, research on the interaction of gender, race, and class effects on equity in mathematics. An examination of this lack of research then became another objective of the course.

The second course objective constitutes the study of ethnomathematics. *Ethnomathematics* is a field that was developed in the early 1980s. The man usually credited with coining the terms is a Brazilian educator, Ubiratan D'Ambrosio (1985, 1990). He breaks the word down into "ethno" meaning "cultural environments," "mathema" meaning "explaining and understanding (the world) in order to transcend, managing and coping with reality in order to survive," and "tics" meaning "technics."

Thus, ethnomathematics studies how people within a given culture develop techniques to explain and understand their world and to solve their daily problems. Culture is defined rather loosely and may include traditional, small-scale cultures or historical cultures such as indigenous cultures of the world (Hadingham, 1992; Mac-Pherson, 197), the pre-Columbian cultures of the Americas (Ascher and Ascher, 1981; Ortiz-Franco, 1993), the historical cultures of Africa (Zaslavsky, 1973), or American folk cultures (Zaslavsky, 1990). It may also include subcultures such as the children candy sellers of Brazil (Saxe, 1988), or contemporary U.S. video game "kid culture" (Shirley, 1991), or carpet layers (Masingila, 1993).

The Mathematics, Gender, and Culture course then has two themes: (1) the study of gender and race differences in mathematics; and (2) the study of ethnomathematics. While it is an approved course within the Mathematics Department, it is also cross-listed with the Women's Studies Program at SUNY Plattsburgh, and is an elective for the Minor in Women's Studies.

The Course Description

The course is organized primarily as a discussion course. In addition, I use a variety of group activities and hands-on exercises.

The assignments for the course include:

1. Daily reading quizzes
2. Weekly journals
3. Presentation of a biography of a mathematician who was not a white male

4. Development of an action plan for addressing the Eurocentrism and androcentrism in mathematics
5. Ethnomathematics project using mathematics from a culture other than academic mathematics
6. Group problem solving

Teaching the Course

After teaching this course for two semesters, I believe it has been successful. In end-of-the-semester comments, many students said that at the beginning of the course they could not see how mathematics, gender, and culture were related. However, by the end of the semester their primary comment was that their eyes had been opened, and that they were now aware of the sexism and racism within mathematics. For many students this was the first course in which they had dealt with sexism or racism in a substantial way.

For many students, mostly female, this course enabled them to put their own experiences with mathematics into perspective. One female student wrote:

> This class was a real eye-opener for me. It has helped me make a lot more sense out of my own education. I realize that if I was encouraged to do well in math and expected to do as well in math as I did in other areas, I might have done better.

For another female student, this awareness lead to a sense of empowerment:

> I have gained so much after taking this class. I am not only aware of the problems inside the mathematical system, but I have gained a better sense of myself. I now can evaluate my own life and see how I was discouraged from math. I have also gained a great amount of math confidence that I can use for future classes. Although I vowed never to take another math class, I am actually contemplating registering for one.

For many education students, both primary and secondary, a newly found awareness of the sexism and racism in the education system gave them the resolve to monitor their own future efforts in the classroom. A female secondary education mathematics student, who had previously described her experiences with sexist and racist mathematics instructors, wrote:

Overall, this course has helped me to realize that helping a single individual by teaching mathematics and telling students about my bouts with ethnocentric and gender-biased individuals is a worthwhile venture.

Since most students took this course to fulfill a general education requirement there were many females as well as males, who would not otherwise be inclined to take a women's studies course. Many of them were surprised to find a mathematics course with a women's studies content. Although there was hostility from some male students at first during one of the semesters, it soon dissipated. I believe this was due to two demonstrations. The first day of class I asked students to visualize a mathematician as I discussed at the beginning of this essay. The overwhelming number of white males visualized was undeniable evidence of bias in mathematics. Secondly, I asked students who were skeptical of our readings to simply count how many times instructors in their other classes called on males and females. The overwhelming amount of bias against female participation in the classroom soon became apparent to these students in their own classes. Once they granted that bias did in fact exist, they were willing to hear the remainder of the messages about sexism and racism in mathematics. In the words of one of these students:

> The first few days of class, I thought you made all men out to be pigs, and thus, began to develop an immediate negative impression of you. After a few weeks, I began to see some of the points you made in class when I started doing surveys of my own in my other classes. I began taking notice of the attention my professors gave to males over females and the amount male students spoke out over female students in classes. By seeing first hand what you discussed in class, made a compounding impression. I realized then the difference between making men out to be pigs, and trying to fight for the rights of women.

I also expect that nearly all students have at one time or another been subjected to the elitism that pervades mathematics. Students' own experiences of "math abuse" (Kellermeier, 1994), even among those students who were successful in mathematics, gives them an intuitive understanding of elitism and consequently sexism and racism in mathematics.

All of the assignments used in the course proved to be successful. While there were some initial complaints about the daily reading quizzes, students quickly learned that a combination of active reading and taking notes greatly increased their scores and added to the quality of class discussions.

Student journal writing is a fairly standard feminist pedagogy

strategy that I incorporate in all my classes (see Kellermeier, 1994). In this course, it provided an opportunity for students to confront the personal nature of the gender and race discrimination we were studying. Journals also provided a way for me to listen to what students were thinking and saying and to communicate privately with them.

The most important lesson students learned from doing the biographies is the scarcity of information on mathematicians who are not white males. There are many available sources on white male mathematicians, but to find a person of color and/or a woman who is a mathematician requires diligent research.

One semester, after two days of presentations about mostly white women, we realized that we had listened to story after story of women throughout the centuries who had struggled to work in the field of mathematics. We ended with a biography of a contemporary woman. We noted that she was the same age as many of those currently teaching in academia. Her struggles to achieve in mathematics echoed those struggles of the women throughout the centuries of whom we had just heard. The class concluded that little progress had been made for women's equality in the field of mathematics.

The students presented a variety of action plans for addressing the Eurocentrism and androcentrism in mathematics. Some of those who were education majors developed lesson plans for teaching mathematics from a multicultural perspective using ideas learned from the study of ethnomathematics. Other education majors discussed the ways in which they intended to incorporate feminist pedagogy and other strategies for encouraging people of color and women in mathematics into their future classrooms.

During the course we learned that a lack of perception of the usefulness of mathematics was a major factor in explaining both gender and particularly race differences in mathematics achievement (Campbell, 1989; Reyes and Stanic, 1988; Schindler and Davidson, 1985). Consequently, many students dealt with ways to help children see mathematics as useful and related to their lives, including such daily activities as cooking, shopping, gardening, and game playing.

Lastly, several students used their action plans to deal with their own experiences with mathematics with some resolving to take another math class.

The ethnomathematics project provided students with the opportunity to see mathematics as creative and fun, something that we learned was an important component of successful mathematics instruction (Campbell, 1989). Ethnomathematics projects presented

by students included examples from the cultures we had studied such as the Incan ouipu and various board games from Africa and New Zealand. One student even built an igloo to scale out of ice cubes, bringing the igloo to class in a cooler.

There were many examples of students' artwork such as string art, cross-stitch, sand painting, quilt making, origami, and ceramics complete with a description of the mathematics required for its completion. In addition, one student used the culture of car racing for his project. He gave a description and explanation of the mathematics needed in the preparation of an automobile for racing.

The group problem-solving assignments were, for many students, the most instructive aspect of the course. Students felt they learned about gender differences in problem solving. My intention in developing this assignment was to have students experience the doing of mathematics (as opposed to the learning of mathematics in the traditional sense). I assigned students to groups and then gave them a problem to solve. They were given one to two weeks to solve the problem on their own outside of the classroom. Students were told that the point of this assignment was not to determine the right answer but to look at the process of solving a problem. During class time each group presented their solution. This was followed by a discussion of the process that the groups went through to solve the problem.

By assigning the students to groups by sex and mathematics background, I intended to manipulate the problem-solving environment so that they could experience the effect this would have on the group process. In particular I expected students to discover gender differences in problem solving.

What we found was that the females in same sex groups tended to work cooperatively, deriving a solution in collaboration with others in the group. Males in same sex groups, on the other hand, tended to work individually first and then combine their individual solutions into a group solution. In mixed sex groups, males tended to take leadership roles; females tended to speak less. At the same time, there were exceptions to these behaviors, both in females and males.

I also chose the problems in order to give students a variety of experiences with mathematics and problem solving. For the first set, I assigned students to same sex groups with homogeneous math backgrounds. The problem assigned to these groups was a variation of a problem used by Buerk (1982) in her work with math avoidant women:

Suppose that all the people in your group want to meet by shaking each other's hands. You need to determine how many handshakes this would mean. How would you envision the number of handshakes? Suppose there were 10 people in your group, how many handshakes would be required? What about 20 people, 50 people, 100 people? How could you make a formula to represent the problem?

Buerk intended this problem to help the women form a view in which mathematics is seen as consisting of only right and wrong answers to a view in which mathematics is also seen as a dynamic process, involving creativity and intuition. My students' reactions to this problem were consistent with this intent. Students arrived at a solution using a variety of methods. It built confidence among students who initially viewed themselves as weak in mathematics. And depending on how they viewed handshakes there was more than one answer.

This problem served as an excellent introduction to the group problem-solving assignments. Since there were so many ways to solve the problem and more than one possible answer, it became clear to the students that the process of solving the problem, the process of actually doing, and creating mathematics, was more important than getting the "right answer."

For the second group problem, students were again assigned to same sex groups but this time with a mixed mathematics background. For this assignment I chose a problem from the traditional male activity of roofing. Unfortunately, this problem turned out to be much harder than I expected. For the second semester, I changed to the following problem:

How many square feet of carpet would be required to carpet the Blue Room in the Angell Center? Take into account the following constraints:

1. Carpet comes in twelve-foot wide rolls.
2. Carpet throughout the room must have the nap running in the same direction.
3. Consideration of seam pattern is very important because of traffic patterns.

The Blue Room is a large public room in our student center, the Angell Center, so named because of its blue carpeting. This problem was inspired by the work of Masingila (1993) on the ethnomathematics of carpet laying. The male groups tended to be more comfortable than the female groups with both the roofing and carpet-laying problems. The need to do measuring for both of the problems led to a

gender difference in measuring techniques. The female groups tended to measure with tape measures while the male groups tended to pace off the distances.

Solutions to these problems varied greatly, not only in approach but in actual answers. We never did determine the "correct" answer for either problem. This helped students understand that the mathematics involved in applications as these is never as "neat" as it is taught in academic mathematics.

Students were assigned to the third groups based on a homogeneous math background. However, mixed sex groups were used. The gender mix was chosen to keep all groups at about the same ratio of males to females. For this assignment, I countered with a problem from the traditional female activity of sewing. Each group was given an identical set of pattern pieces. They were asked to determine how much fabric of various widths would be needed to cut out the pattern. They were reminded to take into account the nap of the fabric. While it was agreed that this problem derived from traditional women's experience, very few of the students of either gender had any sewing experience. Several groups made a trip to a local fabric store to seek advice and a definition of nap.

The last groups were chosen by the students themselves. This gave them the option to choose same sex or mixed sex groups as they wished. In both semesters there were a mix of female, male, and mixed sex groups. For the fourth problem I used a set of fifteen math puzzles intended for use in the middle grades (Jamski, 1991).

Many students had begun the semester expecting to have to find "the method" to get "the answer" whenever confronted with a mathematics problem, not able to think creatively or to question the validity of the stated problem. Now, however, when confronted with problems from what we had come to see as the culture of academic mathematics, the attitude and approach of the students had changed. For example, they were quite willing to accept multiple answers for the question, "How many times will your heart beat this month?" depending on whose pulse rate was used as a base for the problem. No one asked, "How many heartbeats a minute should we use?"

The following problem pointed out the contrived nature of many of the problems encountered in academic mathematics:

> With a seven-minute sand timer and an eleven-minute sand timer, what is the easiest way to time the boiling of an egg for fifteen minutes?

One group presented the "correct" answer. This was to start both timers at the same time and to wait until the seven-minute timer is

done. Then start to boil the egg. There will be four minutes left on the eleven-minute timer. When those four minutes are over, restart the eleven-minute timer. Then the four minutes and the eleven minutes will make the required fifteen minutes. After this solution was presented, another group suggested that the easiest approach would be to use the seven-minute timer twice and then to count to sixty. "After all," a spokesperson for the group said, "hard-boiled eggs aren't that precise. And besides, you get to eat your egg seven minutes earlier." This was a critique of academic mathematics that the students in that group would probably have been too intimidated to express at the beginning of the semester.

Conclusion

Overall, I believe that this course effectively met both objectives: (1) to examine from a global perspective the experiences of women and people of color with mathematics; and (2) to consider the effects of culture, particularly non-white culture, on the development and doing of mathematics.

Students learned that not all mathematicians are white males standing in front of a blackboard. They learned that women of color were the first mathematicians, that mathematical ideas come from many cultures not just Western society, and that mathematics is something they successfully do everyday of their lives. As one student said, "Now I see that a construction worker is a mathematician just as much as a baker is and a math teacher is."

This course is a first step toward changing students' perceptions of mathematics and making them aware of the sexism, racism, and elitism in mathematics. In the words of one of the students,

I learned about the effects of thinking who the mathematicians of the past were . . . about the importance of finding the relevance math . . . that math is everywhere such as cooking and sewing. I think the biggest thing I learned is that we can all do math but we need support and encouragement from others. I now know that there are no differences in the genes of females or Blacks that do not allow them to do math as well as other groups.

References

Ascher, M. and Ascher, R. (1981). *Code of the Ouipu*. Ann Arbor: University of Michigan Press.

Buerk, D. (1982). "An Experience with Some Able Women Who Avoid Mathematics." *For the Learning of Mathematics* 3, no. 2, pp. 19–24.

Burton, L. (1990). *Gender and Mathematics: An International Perspective.* London: Cassel.

Campbell, P. (1989). "So What Do We Do with the Poor, Non-White Female? Issues of Gender, Race, and Social Class in Mathematics and Equity." *Peabody Journal of Education* 66, no. 2, pp. 96–112.

D'Ambrosio, U. (1985). "Ethnomathematics and Its Place in the History and Pedagogy of Mathematics. *For the Learning of Mathematics*, no. 1, pp. 44–48.

———. (1990). "The History of Mathematics and Ethnomathematics. How a Native Culture Intervenes in the Process of Learning Science." *Impact of Science on Society* 40, no. 4, pp. 369–78.

Fennema, E. and G. Leder. (1990). *Mathematics and Gender.* New York: Teachers College Press.

Hadingham, E. (1992). "Europe's Mystery People." *World Monitor* 5 pp. 34–42.

Hobart, N. Cartoon. (1992). *The Chronicle of Higher Education* 39, no. 9, p. B6.

Jamski, W. (1991). *Mathematical Challenges for the Middle Grades.* Reston, Va.: National Council of Teachers of Mathematics.

Joseph, G. (1987). "Foundations of Eurocentrism in Mathematics." *Race and Class* 27, no. 3, pp. 13–28.

Kellermeier, J. (1994). "Feminist Pedagogy in Teaching General Education Mathematics: Creating the Riskable Classroom." Paper presented at the National Women's Studies Association Annual Conference, Ames, Iowa, June.

Masingila, J. (1993). "Connecting the Ethnomathematics of Carpet Layers with School Learning. *International Study Group on Ethnomathematics Newsletter* 8, no. 2, pp. 4–7.

MacPherson, J. (1987). "Norman." *For the Learning of Mathematics* 7, no. 2, pp. 24–26.

National Research Council. (1989). *Everybody Counts: A Report to the Nation on the Future of Mathematics Education.* Washington, D.C.: National Academic Press.

Ortiz-Franco, L. (1993). "Chicanos Have Math in Their Blood: Pre-Columbian Mathematics." *Radical Teacher* 43, pp. 10–14.

Reyes, L. and G. Stanic. (1988). "Race, Sex, Socioeconomic Status, and Mathematics." *Journal for Research in Mathematics Education* 19, no. 1, pp. 26–43.

Richter, M. and H. Bakken. (1993). *The Chronicle of Higher Education* 39, no. 46, p. B4.

Saxe, (1988). "Candy Selling and Math Learning." *Educational Researcher* 17, no. 6, pp. 14–21.

Schindler, D. and D. Davison. (1985). "Language, Culture, and the Mathematics Concepts of American Indian Learners." *Journal of American Indian Education* 24, no. 3, pp. 27–34.

Shirley, L. (1991). "Video Games for Math: A Case for 'Kid Culture.'" *International Study Group on Ethnomathematics Newsletter* 6, no. 2, pp. 2–3.

Sjöö, M. and B. Mor. (1987). Lunar Calendars. In *The Great Cosmic Mother.* San Francisco: Harper.

Zaslavsky, C. (1973). *Africa Counts*. Boston: Prindle, Weber & Schmidt.

————. (1990). "Symmetry in American Folk Art." *Arithmetic Teahcer* 38, no. 1, pp. 6–12.

————. (1992). "Women as the First Mathematicians." *International Study Group on Ethnomathematics Newsletter* 7, no. 1, p. 1.

Interdisciplinarity and Identity: Women's Studies and Women in Science Programs

Sue Rosser

Introduction

DEMOGRAPHIC predictions indicate that men of color and women will constitute between 80 and 90 percent of work force growth by the twenty-first century. The work force in the year 2000 is predicted to differ significantly from that of today:

> There will be a larger segment of minorities and women: 23% more Blacks, 70% more Asians and other races (American Indians, Alaska natives and Pacific Islanders), 74% more Hispanics and 25% more women, adding 3.6 million, 2.4 million, 6.0 million and 13.0 million more workers respectively. Altogether, the minorities and women will make up 90% of the work force growth and 23% of the new employees will be immigrants. (Thomas, 1989, p. 30)

During the same time period that demographers predicted these significant shifts in the composition of the work force, the President and the nation's governors met in Charlottesville, Virginia, in 1989 to agree upon six goals for education to be achieved by the turn of the century. One of the goals was that the United States be first in the world in science and mathematics achievement by the year 2000. Of the three objectives to support this goal, one focused on the need to increase significantly the participation of women and minorities in science and engineering careers (Matyas and Malcolm, 1991).

Men of color and women have not constituted the groups from which the mathematics, science, engineering, and technological work force has attracted large numbers in past decades in the United States. Women comprise 45 percent of the U.S. employed labor force but only 16 percent of all employed scientists and engineers (NSF, 1992). A recent report revealed that women constitute only 12 percent of scientists employed in industry (NRC, 1994). Women employed in science and engineering are concentrated in psychology

252

and in the life and social sciences, while male scientists and engineers are concentrated primarily in engineering (NSF, 1990). For example, in 1993, women made up only "1 percent of working environmental scientists, 2 percent of mechanical engineers, 3 percent of electrical engineers, 4 percent of medical school department directors, 5 percent of physics Ph.D.'s, 6 of close to 300 tenured professors in the country's top 10 mathematics departments" (Holloway, 1993, p. 96). Although 41 percent of working life scientists and biologists and 17 percent of the members of the American Chemical Society in 1991 were women, in the physical sciences such as physics, geology, and engineering the percentage of women remains very low (Holloway, 1993).

With the exception of Asian Americans, underrepresentation of minorities in science and engineering also continues to be a serious problem. Although blacks and Hispanics comprise 10 percent and 7 percent respectively of the U.S. employed labor force, each represented only 3 percent of all employed scientists and engineers in 1988 (NSF, 1990). A large percentage (44 percent) of black scientists work in the life and social sciences, although a higher percentage of blacks (62 percent) than women work in engineering (Matyas and Malcolm, 1991). The small numbers of American Indians and difficulties in obtaining accurate reports of heritage on survey instruments have made statistics on this group problematic. Based on limited data it would appear that American Indians are underrepresented as scientists relative to their proportions in the overall population (NSF, 1992).

Despite the relatively low percentages of women in most areas of science and engineering, until recently very few programs have directly targeted females. The results of a 1991 study by Matyas and Malcolm that surveyed presidents/chancellors of 276 colleges and universities and the directors of nearly 400 recruitment/retention programs revealed that less than 10 percent of the programs included in the study were specifically focused on the recruitment and retention of women in science or engineering. This study reconfirmed similar findings from previous studies that virtually no programs directly target female students or faculty (Matyas and Malcolm, 1991).

The demographic predictions coupled with the national educational goal and with other factors have led to increased interest in, and attention to, efforts to attract and retain women in science and engineering. Funds from federal and foundation sources have enabled faculty at colleges and universities to develop or enhance existing projects and to specifically target them toward attracting and

retaining females in science. Typically the faculty who develop these projects come from the sciences, mathematics, and engineering. They tend to have limited knowledge of women's studies and feminist theory.

A few projects (Rosser and Kelly, 1994; Ross and Rosser, 1994) explicitly apply approaches and curricular content gleaned from women's studies. Even these projects, as well as the bulk of the projects that make no direct applications of, or references to, women's studies or feminist theories, state goals and objectives that might be described as liberal feminist: They seek to remove overt and covert barriers and discrimination so that females will have the same access to education and careers in science and mathematics as that now enjoyed by their male counterparts.

Although the stated goals and objectives of many projects appear to have what might be described at most as a liberal feminist theoretical underpinning, elements common to many projects emanate from a variety of feminist theoretical perspectives ranging from essentialist through African-American to radical. An examination of various feminist theories reveals useful information that may result from their applications in projects to retain women in science, despite the lack of knowledge about the theory held by the individuals designing and implementing the projects.

Feminist Theories

Individuals unfamiliar with feminism or women's studies often assume that feminist theory provides a singular and unified framework for analysis. In one sense this is correct; all feminist theory posits gender as a significant characteristic that interacts with other characteristics, such as race and class, to structure relationships between individuals, within groups, and within society as a whole. However, using the lens of gender to view the world results in diverse images or theories: liberal feminism, Marxist feminism, socialist feminism, African-American feminism, lesbian separatist feminism, conservative or essentialist feminism, existentialist feminism, psychoanalytic feminism, radical feminism, and postmodern feminism. The variety and complexity of these various feminist theories provide a framework through which to explore interesting issues raised by elements in projects designed to attract women to science.

Liberal Feminism

Beginning in the eighteenth century, political scientists, philosophers, and feminists (Wollstonecraft, 1975; Mill [John Stuart], 1970; Mill [Harriet Taylor], 1970; Friedan, 1981; Jaggar, 1983) have described the parameters of liberal feminism. The differences between nineteenth-century and twentieth-century liberal feminists have varied from libertarian to egalitarian, and numerous complexities exist among definitions of liberal feminists today. However, a general definition of liberal feminism is the belief that women are suppressed in contemporary society because they suffer unjust discrimination (Jaggar, 1983). Liberal feminists seek no special privileges for women and simply demand that everyone receive equal consideration without discrimination on the basis of sex.

Most scientists would assume that the implications of liberal feminism for the sciences revolve solely around removal of documented overt and covert barriers (NSF, 1992; Rosser, 1990; Rossiter, 1984; Vetter, 1988, 1991; Matyas and Malcolm, 1991) that have prevented women from entering and succeeding in science. Most projects to attract women have this as an explicitly stated goal with accompanying criteria documenting the barriers and their particular strategies to overcome them. Most scientists, including those who initiate and implement such projects and even those who are brave enough to call themselves feminists, assume that the implications of liberal feminism extend only to employment, access, and discrimination issues.

In fact, the implications of liberal feminism extend beyond this. Liberal feminism shares two fundamental assumptions with the foundations of the traditional method for scientific discovery: (1) Both assume that human beings are highly individualistic and obtain knowledge in a rational manner that may be separated from their social conditions; and (2) Both accept positivism as the theory of knowledge. Positivism implies that "all knowledge is constructed by inference from immediate sensory experiences" (Jaggar, 1983, pp. 355–56).

These two assumptions lead to the belief in the possibilities of obtaining knowledge that is both objective and value-free, concepts that form the cornerstones of the scientific method. Objectivity is contingent upon value neutrality or freedom from values, interests, and emotions associated with a particular class, race, or sex. Although each scientist strives to be as objective and value-free as possible, most scientists, feminists, and philosophers of science rec-

ognize that no individual can be neutral or value-free. Instead, "objectivity is defined to mean independence from the value judgments of any particular individual" (Jaggar, 1983, pp. 357). Liberal feminism and projects with liberal feminist goals imply that once barriers are removed and women receive equal consideration without discrimination on the basis of sex in science, women will constitute 45 percent of scientists, since that is their proportion in the overall work force population. Liberal feminism also implies that this proportional representation will be achieved without changes in science itself, except for the removal of barriers, and that women-scientists, just as their male counterparts, will perceive the sensations and experiences upon which their empirical observations are based separately and individually, while controlling their own values, interests, and emotions.

In the past two decades feminist historians and philosophers of science (Fee, 1982; Haraway, 1990; Harding, 1986) and feminist scientists (Birke, 1986; Bleier, 1984, 1986; Fausto-Sterling, 1992; Hubbard, 1990; Keller, 1983; 1985; Rosser, 1988; Spanier, 1982) have pointed out a source of bias and absence of value neutrality in science, particularly in biology. By excluding females as experimental subjects, focusing on problems of primary interest to males, faulty experimental designs, and interpretations of data based in language or ideas constricted by patriarchal parameters, experimental results in several areas in biology have been demonstrated to be biased or flawed.

For example, much of the early work in primatology suffered from problems of selective use of species, anthropomorphic and vague language, and univeralizing and extrapolating beyond the limits warranted by the data. R. M. Yerkes stated clearly in his early work (1943) that he had chosen particular primate species such as the baboon and chimpanzee because their social organization, in his eyes, resembled that of human primates. Subsequent researchers tended to forget the "obvious" limitations imposed by such a selection of species and proceeded to generalize the data to universal behavior patterns for all primates. It was not until a significant number of women entered primatology that the concepts of the universality and male leadership of dominance hierarchies among primates were questioned and shown to be inaccurate for many species (Lancaster, 1975; Leavitt, 1975: Leibowitz, 1975; Rowell, 1974).

In addition to the problems of the selective use of species, anthropomorphic and vague language, and universalizing and extrapolating beyond limits of the data, feminist scientists revealed another obvious flaw in much animal behavior research: failure to study females.

When females were studied, it was usually only in their interaction (usually reaction) to males or infants. Presumably the fact that until recently most animal behavior researchers were male resulted in an androcentric bias in the conceptualization of design for observation of animal behavior. Because male researchers had only *experienced* male-male and male-female interactions themselves, their male worldview prohibited them from realizing that female-female interaction might be *observed* in their own and other species. Female primatologists (Goodall, 1971; Fossey, 1983) and sociobiologists (Hrdy, 1977, 1979, 1981, 1984) revealed new information that led to the overthrow of previously held theories regarding dominance hierarchies, mate selection (Hrdy, 1984) and female-female competition (Hrdy, 1983) by focusing on female-female interactions.

These and other examples of flawed research resulting from the critiques of feminists have raised fundamental questions regarding gender and good science: Do these examples simply represent "bad science"? Is good science really gender-free or does the scientific method when properly used permit research that is objective and unbiased?

Liberal feminism suggests that now that the bias of gender has been revealed by feminist critiques, scientists can take this into account and correct for this value or bias that had not previously been uncovered. It implies that good scientific research is not conducted differently by men and women and that in principle men can be just as good feminists as women and that women can be just as good scientists as men. Now that feminist critiques have revealed flaws in research due to gender bias, both men and women will use this revelation to design experiments, to gather and interpret data, and to draw conclusions and theories that are more objective and free from bias, including gender bias (Biology and Gender Study Group, 1989). Once aware of the bias, projects to attract women to science might be designed and directed equally well by men or women scientists to illustrate the gender-free nature of science.

Liberal feminism also does not question the integrity of the scientific method itself or of its supporting corollaries of objectivity and value neutrality. Liberal feminism reaffirms the idea that it is possible to find a perspective from which to observe that is truly impartial, rational, and detached. Lack of objectivity and presence of bias occur because of human failure to properly follow the scientific method and to avoid bias due to situation or condition. Liberal feminists argue that it was through attempts to become more value-neutral that the possible androcentrism in previous scientific research has been revealed. Projects to attract more women to science are im-

portant since more women scientists should help to prevent the flaw introduced from objectivity becoming congruent with male bias, in the absence of substantial numbers of women scientists.

It is not surprising that most projects to attract women to science present goals that might be defined in liberal feminist terms. Liberal feminism supports the elimination of bias by adding women scientists as a corrective to make the scientific method function better. Liberal feminism shares beliefs in objectivity, value neutrality, logical positivism, and individualism that constitute fundamental assumptions underlying the scientific method.

In contrast to liberal feminism, all other feminist theories call into question the fundamental assumptions underlying the scientific method, its corollaries of objectivity and value neutrality, or its implications. They reject individualism for a social construction of knowledge and question positivism and the possibility of objectivity obtained by value-neutrality. Many also imply that men and women may conduct scientific research differently, although each theory posits a different cause for the gender distinction.

Socialist Feminism

Socialist feminism serves as the clearest example of a feminist theory that contrasts with liberal feminism in its rejection of individualism and positivism as approaches to knowledge. Marxist critiques of science form the historical precursors and foundations for socialist feminist critiques. Marxism views all knowledge as socially constructed and emerging from practical human involvement in production that takes a definite historic form. According to Marxism, knowledge, including scientific knowledge, cannot be solely individualistic. Since knowledge is a productive activity of human beings, it cannot be objective and value free because the basic categories of knowledge are shaped by human purposes and values. Marxism proposes that the form of knowledge is determined by the prevailing mode of production. In the twentieth-century United States, according to Marxism, scientific knowledge would by determined by capitalism and reflect the interests of the dominant class. Current scientific projects such as the billions of dollars spent on defense-related scientific research and on the Human Genome Initiative (Murray, Rothstein, and Murray, 1996) would be interpreted by Marxists as reflecting the interests of the dominant class. Relatively small amounts of money going into AIDS research and pollution prevention also coincide with interests of the dominant class.

In strict Marxist-feminism, where class is emphasized over gender, only bourgeois (liberal) feminism or proletarian feminism can exist. A bourgeois woman scientist would be expected to produce scientific knowledge that would be similar to that produced by a bourgeois man scientist but that would be different from that produced by a proletarian woman scientist. Some of the data (Holloway, 1993) demonstrating that many other countries, including many less developed countries, produce a higher percentage of women scientists than the United States, might be explained using a Marxist-feminist analysis. In many of these countries such as the Philipppines, Brazil, Turkey, India, Portugal, and Thailand, class may be a more significant factor than gender for distinguishing who goes into science (Barinaga, 1994).

Socialist feminism places class and gender on equal ground as factors that determine the position and perspective of a particular individual in society. Socialist feminism asserts that the special position of women within (or as) a class gives them a special standpoint that provides them with a particular worldview. This worldview from the standpoint of women is supposed to be more reliable and less distorted than that of men from the same class. Implicit in the acceptance of the social construction of knowledge is the rejection of the standpoint of the neutral, disinterested observer of liberal feminism. Because the prevailing knowledge and science reflect the interests and values of the dominant class and gender, they have an interest in concealing, and may in fact, not recognize the way they dominate. Women oppressed by both class and gender have an advantageous and more comprehensive view of reality. Because of their oppression, they have an interest in perceiving problems with the status quo and with the science and knowledge produced by the dominant class and gender. Simultaneously, their position requires them to understand the science and condition of the dominant group in order to survive. Thus, the standpoint of the oppressed comprehends and includes that of the dominant group, so it is more accurate.

An example that might be cast as socialist feminism is the current work of the National Breast Cancer Coalition. Dissatisfied with the research direction and solutions provided by the modern medical establishment, the National Breast Cancer Coalition, made up of over 250 organizations nationwide, presented the President and First Lady on 18 October 1993, with petitions containing 2.6 million signatures demanding a comprehensive strategy plan to end the breast cancer epidemic (wccp, 1994). In 1992, the Women's Community Cancer Project presented *A Woman's Cancer Agenda: The Demands*

to the National Cancer Institute and to the U.S. government asking for alternative treatments and research into environmental causes for the breast cancer epidemic (WCCP, 1992).

Socialist feminism provides a theoretical framework that might be used to explain several issues that continue to be problematic for women in science. Repeated studies have demonstrated that women pursuing graduate training in scientific fields receive less financial aid or different types of financial aid (Vetter, in press) from their male counterparts. For example the National Science Foundation documented that women graduate students were more likely to receive teaching assistantships while male graduate students receive research assistantships (NSF, 1992). Although women often enjoy teaching and are considered to be good teachers, the data, work with equipment, and laboratory procedures developed in research assistantships are more directly applicable to completing the research for the Ph.D. dissertation.

Teaching assistantships may prolong the number of years it takes women to complete their graduate work in the sciences. Extension of the time in graduate school becomes especially difficult for women who may receive smaller amounts of financial aid from their institutions, are less likely to obtain federal support, and are more likely than men to have to support themselves during graduate study (Vetter, in press). Socialist feminism would suggest that the differential treatment of women in financial aid situations provides an example of gender intersecting with class, since higher education in general is only available to those who have adequate resources or who can defer paid employment to further their education beyond high school. The time commitment for science and engineering education in particular makes it especially difficult for individuals who must work extensively outside of academia to finance their education.

Women scientists on the average earn less than their male counterparts; the overall salary gap between men and women doctoral scientists in 1991 is about $12,000 per year, with some variation by field (Vetter, in press). Women scientists and engineers also encounter two to five times the amount of unemployment or underemployment (Vetter, in press) than that experienced by their male peers. Despite their relatively lower earnings and higher unemployment compared to men scientists, women scientists fare better than women professionals with comparable training in other female-dominated fields. Since science and engineering continue to be male-dominated occupations, women who become scientists and engineers benefit somewhat from the higher wages associated with tradi-

tionally male fields, compared to women who enter traditionally female-dominated occupations or fields where women with four or more years of college in 1990 earned average salaries ($28,017) that are only slightly above the average salary ($26,653) of men with only a high school diploma, and well below salaries of men with a bachelor's degree ($39,238) (Bureau of the Census, 1992). Socialist feminism suggests that the labor market, including the scientific labor market, is gender-stratified, as well as class-divided.

Mathematics often becomes the gatekeeping course that determines whether or not students will be able to pursue courses in science and engineering. To a student without the full complement of four years of high school mathematics, 75 percent of college majors are closed (Sells, 1975). These tend to be the majors in scientific and technical fields that lead to higher-paying professions with considerable stability.

More girls than boys drop out of high school mathematics (OTA, 1987) before they have completed the four-year sequence. Studies have shown that girls who drop out of mathematics in high school and women who switch from mathematics or science majors in college do not do so because of poor grades (Arnold, 1987; Gardner, 1986). The grades of the females leaving are as good or better than the males persisting in the science and mathematics courses. Whatever they studied, women earned consistently higher grade point averages in college than the men in the class, and the differences were greatest in the traditionally male-dominated fields of engineering, science, and business (Vetter, in press). A variety of factors such as differential responses of guidance counselors, parents (Keynes, 1989), and peers to the desire and discussion surrounding decisions to drop out of mathematics or science may be responsible for the differential persistence rates of males compared to females. For example, parents tend to praise their daughter's hard work in attaining good grades, while attributing their son's success to talent (Keynes, 1989).

A socialist-feminist analysis of the gender-differentiated dropout rates for mathematics despite the superior grades of a female might focus on an analysis of so-called gatekeeping courses in our educational system. In addition to "weeding out" individuals with less skill in a particular area, other individuals may be removed by differential encouragement (Keynes, 1989; Davis, 1993). Mathematics courses often serve as such gatekeepers, which control access to more lucrative professions. Some individuals are removed from the pipeline due to lack of ability and/or performance (which may be related to class, given the structure of public schools in the United States).

For females, differential encouragement to continue in mathematics, particularly when difficulties arise, may provide an additional filter.

Studies have documented that when computer camps are relatively inexpensive (less than $100), approximately one-third of the enrollees are girls; when the cost exceeds $1000, female enrollment drops to one sixth (Sanders, in press). This study, coupled with ones (Martinez and Mead, 1988; Sanders, 1985) documenting that families buy computers more often for their sons than for their daughters, suggests that families provide more emphasis upon mathematics for their sons than for their daughters.

Some projects to attract and retain girls and women in science demonstrate knowledge of the intersection of class with gender as a particular problem. Most projects directed toward K–12 aged girls have a component directed toward encouraging females to stay in mathematics. Staying in mathematics in college provides a direct path to more lucrative livelihoods for women since women achieve near pay equity in some occupations (accounting, management, and engineering) as a correlate of the amount of mathematics they studied in college (Adelman, 1991).

A few programs such as Operation SMART, run by Girls Incorporated (Wahl, 1993) target girls from the inner city and lower socioeconomic strata. Their emphases upon science, "hands-on" activities, and building teamwork through sports represent deliberate attempts to provide girls from urban and lower-income families with experiences often available only to boys or to girls from higher-income families to develop skills useful for persisting in science and in other male-dominated professions. In their recognition of the role of the intersection that class and gender play as barriers for these girls, such programs might be interpreted as adopting a socialist-feminist perspective.

African–American Feminism

Like socialist-feminism, African-American or black feminism also rejects individualism and positivism for social construction as an approach to knowledge. It is based on the African-American critique of a Eurocentric approach to knowledge. In addition to the rejection of objectivity and value-neutrality associated with the positivist approach accepted by liberal feminism, African-American approaches critique dichotomization of knowledge, or at least the identification of science with the first half and African-American with the latter half, of the following dichotomies: culture/nature; rational/emo-

tional; objective/subjective; quantitative/qualitative; active/passive; focused/diffused; independent/dependent; mind/body; self/others; knowing/being. African-American critiques also question methods that distance the observer from the object of study, thereby denying a facet of the social construction of knowledge.

Whereas Marxism posits class as the organizing principle around which the struggle for power exists, African-American critiques maintain that race is the primary oppression. African-Americans critical of the scientific enterprise may view it as a function of white Eurocentric interests. The fact that African-Americans are underrepresented in the population of scientists while Caucasians are overrepresented, relative to their respective percentages in the population as a whole (NSF, 1992) makes it particularly likely that in its choice of problems for study, methods, and theories and conclusions drawn from the data, the scientific enterprise does represent and function to further white Eurocentric interests.

Just as Marxists view class oppression as primary and superseding gender oppression, African-American critiques place race above gender as an oppression. A strict, traditional interpretation of African-American critiques would suggest that scientific knowledge produced by African-American women would more closely resemble scientific knowledge produced by African-American men than that produced by white women. In contrast, African-American feminist critiques assert that in contemporary society, women suffer oppression due to their gender, as well as race (Giddings, 1984; Hooks, 1981, 1983, 1990; Lorde, 1984). For African-American women, racism and sexism become intertwining oppressions that provide them with a different perspective and standpoint than that of either white women or African-American men.

In addition to the underrepresentation of African Americans in science, other evidence suggests that science and science education may represent white Eurocentric interests. Despite much more limited funding and other resources, historically black colleges and universities have produced a much higher percentage of African-American scientists (Matyas and Malcolm, 1991) than integrated institutions of higher education. Although such integrated institutions enroll larger numbers of African-American students than historically black colleges and universities, some combination of black role models as faculty, encouragement, and lack of identification of certain majors with a particular race at the historically black colleges and universities yields more scientists.

The work of Treisman (1992) suggests that isolation or separation of students from their racial peers may have a negative impact upon

their retention in mathematics and science. Treisman (1992) demonstrated that African-American and Hispanic students were more likely to drop out of mathematics when they were not in study groups or when they were the only person from their race in a study group. Retention in mathematics was facilitated when two or more students of the same race were in the same study group.

Because of the importance of community and the ethos within the African-American community that those who are successful have an obligation to return something to their communities, some careers in science may present conflicts for some African Americans. In some well-documented cases, science and scientific research have been used to produce information that may help white Eurocentric interests while clearly harming the African-American community. Such was the case with the Tuskegee Syphilis Experiments (Jones, 1981). African-American students majoring in science may be more eager to pursue careers in medicine, where they can provide positive services that clearly aid and keep them connected with their home communities, rather than moving thousands of miles away to work on a nuclear accelerator that may be of questionable benefit to their own community. An African-American analysis provides a perspective on the question of why many projects such as the Howard Hughes grants targeted toward minority students have succeeded in attracting them to careers in medicine but not to basic science research in large numbers.

As an African-American feminist analysis would suggest, African-American women suffer the effects of racism, not an obstacle for their white sisters, and sexism, not experienced by their black brothers. In their survey of programs for women, minorities, and the disabled in science, Matyas and Malcolm (1991) found that most of the programs directed toward minorities, had no particular component for women; most of the programs directed toward women, failed to attract women of color. Treisman's work (1992) while thoroughly exploring the effects of race on group work in mathematics, fails to address the effects of gender in group dynamics. Similarly, much of the work on gender dynamics in group interactions (Tannen, 1990; Kramarae and Treichler, 1986; Lakoff, 1975), fails to explore the effect of race.

An African-American feminist analysis suggests why African-American women have fallen through the cracks in research and programs that were developed to attract and retain women in science. Such an analysis also explains why a historically black women's college such as Spelman has produced a disproportionately large number of successful women-scientists (Falconer, 1989). With

African-American women role models on the faculty and teaching approaches geared toward their students, at Spelman, African-American young women receive the focus and attention missing from other programs.

Essentialist Feminism

Essentialist feminist theory posits that women are different from men because of their biology, specifically their secondary sex characteristics and their reproductive systems. Frequently, essentialist feminism may extend to include gender differences in visuo-spatial and verbal ability, aggression and other behavior, and other physical and mental traits based on prenatal or pubertal hormone exposure. Nineteenth-century essentialist feminists [Blackwell (1895) 1976; Calkins, 1896; Tanner, 1896] often accepted the ideas of male essentialist scientists such as Freud [anatomy is destiny (1924)] or Darwin as interpreted by the social Darwinists that there are innate differences between men and women.

These nineteenth-century essentialist feminists proposed that the biologically based gender differences meant that women were inferior to men in some physical (Blackwell, 1976) and mental (Hollingsworth, 1914; Tanner, 1896) traits, but that they were superior in others. Biological essentialism formed the basis for the supposed moral superiority of women that nineteenth-century suffragettes (DuBois, Kelly, Kennedy, Korsmeyer, and Robinson, 1985; Hartmann and Banner, 1974) used as a persuasive argument for giving women the vote.

In the earlier phases of the current wave of feminism, most feminist scientists (Bleier, 1979; Fausto-Sterling, 1985; Hubbard, 1979; Rosser, 1982) fought against some sociobiological research such as that by Wilson (1975), Trivers (1972), and Dawkins (1976) and some hormone and brain lateralization research (Buffery and Gray, 1972; Gorski, Harlan, Jacobson, Shryne, and Southam, 1980; Goy and Phoenix, 1971; Sperry, 1974) which seemed to provide biological evidence for differences in mental and behavioral characteristics between males and females. Essentialism was seen as a tool for conservatives who wished to keep women in the home and out of the workplace. More recently, feminists have reexamined essentialism from perspectives ranging from conservative to radical (Corea, 1985; Dworkin, 1983; O'Brien, 1981; Rich, 1976) with a recognition that biologically based differences between the sexes might imply superiority and power for women in some arenas.

Many of the earlier projects to attract and retain women in science might be seen as underpinned by an essentialist theoretical perspective. Programs to improve the visuo-spatial ability of females (Wheeler and Harris, 1979), increase problem-solving ability, or assertiveness training might be interpreted as essentialist feminist, if biological differences such as X-linked genes for visuo-spatial ability (Benbow and Stanley, 1980) and hormonal differences causing differential aggression patterns between males and females serve as the rationale for such programs.

Some interpretations of research such as that by Belenky et al. (1986) on *Women's Ways of Knowing* and Gilligan (1982) and Gilligan, Ward, and Taylor (1988) on women's moral and ethical decision-making may spring from an essentialist feminist perspective. Programs that evolve methods of teaching science and mathematics more in tune with preferred ways of learning for the majority of females apply such research. If the individuals developing and implementing these programs believe and convey to the students that they may learn science more easily because these techniques were developed to account for the inherent biological factors that make males and females learn differently, such programs might be said to use an essentialist feminist perspective.

Existentialist Feminism

In contrast to essentialist feminism, many individuals who develop and implement exactly the same types of programs as described in the previous two paragraphs, do so from an existentialist perspective. Existentialist feminism, first elaborated by Simone de Beauvoir (1974), suggests that women's "otherness" and the social construction of gender rest on society's interpretation of biological differences, rather than the actual biological differences themselves:

The enslavement of the female to the species and to the limitations of her various powers are extremely important facts; the body of woman is one of the essential elements in her situation in the world. But that body is not enough to define her as woman; there is no true living reality except as manifested by the conscious individual through activities and in the bosom of a society. Biology is not enough to give an answer to the question that is before us: why is woman the other? (de Beauvoir, 1974, p. 51).

In other words, it is the value that society assigns to biological differences between males and females that has led woman to play the role of the Other (Tong, 1989); it is not the biologic differences

themselves. Existentialist feminism would suggest that visuo-spatial differences between males and females and disparate preferential learning styles between the two sexes might be the result of the differential treatment and reactions that males and females in our society receive based on their biology.

For example, studies demonstrating that parents and other adults present more visual objects or toys to baby boys and talk and interact verbally more with girls to comfort and quiet them when they are upset might partially explain the differing visuo-spatial ability of boys and verbal ability of girls. These studies and others documenting differential treatment of girls and boys from birth onward (Will, Self, and Datan, 1974; Sadker and Sadker, 1994) when coupled with sex-role stereotyping enforced by toys and extracurricular activities indicate reasons why males and females in our society may develop different learning styles and skills. Playing video games, building model airplanes, and working with chemistry and erector sets provide boys with practice in visuo-spatial skills in play activities. In contrast, playing with dolls, talking on the telephone, and playing school stimulate verbal and interactional skills in girls.

Superficially, the programs to address the enhancement of girls' visuo-spatial abilities, provide them practice in using circuit boards, or approach topics in a more relational fashion (Belenky et al., 1986) developed using an existentialist theoretical framework would resemble in content and approaches, and might be exactly the same as those, undergirded by an essentialist feminist perspective. The difference would lie in the rationale for the program, which might or might not be expressed to the participants. For essentialist feminists, inherent biological differences become the rationale for such programs. In contrast, the differential treatment, activities, and social experiences that boys and girls in our society have because of their underlying biological differences would constitute the rationale for such programs evolved from an existentialist perspective.

Psychoanalytic Feminism

In many ways, psychoanalytic feminism takes a stance similar to that of existentialist feminism. Derived from Freudian theory, psychoanalysis posits that girls and boys develop contrasting gender roles because they experience their sexuality differently and deal differently with the stages of psychosexual development.

Based on the Freudian prejudice that anatomy is destiny, psychoanalytic theory assumes that biological sex will lead to different ways

for boys and girls to resolve the Oedipus and castration complexes that arise during the phallic stage of normal sexual development. As was the situation with existentialism, psychoanalysis recognizes that gender construction is not biologically essential; in "normal" gender construction the biological sex of the child–caretaker interaction differs depending on the sex of the child (and possibly that of the primary caretaker). However, psychoanalytic theory is not strictly biologically deterministic since cases of "abnormal" sexuality may result when gender construction is opposite or not congruent with biological sex.

In recent years, a number of feminists have become interested again in Freud's theories, after a period of attacking Freudian and successor analytic theories (Firestone, 1970; Friedan, 1981; Millett, 1970). Rejecting the biological determinism in Freud, Dinnerstein (1977) and Chodorow (1978) in particular have used an aspect of psychoanalytic theory known as object relations theory to examine the construction of gender and sexuality. Chodorow and Dinnerstein examine the Oedipal stage of psychosexual development to determine why the construction of gender and sexuality in this stage usually results in male dominance. They conclude that the gender differences resulting in male dominance can be traced to the fact that in our society, women are the primary caretakers for most infants and children.

Accepting most Freudian ideas about the Oedipus complex, Chodorow and Dinnerstein conclude that boys are pushed to be independent, distant, and autonomous from their female caretakers while girls are permitted to be more dependent, intimate, and less individuated from their mothers or female caretakers. Building upon the work of Chodorow and Dinnerstein, feminists (Keller, 1982; Harding, 1986; Hein, 1981) have explored how the gender identity proposed by object relations theory with women as caretakers might lead to more men choosing careers in science.

Keller (1982, 1985) in particular applied the work of Chodorow and Dinnerstein to suggest how science has become a masculine province that excludes women and causes women to exclude themselves from it. Science is a masculine province not only in the fact that it is populated mostly by men but also in the choice of experimental topics, use of male subjects for experimentation, interpretation and theorizing from data, as well as the practice and applications of science undertaken by the scientists. Keller suggests (1982; 1985) that since the scientific method stresses objectivity, rationality, distance, and autonomy of the observer from the object of study (i.e., the positivist neutral observer), individuals who feel comfortable

with independence, autonomy, and distance will be most likely to become scientists. Because most caretakers during the Oedipal phase are female, most individuals in our culture who will be comfortable as scientists will be male. The type of science they create will also in turn reflect those same characteristics of independence, distance, and autonomy. It is upon this basis that feminists have suggested that the objectivity and rationality of science are synonymous with a male approach to the physical, natural world.

Although some adaptations of science teaching to accommodate the way in which women learn more easily as suggested by the research of Belenky et al. (1986) may evolve from individuals who hold essentialist or existentialist feminist theoretical perspectives, many people proposing such adaptations are likely to align themselves with a psychoanalytic perspective. The particular interest of females in the social applications of science (Hynes, 1989, in press; Rosser, 1990), the connection of science to human beings (Harding, 1985; Rosser, 1990), and feelings for the organism under study (Keller, 1983; Goodfield, 1981) seem understandable in the light of the differences encouraged in males and females by the primary caretaker suggested by psychoanalytic feminism.

Mentoring female students by women scientists (AWIS, 1993) may be particularly crucial for attracting and retaining women in science because women are socialized to value connection. Psychoanalytic feminism would also suggest that female students might feel more comfortable having a closer degree of dependence upon, and connection with, a female mentor than they would with a male mentor. The notion of a critical mass of female students in a class, the success women's colleges have in retaining women in science (Tidball, 1986; Sebrechts, 1992), and the significance of women in science dormitories or in other living arrangements where connection among female students is supported might be explained partially by the socialization of women for close interaction and interdependence with other females.

Part of the success of programs such as EQUALS (Steinmark, Thompson, and Cossey, 1986) may be attributed to a component in which parents are included explicitly as one of the factors that must be targeted for the successful recruitment of females to science. Although parents serve as a critical determinant in the career choice of both males and females, psychoanalytic feminism would suggest that because females are encouraged to be less separate, parents, including the mother, may be particularly important in the career decision of females. Women who choose engineering as a career are particularly likely to have no brothers (Vetter, in press).

Other programs to encourage women in science might also be explained as attempts to compensate for lack of autonomy, separation, and independence that girls might have experienced during resolution of the psychoanalytic crisis with female primary caretakers. Programs to teach females to be risk-takers, strategies that foster competition, rather than cooperation and connection among peers (including female-female peers), and assertiveness training might be viewed as attempts to correct the "deficit" in female socialization and to equip them to enter the world of scientists in which competition, objectivity, and separation are fostered.

Research demonstrating that male mentors provide significant, but different, information and support for female students compared to that provided by their female mentors (Yentsch and Sinderman, 1992) suggests that they play a crucial role that may come from their socialization as more separate, distant, and autonomous individuals whose personalities may be more congruent with the culture of science (Keller, 1985; Haraway, 1990). Similarly, the studies documenting the importance of both parents (O'Connell and Rosso, 1983; Hennig and Jardim, 1977), including the father and professional mothers, in encouraging daughters who become scientists would suggest that they may compensate for dependence and for other characteristics that may be engendered by traditional female primary caretakers.

Psychoanalytic feminism implies that if both males and females become involved as primary caretakers of infants and if both male and female scientists serve as mentors for students of both genders, gender roles would be less polarized. Science itself might then become gender-free and less reflective of its current masculine perspective. Equal numbers of men and women would be attracted to the study of science and the science produced by male and female scientists would be indistinguishable since it would be freer of gender constraints.

Radical Feminism

Radical feminism, in contrast to psychoanalytic feminism and liberal feminism, rejects the possibility of a gender-free science or of a science developed from a neutral, objective perspective. Radical feminism maintains that women's oppression is the first, most widespread, and deepest oppression (Jaggar and Rothenberg, 1984). Since men dominate and control most institutions, politics, and knowledge in our society, they reflect a male perspective and are effective

in oppressing women. Scientific institutions, practice, and knowledge are particularly male-dominated and have been documented by many feminists (Bleier, 1984; Fee, 1982; Griffin, 1978; Haraway, 1978, 1990; Hubbard, 1990; Keller, 1985; Merchant, 1979; Rosser, 1990) to be especially effective patriarchal tools to control and harm women. Radical feminism rejects most scientific theories, data, and experiments precisely because they not only exclude women but also because they are not women-centered.

The theory that radical feminism proposes is evolving (Tong, 1989) and is not as well developed as some of the other feminist theories for reasons springing fairly directly from the nature of radical feminism itself. First it is radical. That means that it rejects most of currently accepted ideas about scientific epistemology—what kinds of things can be known, who can be a knower, and how beliefs are legitimated as knowledge—and methodology—the general structure of how theory finds its application in particular scientific disciplines. Second, unlike the feminisms previously discussed, radical feminism does not have its basis in a theory such as Marxism, positivism, psychoanalysis, or existentialism, already developed for decades by men. Since radical feminism is based in women's experience, it rejects feminisms rooted in theories developed by men based on their experience and worldview. Third, the theory of radical feminism must be developed by women and based on women's experience (MacKinnon, 1987). Because radical feminism maintains that the oppression of women is the deepest, most widespread, and historically first oppression, women have had few opportunities to come together, to understand their experiences collectively, and to develop theories based on those experiences.

Radical feminism deviates considerably from other feminisms in its view of how beliefs are legitimated as knowledge. A successful strategy that women use to obtain reliable knowledge and correct distortions of patriarchal ideology is the consciousness-raising group (Jaggar, 1983). Using their personal experiences as a basis, women meet together in communal, nonhierarchical groups to examine their experiences to determine what counts as knowledge (MacKinnon, 1987).

Research by Tidball (1986) and Sebrechts (1992) has documented the disproportionate number of female scientists who received their undergraduate education at women's colleges. A variety of factors present in women's colleges such as collective living with other females, a relatively large number of female faculty to serve as role models, teaching strategies geared to a female-only audience, and absence of gender role prescriptions for use of equipment or major

selection may account for the success of women's colleges in attracting and retaining women-scientists. Radical feminism would suggest that the presence of an environment that permits female-only classes and discussions would serve the role of a consciousness-raising group to influence women in their decision to become scientists.

Several of the strategies such as women in science groups, summer science camps for girls, or afterschool programs to encourage girls in computers or science attempt to provide a female-only experience within the overall context of a coeducational environment. In the female-only environment, concepts can be introduced at the appropriate developmental stage for females. Teaching techniques more in tune with female styles that emphasize interrelationships and connection, and cooperative approaches, rather than competition for equipment with males, may be attempted. These programs seek to duplicate some of the benefits of the single-sex environment for females found naturally at a women's college.

Lesbian separatism, often seen as an offshoot of radical feminism, would suggest that separation from men is necessary in a patriarchal society in order for females to understand their experiences and to explore the possibility of becoming a scientist. Lesbian separatist theory would provide an explanation for the success of women's colleges in producing a much higher proportion of female scientists than comparable private liberal arts colleges that are coeducational. The absence of male classmates, designation of certain majors as predominately for one sex, and coeducational science-related activities coupled with increased numbers of female science faculty, living with females only, and strong alumnae role models create a mini-female-only environment within a larger patriarchal society. To the extent that interactions among the women-students simulate a consciousness-raising group that permits them to explore their ideas, attitudes, and beliefs about science and becoming a scientist in the absence of a hierarchical structure, these environments simulate the methods of radical feminism.

Postmodern Feminism

In the earlier discussion of liberal feminism in this essay, I emphasized its fundamental assumptions of individualism and positivism and the extent to which the traditional method for scientific discovery also shares these two assumptions. Based upon liberal humanism (Rothfield, 1990), which suggests that the self is an individual, au-

tonomous, self-constitutive human being, liberal feminists (Lloyd, 1984; Grimshaw, 1986; Tapper, 1986) critique liberal humanism for its implicit assumption that the abstract individual is male or congruent with man. While criticizing liberal humanists for inappropriately universalizing what are really characteristics of men to all individuals, both male and female, liberal feminists do not reject or critique other aspects of liberal humanism such as equality and freedom of the individual (Rothfield, 1990). Liberal feminism suggests that women have a unified voice and can be universally addressed (Gunew, 1990).

In contrast to liberal humanism, postmodernism problematizes the self in "decentered modes of discourse. The self is no longer regarded as self-constitutive, but rather as a production of, variously, ideology, discourse, the structure of the unconscious, and/or language" (Rothfield, 1990, p. 132). At least some postmodern feminists (Kristeva, 1984,1987; Cixous and Clement, 1986) suggest that the woman, having been marginalized by a dominant male discourse, may be in a privileged position, that of outsider to the discourse that might otherwise threaten to rigidify all thought along previously established lines. Perhaps women can find the holes in what appeared solid, sure, and unified. In short, postmodernism dissolves the universal subject and postmodern feminism dissolves the possibility that women speak in a unified voice or that they can be universally addressed. Race, class, nationality, sexual orientation, and other factors prevent such unity and universality. Although one woman may share certain characteristics and experiences with other women because of her biological sex, her particular race, class, and sexual differences compared to other women, along with the construction of gender that her country and society give to someone living in her historical period prevent universalizing of her experiences to women in general. Insofar as postmodern feminism questions the nature of understanding the subject as defined in the Western world, it also puts the entire edifice of knowledge into question. This questioning may create the cracks or openings through which the marginalized woman might be able to walk.

As programs for women in science have increased in number and have operated for lengthier periods of time, individuals administering such programs realize that suggesting that strategies that work to attract and retain particular groups of girls and women to science might work for all women. It has become increasingly clear that no panacea will be found to make science, mathematics, and engineering attractive to all women and girls.

Some of the more successful programs have begun to target spe-

cific groups of girls. Several projects such as the Model Program to Motivate and Educate Women Minority High School Students for Careers in Science run as a partnership between Wright State University and the Dayton Board of Education (NSF, 1994) are aimed at girls from particular racial/ethnic backgrounds. Other projects select partipants on the basis of class, geographic location, academic ability, or age. For example, the New Careers in the Sciences for Rural Girls in Nebraska Project (NSF, 1994) is particularly geared toward girls coming from rural families. Although many programs to attract girls to science aim at particularly gifted students, some projects targeted the "second tier" of girls who tend to receive Bs and have above average, but not outstanding scores on achievement tests. The Regional Employer-Education Partnerships to Attract Women into Engineering at the University of Tennessee-Chattanooga (NSF, 1994) aids nontraditional aged women returning to school who seek careers in engineering.

Few of the individuals who design and implement such programs specified for particular groups of women are likely to be aware of postmodernism or to think of themselves as operating from a postmodern feminist perspective. However, in their recognition that the standpoint and experiences that impinge upon any one girl or woman in her decision to become a scientist are shaped by a multitude of socially constructed factors including, but not limited to, her race/ethnic background, class, sexual orientation, family dynamics, education, and intellectual abilities, as well as her gender, they are operating from a recognition consistent with postmodern feminist theory.

Conclusion

As feminism has matured during this wave of its development during the latter half of the twentieth century, feminist theory has become increasing complex. Springing from a growing knowledge that the diversity among women meant that the universalism suggested by liberal feminism was not appropriate to describe the experiences of all women, other feminist theories evolved. Although essentialist and existential feminism might be interpreted to imply that biological sex and its interpretation in our society provide an overriding similarity to the experiences of all women, other feminist theories suggest that other factors may be equally or more important than sex/gender. Marxist feminism emphasizes the importance of class as well as gender. African-American and other racial/ethnic

theories of feminism underline the significance of both race and gender/sex. Family dynamics and the role of the primary caretaker become powerful determinants in psychoanalytic feminism, while radical feminism questions all categories and knowledge developed in a patriarchal society in which women are oppressed. Postmodern feminism suggests that each woman in each society during a particular historical period may have a differing standpoint from which to view the world as shaped by her race, class, and numerous other factors, including her gender.

As women in science programs have begun to evolve, partially as a result of feminism, and in some cases with little formal knowledge of feminism or feminist theory, they too have become increasingly complex. Most projects continue to state goals and objectives that might be described as liberal feminist in their attempts to remove overt and covert barriers and discrimination so that females will have the same access as males to careers in science and mathematics. Although few individuals developing such programs have a grasp of the breadth and depth of feminist theories, the programs they evolve to attract and retain women in science include elements underpinned by feminist theoretical frameworks ranging from Marxist through African-American to radical. Larger numbers and increased longevity of projects has led to a recognition that no one universal strategy will reach all females. The evolution of particular strategies in response to the needs and experiences of individual females whose situation is shaped by a variety of factors may demonstrate a postmodern feminist approach to what works to attract and retain women in science.

References

Adelman, Clifford. (1991). *Women at Thirtysomething: Paradoxes of Attainment.* Washington, D.C.: U.S. Department of Education Office of Educational Research and Development.

American Women in Science. (1993). *A Hand Up: Women Mentoring Women in Science.* Washington, D.C.: AWIS.

Arnold, Karen. (1987). Retaining High Achieving Women in Science and Engineering. Paper presented at Women in Science and Engineering: Changing Vision to Reality Conference, University of Michigan, Ann Arbor. Sponsored by the American Association for the Advancement of Science.

Barinaga, Marcia. (1994). Surprises Across the Cultural Divide. *Science* 263, pp. 1468–72.

Belenky, M. F. et al. (1986). *Women's Ways of Knowing.* New York: Basic.

Benbow, C., and J. Stanley. (1980). Sex Differences in Mathematical Ability: Fact or Artifact? *Science* 210, pp. 1262–64.

Biology and Gender Study Group. (1989). The Importance of Feminist Critique for Contemporary Cell Biology. In N. Tuana (Ed.)., *Feminism and Science*, pp. 172-87. Bloomington: Indiana University Press.

Birke, L. (1986). *Women, Feminism, and Biology: The Feminist Challenge*. New York: Methuen.

Blackwell, A. [1875] (1976). *The Sexes Throughout Nature*. New York: Putnam; reprinted, Westport, Conn.: Hyperion Press.

Bleier, R. (1979). Social and Political Bias in Science: An Examination of Animal Studies and Their Generalizations to Human Behavior and Evolution. In Ruth Hubbard and Marian Lowe, (Eds). *Genes and Gender II: Pitfalls in Research on Sex and Gender*, pp. 49-70. New York: Gordian Press.

———. (1984). *Science and Gender: A Critique of Biology and Its Theories on Women*. Elmsford, N.Y.: Pergamon Press.

———. (1986). Sex Differences Research: Science or Belief? In *Feminist Approaches to Science*, pp. 147-64. Elmsford, N.Y.: Pergamon Press.

Buffery, W., and J. Gray. (1972). Sex Differences in the Development of Spatial and Linguistic Skills. In C. Ounsted and D. C. Taylor (Eds.). *Gender Differences: Their Ontogeny and Significance*. Edinburgh: Churchill Livingstone.

Bureau of the Census. (1992). Series P–60, no. 174.

Calkins, M. (1896). "Community Ideas of Men and Women." *Psychological Review* 3, no. 4, pp. 426-30.

Chodorow, N. (1978). *The Reproduction of Mothering: Psychoanalysis and the Sociology of Gender*. Berkeley and Los Angeles: University of California Press.

Cixous, H., and C. Clement. (1986). *The Newly Born Woman*. Minneapolis: University of Minnesota Press.

Corea, G. (1985). *The Mother Machine: Reproductive Technologies from Artificial Insemination to Wombs*. New York: Harper.

Davis, C. S. (1993). "Stepping Beyond the Campus." *Science* 260 (16 April): 414.

Dawkins, R. (1976). *The Selfish Gene*. New York: Oxford University Press.

de Beauvoir, S. (1974) *The Second Sex*. Trans. and ed. H. M. Parshley. New York: Vintage Books.

Dinnerstein, D. (1977). *The Mermaid and the Minotaur: Sexual Arrangements and Human Malaise*. New York: Harper Colophon Books.

Dubois, E. Kelly, et al. (1985). *Feminist Scholarship: Kindling in the Groves of Academe*. Urbana: University of Illinois Press.

Dworkin, A. (1983). *Right-wing Women*. New York: Coward-McCann.

Falconer, E. (1989). "A Story of Success: The Sciences at Spelman College." *SAGE*, 6, no. 2, pp. 36–38.

Fausto-Sterling, A. (1985). *Myths of Gender*. New York: Basic.

Fee, E. (1986). Critiques of Modern Science: The Relationship of Feminism to Other radical Epistemologies. In Ruth Bleier (Ed.), *Feminist approaches to Science*. Elmsford, N.Y.: Pergamon Press.

———. (1982). "A Feminist Critique of Scientific Objectivity." *Science for the People* 14, no. 4, p. 8.

Firestone, S. (1970). *The Dialectic of Sex*. New York: Bantam Books.

Fossey, D. (1983). *Gorillas in the Mist*. Boston: Houghton.

Freud, S. (1924). *Collected Papers*. London: The International Psycho-analytic Press.

Friedan, B. (1981). *The Second Stage*. New York: Summit Books.

Gardner, A. L. (1986). Effectiveness of Strategies to Encourage Participation and Retention of Precollege and College Women in Science." Ph.D. diss., Purdue University.

Giddings, P. (1984). When and Where We Enter: The Impact of Black Women on Race and Sex in America. New York: Morrow.

Gilligan, C. (1982). *In a Different Voice: Psychological Theory and Women's Development*. Cambridge: Harvard University Press.

———, J. V. Ward, and J. M. Taylor. (1988). *Mapping the Moral Domain*. Cambridge: Harvard University Press.

Goodall, J. (1971). *In the Shadow of Man*. Boston: Houghton.

Goodfield, J. (1981). *An Imagined World*. New York: Penguin Books.

Gorski, R. et al. (1980). "Evidence for the Existence of a Sexually Dimorphic Nucleus in the Preoptic Area of the Rat." *Journal of comparative Neurology* 193, pp. 529–39.

Goy, R., and C. H. Phoenix. (1971). The Effects of Testosterone Propionate Administeredd Before Birth on the Development of Behavior in Genetic Female Rhesus Monkeys. In C. H. Sawyer and Robert A Gorski (Eds.), *Steroid Hormones and Brain Function*. Berkeley: University of California Press.

Griffin, S. (1978). *The Death of Nature*. New York: Harper.

Grimshaw, J. (1986). *Feminist Philosophers: Women's Perspectives on Philosophical Traditions*. Sussex: Wheatsheaf.

Gunew, S. (1990). *Feminist Knowledge: Critique and Construct*.New York: Routledge.

Haraway, D. (1978). "Animal Sociology and a Natural Economy of the Body Politic." *Signs* 4, no. 1, pp. 21–60.

———. (1990). *Primate Visions,* New York: Routledge.

Harding, J. (1985). Values, Cognitive Style and the Curriculum. Contributions to the Third Girls and Science and Technology Conference. London: Chelsea College. University of London.

Harding, S. (1986). *The Science Question in Feminism*. Ithaca: Cornell University Press.

Hartman, M., and L. Banner. (Eds.) (1974). *Clio's Consciousness Raised*. New York: Bantam Books.

Hein, H. (1981). "Women and Science: Fitting Men to Think about Nature." *International Journal of Women's Studies* 4, pp. 369–77.

Hennig, M., and A. Jardim. (1977). *The Managerial Woman*. New York: Anchorage-Doubleday.

Hoffman, J. (1982). "Biorhythms in Human Reproduction: The Not So Steady States." *Signs* 7, no. 4, pp. 829–44.

Hollingsworth, L. S. (1914). "Variability as Related to Sex Differences in Achievement." *American Journal of Sociology* 19, no. 4, pp. 510–30.

Holloway, M. (1993). "A Lab of Her Own." *Scientific American* 269, no. 5, pp. 94–103.

hooks, b. (1981). *Talking Back: Thinking Feminist, Thinking Black*. Boston: South End Press.

———. (1983). *Feminist Theory from Margin to Center*. Boston: South End Press.

———. (1990). *Yearning: Race, Gender, and Cultural Politics.* Boston: South End Press.

Hrdy, S. B. (1977). *The Langurs of Abu: Female and Male Strategies of Reproduction.* Cambridge: Harvard University Press.

———. (1979). "Infanticide among Animals: A Review, Classification and Examination of the Implications for the Reproductive Strategies of Females." *Ethology and Sociobiology* 1, pp. 3–40.

———. (1981). *The Woman That Never Evolved.* Cambridge, Mass: Harvard University Press.

———. (1984). Introduction to Female Reproductive Strategies. In M. Small (Ed.), *Female Primates: Studies by Women Primatologists.* New York: Alan Liss.

Hubbard, R. (1979). Introduction to Ruth Hubbard and Marian Lowe. (Eds.), *Genes and Gender II: Pitfalls in Research on Sex and Gender,* pp. 9–34. New York: Gordian Press.

———. (1990). *The Politics of Women's Biology.* New Brunswick, N.J.: Rutgers University Press.

Hynes, P. (1989). *The Recurring Silent Spring.* Elmsford, N.Y.: Pergamon Press.

———. (in press). No Classroom Is an Island. (Ed.) Sue V. Rosser, *Teaching the Majority.* New York: Teachers College Press.

Jaggar, A. (1983). *Feminist Politics and Human Nature.* Totowa, N.J.: Rowman and Allanheld.

———, and P. Rothenberg. (Eds.). (1984). *Feminist Frameworks.* New York: McGraw-Hill.

Jones, J. H. (1981). *Bad Blood: The Tuskegee Syphilis Experiment—A Tragedy of Race and Medicine.* New York: Free Press.

Keller, E. F. (1982). "Feminism and Science." *Signs* 7, no. 3, pp. 589–602.

———. (1983). *A Feeling for the Organism.* San Francisco: Freeman.

———. (1985). *Reflections on Gender and Science.* New Haven: Yale University Press.

Keynes, H. B. (1989). University of Minnesota Talented Youth Mathematics Project (UMPTYMP); Recruiting Girls for a More Successful Equation. *ITEMS* University of Minnesota Institute of Technology. Spring.

Kramarae, C., and P. Treichler. (1986). *A Feminist Dictionary.* London: Pandora Press.

Kristeva, J. (1984). *The Revolution in Poetic Language.* New York: Columbia University Press.

———. (1987). *Tales of Love.* New York: Columbia University Press.

Lakoff, R. (1975). *Language and Woman's Place.* New York: Harper.

Lancaster, J. (1975). *Primate Behavior and the Emergence of Human Culture.* New York: Holt.

Leavitt, R. (1975). *Peaceable Primates and Gentle People: Anthropological approaches to women's studies.* New York: Harper.

Leibowitz, L. (1975). Perspectives in the Evolution of Sex Differences. In Rayna Reiter (Ed.), *Toward an Anthropology of Women.* pp. 20–35. New York: Monthly Review Press.

Lloyd, G. (1984). *The Man of reason: 'Male' and 'Female' in Western Philosophy.* London: Methuen.

Lorde, A. (1984). *Sister Outsider,* Trumansburg, N.Y.: Crossing Press.

MacKinnon, C. (1987). *Feminism Unmodified*. Cambridge, Mass: Harvard University Press.

Martinez, M. E., and N. A. Mead. (1988). *Computer Competence: The First National Assessment,* pp. 43–47. Princeton, NJ: Educational Testing Service.

Matyas, M. L. (1985). Obstacles and Constraints on Women in Science. In J. B. Kahle (Ed.), *Women in Science.* pp. 77–101. Philadelphia: Falmer Press.

Matyas, M., and Malcolm. S. (1991). *Investing in Human Potential: Science and Engineering at the Crossroads.* Washington, D.C.: AAAS.

Merchant, C. (1979). *The Death of Nature: Women, Ecology and the Scientific Revolution.* New York: Harper.

Mill, H. T. (1970). Enfranchisement of Women. In Alice S. Rossi (Ed.), Essays on Sex Equality, pp. 89–122. Chicago: University of Chicago Press.

Mill, J. S. (1970). The Subjection of Women. In Alice S.Rossi (Eds.). *Essays on Sex equality,* pp. 123–242. Chicago: University of Chicago Press.

Millett, K. (1970). *Sexual Politics.* Garden City, N.Y.: Doubleday.

Murray, T., M. Rothstein, and R. Murray. (1996). *The Human Genome Project and the Future of Health Care.* Bloomington: Indiana University Press.

National Research Council (1994). *Women Scientists and Engineers Employed in Industry: Why So Few?* Washington, D.C.: National Research Council.

National Science Foundation. (1992). *Women and Minorities in Science and Engineering: An Update.* (NSF 92–303). Washington,D.C.: NSF.

———. (1994). Personal Communication from Lola Rogers.

O'Brien, M. (1981). *The Politics of Reproduction.* Boston: Routledge and Kegan Paul.

O'Connell, A., and N. Russo. (1983). *Models of Achievement.* New York: Columbia University Press.

Office of Technology Assessment (1987). *New Developments in Biotechnology Background Paper: Public Perceptions of Biotechnology.* (OTA-BP-BA-45). Washington, D.C.: author.

Rich, A. (1976). *Of Woman Born: Motherhood as Experience.* New York: Norton.

Ross, J., and S. Rosser. (1994). Science and Diversity: Two Systematic Approaches to Curriculum Changes. Presentation at the National Association for Science, Technology, and Society Annual Meeting, 12–23 January, Arlington, Va.

Rosser, S. V. (1982). "Androgyny and Sociobiology." *International Journal of Women's Studies* 5, no. 5, pp. 435–44.

———. (1986). Women in Science and Health Care: A Gender at Risk. In Sue V. Rosser (Ed.), *Feminism Within the Science and Health Care Professions: Overcoming Resistance,* pp. 3–15. Elmsford, NY: Pergamon Press.

———. (1988). *Feminism within the Science and Health Care Professions.* New York: Pergamon Press.

———. (1990) *Female Friendly Science.* Elmsford, N.Y.: Pergamon Press.

———, and B. Kelly. (1994). "From Hostile Exclusion to Friendly Inclusion: USC System Model Project for the Transformation of Science and Math Teaching to Reach Women in Varied Campus Settings." *Journal of Women and Minorities in Science and Engineering* 1, no. 1, pp. 29–44.

Rossiter, M. W. (1984). *Women Scientists in America: Struggles and Strategies to 1940.* Baltimore: Johns Hopkins.

Rothfield, P. (1990). Feminism, Subjectivity, and Sexual Difference. *Feminist Knowledge: Critique and Construct*. New York: Routledge.

Rowell, T. (1974). "The Concept of Social Dominance." Behavioral Biology 11, pp. 131–54.

Sadker, M., and D. Sadker. (1994). *Failing at Fairness: How America's Schools Cheat Girls*. New York: Scribner.

Sanders, J. (1985). "Making the Computer Neuter." *The Computing Teacher* April: 23–27.

———. (in press). Girls and Technology: Villain Wanted. In Sue V. Rosser (Ed.), *Teaching the Majority*. New York:Teachers College Press.

Sayre, A. (1975). *Rosalind Franklin and DNA: A Vivid View of What It Is Like to Be a Gifted Woman In an Especially Male Profession*. New York: Norton.

Schiebinger, L. (1989). *The Mind Has No Sex? Women in the Origins of Modern Science*. Cambridge: Harvard University Press.

Schuster, M., and S. Van Dyne. (1984). "Placing Women in the Liberal Arts: Stages of Curriculum Transformation." *Harvard Educational Review* 54, no. 4, pp. 413–28.

Sebrechts, J. (1992). "The Cultivation of Scientists at Women's Colleges." *The Journal of NIH Research* 4 (April): 22-26.

Sells, L. (1975). "Sex and Discipline Differences in Doctoral Attrition." Ph.D. diss., University of California at Berkeley.

Shaver, P. (1976). "Questions Concerning Fear of Success and Its Conceptual Relatives." *Sex roles* 2, pp. 205–20.

Spanier, B. (1982). "Toward a Balanced Curriculum: The Study of Women at Wheaton College." *Change* 14 (April): 31–34.

Sperry, R. W. (1974). Lateral Specialization in the Surgically Separated Hemispheres. In Schmitt, Francis O., and Frederic G. Wardon, (Eds.), *The Neurosciences: Third Study Program*. Cambridge: MIT Press.

Steinmark, J., V. Thompson, V. and R. Cossey. (1986). *Family Math*. Berkeley: EQUALS Project, Lawrence Hall of Science.

Tannen, D. (1990). *You Just Don't Understand*. New York: Ballantine.

Tanner, A. (1896). "The Community of Ideas of Men and Women." *Psychological Review* 3, no. 5, pp. 548-50.

Tapper, M. (1986). *"Can a Liberal Be a Feminist?"* Supplement to the *Australian Journal of Philosophy*.

Thomas, Valerie (1989). "Black Women Engineers and Technologists." *Sage* 4, no. 2, pp. 24–32.

Tidball, M. E. (1986). "Baccalaureate Origins of Recent Natural Science Doctorates." *Journal of Higher Education* 57, p. 606.

Tong, R. (1989). *Feminist Thought: A Comprehensive Introduction*. Boulder, Colo.: Westview Press.

Treisman, P. U. (1992). "Studying Students Studying Calculus: A Look at the Lives of Minority Mathematics Students in College." *The College Mathematics Journal* 23, no. 5, pp. 362–72.

Trivers, R. L. (1972). Parental Investment and Sexual Selection. In B. Campbell (Ed.), *Sexual Selection and the Descent of Man*. pp. 136–79. Chicago: Aldine.

Vetter, B. (1988). Where Are the Women in the Physical Sciences? In Sue V. Rosser.

(Ed.), *Feminism Within the Science and Health Care Professions: Overcoming Resistance*. Elmsford, N.Y.: Pergamon Press.

———. (In press.) Women in Science, Mathematics and Engineering: Myths and Realities. *Cross University Research in Engineering and Science*.

Wahl, E. (1993). "Getting Messy." *Science* 260 (16 April): 412–413.

Wheeler, P., and A. Harris. (1979). *Performance Differences Between Males and Females on the ATP Physics Test*. Berkeley, Calif.: Educational Testing Service.

Will, C. P. Self, and N. Datan. (1974). Paper presented at 82nd annual meeting of the American Psychological Association.

Wilson, E. O. (1975). *Sociobiology: The New Synthesis*. Cambridge: Harvard University Press.

Wollstonecraft, M. (1975). *A Vindication of the Rights of Woman*. Carol H. Poston (Ed.) New York: Norton.

Vetter, B. M. (1992). What Is Holding Up the Glass Ceiling? Barriers to Women in the Science and Engineering Workforce. Occasional Paper 92–93, Washington, D.C.: Commission on Professionals in Science and Technology.

Women's Community Cancer Project. (1992). *A Woman's Cancer Agenda: The Demands*. Cambridge: Women's Center.

———. (1994). National Breast Cancer Coalition. *Women's Community Cancer Project Newsletter* 4 (winter): 4.

Yentsch, C., and C. Sinderman. (1992). *The Woman Scientist*. New York: Plenum.

Yerkes, R. M. (1943). *Chimpanzees*. New Haven: Yale University Press.

FAMILY AND PUBLIC POLICY

Twenty-First Century Sociocultural and Social Policy Issues of Older African-American and Older African Women

BRENDA KIPENZI JOYCE CRAWLEY

THIS essay focuses on several policy issues that will affect older African-American and older African women in the twenty-first century. Older women in America as well as African older women exhibit similar sociodemographic profiles, for instance, the ratio of men to women is decreasing, women are living longer than men, and marital status is a shifting variable as these women age. In the United States, socioeconomic status concerns include poverty's disproportionate effects on older African-American women and income (in)security as expressed through the social security system. Finally, older African-American women face social and family life concerns that must come to terms with the role of older women as caregivers and the effects of desertion/divorce. Older African women, as described in this essay, face three concerns and issues of importance: (a) minorization of females/women/wives; (b) selected effects of development; and (c) faltering and failing traditional support for elders.

This essay first discusses African-American women and then African women. No effort is made to force false analogies or dichotomous thinking about the two groups. Rather, the focus is on presenting a picture of concerns and issues in later life for women of African descent. The attempt is to stand two portraits side by side and to observe the features of each. As with any portrait, one may notice specific or vague familiarities but not impose characteristics on each. The position taken here is that observing the tapestry of the lives of older women of African descent held in juxtaposition can provide its own illumination.

285

Older African-American Women

Sociodemographic Profile of Older African-American Women

Age and Location

In 1992, there were approximately 3 million African Americans 65 years of age or older. Of these, almost 64.0 percent were older African-American women. Overall, older African Americans are the fastest-growing segment of the African-American population. Between 1970 and 1980, older Blacks increased 34.0 percent while the total Black population increased 16.0 percent (portrait of Older Minorities; n.d.).[1] By 1992, older African-American women represented three out of five elderly African Americans (Bennett, 1992, p. 22). Among older African-American women between 1910 and 1980, there was an almost sixfold increase in those 60 to 64 years of age, an eightfold increase in those 65 to 74 years of age, and a sevenfold increase for those 75 years of age and older (U.S. Department of Commerce, 1983, pp. 1–43). The majority of African-American women over age 60 live in urban areas, the remainder in rural areas. Of those aged 55 years and older, the majority of African-American women live in the South—56.0 percent. Whereas 17.6 percent live in the Northeast; 20.0 percent in the Midwest; and 6.4 percent in the West (Bennett, 1992, p. 27).

Marital Status

The majority of older African-American women are unmarried— over one half (56.2 percent) of older African-American women aged 65 years or older are widowed, approximately one-eighth are divorced/separated (13.3 percent), and 5.7 percent are single (never married)—one quarter are married (Bennett, 1992, p. 30).

Poverty Status

Slightly over one half of all elderly African-American women "were either poor or marginally poor" in 1983 (National Caucus, 1985, p. 5). By 1991, these figures had not significantly changed. When consideration is given to poverty rates for African-American women 55 years of age and older, 74.0 percent or three-fourths are below the poverty level. Those aged 65 years and older reflect a 39.3 percent below-the-poverty-level rate (Bennett, 1992, p. 68). The U.S. House Select Committee on Aging (1987, p. 8) reports "that

the situation is especially precarious for single elderly Black women (individuals living in single households or with non-relatives). Of those in this group, about seven out of every eight (87.9 percent) are either poor or economically vulnerable."

Economic Status

While older women in general have lower incomes than older men, the differences can also be seen between older African-American women and older white women. The U.S. House Select Committee on Aging noted that: (a) median income for older African-American women was 67.0 percent of that for older white females; and (b) a retired older African-American female's average social security benefit was 82.1 percent of the older retired white female's benefits (1987). Older African-American women are disproportionately dependent on social security benefits and on supplemental security income programs. They, in general, lack income from private pensions, annuities, and assets.

Economic Status Policy Issues

This sociodemographic information suggests that several concerns related to financial security for older African-American women be explored as we face the twenty-first century. Albeit gradually, an increasing number of African-American women are exposed to occupations that provide private pension plans (U.S. Commission on Civil Rights, 1990). Thus, it will be necessary to examine the terms and provisions of private pension laws that can affect their income in old age. Additionally, it is also likely many older African-American women in the twenty-first century will have a strong reliance on social security benefits. As a result, the inequities against women posed by the social security system will be examined.

Private Pension Plans

It is necessary to acknowledge that the current cohort of older African-American women did not have, in most cases, the opportunity for employment in occupations providing private pension plans. For example, the U.S. Commission on Civil Rights (1990) reported the following occupational profile for African-American women who were 35–44 years of age in 1960 (in 1990, they would have been 65–74 years of age); private household workers (35.7 percent); service workers (24.4 percent); operatives (16.4 percent); 7.5 percent

clerical workers; 7.9 percent professional and technical workers; and all other occupational categories (approximately 10.0 percent).[2] Nor did older African-American women possess adequate paying jobs that permitted sufficient savings to acquire annuities or to build retirement portfolios. This is also the case for numerous older white women (Crawley, 1994). In fact, older men receive private pensions at twice the rate of all older women (Leonard, 1987, p. 1). Additionally, when differences are noted by gender and race, older white females are ". . . more than twice as likely to receive a private pension. . . ." as their African-American female counterparts (U.S. House Select Committee on Aging, 1987). Given older African-American women's overall low income levels from all sources in retirement and given their high rates of widowhood and divorce, the lack of private pension by so many of them is very problematic.

In addition to the concern for the lack of pensions for the current cohort of older African-American women, attention must be given to those who will enter older adulthood, for instance, 65 years of age, within the first decade of the twenty-first century. When we examine the 1980 labor force participation rates of those 45–54 years of age we note that slightly over two-thirds of African-American women were employed (U.S. Commission on Civil Rights, 1990, pp. 137–38). For example, of those 45–54 years of age in 1980 (they will be 65 to 74 in 2000), 10.5 percent were private household workers; 33.6 percent were service workers; 10.8 percent were operatives; 18.1 percent were clerical workers; 17.3 percent were professional and technical; and all other occupational categories (approximately 10.0 percent) (1990 pp. 137–38).[3]

With increased opportunities in occupations offering pensions, a segment of older African-American women will face the following issues regarding private pension policy: vesting rights and break-in service. These policies have been selected because they represent areas of concern to women's work histories. Women find it necessary to interrupt their work histories for pregnancy, child care responsibilities, and increasingly for parent care and for other general family demands. Such interruptions do not mean that female workers welcome these breaks in their work lives. Rather, there is clear evidence that females more than males are expected to accommodate their work experiences to these care demands. Older African-American women in the twenty-first century will need to consider the impact of interruptions on their eligibility for collecting on a private pension plan at the time of retirement.

Vesting rights address criteria used to determine an employee's eligibility to receive a pension from an employer. Prior to the Tax

Reform Act of 1986 (TRA), ten years of employment was required by the majority of firms before an employee would be vested, that is, able to draw benefits upon retirement. The TRA reduced the eligibility period to five years of employment, on average, before an individual is considered to have been vested.

Along with this five-year period criterion, there is a graded vesting feature that will, under certain circumstances, assist all workers who have breaks in their work histories (Crawley, 1994). In particular, women will benefit from this feature. The Retirement Equity Act of 1984 (REACT) prevents loss of vesting credits if the break-in service does not exceed five years or the period of earlier employment (Leonard, 1988, p. 6).

The change from a ten-year to a five-year vesting period theoretically made it possible for more workers in general and more female workers in particular to qualify for private pension plans. A report to the U.S. House Select Committee on Aging recommends an additional change from five years to three years of employment for full vesting (1987, p. 2). A policy shift to the three-year period would recognize that "the median number of years of employment for women workers is 3.1 (5.1 for men)" (U.S. House Select Committee, 1987, p. 20).[4] The use of a three-year vesting period takes into account the discontinuous work record many women experience because of familial and household responsibilities. As African-American women move into more of the occupations where the provision of private pension plans are common, they can be expected to benefit from improved vesting rights policies.

Vesting and break-in service policies are not, of course, the only private pension issues older women will face in the twenty-first century. As shifts in the structure of the economy, plant closings, business downsizing, and pension fund insolvencies increase, many workers are at risk of not having or losing private pensions. Increasingly, workers will be expected to assume more responsibility for their retirement private pension provisions. For example, Lewis (1991) points out that the American Association of Retired Persons reports in its study, "to a greater extent than in the past, the study says, employees will be on their own in building pension income and furthering their own careers" (p. 1).

This means that African-American women must assume greater responsibility for developing their retirement portfolios. It will become necessary for older African-American women (and for current middle-life African-American women) to become educated about IRAS, 401(K) plans, ". . . and other forms of capital accumulation for their retirement income" (Lewis, 1991, p. 1). In the twenty-first

century, older African-American women must face the issues of retirement planning by being aware of laws affecting private pensions as well as tax laws and policies governing the development of their own retirement pension income.

Inequities in the Social Security System

If the following five inequities in the social security system persist into the twenty-first century, older African-American women will continue to bear the brunt in their high levels of poverty. First, if an older woman's social security pension is based on her earnings, the benefits are usually low due to low wages. This poses an especially bleak picture for older African-American women, many of whom have been confined to low-wage occupations. For while there has been some moderate upward occupational mobility for African-American women, ". . . relative to comparative white women, black women were found to be underrepresented in middle- and high-status occupations and overrepresented in low-status occupations" (U.S. Commission on Civil Rights 1990, p. 3).
Low-status occupations mean low wage occupations, as the U.S. Commission on Civil Rights (1990) points out:

> In the 1980s, black women over 40 earned only 88 percent as much as comparable to white women. . . . Older black women's lower relative earnings appear to be because they are in lower status occupations relative to their white counterparts. This result suggests that older black women have not overcome the effects of past labor market discrimination. . . . Thus, past discrimination reduces older black women's economic status today. (p. 3)

Not only today's cohort of older African Americans, but also those who will become older cohorts in the first quarter of the twenty-first century will face low social security benefits based on their lifelong wages. This means that older African-American women are twice penalized by societal discrimination and inequities, for instance, once through lifelong low wages due to occupational/labor force discrimination and again through the structure of the social security system that will penalize them (by low pension amounts) for such low wages. For example, a retired older African-American female worker's average social security benefit of $317, is 82.1 percent of the older retired white female's benefit of $386 (U.S. House Select Committee on Aging, 1987, p. 11).
Second, if married, a woman and her husband must give up one of their social security checks. While not an issue unique to older

African-American women, it is one that hits them particularly hard. As the older African-American woman and her older African-American husband have likely both been subject to lifelong discrimination in the form of low wages, it is disturbing to find their income choice in old age limited to the use of only one low-wage work history for determining the public pension amount they will receive.

Third, a compounding of the second inequity occurs when a spouse dies and the surviving spouse then receives a reduction in the pension amount. Thus, it is the case that low income through earnings and the national pension system plague the older African-American female through life.[5]

The fourth inequity relates to the fact that divorced spouses can receive spousal benefits only if they had been married ten years. This condition holds regardless of the family life contributions the wife has made "which made it possible for her husband to pursue a high-paying career" (Crawley, 1994a, p. 169). The final issue relates to the fact that paid employment in several occupations are not covered by the social security system until the wage levels reach a certain limit. Regrettably, compared to their white counterparts, older African-American women are overrepresented in domestic work and farm labor—neither of which are covered by social security unless wage levels meet this requirement.

It is obvious to many that reform of the social security pension system is essential for women-workers (Fackos, 1981, pp. 19–21). Possible policy responses to the inequities include using the work histories of both spouses in determining the final pension amount for two-earner families whose incomes fall below a certain level. With divorces occurring during shorter periods of marriage than in the past, it may be necessary to shorten the period to less than ten years. Finally, it may be in society's best interest (especially if women are expected to serve as full- or part-time homemakers) to institute a policy that values homemaking as a legitimate occupation, impute economic value to its worth, and pay a public pension in retirement to those who work in this occupation.

Family Life Policy Issues

Economic status and family life policy issues intersect each other and hence no clear lines can necessarily be drawn between them. For example, break-in service from employment to provide care to a family member significantly affects one's earning record as well as pension planning. Likewise, divorce can significantly affect the income level of older women.

Divorce

Older African-American women are more than twice as likely to be divorced as older white women. In fact, older women of color, for instance, Hispanics/Latinas, Asians, Pacific Islanders, and Native Americans have proportionately higher divorce rates than their white counterparts (Portrait of Older Minorities, n.d.; Zastrow and Kirst-Ashman, 1990). In the face of this, older African-American women must be concerned with divorce laws and practices. There are two areas of special concern in this section: the handling of spousal support and the disposition of marital property.

As reported by Crawley, spousal support is currently handled as a privilege and/or temporary income award—until employment is found (1994a). This means that women cannot expect to be automatically awarded spousal support (as assumed in the past). So even if an older African-American woman extensively contributed to the maintenance of the household and supported her spouse's career development and hence lifetime earnings potential, upon divorce she, like other women, cannot depend upon the legal system and courts to fairly or justly compensate her efforts. This is particularly tragic in situations where the woman may have bypassed a career in favor of part-time work, selected a low-status occupation that did not demand educational/professional upkeep, or settled for marginal wages to accommodate the needs of the husband's employment and her family responsibilities. It cannot be assumed this has not been the case for some older African-American women, for as Jackson has frequently pointed out, older African-American women are not a homogeneous group (1988, pp. 31–32).

The next issue related to divorce is the disposition of marital property. Two properties—pension benefits and education and licenses—are increasingly being involved in divorce settlements. Each of these properties represent important opportunities for the older African-American woman's financial planning for retirement. Older African-American women, as do women in general, have a stake in how pension benefits are legally defined. "For many, if pension benefits are defined as marital property they will be treated as divisible property" (Crawley, 1994a, p. 170). Through the use of the concept of enhanced earning power, spouses would become entitled as a right to some of the economic value of licenses and/or education if she contributed to these properties being obtained and used in ways to increase their value (Leonard, 1987, p. 6).

As more spouses lay claim to pension benefits and to the financial value of education and/or the financial value of licenses during di-

vorce proceedings, the courts' view on women's entitlement to these marital properties will become clearer. Legal judgments made in regard to these properties are of vital interest to the older woman as the outcomes have important consequences for her economic status as she ages.

Caregiving

Caregiving as a social policy issue is moving to the forefront of national attention. Among the factors contributing to the increasing attention are increased life expectancy accompanied by greater risks of illness and need of assistance, lack of national caregiver policies, and shortages of noninstitutional personal care services such as day care, adult foster care, respite care, and home health aides.[6]

African-American women have always had to juggle family care responsibilities, parenting, and elderly caregiving along with employment. In the past, however, these women have relied on extended family networks, relatives and kin, and/or persons from the neighborhood/community as informal support networks. While it is beyond the scope of this essay to resolve the debate over whether the Black American extended family structure is diminishing, what is clear is that the extended family form is significantly affected by modern stresses and strains that may create less support from such sources (Young, 1989, p. 212).

As they age, African-American women will likely face caregiving responsibilities with fewer familial-relative-kinship-informal network support than previous generations. In light of this, it is essential that older African-American women (a) support legislators who advocate for family leave policies that cover care of spouses, children, and parents; (b) encourage their employers to view caregiving-friendly policies as important to the business firm as ". . . absenteeism is reduced, productivity is maintained or upgraded, and employees have a more positive outlook" (Crawley, 1994b, p. 168); and (c) assist religious institutions in their communities to develop programs to aid older African-American women struggling with caregiving. It is also important for older African-American women to develop or maintain the types of social networks they will need to assist with caregiving responsibilities. Such networks include ongoing healthy relationships with adult children, cultivation and maintenance of friendships near and far, active membership in valued religious and social groups, and connections with neighbors that include reciprocal exchanges of services when in need.

Older African Women

There is no single profile of *the* older African woman (women). Africa is a very diverse continent currently with fifty-two countries. Each country boasts many and varied ethnic and cultural groups. In addition, regional and geographic peculiarities differentiate populations on the continent. For purposes of this essay, several countries from mostly the southern region of sub-Saharan Africa (SSA) will be used: Zimbabwe, Zambia, Tanzania, Lesotho, Mauritus, and Swaziland plus Kenya, Ivory Coast, and Ghana. Hereafter, these countries will be referred to as "these countries" unless a specific country is named.

Additionally, because of a paucity of census and other data, for purposes of this essay, composite portraits will be drawn to discuss older African woman/older African women.[7] It is necessary to extrapolate information about these older African women from the extremely limited materials available about them and also from materials dealing with the policy and sociocultural issues facing African women of all ages from these locations. It is hoped that in broaching these three areas, for instance, (1) minorization of women and especially married women; (2) selected effects of development; and (3) faltering and failing traditional support for the elderly, additional studies and research will be encouraged. Discussion of these areas will be preceded by a sociodemographic sketch.

Sociodemographic Sketches of Older African Women

Data generally show that African women from these countries have higher life expectancy rates than the men. For example, in Tanzania life expectancy for males is 49 years of age and for females it is 52 years of age. Whereas in Zimbabwe the ages are 52 and 60 respectively for males and females. In Kenya nondisaggregated figures were used and showed that in the early 1980s overall life expectancy was 55 years of age, but recently increased to 60 years of age (Dixon, 1987). One also reads accounts of 70-, 80-, 90-, and even 100-year-old survivors, both male and female (Barnes and Win, 1992).

Whether using the few statistics available or anecdotal materials, the picture that generally emerges for these older African females appears to be similar to that reported by the United Nations (1991) on the picture worldwide—women are much more likely to make it to older age than men. Though in a few developing countries life expectancy is greater for men than women (United Nations, 1991).

The U.N. report notes that differences by sex are projected to increase: "Between 1985 and 2025, projected increases for persons aged 70 and above are 32 million for males and 38 million for females in the developed regions, and 284 million for males and 317 million for females in the developing regions" (p. 19).

It may not be the case that today we find large populations of 70-year-olds in these developing African nations. However, it is reasonable to assume that if the following conditions persist, for instance, continued lower infant mortality rates, increased nutritional standards, improved housing and sanitation, and other favorable factors, a larger older population may result. What is clear is that in the future the developing regions of the world will have a larger share of the world's elderly—there will be increases in Asia, Latin America, and Africa (United Nations, 1991, p. 15).

In light of the fact that Africa is among the developing regions of the world that will experience a larger share of the world's elderly and because of the greater likelihood of women outliving men, it is reasonable to examine some sociocultural and social policy issues that will affect older African women in the twenty-first century. The three issues include: (a) the minorization of females/women and especially married women; (b) selected effects of development; and (c) faltering and failing traditional supports and social sanctions for the care of the elderly by family and community. These three issues encompass the legal, judicial, political, economic, and social fabric of women's lives. Attention to, and action on, these issues can significantly improve the quality of older women's lives in the future.

Minorization of Females/Women/Wives

The idea that females are the property of their fathers and husbands is not new to American and Western cultures and legal systems. Nor would it greatly surprise an informed reader that women and wives in American society have been treated as minors. Hence, it will not come as any surprise that in a number of African countries there are laws and/or customs that treat women as property and minors. One notes for examples in Lesotho that:

> In theory, a woman under customary law is a perpetual minor. She lacks capacity to own and control property in her own right. Before marriage she is under the father's guardianship. Upon marriage she comes under her husband's guardianship. Once the marriage is dissolved by divorce, she reverts back to her father's guardianship. If the marriage is dissolved by death of the husband, she remains at the marital home. She will be

under the guardianship of senior male elders of the family. (Mamashela, 1992, p. 170)

In Swaziland, the situation is characterized:
For example as far as women are concerned age is irrelevant; for all practical purposes she is a minor from cradle to grave. As an infant she is a minor under the guardianship of her father and this right passes to her husband upon marriage. Upon divorce it reverts to her father or his heir where the father is deceased. De jure discrimination against women under Swazi law and custom must, therefore, be understood against this kind of background of patrilineal heritage. (Iya, 1992, pp. 154–55)

The minorization of females throughout their lives have had and continue to have a profound effect on the quality of women's lives (*Maintenance in Lesotho,* 1991). This minorization expresses itself in women's lack of rights to control over property in the marriage, lack of inheritance rights and restrictions on making contracts, opening bank accounts, securing loans (without the husband's approval); and the like (Iya, 1992; Lesaoana, 1993; *Maintenance in Lesotho,* 1991; Mamashela, 1991; Mwansa, 1992). For the majority of older African women these conditions can create tremendous hardships, such as in the case of divorce in the later years. A divorced older African woman may find herself homeless and/or destitute. Mamashela (1992) acknowledges this point when she indicates that

Upon dissolution of the marriage by divorce, the husband would expect the former wife to go back to her maiden home with only her personal belongings. Depending on the duration of the marriage, she may not have a home to go back to. If the home still exists, the heir in her family would have stepped into his father's shoes and would be occupying the home with his wife. Hostility in a different kind awaits her; she will be a stranger to the brother's wife and invariably the relationship between them will be one of muted envy and jealousy. A woman under customary law is in an unenviable invidious position. Except for her personal belongings, a divorced woman is not entitled to property accumulated during the subsistence of the marriage through joint effort. (p. 170)

Thus, for the divorced older woman, a lifetime of labor and goods can be lost with a change in marital status.

Not only divorce laws but laws of inheritance severely impoverish widows, as the property passes to male heirs and in-laws. Some widows' property is cannibalized within hours of the husband's death. This, of course, affects not just older widows. The situation in Zambia has reached such alarming proportions that in-laws have been dubbed "outlaws," as they raid and strip bare a widow and

her children's home, bank accounts, and businesses (The Disgusting Grabbers, 1993; Rude, 1993). As with the other areas of development and traditional support, policy changes that are gender sensitive and make use of women in the debates, decision-making, implementation and evaluation of society's institutions, laws, and programs, can benefit all women older and younger.

Reform of laws be they common law, customary law, statutory law, and/or "living law" (Mamashela, 1992, p. 168) is essential to relieve older (and all) women in the following ways: (a) after divorce women need legal protection of their interests in joint/common property they helped to accumulate in a household (nonpaid child-rearing and household responsibilities along with any income-generating work that constitutes their contribution) or a business; (b) the joint accumulation of an estate, however modest or elaborate, should not be distributed in ways or under conditions that disadvantage a spouse who over a lifetime helped to develop the estate; and (c) making contracts, opening bank account(s), and/or securing loans—any or all of these actions are necessary to run a business and in most cases to operate a household. Restrictions on a woman's right to use any of these for income development or for any purpose that a woman deems necessary clearly restricts her options to be self-supporting and to plan and save for her later years.

It is fortunate that some women and men behave contrary to the aforementioned restrictive laws. "In practice, the situation is different. As customary law is not static, the position of women under customary law has changed tremendously with the socioeconomic changes that have affected the Basotho society.[8] Some women in practice do in fact control property, enter into legal transactions on their own, bring civil and criminal actions in court unassisted by their husbands/guardians, [sic] make written instructions to dispose of their property after death" (Mamashela, 1992, p. 170).

As long as the laws remain as they are written, women will remain in a precarious position and subject to the political and economic vicissitudes of a society. Legal protection for these older African women must catch up with the level of changes that Mamashela and others cite (Iya, 1992; Mamashela, 1992; Rude, 1993; United Nations, 1991). Changes to improve the lives of these older African women and women in general are needed not only in the legal sphere but in the two remaining areas to be addressed, for instance, selected effects of development and faltering and failing traditional supports.

Effects of Development

It is not possible to think about development in sub-Saharan Africa without thinking of the role of women in agriculture (Fighting for

Rural Rights, 1994; Nindi, 1992; Rempel, 1992). More specifically, in this essay's context, one thinks of "female farming" that is described as the case where ". . . food production is taken care of by women with little help from men" (Nindi, 1992, p. 125). Current estimates are that ". . . on average women are a high 46 percent of the agricultural labor force of SSA" (Nindi, 1992: 125). Younger and older women frequently must use their agricultural products not only for feeding their families but must produce them to earn money to support their families (Fighting for Rural Rights, 1994; Rempel, 1992).

The oft-repeated policy issue is that women are excluded from decision-making and from policy development in the agricultural sphere (Fighting for Rural Rights, 1994; Nidi, 1992). If there are loan schemes, technological knowledge and skills, and commercial structures that will impact farming and agricultural work, then women must be included as policy decision-makers. Yet, these African countries' continued adherence to ". . . clear differentiation of roles according to gender leaves men in salient policy decision-making and development positions (African Women Assess Role in Development, 1984, p. 1). Not infrequently policies are developed and implemented that are inimical to the interests and progress of women farmers (Expert Group Meeting on Integration of Aging Elderly Women into Development, 1991; Nindi, 1992).

To ignore the role and years of experience of these older African women and their expertise in agriculture delays progress and supports a lower quality of life for older women and for those dependent on them. The following example is a case in point. Seventy-six-year-old Mrs. Khuzwayo tried for over ten years to convince the chief and men of Mansomini, South Africa, that self-help would be the wisest course of action for developing the sugar cane area of their community. Reasons given by the men for their refusal to accept her repeated proposal included a belief by the chief that the women were ". . . going to become rich, and they're not going to respect me anymore" and some believed she was going to give the land to white people (Gales, 1994, p. 42). However, today, after eleven years of experience with her community-based program, this area relative to surrounding communities is described as ". . . a model in an industry that has developed the most substantial and successful small-holder sector of the country" (Gales, 1994, p. 42).

It is not only in the area of agriculture that older African women can and should make a contribution. Older African women can make responsible decisions and development in their own behalf as demonstrated by a self-help project in Kenya's Shimba Hills. Women

concerned with being able to maintain their independence as they aged organized, developed, and managed a program of securing clean and safe water and poultry-keeping—the latter involved selling chickens and eggs to tourist hotels as well as to local residents (United Nations, 1991, pp. 97–98).

What also must be recognized is that today's African women from these countries who are now between the ages of thirty to forty will be the older women of the twenty-first century. These African women are presently living through turbulent transitions and cultural revolutions where the United Nations Universal Declaration of Human Rights and the African Charter on Human and People's Rights are at least on record for an elimination of all forms of discrimination against women (Expert Group Meeting, 1991; Mamashela, 1992, p. 175; Violence against Women, 1991). One response to these documents is that legal experts in various African countries are using the human rights provisions of the charter and declaration to change national legislation to reflect equality before the law *for women* and men. This involves contract law, property rights, freedom of movement—in short, the whole of women's existence should be subject to ". . . equality before the law; . . ." (Mamashela, 1992, pp. 173–74). To the extent that these African legal experts are successful in transforming the charter and declaration into instruments of greater legal and judicial liberation for all women, older women will also receive the benefits.

Policies that begin now to take account of these women's lives and roles in economic, agricultural, ecological, and all development aspects can make significant strides toward the elimination of discrimination of women in the twenty-first century. Additionally, gender sensitive policy development and implementation can assist today's older women—and the society as a whole (Dick, 1992; Fighting for Rural Rights, 1994; Nindi, 1992; Rempel, 1992). King Ooshoeshoe II, of Lesotho, spoke to the issue of improvement for society through improvement of women's lives:

It is our women who, more than any other section of our society, have had to pay the price of the lack of economic progress in development. The amount of responsibility they take has not been matched by any significant growth in their status; or their influence. . . . We shall not succeed in socially transforming our society unless we are prepared to alter the status of women. (as quoted in Ntimo-Makara, 1993, p. 65)

A call to right past wrongs as relates to effects of development is made all the more urgent when one considers the precarious position

some older African women face as traditional practices of support for the elderly falters and fails in changing African environments. Urbanization, impacts of structural adjustment programs, changing patterns of migration, rise of nuclear families (related to urbanization), and socioeconomic developments make it urgent that older African women be freed of limitations that negatively affect their opportunities.

Faltering and Failing Traditional Support for the Elderly

In reviewing the sections on the aged and social welfare in Dixon (1987), authors from nine of the ten African countries featured in the book identified care of the elderly as the primary traditional responsibility of one of the following: "a/the family," "the care of the young," "the village and the state," and "family and community" (Dixon, p. 13, p. 173, p. 227, p. 258). Some of the authors indicated that a few small and insignificant social programs and income maintenance schemes exist for the (mostly) wage-employed retired worker. Older women represent only a minuscule segment of this limited group. Only the country of Zimbabwe provided information on how the elderly in different sectors cared for themselves or how the boundaries of personal social services are restricted and do not suffice to assist the elderly who are in need.

In some countries it is the tradition that sons are responsible for their mothers in old age. In practice, daughters-in-law assume the day-to-day role of caregivers. Also, as reported in Dixon (1987), there are traditional expectations that the young, relatives and kin, chiefs and elders, and the community are responsible for the care of older adults. As urbanization has increased, anecdotes are growing that more elderly are being neglected and isolated (Dixon, 1987). Fortunately, there is beginning public acknowledgment and recognition of the gap between traditional expectations of care of the elderly by families and communities and what actually happens for some older females and males. Sometimes the press highlights the matter, as was done in Zambia for example,

> We live in a world that discards the old like broken bottles, by denying old people a place in society we make rubbish of a valuable resource. And we don't realize what we are throwing away. (Debbie Taylor, [quoted in Dixon, 1987, p. 257])

Sometimes academicians as policy analysts can succinctly evaluate the current realities as do Balayoko and Ehouman when they report that

The breakdown in traditional values, the growing incidence of nuclear families and harsh economic circumstances have all resulted in less family support being available to the elderly in the Ivory Coast. Old people, particularly those in the rural areas, do not have recourse to formal support systems to fill the gap left by the withdrawal of family support. (Dixon, 1987, p. 84)

Whereas Nyanguru reports that in Zimbabwe ". . . many of the nation's elderly face severe economic hardship" (quoted in United Nations, 1991, p. 83).

There are no figures designating how many of these older African women are facing declining traditional support or if the situation of declining traditional support is currently at the level of a serious social problem. If, however, one is to accept that more women survive into old age than men, it is assured that they suffer from the gap between traditional expectations and traditional practices and the *present* realities and behaviors of sons, daughters, relatives, kin, and communities. (Certainly there has not been a 100-percent failure of traditional means of support.) What is emerging is that there are sufficient cracks in traditional and informal systems and sanctions to warrant social policy attention and action. Failure to recognize and act on these conditions only harms those in need and delays society's full development (Expert Group Meeting on Integration of Aging Elderly Women into Development, 1991; United Nations, 1991).

Discussion

Older African-American Women

Older African-American women are a heterogeneous group. They vary along a continuum from being well-off financially, to living in abject poverty. While it is the case that a far larger number occupy the latter condition than the former, within each extreme condition and along the continuum, African-American women require multi-faceted analyses of their life conditions.

The first section of this essay presented sociodemographic information on older African-American women and identified several policy issues they will face in the twenty-first century: the provisions affecting private pension plans in the areas of vesting rights and break-in service coverage; inequities in the social security system; the impact of divorce; and emerging caregiver concerns. Microlevel recommendations provide for older African-American women (a) to educate themselves about each of these issues; (b) to vote for those who will seek reform in private pension laws, the elimination of

inequities in the social security system, and family leave policies that include care of spouses, children, and parents; and (c) to educate and assist their community systems in developing programs and services related to the concerns of older African-American women. Macrolevel recommendations include (a) the need for legal and judicial remedies in divorce cases that recognize the older African-American women's contribution to the development of her household and family income; (b) the need for reform of the social security program to correct inequities to women workers; and (c) a proactive role by business to provide for caregivers.

Older African Women

Africa is not an undifferentiated mass. Thus, selected countries were used and composite portraits were draw of older African women. Certainly, it is recognized even with their broad effort, which is necessitated by the dearth of information on older African women, that like older African-American women, older African women are a heterogenous group. There cannot be a single entity that can be known as an African woman, older or younger.

Before briefly discussing the three areas identified for older African women, it must be pointed out that it is beyond the scope of this present effort to cover other vitally relevant and critical sociocultural and policy areas including but not limited to the following: maintenance laws and practices; violence against women; land tenure, use, and control; roles and status in changing environments; differences and similarities in rural and urban environments; the ubiquitous and brutal effects of colonialism and imperialism on women's lives; and refugee status in old age. As we look toward the twenty-first century, it will be interesting to observe how the current cadre of educated, professional, and/or activist African women thirty to forty years of age, who are advocating for (their versions) of change and liberation face their old age. Longitudinal studies of older African women could prove to be very informative for social policy and program development.

The three sociocultural and policy issues dealt with included the minorization of females/women, selected effects of development, and faltering and loosening traditional supports for the elderly. The legal entrapment of older African women by laws that restrict their fair share of property in the situation of divorce is unjust and unacceptable. Current laws require revision. Additionally, new laws are needed that provide for equity in the distribution of property and inheritance to the wife and husband.

The effects of development, especially in agriculture, are keenly felt by women. Changing socioeconomic realities coupled with changing sociocultural environments can place older African women in positions of extreme deprivation or exacerbate existing conditions of privation. Policymakers need to include older African women in decisions about agricultural developments as well as decisions on all facets of development affecting their opportunities to generate income. For example, as long as the informal economic sector (street vending, hawking, etc.) remain viable and in some cases the only income-generating sector for numerous women, they must have a say in protection of its continuance and regulation.

Finally, the faltering and failing traditional practices of support for the elderly was viewed. In the midst of sweeping social, economic, and cultural transitions (some would say revolution), it should not be surprising that traditions have been loosening around support of one's aged parents. Urbanization and economic realities force well-meaning daughters, sons, and relatives to feel overwhelmed by the demands on their limited incomes. Every society that faces urbanization encounters loosening of traditional and long-held social, familial, and relational ties (Rizer, Kammeyer and Yetman, 1979; Tischler, Whitten, and Hunter, 1986). What becomes important is whether the society shapes policy to take account of changing realities for its older women. Hence, some form of supplementation and/or substitution for family care becomes necessary. As the twenty-first century approaches, each of the countries cited herein must face its changing social landscape and the effect it is having on its older African women.

Conclusion

Several observations can be made from examining some of the twenty-first century sociocultural and policy issues older African women and older African-American women will encounter in their respective cultural contexts. Each must face the economic effects of divorce. Most women experience a drop in income/financial levels after divorce. This can be especially devastating to older women and to their life-styles as opportunities for income-generating activities decrease.

Numerous older African women can expect the effects of development to push them further into poverty—this may be especially the case with the impacts of structural adjustment programs (Dick, 1992; *Situation of Women and Children in Lesotho,* 1991). The continuing and deepening experiences of poverty among African women are

part of the devastating and haunting legacies of colonialism and imperialism (Dixon 1987; *Situation of Women and Children in Lesotho,* 1991; Nindi, 1992). Older African-American women face deepening poverty from a lifetime of racial discrimination that forces them into low-status, low-pay occupations and jobs with limited or no retirement pensions. Interestingly, both groups may likely face diminishing support from family and community. The critical difference is that older African-American women will be able to use formal sector income maintenance programs such as the social security system and/or supplemental security income programs. Though questions regarding the adequacy of payment levels in these programs must be raised, nonetheless, an income floor is available to this group.

In summary, no attempt has been made to force artificial similarities or dissimilarities on these groups, for instance, parallel sections were employed to present a portrait of each. The earlier point about juxtapositioning the two discussions without truncating their experiences into either/or dichotomies is here reiterated. Thus, one can read in each group's section sociocultural and policy issues the respective groups and their governments and societies will face in the twenty-first century. The intent has been to profile some issues older women of African descent, though separated by continental divides, will encounter as we enter a new century.

Notes

1. The terms *Blacks, Black Americans,* and *African Americans* are used interchangeably in this essay.

2. The other occupational categories include managers, sales workers, craft workers, laborers, farmers, and farm laborers (U.S. Commission on Civil Rights, 1990, pp. 137–38).

3. See Note number 2 for other occupational categories.

4. The Women's Equity Action League (as cited in the House Select Committee on Aging 1987, p. 20) reported the 3.1 and 5.1 median years for women and men, respectively. What is suggested by the recommendation ". . . . to provide for full vesting after three years' employment" (p. 20) is that policies be based on current realities of the labor force and not on the model of full-time long-term male employment patterns (Crawley, 1994a).

5. For a sampling of useful source materials, see Crawley, 1994; Levitan, 1990; Survivors, n.d.; and Understanding Social Security, n.d.

6. For a sampling of useful source materials, see Creedon, 1988; Myers, 1989, p. 120; and Older Women's League, 1989, p. 6.

7. Thus, the term *older African women* in this essay refers to the composite portraits garnered from the countries identified.

8. The Basotho (plural) are the people who inhabit the country of Lesotho in

southern Africa. The country of Lesotho is totally surrounded by the country of South Africa.

References

A Portrait of Older Minorities. (n.d.). Washington, D.C.: American Association of Retired Persons.

African Women Assess Role in Development. (1984). *Africa News* 22, no. 18, pp. 1–2.

Barnes, T. and E. Win. (1992). *To Live a Better Life,* Harare. Zimbabwe: Baobab Books, of Academic Books.

Bennett, C. E. (1993). The Black Population in the United States: March 1992. *U.S. Bureau of the Census, Current Population Reports, P20–471.* Washington, D.C.: U.S. Government Printing Office.

Crawley, B. (1994). Older Women: Policy Issues in the 21st Century. In L. V. Davis (Ed.), *Building on Women's Strengths: A Social Work Agenda for the 21st Century,* pp. 117–59. New York: Hayworth Press.

———. (1994b). "Twenty-first Century Socio-Cultural and Social Policy Issues of Older African American and African Women." Paper presented at the Women's Studies conference on Interdisciplinarity and Identity, University of Delaware, Newark, Delaware.

Creedom, M. (1992). "The Corporate Response to the Working Caregiver." *Aging* 358, nos. 16–19, p. 45.

Dick, M. (1992). Women and the Debt. *Women's Concerns Report,* no. 104 (September-October) 1–2.

The Disgusting Grabbers. (1993). *Africa—South & East* 35, no. 1.

Dixon, J. (Ed.). (1987). *Social Welfare in Africa.* London: Croom Helm.

Expert Group Meeting on Integration of Aging Elderly Women into Development. (1991). United Nations Office at Vienna, Centre for Social Development and Humanitarian Affairs, Division for the Advancement of Women.

Fackos, L. (1981). *Perspective on Aging* 10 (May/June): 19–21.

Fighting for Rural Rights. (1994). *Speak* 59 (April): 5–7.

Gales, C. (1994). *Valley of Plenty. Tribute* (February): 40–43.

Iya, P. Women and Law: An Analysis of Discrimination Against Women in Swaziland. In R. Leduka, K. Matlosa, and T. Pennale (Eds.). (1992). *Women in Development: Gender and Development in Southern Africa—Problems and Prospects.* Lesotho: Published in SAUSSC pp. 151–67.

Jackson, J. (1988). Aging Black Women and Public Policies. *Black Scholar* 19 pp. 31–43.

Leonard, F. (1987). *Divorce and Older Women.* Washington, D.C.: Older Women's League.

———. (1988). *Older Women and Pensions: Catch 22.* Washington, D.C.: Older Women's League.

Lesaoana, M. (1993). "Priorities on Gender Issues—The Case of Lesotho." Paper presented at the meeting for the Workshop Concerning Priorities for Research on Gender Issues, Windhoek, Namibia.

Levitan, S. (1990). *Programs in Aid of the Poor,* 6th ed. Baltimore: Johns Hopkins.

Lewis, R. (1991). Pension Risk Shifts to Workers. *AARP Bulletin* 32 (October): 1, 9.

Maintenance in Lesotho. (1991). Women in Southern Africa Research Project. Lesotho: Published by Women and Law in Southern Africa Research Project.

Mamashela, M. (1991). *Family Law through Cases in Lesotho.* Roma, Lesotho: National University of Lesotho.

———. (1992). Women's Property Rights in Lesotho: A Basic Right or a Privilege? In R. Leduka, K. Matlosa and T. Pellane (Eds.), *Women in Development: Gender and Development in Southern Africa—Problems and Prospects,* pp. 168–83. Lesotho: Published by SAUSSC.

Mwansa, L-W. (1992). Structural adjustment and the Question of Poor Urban Women in Zambia. In R. Leduka, K. Matlosa and T. Pellane (Eds.), (1992). *Women in Development: Gender and Development in Southern Africa—Problems and Prospects,* pp. 60–76. Lesotho: Published by SAUSSC.

Myers, J. (1989). *Adult Children and Aging Parents.* Dubuque, Iowa: Kendall/Hunt Publishing Company.

National Caucus and Center on Black Aged. (1985). *A Profile of Elderly Black Americans.* Washington, D.C.: Author.

Nindi, B. (1992). "Gender, Exploitation Development and Agricultural Transformation in Sub-Saharan Africa." *Eastern Africa Economic Review* 8, no. 2, pp. 123–34.

Ntimo-Makara, M. (1993). The Implications of the Socio-Cultural Environment for Women and Their Assumption of Management Positions: The Case of Lesotho. In *Southern Africa in the 1980s and Beyond.* Selected papers presented to the ISAS 10th Anniversary Workshop, Maseru, Lesotho, October/November.

Older Women's League. (1989). *Failing America's Caregivers: A Status Report on Women Who Care.* Washington, D.C.: Author.

Rempel, R. (1992). African Women and the Economic Crisis. *Women's Concerns Report,* no. 104 (September/October): 5–7.

Rizer, G., Kammeyer, and N. Yetman. (1979). *Sociology—Experiencing a Changing Society.* Boston: Allyn and Bacon.

Rude, D. (1993). "Horror Story of the In-Law Outlaws." *Africa South and East,* no. 35 (October): 35.

The Situation of Women and Children in Lesotho—1991. Lesotho: Ministry of Planning, Economic and Manpower Development, with technical and financial assistance from UNICEF Lesotho.

Staff. (1991). "Violence Against Women." *Women News,* nos. 7–8.

Survivors. (n.d.). U.S. Department of Health and Human Services Social Security Administration, SSA Publication no. 05–10084. Baltimore: Social Security Administration.

Tischer, H., P. Whitten, and D. Hunter. (1986). *Introduction to Sociology.* New York: Holt.

Understanding Social Security. (n.d.). U.S. Department of Health and Human Services Social Security Administration, SSA Publication no. 05–10024. Baltimore: Social Security Administration.

United Nations. (1991). *The World Aging Situation 1991.* New York: United Nations Office at Vinna, Centre for Social Development and Humanitarian Affairs.

United States. (1990). Commission on Civil Rights, Staff Report. *The Economic Status of Black Women: An Exploratory Investigation.*

———. (1983). Department of Commerce. Bureau of the Census. *General Population Characteristics. Part I. United States Summary.* Washington, D.C.: GOP.

———. (1987). House Select Committee on Aging. *The Status of the Black Elderly in the United States.* 100th Cong., 1st sess. Committee Publication no. 100–622. Washington, D.C.: GOP.

Young, C. (1989). "Psychodynamics of Coping and Survival of the African-American Female in a Changing World." *Journal of Black Studies* 20, pp. 208–23.

Zastrox, C. and K. Kirst-Ashman (1990). *Understanding Human Behavior and the Social Environment.* Chicago: Nelson-Hall Publishers.

Interdisciplinarity in Research on Wife Abuse: Can Academics and Activists Work Together?

Jacquelyn C. Campbell

There is very real distrust between domestic violence researchers and battered women's advocates. It might be said that this is a false dichotomy and that some activists work as academics and that some academics are activists. This is technically true in the field of domestic violence as in other areas of concern, but in this particular arena, most have chosen an identity for themselves as at least primarily one or the other. Even the terminology is different, with academics talking about "domestic violence" as a subspecialty under sociology or psychology, and activists describing their area as the battered women's movement. Some of the sources of this distrust are related to history, some to economics, some to gender issues, and some differing theoretical perspectives. Naomi Wolf (1993) might characterize the divisions along the lines of "victim feminism" versus "power feminism." But I do not believe it is that easy, and at the same time, I believe that the divides can and should and will be healed. Much of the distrust, I am convinced, is related to the difference between the everyday contexts that academics live versus that of activists.

Naomi Wolf's work is important here, because it identifies with young women currently in colleges and universities, sometimes more powerfully than the feminism we teach in women's studies. Wolf (1993) has many important insights, and I am both challenged and heartened by her call to seize this moment of opportunity to advance our feminist agenda and especially by her vision of a more inclusive brand of feminism. This is a vision particularly appealing to the young women I have observed in her audiences such as my own twenty-four year old daughter, Christy. At the same time, I react with deep ambivalence to her characterization of single-issue committed advocacy for women who have been harmed by male violence as "victim feminism." I agree with her stance of not concentrating on victimization and yet am concerned that she and her fol-

lowers may not understand all of the historical and pragmatic issues involved in that "victim first" concern. I know the battered women's movement best, having worked in its midst for the last fifteen years. There is much to say from that particular example of both the difficulties and the opportunities of interdisciplinarity and of the challenges of combining research with advocacy.

Herstory

It is important to start with the herstory. In the early 1970s, the antirape movement began in the United States. Building on the principles of feminism and on the horrible realities and needs of those violated, brave, and pioneering women, both survivors and not, organized together to provide services to their sister women. Shortly afterward and involving many of the same women, the battered women's movement began to emerge. As Susan Schecter (1982) powerfully recounts, these antirape and battered women's activists were primarily concerned with saving women's lives and with allowing them the space and support to rebuild their futures. Many were survivors of gender violence themselves. They were relatively short on analysis but long on courage, action, and organization. They obtained an amazing amount of significant local, state, and federal resources in a very short amount of time. They organized together in localities all over the country and built a grass roots battered women's shelter network that is still the primary lifeline for millions of abused women. It was a powerful movement and a powerful moment in herstory, and one that Naomi Wolf is too young to remember. We thought *that* was the "genderquake" that Wolf (1993) talks about.

Actually I wasn't really *there* at the beginning either. This is a personal story as much as a political analysis, in the best tradition of feminist analysis. As the battered women's movement was being born, I was busy in the middle-class white suburban world having babies. My own particular political focus was more related to the war on poverty and on the civil rights struggle, because my work world at the time was inner-city community health nursing. Racism and poverty seemed more relevant to both my work, as well as to my life than feminism.

However, as for most of us, the threads of our lives and of "herstory" come together in ways that seem amazing at the time, but on reflection seem inevitable. Through those common combinations of profession and personal realities and political forces, I came face-to-

face with the horrors of wife abuse, although fortunately not in my own life (only by chance, since research shows that there are no consistent demographic or personal risk factors that make one woman more likely to be abused than another) (Campbell et al., 1994; Hotaling and Sugarman, 1986). A young woman, Anne, was first one of my students, then a friend, and finally and horribly, became a statistic (Campbell, 1992). Anne was a victim of homicide, the number-one killer of young African-American women then in the late seventies and still now (DHHS, 1992). Homicide of women in this country and in most other countries usually involves battering of the woman before she is killed. I discovered that generalization through research into homicide of women for my master's thesis (Campbell, 1992b). Only after the fact, I discovered that ongoing abuse from her boyfriend, the father of her child, was the reality of that young woman's life. I discovered feminism at about the same time through the mentorship of my radical feminist nursing instructors. The only radical feminist nursing faculty in the late 1970s had been recruited to the same midwestern city as I was living in—an amazingly fortuitous convergence of time and place and people for me. And the battered women's movement was where it all came together, where the theory met the research and met the activism and met my personal life. Where one could learn from incredibly strong, intelligent, and powerful women who were really making a difference in people's lives.

The Research Tradition

Sociology was also discovering battered women, but the first sociologists in the field called it "family violence." There is a fundamental theoretical difference exemplified by that difference in language. Family violence connotes that these early sociologists saw wife abuse and child abuse as closely related phenomena (Straus et al., 1980). Many sociologists have also been educated in the family systems tradition, where if one family member is having a problem, the other family members are contributing to the situation. Both of these traditions are anathema to the cherished beliefs among activists that the batterer is totally to blame, and that wife abuse is more closely related to other forms of violence against women than to child abuse. Although many other sociologists conceptualize domestic violence from a strongly feminist viewpoint (e.g., Dobash and Dobash, 1979, 1992; Kurz, 1987; and Yllö and Bograd, 1988), that preliminary family systems perspective, closely aligned with traditional, and

more powerful, "science," came to represent academia in the perspective of many, if not most, activists.

Almost as soon as the media started to publicize battered women, we were faced with the specter of abused men. Back then, Phil Donahue was the only talk show host in the genre that is ubiquitous today, and the first program he did on wife abuse was groundbreaking. It brought the issue out from "behind closed doors." Thousands of women called the program and called their local shelters that day. Thousands more were inspired to start shelters in localities where they didn't yet exist. But "backlash" was almost immediate. In 1978, the media trumpeted the discovery of "husband abuse," and this was the result of research. The first national random sample of family violence, conducted by sociologists and federally funded partly because of feminist activism and concern for abused women, could be interpreted to show "husband abuse" to be as prevalent as wife abuse (Straus et al., 1980).

The scale (Conflict Tactics Scale) that was used in that research counts the number of aggressive behaviors committed as part of family arguments within a period of time (Straus and Gelles, 1990). Although it has been supported psychometrically, it does not take into account self-defense or degree of injury sustained as a result of these acts. Additionally, men tend to minimize the amount of violence they report, while women are more likely to be accurate (Saunders, 1988). Yet this scale is the most widely used in sociological research to measure violence between intimate partners (Straus and Gelles, 1990).

Battered women's activists were horrified at the first reports of husband abuse. Just as they were beginning to be successful in raising money for shelters and services, people were starting to argue to activists that men were equally victimized. The question "What about abused husbands?" became the dreaded daily staple of fundraising and informational presentations that continues to this day. This was the beginning of a deep distrust between the activists and the academic community.

Shelter Realities

In order to truly understand the depth of that division, I think you have to hang around a battered women's shelter for a while. For every well-established, well-funded wife abuse shelter there are many that are desperate for funding, which are deeply mired in that horrible cycle of many urban and rural social service agencies that is so common today (National Coalition against Domestic Violence,

1994). These are settings where you have to constantly write grants and constantly feel like your are "selling your soul" to funding agencies. They are places where you constantly have to reinvent and repackage your services to meet some new funding proposal guidelines. Agencies where payrolls are often not met because funding agencies work on a reimbursement basis, and their bureaucracy is slow and your staff is only one reimbursement check away from another payless payday. The staff are often underpaid, often single-parent women, only one paycheck away from total destitution themselves.

These are shelters that have served women for ten and twenty and twenty-five years. The staff *know* that they save women's lives every day. They do incredibly hard work, and they get paid very little. Their shelters are always facing imminent financial disaster, and they know of many that have closed. The battered women's activists have seen the rape crisis centers totally lose funding in many states and localities. They, deeply ashamed, have sometimes fought with the rape crisis activists for the same scraps from the table thrown to "women's" services in the late 1980s. The governor of Michigan made wife abuse his women's issue when he ran for office in 1990. What he failed to mention was that in his view, there could be only one women's issue for funding purposes, so he marginally increased state funding for wife abuse shelters but totally eliminated rape crisis center funding. When Naomi Wolf (1993) complains about the grimness of "victim" feminist rape crisis centers and wife abuse shelters, I don't think she realizes the depth of the problem. I don't think she realizes that it's not just a sense of humor that these activists lack.

Other Academic Strands

Meanwhile the battered women's movement looks at us in academia and says, all your research and your theorizing has hurt us as much as helped us. Another strand of research on battering was in psychology, the research attempting to answer the "why does she stay?" question. Lenore Walker's (1984) famous book on wife abuse painted battered women in the pathetic victim light. She applied the behavioral psychology framework of learned helplessness to battered women. Walker and other researchers in the same genre generated a list of battered women characteristics that are prevalent in the literature and in the public psyche today. Battered women were described as passive, blaming themselves for the abuse, usually unemployed, victimized as children, depressed, having low self-esteem, and so on (Walker, 1979). This is a picture of a woman perhaps to

be pitied but not to be respected. It is the portrait most often painted in the popular media. Although helpful in some ways in generating sympathy, and although supported by other research for some women especially at that far end of the continuum of abuse where torture is the more apt word (like the Hedda Nessbaum case), the learned helplessness paradigm didn't really square with the majority of abused women (Campbell, 1989; Campbell et al., 1994). The strong, resourceful battered women that activists were seeing in shelters and that nurses were seeing in health care settings weren't the same as the ones that psychologists were seeing in their offices.

A more current strand of research from psychology is the attempt to apply the diagnosis of Post Traumatic Stress Disorder (PTSD) in battered women. Several studies have documented that some abused women experience PTSD, especially those most seriously battered (Dutton, 1992). In some ways PTSD is a useful way to conceptualize the response of women as a normal response to a horrible situation. Yet it is still a psychiatric diagnosis and the temptation of professionals and the public is to pathologize abused women, as with any group more comfortably viewed as different. Diagnosing, labeling, and pathologizing serves to distance those "others" whose reality is otherwise uncomfortably close to our own. It also legitimizes and mandates "treatment" by professionals rather than the grass roots, support group model of intervention provided by shelters.

The learned helplessness and PTSD frameworks have been important in advancing our understanding of the psychological damage that violence can inflict. The research that has been conducted from those perspectives is often impeccable in terms of traditional science and has been instrumental in both increasing sympathy for abused women and for successful advocacy for some victims in the criminal justice system. Yet, at the same time, these frameworks are the research mother of the victimization feminism that Naomi Wolf (1993) has such problems with, and it is the legal mother of the battered women's syndrome legal defense and "diminished capacity" victimization defense.

Culture and Ethnicity

This thread of research was especially harmful to battered women of color. They tended not to look like "pathetic victims" or at least not to let on the extent of their pain. In many courtrooms across the country, African-American women who killed their abusive husbands did not fit the pathetic victim profile. They were often em-

ployed, usually assertive, and frequently had a history of fighting back. They might even have a record of other crimes. They weren't the "good victim" that fit the research that was meant to help them. As a result, they more often do time for killing abusive husbands (Mann, 1993).

Most of the research on battered women has ignored ethnicity (Torres, 1987). The battered women's movement tended to be white and middle class in its early days also, and has rightfully been critiqued for that. To its credit the movement early on addressed that. In 1981, the Women of Color Task Force of the National Coalition against Domestic Violence (NCADV) was formed in order to address complaints that the coalition had not used the talents of women of color in organizing the first national conference and in order to address issues of racism in the movement. Ethnicity in battered women's research was eight to ten years later in coming and is still seriously neglected.

Paternalism Personalized

There has been a paternalistic attitude toward the battered women's movement by many researchers that is perhaps best illustrated by the events surrounding the University of New Hampshire Family Violence Research conferences, the first in 1982, and the second in 1987. Battered women's activists were not invited to the first conference because they weren't on anyone's academic research list. They came anyway, challenged findings, and generally made their presence felt. In an attempt to be more inclusive, the second conference included two three-day sessions, the first a research conference with peer-reviewed research abstracts solicited and selected beforehand. Activists were invited to the second, where selected "researchers" were invited to present synthesis papers to the enraged activists, who felt they knew the issue better than the speakers.

From the experience at the second New Hampshire conference, an Activist Research Task Force was formed that made recommendations for future research questions that would be helpful to the activist movement as well as to researchers (Parker, 1988). Perhaps most distressing to battered women's activists have been the current critiques by scientists and policymakers that the shelters themselves have never been demonstrated by researchers to work. For activists who *know* that they save women's lives every day, and have been doing so for twenty years against almost impossible odds, it is galling to be told that you need a researcher to demonstrate your effec-

tiveness. It is especially disturbing to be told that your own efforts at evaluation have been insufficiently rigorous and insufficiently scientific. Recently, the anger has been rekindled by messages that new federal funding initiatives will prioritize research, rather than services, once again.

Nursing and Women's Studies

Nursing's experience in the battered women's movement and with wife abuse research has also been instructive. Nursing was first seen as part of the problem rather than part of the solution, as the "token torturers" of Mary Daly's (1979) analysis of violence against women by the medical profession. As was true of most of the early feminists, battered women's activists did not see nursing's struggles against medical oppression but only saw our second-class status. They saw the terrible treatment battered women were getting in the health care system (Kurz, 1987; Stark, Flitcraft, and Frazer, 1979), and figured we were equally to blame rather than relatively powerless to change it. But at least some nurses have been on the forefront of the attempts to make the health care system more responsive to battered women. Those of us who started the Nursing Network on Violence against Women in 1985, have gradually made that case to the battered women's movement (Campbell, 1994), but meanwhile, medicine has been persuaded to become involved. With its more extensive resources and political clout, the American Medical Association (AMA) has done much to change the health care system and has also generated much publicity in doing so. We in nursing are both thrilled to have our still more powerful colleagues on board and a bit resentful of their tendency to forget that anyone else has ever done work in the area. At the same time, academic nursing needs to work harder to align itself with other disciplines, such as women's studies, rather than primarily seeking interdisciplinarity with those in the health care professions, especially medicine. As oppressed groups tend to do, nursing has both identified most closely with (as well as most strongly reacted against) its primary oppressor. The ties with women's studies, perhaps nursing's most natural ally, especially in terms of women's health, have not been developed on many campuses.

Women's studies has sometimes been less than useful to the battered women's movement as well. As Naomi Wolf (1993) complains, the language and analysis and discourse of women's studies can sometimes be incomprehensible to women outside of academia,

both those who are activists and those who are abused. Whether a backlash phenomena or not, the most publicized strands of women's studies analysis of violence against women can be interpreted as polemic and male-bashing and hard for the public that the activists need so desperately for funding, to relate to. Unfortunately the public neither reads nor hears about the carefully reasoned analyses that scholars who call themselves "feminists" and often come out of women's studies departments put forward (e.g., Hamner and Maynard,1987; Radford and Russell, 1992; and Yllö and Bograd, 1988). Even those brilliant approaches can be interpreted as fundamentally antimale, a position that is particularly problematic for some women of color, for the general public, and for many young women. As Wolf says, we are losing our youth. My own twenty-one-year-old daughter finds Naomi Wolf's brand of feminism easier to identify with than the form she thinks her mother espouses.

Victim Feminism

One of the elements of Naomi Wolf's (1993) juxtaposition of "victim feminism" and "power feminism" is her analysis of cases where battered women kill. Although there are many problems with Wolf's division, she has identified an important conundrum that is part of the division between academics and activists. As Wolf states,

> For many women, most of the time, battering is exactly like enslavement; but not for all women, all the time. We can never waive a woman's moral responsibility for another life entirely, just as we can never entirely waive a man's. We need not convict, but we should be wary of a moral exoneration that seals the tomb on a women's will in the name of compassion. (Wolf, 1993, p. 210)

When I first read this passage, I immediately said that Naomi Wolf never knew a young woman I will call Denise. With Denise's permission, I will tell her story. Denise killed her husband after he had physically, sexually, and emotionally abused her for three years. She was pregnant three times and after being beaten during each pregnancy, miscarried three times. When she first tried to leave, her mother told her to try again. Other times that she tried to leave, Dan physically prevented her from doing so. Denise was packing, determined to leave for good the night she killed Dan. He was the first to pick up the rifle to threaten to kill her if she tried to leave and then put it down again to hit her. Denise felt like she wouldn't

be able to get past him and picked up the rifle to make sure she could get by him to the door. She doesn't clearly remember shooting, and thinks the rifle just "went off" as he came at her. The jury was not persuaded that she couldn't get by him with a gun in her hands and was not sure that she was really battered because there was no real documentation. Denise was convicted and is doing time.

Denise had access to things other women don't have. She is white, and if not middle class, at least not desperately poor. She is extremely attractive and very, very intelligent. It is true that not all women are enslaved by battering, but some women, at the far end of the continuum of abuse by virtue of various combinations of the nature of the abuse, the women's contextual reality, and her own characteristics such as relative youth or a history of victimization, may find it especially hard to see any choices. I see these women every day, in my research and in my advocacy work. Is acknowledging their "diminished capacity" in legal defense terminology "victim feminism" according to Wolf's terminology and abrogating our historic moment to make a difference?

Interdisicplinarity Future

Is there any hope for Denise and Christy and Hedda and me and Naomi to get together? I think all of our stories are instructive. First of all, we do need research. We need our psychological research to help us with the seriously traumatized, the Heddas. We cannot ever forget, not ever underemphasize the incredible pain of these survivors. But we need for it to emphasize strengths as well as weaknesses and to explore ways of building on strengths for healing. We need research to demonstrate the powerful effects of the shelter model, that women who have escaped abuse tell us has been the most effective yet has never been fully tested by "state of science" evaluation research (Bowker, 1983). All of the sophisticated techniques in a researcher's arsenal are needed to develop methods of showing that shelters work. At the same time, we need to discover what about shelters work, and be prepared for finding that not everything does. In addition, that research needs to be designed to go beyond traditional experimental methods and also include the contextual and the more in-depth stories. Thus, we need the best of traditional science and the best of the more interpretive tradition as well as the critique of women's studies, the concern for the interplay of affective, physical and community context of nursing research, and the activism of

the battered women's movement. Russell Dobash and Rebecca Dobash (1992) have perhaps described this kind of research best.

To help the Denises of this world, we need research toward expanding self-defense rather than emphasizing diminished capacity. The "reasonable man" standard has traditionally been used for establishing self-defense, where the archetypal scenario is two men fighting and the one is not justified in killing the other in self-defense unless he uses no more force than the other can (he can only use a gun if the other has one), and his "back is up against the wall"; there is no viable means of escape. We can approximate a power feminism by widening the self defense scenario to show that abused women may need a gun to equalize years of battering and that their escape avenues are blocked more by society than by the batterer. This has the potential to diminish the public and the professionals' assumptions of pathology about battered women and to increase their identification with them.

Sophisticated battered women-activists are realizing that sound statistics are very helpful in changing policy. The kind of research I am talking about is more than "using the master's tools." It is using the wonderful developments in feminist and action research methods to show what activists need to be shown in order to get their stable funding, to mainstream their services. It is research methods that have moved beyond the traditional, that are truly *for women*, which are nonhierarchical. Shulamith Reinharz (1992) gives us many models to do so. It is research that is truly interdisciplinary, not only between and among the various academic disciplines but with the battered women-activists and the women that they serve. It is research that is truly partnership research.

I see a future where interdisciplinarity includes not only academic types across disciplines like nursing and women's studies, but research efforts that include activists and battered women themselves *and* our youth. Interdisciplinarity means we academics join our colleagues in working at the shelters and in the schools to prevent battering as well as the other partners collaborating in using our scholarship. And interdisciplinarity means working from the viewpoints of all our different cultures and classes and sexual orientations. It's an exciting possibility!

References

Bowker, L. (1983). *Beating Wife Beating*. Lexington, Mass.: Lexington Books.

Campbell, J. (1989). "A Test of Two Explanatory Models of Women's Responses to Battering." *Nursing Research*, 38, pp. 18–24.

———. (1992). "Ways of Teaching, Learning, and Knowing about Violence against Women." *Nursing and Health Care* 13, pp. 464–70.

———. (1992b.) If I Can't Have You, No One Can: Power and Control in Homicide of Female Partners. In J. Radford and D. Russell (Eds.), *Femicide: The Politics of Woman Killing*. New York: Twayne Publishers.

———. (1994). "Nursing and the Battered Women's Movement." NCADV *Newsletter*.

——— et al. (1994). "Relationship Status of Battered Women over Time." *Journal of Family Violence* 9, no. 2, pp. 99–112.

Daly, M. (1979). *Gyn/Ecology*. New York: Beacon.

Department of Health and Human Services. (1990). *Healthy People 2000*. Washington, D.C.: United States Department of Health and Human Services.

Dobash, R. E., and R. P. Dobash. (1979). *Violence against Wives*. New York: The Free Press.

———. (1992). *Women, Violence, and Social Change*. London: Routledge.

Dutton, M. (1992). *Empowering and Healing the Battered Woman*. New York: Springer.

Hamner, J., and M. Maynard. (Eds.). (1987). *Women, Violence and Social Control*. Atlantic Highlands, N.J.: Humanities Press International.

Hotaling, G., and D. Sugarman. (1990). "A Risk Marker Analysis of Assaulted Wives." *Journal of Family Violence,* 5, pp. 1–3.

Kurz, D. (1987). "Emergency Department Responses to Battered Women: Resistance to Medicalization." *Social Problems* 34, pp. 69–81.

Mann, C. (1993). *Unequal Justice: A Question of Color*. Bloomington: Indiana University Press.

National Coalition Against Domestic Violence. (1994). *Voice*. Fall, pp. 20–21.

Parker, B. (1988). "New Perspectives on Family Violence Research." *Response* 11, no. 3, pp. 17–18.

Radford, J., and D. Russell. (1992). *Femicide: The Politics of Woman Killing*. New York: Twayne Publishers.

Reinharz, S. (1992). *Feminist Methods in Social Research*. New York: Oxford University Press.

Saunders, D. (1988). Wife Abuse, Husband Abuse, or Mutual Combat? A Feminist Perspective on the Empirical Findings. In K. Yllo and M. Bograd (Eds.), *Feminist Perspectives on Wife Abuse*, pp. 90–113. Newbury Park: Sage.

Schecter, S. (1982). *Women and Male Violence*. Boston: South End Press.

Stark, E., A. Flitcraft, and W. Frazier. (1979). "Medicine and Patriarchal Violence: The Social Construction of a 'Private' Event." *International Journal of Health Services* 9, pp. 461–493.

Straus, M., R. Gelles, and S. Steinmetz. (1980). *Behind Closed Doors*. Garden City, N.Y.: Anchor Books.

———, Straus, M. and R. Gelles. (1990). *Violence in American Families*. New York: Transaction Press.

Torres, S. (1987). "Hispanic-American Battered Women: Why Consider Culture Differences?" *Response* 10, no. 3, pp. 20–21.

Walker, L. (1984). *The Battered Woman Syndrome*. New York: Springer.

Wolf, N. (1993). *Fight Fire with Fire*. Toronto: Random House of Canada.

Yllö, K. and M. Bograd. (1988). *Feminist Perspectives on Wife Abuse*. Newbury Park, Calif.: Sage.

Rebecca West's Traversals of Yugoslavia: Essentialism, Nationalism, Fascism, and Gender

BONNIE KIME SCOTT

Dedicated today, as it was when first delivered in an early
version in December, 1992:
To the beleaguered people of Bosnia.

As an author who wrote in eight decades of the twentieth century,
adapting and reacting to various political and artistic "isms,"
Rebecca West is of strategic value for interpreting contemporary
culture. West was diversely British. Raised in London and Edin-
burgh, she was the child of an Anglo-Irishman and a Scottish mother
who had met in Australia. In addition to her Celtic strains, at various
times she also claimed Berber and Slavic blood (see *Family Memories*).
Her father deserted the family when she was eleven, and so West
spent much of her youth in a female household, composed of her
mother and three sisters. Perhaps it was uncertainty of her cultural
status that made her take on the commanding discussion of art and
politics, as one way to claim her place in culture.

West's epic study of Yugoslavia, *Black Lamb and Grey Falcon,* was
published in 1941, in an effort to take its "inventory down to its last
vest-button" (letter to Wollcott) just ahead of the Nazi invasion in
the early stages of World War II. West writes as an English woman
traveler, though as Larry Wolff has pointed out, not as one who
privileges Western Europe. Furthermore, she straddles the supposed
divide between art and politics. West saw these as inextricable, from
her teen years when she wrote for feminist, socialist, and avant-
garde publications. When Doris Lessing was trying to write in oppo-
sition to nuclear proliferation in the 1970s, she turned to *Black Lamb
and Grey Falcon* as a reference, showing that, with at least one other
author, West's model worked. As the world has watched the agoniz-

320

ing dissolution of Yugoslavia on ethnic and nationalist grounds, *Black Lamb and Grey Falcon* has again become recommended reading.

West became committed to Yugoslavia in 1936, while lecturing mostly to English-speaking clubs there for the British Council. Her autobiographical account combines what she learned from several visits, including a later one with her husband, Henry Andrews. He survives in the book as a partner in conversations, whose knowledge of architecture comes in handy. Through the 1940s, West and Andrews entertained and even briefly housed Yugoslavian refugees at Ibstone, their country home in Berkshire, and helped them organize politically. West resisted British acceptance of the communist, Tito, as the leader of Yugoslavia in the postwar years, favoring Serbian colonel Dragoljub Mahailjlovic. He was originally the choice of the monarch in exile, and had a history of fierce resistance to the Croatian fascists, who were responsible for the mass slaughter of Serbs, in the last episode of Yugoslavian carnage.

Black Lamb is a confounding work, frequently shifting focus and form. H. G. Wells, West's lover for a tumultuous decade, had complained of her tendency to combine wonderlands with history; this was in 1922, toward the end of their liaison (p. 100). But her unusual combination of history and imagination may have worked to best advantage twenty years later. In moving from Croatia south to Montenegro, West's account oscillates from recording realist detail to reading cultural symbols, from dialogue with companions to essentialist generalizations. She breaks categories with strikingly different analogies, playing upon gender and domestic images. West makes an introductory foray into gender, protesting it as an overdetermined binary. Still, she uses it to set her own goal of intellectual sanity:

> Idiocy is the female defect: intent on their private lives, women follow their fate through a darkness deep as that cast by malformed cells in the brain. It is no worse than the male defect with is lunacy: they are so obsessed by public affairs that they see the world as by moonlight, which shows the outlines of every object but not the details indicative of their nature. (p. 3)

The thought occurred to her in 1934, as she lay in a hospital bed, susceptible to the "archaic outlook of the unconscious," upon hearing of the assassination of the Yugoslavian king. It was the quotation admired by Lessing, who wanted to use it in her own writing. With her authoritative voice, deployment of essentialism, and nostalgia for underlying primitive values, West may arouse the postmodern feminist reader's resistance.[1] But we also find something useful, as

she had hoped, when she went on with a work that offered little prospect of financial reward, and obsessed her for five years of her life, qualifying as a "preternatural event" (letter to Wollcott).

West's favorite theme (shared with D. H. Lawrence) is that life-giving philosophies are preferable to the sacrificial ones she finds in both Christian and Muslim rites. In Montenegro she watches a Muslim ritual, commemorating fertility. Two lambs in succession are sacrificed atop a bloody rock, by drawing a knife across their throats. Many pages later she recollects one victim in greater detail: "the lamb forcing out the forceless little black hammer of its muzzle from the flimsy haven of the old man's wasted arms" (p. 914). West makes an equation to Christianity: "All our Western thought is founded on this repulsive pretence that pain is the proper price of any good thing. Here it could be seen how the meaning of the Crucifixion had been hidden from us, though it was written clear" (p. 827).

Confronted daily by newspaper accounts of atrocities and having gone over the same ground she did via a series of sieges—Dubrovnik, Sarajevo, and Gyorazde (which received its most serious Serbian incursion the day this paper was delivered)—we can use West's work for insights into the dynamics of nationalism and imperialism. Her interest in these subjects comes mainly in association with the many incursions of empires into the Balkan region, set as it is amid Eastern Europe, Western Europe, and the Near East. The inside back cover of the 1943 Viking edition of *Black Lamb* offers a geographical patchwork of various provinces of Yugoslavia, which since the fall of communism have been breaking apart roughly along provincial lines. In the "key" to the map's variegated hatch marks, West registers the comings and goings of dominions from 1800 onward, within borders set for the "Kingdom of Serbs, Croats, & Slovenes" following World War I. Her historical coverage includes the infamous defeat of the Serbs by the Turks at Kossovo in 1389—an event that still haunts the Serb leader, Slobodan Milosevic as a major defeat of his people by Moslem Turks. It was featured recently in a *New York Times* explanation of the Serb point of view. This article, "Through the Serbian Mind's Eye" by John Kifner, featured a 1917 painting that clearly mixed gender and nationalism. Titled "The Maiden of Kossovo," it shows a woman in richly embroidered robes, ministering to a fallen Serb, who is handsomely reposed on a dead Moslem figure, his bald head face down, still clasping a sword.

The utility of women enhancing masculine strength and a celebration of national embroidery figure in West's account, as in a negative way does the urge toward sacrifice in war. Inconography is just as strong in the grey falcon of West's title, taken from a poem on the

fateful battle of Kossovo. It was used to commemorate the flight of the child-king Peter Karageorgevitch II out of Yugoslavia in 1940, both by Serbs and in West's epilogue. In West's account, some days before the Nazi invasion, the youth renounced his regent, Prince Paul, and joined in a state coup, defying the pact of appeasement signed with Hitler by Yugoslavian ministers. The grey falcon that had once been a symbol of mortal sacrifice, made with the prospect of heaven, became in West's epilogue a promise of life, reasserted on earth. King Alexander Karageorgevitch, the father of King Peter II, had been assassinated in 1934 by fascist forces in Marseille, an event that had marked the beginning of West's fascination with Yugoslavia. He might live again through his young son's flight. Were she alive today, I think that West might be a proponent of Alexander Karageorgevitch, Crown Prince of Yugoslavia, as a healing force for that troubled nation. This is a role he welcomed in August 1992, through the Op-ed page of *The New York Times*.

Balkan violence in West's youth involved a series of murdered Austrian royalty—the most famous being Archduke Franz Ferdinand, gunned down by a Serb in Sarajevo, in an incident that many think sparked World War I. West visited the site and recorded the "pathetic fallacy" of a river running red. Brought to her fascination with royalty, West's interest in psychology and dysfunctional families makes for a series of outstanding character studies in *Black Lamb and Grey Falcon,* richly blending art and politics so as to fill in the masculine defect of working merely from outlines. To West, one of the most poignant losses was the Austrian empress Elizabeth, whom she retrieves from obscurity. She sees her as a life force and a liberal thinker who "should have gone on and medicined some of the other sores that were poisoning the [Austro-Hungarian] empire" (p. 4). She could not because "the medium for her work, her marriage, was intolerable" (p. 5). West takes her assassin, Lucceni, as the first fascist, a product of "new towns which the industrial and financial developments of the nineteenth century had raised all over Europe" in the interest of the rich, and "careless of the souls and bodies of the poor" (p. 612). "The new sort of people [had] been defrauded of their racial tradition, they enjoyed no inheritance of wisdom" (p. 612). Behind this statement, I see the formula of a positive national identity, differentiated from the deadly fascist uses of nationalism. Despite his Serbian identity, I have no doubt that West would place the communist-trained Milosevic in this fascist category today, as Anthony Lewis has done in a memorable series of articles in the *New York Times*.

West was not immune from the imperial patterns she traced in

Yugoslavia. On her first visit, as a lecturer for the British Council, she was, in effect, a representative of her nation in postimperial outreach. She filed a required report on the cultural groups and government officials she met with, suggesting how the council could best match future speakers with their audiences in specific locations. She used the word "propaganda" straightforwardly, realizing that this was what the fledgling council was about. She warned of the competition between Serbs and Croats, even in English clubs, and suggested that with diminishing French interest in the area, there were opportunities for British influence. Col. Charles Bridge, the official of the British Council who had received her report, urged the BBC to broadcast portions of what was to become *Black Lamb and Grey Falcon,* reasoning the "conditions make it important to do everything possible to increase British influence." West was not just striving for an advantage over the French; she was clearly feeding skepticism of Nazi Germany to the public as a national, if not an imperial, project. Through the 1940s and early 1950s, West's writing on treason and on communist infiltration of the British and United States governments made her look like a sympathizer of Joseph Mc-Carthy, to many eyes. Dame Commander of the British Empire, the title granted West in 1959, shows her embrace by a nation still proffering imperial credentials, though she has said that she assumed the title to enhance the prestige of women journalists.

Despite that eventual honor, West's relation to Britain was restive. As early as 1913, in the essay "Trees of Gold," West posed herself as a young suffragette journalist in flight from British politics. The account begins, like *Black Lamb and Grey Falcon,* on a train; it mixes genres and designs, combining spiritual autobiography, travel essay, and critiques of capitalism and Christianity. In the "fierce splendor" of the "burning valley and naked hills" of the Pyrenees (p. 572), and in trees glowing with a fungus that was destroying them, she had found the forms of beauty and passion she had always worshiped, but never found in Britain. Yugoslavia was another such departure. Her skepticism of empires in *Black Lamb* extends in the epilogue to Britain, that "bustling polychrome Victorian self . . . that would assume, at a moment's notice and without the slightest reflection the responsibility of determining the destiny of the most remote and alien people" (p. 1115). She reviews the theory that the British Empire existed to bring order to the disordered parts of the world, and despite the fact that her father and sister had held this view very strongly, she finds it "more than half humbug." Times have also changed, and she suggests that "long ago it became untrue that peoples presented any serious damage because of backwardness; the

threat of savagery has for long lain in technical achievement" (p. 1090). She does relate positively to one set of participants in empire—"common people" who thought of themselves as adopting "the standpoint of chivalry" when, moved to action they "fought plagues and flood and drought and famine on behalf of the subject races, and instituted law courts where justice, if not actually blind when governors and governed came into conflict, was as a general rule blindfolded" (p. 1090).

Among Yugoslavs, West admired the Serbs more than the Croats because they had defied empire, first with the Turks and in World War II with the Nazis. But, unlike any Serbian general I have ever heard of, West identifies as feminine a basic strategy for Yugoslavian survival under its various invaders. She suggests that Slavs have twice "played the part of . . . woman in the history of Europe." The woman she has in mind is one who resists by yielding. Though he "takes possession of her and perhaps despises her for it . . . suddenly he finds that his whole life has been conditioned to her." He "has not conquered her mind, and . . . he is not sure if she loves him, or even likes him, or even considers him of great moment." She may even have let him into her life "because she hated him and, wanted him to expose himself" for her own despising (p. 301–2).

One of the things West valued most in Yugoslavian cities was multiculturalism, even though this is indisputably a product of imperialism. She shares her mid-thirties train ride into Yugoslavia with German vacationers—modern businessmen already edgy about Nazi intentions. The German tourists, unlike her, are heedless of local culture. Gerda, the German wife of her Serbian host, proves aloof to the Slavic art West appreciates. West assigns Gerda to a supranational, capitalist category of parasitic woman—a group she had condemned since her early socialist writing for the *Clarion*. She also feels "feminist outrage" at a war memorial visited with Gerda, where mothers of slain boys served as caryatids. West noted with dread the recent disposition of a wreath by officials of Nazi Germany (p. 488).

The first ethnic group West meets in any numbers are the Croatians. In her general assessment, she apprehends a lasting cultural servitude on the part of the Croats to the decadent Austro-Hungarian Empire. This earns her disrespect; indeed, Croatian collusion with the Germans in the early stages of World War II led to internecine atrocities. As just noted, the Serbs are more admirable to her for defiance of empire; she credits them with helping to contain the march of the Ottoman Empire into Europe.

Though the Turks play villains in the parts of her account that relate to imperialism,[2] they are an asset to Yugoslavian culture, as

she presents it. She records the beauties of Sarajevo as a city of a hundred minarets, with a Moslem bazaar whose stuffs say "Yes" to the idea of brightness, and whose tranquil sensuality is of Moslem origin (pp. 298, 314). West's careful observation reveals how inseparable the Muslims are from Bosnia, casting doubt on the current wave of "ethnic cleansing." She watches a Moslem woman drinking Turkish coffee in a café. "When she was not drinking she sat quite still, the light breeze pressing her black veil against her features. Her stillness was more than the habit of a Western woman, yet the uncovering of her mouth and chin had shown her completely un-Oriental, as luminously fair as any Scandinavian" (p. 297). Not only Slavs were converted to Islam in this province. Under Turkish domination, the Bogomils, a Manachian heretical sect, could pursue a faith denied them by both Roman and Orthodox Catholic churches, according to West, who accuses agents of the Pope of forced expatriation of Bogomils.

West's guide through Yugoslavia is another manifestation of blended cultures. Patterned on an actual official named Stanislaw Vinaver, who was both a poet and journalist, the fictional Constantine is a Serbian Jew who ironically had married the German ultranationalist just described. It is probably multiculturalism that compels West to write her long study: "It is precisely because there are so many different peoples that Yugoslavia is so interesting. So many of these peoples have remarkable qualities, and it is fascinating to see whether they can be organized into an orderly state" (p. 662).

There are other reasons related more clearly to her own sense of needs as a woman alienated somewhat by modern British culture. Early in *Black Lamb and Grey Falcon,* West's persona proclaims that "everything we don't have in the West is there." Near the end, she finds that Yugoslavia "writes obscure things plain, which furnishes symbols for what the intellect has not yet formulated" (p. 914). By being "dear to the primitive mind," it is vital also to her, since the primitive mind is the foundation of the modern mind (p. 914). West's assumptions and borrowed discourses here require a great deal of unpacking. Her sense of the human mind is multistoried, and contains the primitive; she is most aware of that component when ill. Yet she also seems enormously nostalgic for some primitive phase of lost simplicity, including strong expressions of masculinity and femininity. She celebrates the virility of shipbuilders in Korchula, who "could beget children on women . . . [and] shape . . . materials for purposes that made them masters of their worlds" (p. 208). In *Black Lamb,* as in letters written home from American cities, the bespectacled men of urban modernity come off poorly in

comparison.[3] The clarity of her vision achieved in Yugoslavia may only be an incapacity to grasp the subtleties of an unfamiliar system of cultural signs. Still West set what she saw as remarkable qualities of the Yugoslavian people into a series of brilliant short portraits, many of the best featuring women.

The women of Yugoslavia emerge for West as individuals, despite cultural impositions that are far from utopian. She is haunted by one who hauled a heavy piece of farm machinery into town, walking beside her unencumbered husband. She visits with Astra, a skillful belly dancer, whose professional dangers are apparent to West. Their talk is managed despite the objections of her prudish native chauffeur. She hails women-embroiderers as spiritual, creative artists, favoring designs that have not become influenced by German encroachment. She detects women's subjection to patriarchal religion and attitudes toward sex. In one heavy, grotesque ritual dance garb, she sees evidence of "a society that has formed neurotic ideas about women's bodies and wants to insult them and drive them into hiding" (p. 673). She often finds women salvaging something for themselves. West watches a fertility rite in which a succession of women embrace a rock. Despite the sameness of this ritual, and the patriarchal rule that they be "undifferentiated female stuff, mere specimens of mother ooze," West interprets their gestures as highly individual (p. 803).

West finds a working compromise in "picturesque symbolic rites, such as giving men their food first and waiting on them while they eat." West suspects "that women such as these are not truly slaves, but have found a fraudulent method of persuading men to give them support and leave them their spiritual freedom." With the fraudulent abasement of their women, "men will go on working and developing their powers to the utmost." Though West seems nostalgic for the conditions of the most flourishing ethnic pockets of Yugoslavia, she cannot and would not go back.

West suggests that in contemporary Western culture, women lose, whether they abase themselves or not. During the depression, when women support the family, "their husbands became either their frenzied enemies or relapsed into an infantile state of dependence." But abasement is also risky since it abnegates economic and civil rights. In new urban cultures, employment is so insecure that women's "sacrifice" alone cannot hope to restore men's "primitive power" of productivity. Women also risk abandonment by a man no longer tied to one village, and able to take the next train to a new job (p. 330). Ultimately, West would do away with fraud between the sexes.

West's *Black Lamb and Grey Falcon* assumes its place among more famous modernist texts, such as T.S. Eliot's *The Waste Land,* which worried over the new order of culture. West senses the importance of working out of the deadening influences in twentieth-century culture, such as the mass identifications bereft of living traditions that she detected in fascism. She ponders the spiritual survival of individual women, playing at games of gender, where there was no clear winner.

West admires the spirit of an elderly woman, encountered on a road looping up a mountainside in Montenegro, whose life had mirrored the human toll of Yugoslavian history, from the time that her first husband was slain by Austrians in 1914. Though she was offered help by West and by her guide, Constantine, she replied that she had all she needed. And she had a purpose that quelled even the doubts the English woman traveler may have had about her own purposes:

> I am walking about to try to understand why all this has happened. If I had to live, why should my life have been like this? If I walk about up here where it is very high and grand it seems to me I am nearer to understanding it. (p. 1012)

It was not the achievement of understanding, but the seeking of it, that West celebrated in this wise old woman, and carried on.

Notes

1. See, for example, Loretta Stec's unpublished dissertation, "Writing Treason: Rebecca West's Contradictory Career" (New Jersey: Rutgers University, 1993). Stec is working out a scripting for this aspect of West, along the lines of nostalgic nationalism. West shares the word "primitive" with the anthropology and art history of her day.

2. For a corrective of West's interpretation of Moslem politics in Yugoslavia, see Richard Tillinghast.

3. For a discussion of West's ambivalence about homosexuality, and her sense of a gradual shift toward antifeminism among less virile men, see my *Refiguring Modernism,* Vol. 2: *Postmodern Feminist Readings of Woolf, West, and Barnes* (Bloomington: Indiana University Press, 1995), 149–63. Aspects of this article are presented in that work, within the context of her contribution to literary modernism.

Bibliography

Karageorgevitch, A. (1992). "Punish Serbia's Rulers, Not Its People." *The New York Times* Op-Ed, 11 August 1992.

Kifner, J. (1994). "Through the Serbian Mind's Eye." *New York Times*, 10 April 1994, D1, 5.

Scott, B. K. (1995). *Refiguring Modernism*, vol 2: *Postmodern Feminist Readings of Woolf, West, and Barnes*. Bloomington: Indiana University Press.

Tillinghast, R. (1992). "Rebecca West and the Tragedy of Yugoslavia." The New Criterion (June): 12–22.

Wells, H. G. (Ed). (1984). *H.G. Wells in Love*. London: Faber & Faber.

West, R. (1943). *Black Lamb and Grey Falcon*. New York: Viking.

———. (1989). *Family Memories*. Faith Evans (Ed.). New York: Penguin.

———. (1941). Unpublished letter to Alexander Wollcott (April), Harvard University.

———. (1936). Unpublished letter to Colonel Charles Bridge, British Council (May 1936), British Council Archive.

———. (1990). Trees of Gold. In B. K. Scott (Ed.), *The Gender of Modernism*. Bloomington: Indiana University Press, 570–73.

Wolff, L. (1991). "Rebecca West: This Time Let's Listen." *New York Times Book Review*, 10 February, 1, 28–30.

Afterword

Tʜɪs volume expands a legacy in women's studies scholarship of breaking new ground in interdisciplinary work and in applying the results to "real-life" problems. The work housed here attests to the vigor in theory development and transformation of methodologies that characterize scholarship in women's studies. It is precisely the growth in theory and method that has provided the tools required to translate the academic into action. This volume represents a small fraction of the myriad ways in which women's studies has served as a springboard for change.

Despite a strong emphasis on alteration of the status quo, feminist scholars do not stand outside disciplinary training and historical position. Yet, as we grapple with complex questions, many of us reject the narrow and artificial structure of the individual discipline in our search for more thorough answers.

This volume has not addressed the issue of whether women's studies is interdisciplinary or multidisciplinary. The focus instead has been on women's studies as the juncture where many disciplines join in the discussion of "gender," and this we call interdisciplinarity. At times we speak clearly from one discipline and incorporate some aspects of other disciplines. Sometimes we create a blend of theory or methods that sparks a synergy that moves the discussion farther along. As we move into the twenty-first century, we operate most often as a quilt pieced from many disciplines. The creators of this volume seek to replace the patchwork with a woven fabric of scholarship.

Contributors

KAREN BOJAR is a Professor of English at the Community College of Philadelphia. She holds a Ph.D. in English literature from Temple University, and an M.S. in education from the University of Pennsylvania. She has a second career as a community activist in women's and educational advocacy organizations. She has integrated her activist concerns with her teaching and has developed a service-learning course that provides credit to students for volunteer experiences.

JOY BOSTIC's diverse educational background contributes greatly to her dialogue concerning issues of interdisciplinarity. Bostic holds an undergraduate degree in philosophy and received a juris doctor and master's degree in public policy and management. Finally, she has earned a master of divinity degree and is an ordained Baptist minister.

Currently the Anna D. Wolf Endowed Professor of Nursing at Johns Hopkins University, JACQUELYN C. CAMPBELL has been both an activist and an analyst during her thirteen years of involvement in wife-abuse research. She served on the Board of Directors for Women in Transition, a wife-abuse shelter in Detroit; was Vice President of the Federated Council of Domestic Violence; and served on the Women's Justice Center Board of Directors for My Sister's Place Battered Women's Shelter. Campbell is the recipient of many prestigious awards and grants, including the Wayne State University President's Award for Excellence in Teaching.

SUZANNE CHERRIN holds a Ph.D. in sociology and is an Assistant Professor in the Women's Studies Program at the University of Delaware. Her research focuses on gender equity and international women's experiences. She teaches undergraduate women's studies courses including, International Women's Studies. Her recent activities include spearheading campus and regional activities following the U.N. Women's Conference held in Beijing, 1995. She became interested in researching women and breast cancer when she was diagnosed with breast cancer in 1993.

BRENDA KIPENZI JOYCE CRAWLEY completed her undergraduate degree in sociology at California State University-Northridge and received an M.S.W. and Ph.D. at the University of Illinois-Urbana-Champaign. As a recipient of the competitively awarded Gerontological Society of America Research Fellowship, Crawley conducted a minority elderly needs assessment. She serves on two editorial boards and is presently a Fulbright Scholar on assignment at the National University of Lesotho, developing a Master's Program.

BLANCHE RADFORD CURRY is an Assistant Professor of Philosophy at Fayetteville State University in North Carolina. She is a graduate of Clark Atlanta University and holds a Ph.D. from Brown University. Her research and teaching areas include Social and Value Enquiry, African-American Philosophy, Feminist Philosophy, and Multicultural Theory. She is an assistant editor of the American Philosophical Association's Newsletter on Philosophy and the Black Experience, and a member of the editorial board of *Hypatia: Journal of Feminist Philosophy.*

ELLEN GOLDSMITH directs the Center for Intergenerational Reading in the Developmental Skills Department at New York City Technical College/CUNY. A poet, she has twice received Creative Incentive awards from the City University of New York. Writing poems about her breast cancer experience was a way to avoid the marginalization that serious illness can bring and a way to transform her experience. The next logical step, which her article describes, was to use the poems to bring awareness of the emotional dimensions of illness to health care professionals.

SONJA JACKSON holds a B.S. in radiologic sciences and an ED.M. in higher and adult education. She is currently a doctoral student in the Department of Higher and Adult Education at Teachers College/Columbia University. The article she has coauthored with Ellen Goldsmith is her way of breaking her own silence about the dichotomy that she sees existing between the hardware of medical technology and patient care.

ROBERT W. JENSEN joined the University of Texas faculty in 1992, after completing his Ph.D. in the School of Journalism and Mass Communication at the University of Minnesota. He teaches media law and ethics, qualitative methods and critical theory, and newspaper reporting and editing. He has nine years of professional journalism experience. In his research on media law/ethics/politics,

Jensen draws on feminist theory, critical legal studies, and cultural studies. Past research has focused on pornography and the feminist critique of sexuality. He is coeditor of *Freeing the First Amendment: Critical Perspectives on Freedom of Expression*.

JOHN KELLERMEIER is an Associate Professor of Mathematics and a Women's Studies Teaching Associate at SUNY-Plattsburgh. He has been teaching statistics for sixteen years and women's studies courses for six years. His research interests are gender and cultural issues in mathematics and feminist pedagogy and curriculum inclusion for teaching mathematics and statistics. He has published papers widely, including work in the area of incorporating issues of cultural diversity into teaching statistics.

MARY Y. MORGAN received her Ph.D. in home economics education from the University of Missouri-Columbia in 1980. Presently, she is an Associate Professor and Director of the Undergraduate Programs in the Department of Human Development and Family Studies at the University of North Carolina-Greensboro. She teaches undergraduate and graduate courses, and her research interests focus on feminist approaches to research methodologies, particularly interpretive inquiry and critical science. In 1992, she won the Outstanding Teaching Award in the School of Human Environmental Sciences. Morgan has published widely, including articles in *Journal of Marriage and the Family, Psychology of Women Quarterly*, and *Journal of Divorce*.

VICTORIA J. O'REILLY writes and speaks on women's roles in musical life in the United States. Her work has received support from the National Endowment for the Humanities. Her research interests include late nineteenth- and early twentieth-century New England women-composers, women's orchestras, and women's participation in New Deal music programs. She has been active as a performer, teacher, and arts administrator, and currently is Public Relations and Development Associate of the National Older Women's League. In addition, she serves on the board of Capitol Composers Alliance, and is a member of the American Federation of Musicians, Local 161–710. She holds an M.A. in public policy with a concentration in women's studies from George Washington University and a bachelor's in mathematics from Smith College.

CARLA PETERSON's area of research and teaching interests are in nineteenth-century African-American literary culture. She has co-

authored an essay on Frederick Douglass's journalism, and an essay on the development of the African-American novel in the 1850s. Within this general area her field of expertise lies, however, in the literary and cultural production of black women as exemplified in two essays, "Further Liftings of the Veil: Gender, Class and Labor in Frances Harper's 'Iola Leroy'" and "Unsettled Frontiers Race, History, and Romance in Pauline Hopkins' 'Contending Forces'" and in her book *Doers of the Word: African-American Women Speakers and Writers in the North* (1830–1880). She is on the faculty at the University of Maryland.

Born in New York City in 1936 and having spent her youth in the New Mexican desert, MARGARET RANDALL left this country in her midtwenties. For the next twenty-three years, until her return in January 1984, she lived in Mexico, Cuba, and Nicaragua. She worked as a midwife, translated Latin American prose and poetry, and became involved in the women's movement. Her travels took her to Vietnam, Peru, and Chile. Throughout her twenty-three years in Latin America, Randall spoke and wrote about women's lives and people's culture, wrote poetry, and shared the poetry of others.

SUE ROSSER received her Ph.D. in zoology from the University of Wisconsin-Madison in 1973. She has served as Director of Women's Studies at the University of South Carolina since 1986, where she is also Professor of Family and Preventive Medicine in the Medical School. She has edited collections and written approximately fifty journal articles on the theoretical and applied problems of women in science and women's health. She also served as the Latin and North American coeditor of *Women's Studies International Forum* from 1989 to 1993.

BONNIE KIME SCOTT is a Professor of English and Women's Studies at the University of Delaware where she regularly teaches courses on modernism, British literature, women-writers, feminist theory, and Irish literature. She has written two feminist studies of James Joyce, *Joyce and Feminism,* and *James Joyce,* in the Harvester Feminist Readings Series. She is the general editor of a critical analogy, *The Gender of Modernism,* a collaborative project involving eighteen contributors and twenty-six modernists, most of them neglected women-writers. Her newest work is a two-volume study, *Modernism;* vol. 1, *Women of 1928;* and vol. 2, *Postmodern Feminist Readings of Virginia Woolf, Rebecca West, and Djuna Barnes.*

KATHLEEN DOHERTY TURKEL is an Assistant Professor of Women's Studies at the University of Delaware where she received her bachelor and master's degrees in political science and her doctorate in urban affairs and public policy. Her research focuses on childbirth, birthing centers, and reproductive technologies. She teaches undergraduate women's studies courses including Motherhood in Culture and Politics, Women and Work, and Introduction to Women's Studies. Her first book was *Women, Power, and Childbirth: A Case Study of a Free Standing Birth Center*.

ALMA WALKER VINYARD is an Associate Professor of English and immediate past chair of the Africana Women's Studies Program at Clark Atlanta University. She has also taught at Governor's State University, Knoxville College, and in the Chattanooga Public School System. She has lectured and written on such topics as nineteenth-century African women's autobiographies, women of the Harlem Renaissance, values clarification, multiculturalism in literature, and language attitudes.

Index

actions: transformative, 82–86
activists: black, 113; domestic violence and activists, 308
Activist Research Task Force, 314
Adams, Margaret, 55
African American feminism, 77–78, 81–82, 262–65; theories, 274–78
African American women, 98–99; age and location, 286; and caregiving, 293; demographics of, 285–90; and divorce, 292–93; and domestic violence, 313–14; and economic development/status, 287–94, 297–300; elderly, 300–301; and family life, 291; marital status, 286; as minorities, 295–97; older, 294–304; pensions of, 287–90; and policy issues, 285–305; poverty status, 286; and Social Security, 290–91; sociodemographics of, 294–95
African Americans: in math and science, 263–64
AIDS, 215
Alchemy of Race and Rights, The (Williams), 149
Alexander, King, 323
All the Women are White, 125
Alsop, Marin, 128–29
American Cancer Society, 182, 183, 184, 195, 198, 199, 200
American Chemical Society, 253
American College of Nurse Midwives, 231
American Journal of Public Health, 185
American Medical Association, 315
American Musicological Society, 126
American Women Composers, 122
AMNLAE, 62, 67, 68, 69, 70, 72, 73
AMPRONAC, 63
Anatomy of an Illness (Cousin), 191
Anderson, Benedict, 112
Anderson, Laurie, 125
Andrews, Henry, 321

Anthony, Susan B., 46, 112
antifeminist movements, 50
Antonia: A Portrait of the Woman, 121
Aptheker, Bettina, 78
Arney, W. R., 218, 219

Baltimore Sun, The, 184
Baltodano, Mónica, 66
Bambara, Toni Cade, 147, 152
battered women, 308–18; history of, 309; shelters for, 301–12
Bay Area Woman's Philharmonic, 125, 128
Beethoven, Ludwig von, 125
Beloved (Morrison), 116
Berry, Mary Frances, 49
Bhavnani, Kum-Kum, 98, 100
biological determinism, 268
birth: accounts of , 222–26; beliefs about, 221; medical model of, 219–34; professionalism and, 228–36; statistics on, 218–35; technology of, 222; woman and, 222–33
black aesthetic tradition, 146, 147, 151, 152
black feminists, 140; defined, 99, 100; identification of, 96; self-definition of, 96
black women, 109–17; 144, 185; and breast cancer, 185, 199; social activities of, 110
Black Lamb and Grey Falcon (West), 320–24, 326, 328
black liberation theology, 144, 145
black studies, 110–11
"Black Women" (hooks), 103
black women, 114, 116, 138; experiences of, 142; history of, 113–14; as musicians, 124; oppression of, 142; and slavery, 90
Black Women in American Bands and Orchestras (Handy), 124

337

Eisner, Elliott, 205, 206
Eliot, T., S., 328
Elizabeth, Empress, 323
Ellis, Susan, 36
Elsea, J., 79
empowerment, 159–71
epistemology, 78
Epstein, Selma, 126
Equal Employment Opportunity Commission, 48
Espinosa, Luisa Amanda, 67
essentialism, 77, 78; problems of, 76
essentialist feminism, 265–66
ethnomathematics, 242, 245–51
Eurocentrism, 263, 264
existentialism, 268, 271
existentialist feminism, 266

family dynamics, 275
fathers, 25; responsibilities of, 49–53
Feminine Endings (McClary), 127
Feminine Forever (Wilson), 190
feminism, 16, 19, 20, 21, 24–32; in Nicaragua, 63–64; postmodern, 272–74, 275; psychoanalytic, 269–70, 275; radical, 270–72; socialist, 258–62; victim, 316
feminist musical scholarship, 118–36
Feminist Mystique, The (Friedan), 99
feminist practice, 76–86; black, 78
feminist research: features of, 105; limitations of, 105
feminist studies, 110
feminist theories, 15, 16, 19–32, 76–86, 274; black, 78; radical, 275; white, 157
feminists: of color, 76–86, 97, 98; cultural, 16, movement, 70; multinational, 99; problems of, 98–99, white, 80–86, 98; women's rights, 16
Fennema, E. and G. Leder, 241
fetus, 219
Fields, Rona, 100
First You Cry (Rollin), 196
Fones-Wolf, Ken, 53
Ford, Betty, 198
Foucault, Michel, 218
Fountain of Age, The (Friedan), 38
Franz Ferdinand, Archduke, 323
Freud, theories of, 267, 268
Friedan, Betty, 38, 99
Friedman, Deborah, 126

FSLN, 62, 63, 66, 69, 70, 72, 73
Fugh-Berman, Adrienne, 194–95

Gage, Matilda Joslyn, 47
Gardner, Kay, 122
Gardner, Tracey A., 139
Garnet, Henry Highland, 113
Garrison, William Lloyd, 112
gays, 72, 73
Gender and Mathematics (Burton), 241
gender: bias, 257; construction, 268; politics, 22; relations, 24–26
Gifts of Power (Walker), 140
Gilligan, Carol, 48
Gold, Doris, 39
Goldsmith, Ellen, 206, 210, 214
Grant, Jacquelyn, 142
Green, Judith Mary, 78
Greenpeace, 188
Grimke, Sarah M., 54
Grounding of Modern Feminism, The (Cott), 47, 48

Hampton Institute, 51
Handy, D. Antoinette, 124
Hansberry, Lorraine, 145, 146
Harding, Sandra, 106, 118
Harper, Frances, 109, 112, 116
Hay, Louise, 191
Heal Your Body (Hay), 191
health science education, 215–16
"HealthWords for Women," 190
Helicon Nine, 125
Herman, Judith Lewis, 71
Heresies, 125
Hewitt, Nancy, 52
Hispanics, in math and science, 264
history, study of, 118
History of Woman Suffrage, The (Stanton et al.), 47
hooks, bell, 85, 98, 100, 110–11
Hopkins, Patrick D., 23
hospitals, and childbirth, 222–26
Hot Wire, 125
Hudson-Weims, C., 98
Hull, Margaret C., 95
Hull House, 53
Human Genome Initiative, 258
human rights, violated, 52

identity, 83
identity politics, 20, 21

Mills, Amy, 128
Milosevic, Slobodan, 322, 323
Mind Over Cancer (Richardson), 191
Monteverdi, Claudio, 125
Montini, Theresa, 193
Moral Majority, 50
Morrison, Toni, 116
"Mother Teresa Syndrome," 41, 42, 51
motherhood, 49, 50
"Mothers of Heroes and Martyrs," 63
multiculturalism, 85, 92; in Yugoslavia, 325
music: feminist scholarship in, 123–24; in women's lives, 119
musicology, 119
Musicology and Difference, 127

National Breast Cancer Awareness Month, 189
National Breast Cancer Coalition, 200, 259
National Cancer Institute, 184, 193, 194, 205, 260
National Organization of Women, 39, 40
National Summit on Breast Cancer, 200
National Women Composers Resource Center, 125–26
National Women's Health Network, 194
National Women's Studies Association, 128
National Women's Symphony, 128
Naylor, Fred, 84
Near, Holly, 126
Nessbaum, Hedda, 313, 317
Neuls-Bates, Carol, 121
New England Women's Symphony, 122, 125
New York Times, The, 123, 195, 322, 323
Newsweek, 127
Nicaragua, 57–74; living conditions in, 61; feminist movements in, 72; women in, 61, 71
Nochlin, Linda, 121, 130
Northampton Association, 112
Northern Ohio Soldier's Aid Society, 50
nurse midwives, 231; certified, 229; direct entry, 229; lay, 229; statistics of, 230
nursing, 315–16

Nursing Network on Violence against Women, 315

Oakley, A. and S. Houd, 220, 226, 227
object relations theory, 268
obstetricians, 214, 221; knowledge of, 221–22
Older Women's League, The, 185
"On Losing My Hair," 207
Operation SMART, 262
oppression, 142, 144, 157, 162, 259; defined, 156; male, 16, 22; methodologies of, 143; of women, 270–71
Ortega, Daniel, 70

Page, L., 227
Paid My Dues, 121, 125
Park, Shelly M., 85
patriarchy, 15, 143
Paul, Prince, 323
peasants, 68; in Nicaragua, 60
personal accountability, ethics of, 83
Perspectives, 206, 207
Peter II (Yugoslavia), 323
Platt, Mary Frances, 41
Politics of Parenthood, The (Berry), 49
Pool, Jeannie G., 118
positivism, 271
postmodernism, 273
Post Traumatic Stress Syndrome, 313
pregnancy: care during, 226; outcomes of, 220; tests during, 220
primary prevention, 227
Prince, Nancy, 109
Protecting Soldiers and Mothers (Skocpol), 47
psychoanalysis, 271
psychosexual development, 268

racial divides, and volunteerism, 52
racism, 17, 53, 157, 160–69, 170, 264; women's, 81
Ran, Shulamit, 129
Randall, Margaret, 17
rape, 16, 29, 30, 58
rapist ethics, 28, 30, 31
"Reach to Recovery," 195, 196
"Recent Research and Popular Articles of Women in Music" (Bowers), 121
Redmond, Sarah Parker, 109
Reich, Nancy B., 124, 125